Cultural Encyclopedia of the Breast

Cultural Encyclopedia of the Breast

EDITED BY **MERRIL D. SMITH**

ROWMAN & LITTLEFIELD
Lanham • Boulder • New York • London

Published by Rowman & Littlefield
A wholly owned subsidiary of The Rowman & Littlefield Publishing Group, Inc.
4501 Forbes Boulevard, Suite 200, Lanham, Maryland 20706
www.rowman.com

16 Carlisle Street, London W1D 3BT, United Kingdom

British Library Cataloguing in Publication Information Available

Library of Congress Cataloging-in-Publication Data
Cultural encyclopedia of the breast / edited by Merril D. Smith.
 pages cm
 Includes bibliographical references.
 ISBN 978-0-7591-2331-1 (cloth : alk. paper) — ISBN 978-0-7591-2332-8 (electronic)
 1. Breast—Social aspects. I. Smith, Merril D., 1956–
GT498.B74C85 2014
391.6—dc23 2014025509

∞™ The paper used in this publication meets the minimum requirements of American
National Standard for Information Sciences—Permanence of Paper for Printed Library Materials,
ANSI/NISO Z39.48-1992.

Printed in the United States of America

CONTENTS

Preface ix

Acknowledgments xi

Introduction 1

Chronology of Selected Breast Events 5

Advertising 9

Aging 12

Amazons 13

Ancient Physicians 14

Anne of Austria (1601–1666) 15

Areolae 16

Art, Indian and African 17

Art, Western 19

Avon Foundation for Women 22

Baartman, Saartje (c. 1770s–1815) 24

Barbie Dolls 25

Beauty Ideals, Nineteenth-Century America 28

Beauty Ideals, Renaissance 30

Beauty Ideals, Twentieth and Twenty-First-Century America 32

The Beauty Myth 33

Bible 35

Body Image 36

Bra 38

Bra Burning 38

Brassiere 39

Breast Anatomy 41

Breast Augmentation 44

Breast Binding 45

Breast Cancer 47

Breast Cancer Support Groups 50

Breast Cancer Treatments 53

Breastfeeding 57

Breastfeeding, in Public 61

Breast Milk 63

Breast Milk, as Food Ingredient 65

Breast Milk, Donation/Banking/Selling 66

Breast Milk, Expression of 67

Breast Mutilation 68

Breast Orgasm 70
Breast Reconstructive Surgery 71
Breast Reduction 73
Burney, Fanny (1752–1840) 74
Celebrity Breasts 76
Controversies 79
Corsets 82
Cosmetics 84
Cosmopolitan 85
Cross-dressing, in History 87
Cross-dressing, in Literature 88
Dance 91
Décolletage 94
Doulas 95
Eating Disorders 97
Esquire 101
Exercise 102
Fashion 103
Female Action Heroes 107
Female Superheroes 108
Feminism 109
Fertility Symbols 111
Flappers 113
Flashing 115
Folies Bergère 116
Frederick's of Hollywood 118
Freud, Sigmund (1856–1939) 119
Gender Affirmation Surgery 121
Gynecomastia 123
Hiding Places 126
Hollywood 127
Hooters 128

Hormonal Therapy 129
Hormones 130
Hygiene 132
Iconography 134
Implants 136
International Cultural Norms
and Taboos 137
Intersex 141
Jacob, Mary Phelps
(1891–1970) 144
Klein, Melanie Reizes
(1882–1960) 145
Kourotrophos Cults 146
La Leche League 147
Linnaeus, Carolus (1707–1778) 148
Literature 149
Love, Susan (1948–) 152
Maidenform 154
Mammograms 155
Man Bra 157
Mastectomy and Lumpectomy 158
Mastitis 159
Media 160
Models and Modeling 163
Modesty 166
Mother–Infant Bond 168
Movies 170
Music, Popular 174
Mythology 176
Myths 178
Nipples 180
Obesity 182
Pasties 184

Photography	185	Sports Bras	227	
Pink Ribbon Campaigns	187	Stereotypes	228	
Pinup Girls	190	Striptease	229	
Playboy	192	Susan G. Komen for the Cure	231	
Politics	193	Television	233	
Pornography	195	Theatre	235	
Postpartum Breasts	198	Topless Beaches	237	
Pregnancy	200	Topless Dancing	239	
Prostitution	201	Topless Protests	240	
Puberty	203	Training Bras	242	
Public Art	205	Transgender/Transsexual	243	
Race and Racism	207	Transvestite	245	
Red Light Districts	209	Undergarments	250	
Religion	211	UNICEF	252	
Rochester Topfree 7	213	Virgin Mary	254	
Rousseau, Jean-Jacques (1712–1778)	214	War	256	
Russell, Jane (1921–2011)	215	Weaning	259	
Saints and Martyrs	216	Wet Nursing	260	
Sculpture	218	Wet T-Shirt Contests	262	
Sexism	221	Witch's Teat	264	
Slang	222	Womanhood	265	
Slaves, as Sex Objects	224	Women's Movement	268	
Slaves, as Wet Nurses	225	Wonderbra	270	
		Yank, the Army Weekly	272	

Selected Bibliography 275
About the Editor and Contributors 285

PREFACE

THE BREAST has always been a subject of cultural fascination, if not obsession. Technically, breasts are two fatty protuberances on our chests by which female humans feed their young, yet in reality, they are so much more. This encyclopedia is the first to broadly examine the cultural aspect of this body part and cultural obsession.

Breasts have been displayed in works of art throughout the world, as sensual objects, as part of religious images, and in celebrations of motherhood. The naked breasts of Minerva, Marianne, and Columbia appear in iconic images and statues representing freedom and victory. Breasts have appeared or been discussed in literature and plays from ancient times to the present. They can be seen in movies, on television, on websites, and in advertisements. As fashions have changed over the centuries, breasts have been accentuated or minimized. Since our earliest history, women—and some men—have endured, been treated for, and died from breast cancer. News of breast cancer, breast cancer treatments, and pervasive Pink Ribbon campaigns are now covered by media sources throughout the world. In the United States, and increasingly in other parts of the world, support and services for women with breast cancer are growing, but often such services are inadequate. Because there are so many cultural aspects to the breasts, the encyclopedia is an ideal format for covering the topic.

This volume is aimed at general readers and students who desire to learn more about breasts and breast-related issues. Each entry includes "further reading" for those who want additional information. A timeline of breast events follows the introduction to this book. At the end of the book, there is a resource guide that includes a selected bibliography, along with a list of websites and movies with breast themes.

The international group of scholars involved in the compiling of this volume come from many fields of study, including medicine, sociology, literary, media and gender studies, history, and art. They have made it possible to cover the 141 entries in this encyclopedia. The entries include key terms, events, concepts, organizations, incidents, movements, procedures, and influential works associated with breasts from prehistory to the present. Although I have tried to be as thorough as possible, not every breast-related topic can be covered comprehensively in a one-volume encyclopedia. The entries in this encyclopedia

emphasize the United States, particularly contemporary U.S. culture; however, entries of historical and global significance have also been included.

This encyclopedia is an A-to-Z (or, more precisely, A-to-Y) compilation that covers the culture of the breast from antiquity to the present. In general, subjects are listed under their most common or popular name. Each entry explains the term and describes its significance to breasts. A list of related topics follows each entry.

ACKNOWLEDGMENTS

THANK YOU to so many people! Wendi Schnaufer originated this project at AltaMira Press. In an odd confluence of events, she asked me if I would be interested in taking on the project without knowing that I had recently undergone treatment for breast cancer. Of course, I was interested! With much appreciation, I want to thank editors Andrea O. Kendrick and Leanne Silverman, who took over the project somewhat at the last minute and, after playing some "catch-up," saw it to completion.

I could not have completed the project without the help of the 44 amazing scholars who contributed articles for this book. Some of them stepped in at the last minute to take on writing entries, and many of them wrote multiple entries. I have enjoyed corresponding with all of you.

Daughters Megan Smith and Sheryl Smith read through lists of headwords, offered suggestions, and contributed to numerous discussions of breast-related issues. Husband Douglas Smith offered love and support—particularly as I faced my own ordeal with breast cancer. Doctors Charles J. Butler, Alexis Harvey, and David Ross cared for and treated me with professional skills and doses of humor. My friends and my "gym buddies" also rallied around me after I was diagnosed. I'll never forget the love and support I felt from all of you wonderful women!

Several friends and other family members suggested topics, movies, websites, and other material that should be included in the book. I'm certain I've forgotten some, but at least a partial list includes Lori Schreiber, Megan Smith, Sheryl Smith, Gayle A. Sulik, Edyta Zierkiewicz, Guy Pridy, Jon Geisler, John Duffy, John Scanlon, William Leonard, Bobb Kurinka, Penny Cipolone, and, from the Albright College theatre community, Jeffrey Lentz, Cocol Bernal, Jared Mason, Clark Runciman, and Eric Began.

INTRODUCTION

BOOBS. BOOBIES. Tits. Hooters. Knockers. Jugs. Breasts. We celebrate them; we revile them. They nourish us; they kill us. They have fascinated us since prehistoric times. Unknown craftsmen and women in the Stone Age created figurines with massive breasts, most likely as fertility idols. Renaissance masters painted thousands of images of breastfeeding Madonnas. Today, magazine covers and Internet sites feature celebrity women with extensive cleavage. Breasts, both covered and exposed, appear in advertising, on television, in movies, and in theatres all over the globe. Breasts are displayed during striptease acts. They are mutilated by disease and hate. They are increased and decreased through the use of undergarments, hormones, and surgery. Grocery aisles, advertising circulars, and even American football fields are filled with pink ribbons that claim to support the "war" against breast cancer, while women—and men—continue to die from the disease. Throughout the world, there are debates over how and when breasts should be exposed. Breasts are banal, common, and corporeal. Breasts are extraordinary, remarkable, and exciting. Breasts are ubiquitous.

Humans are obsessed with breasts, and rightly so. Since the dawn of human history, the breast has been the first source of nourishment and comfort. Thus, there is the maternal breast. Breasts also serve as objects of lust and desire, the sexual breast. Breasts have been displayed or hidden according to cultural mores and fashion, the fashionable breast. Breasts have been prodded, treated, and removed, the medical breast. Breasts have been lauded and displayed, the creative breast.

Ancient peoples sculpted figurines with enormous breasts and hips. One such figurine carved from the 6-inch tusk of a mammoth was found in a German cave in 2008. Scientists believe it is at least 35,000 years old, and it may be one of the oldest sculptures ever discovered. Although we do not know why the artist of long ago was moved to carve this figurine with large breasts, it might be a fertility symbol. In any case, artists have been painting, sculpting, and photographing breasts ever since.[1]

The idea of a breast encyclopedia makes people laugh, grimace, or drool, or perhaps all three. The words "breast" and "breasts" evoke many diverse ideas and images, and these images and ideas sometimes overlap. (For example, for some the image of a lactating breast, typically a symbol of maternal love and devotion, is deeply erotic. There is even a subgenre of pornography devoted to lactation.) As Ellen Cole and Esther D. Rothblum write about breasts, "The truth is, the 'not very nice' is hopelessly interwoven with the

1

'nice,' and together the two form a fuller picture of who and what we are. People giggle, get embarrassed, and/or become overwhelmed by cleavage because breasts are the subject of a cultural obsession."[2]

Breasts are unique. They are the only part of the body associated with both sexual attraction and sexual reproduction—*and* also found on both women's and men's bodies, unlike the penis and vagina. The nipples of both women and men are often stimulated as part of sexual activities, and even breastfeeding, which is associated with female breasts, is possible for some men.[3]

Human breasts are distinct. They are different in shape and size from the mammary glands of other mammals. Evolutionary biologists have debated the hows and whys of human breast development. Some argue that large breasts in women developed to attract men. Large breasts, which are large in part because they hold more fatty deposits, may have signaled to early humankind that a woman was fertile and healthy. Other scientists believe that female human breasts developed to feed human babies. Unlike many other creatures, human infants are born fragile and must be held to their mother's chests with their necks supported so they don't break. Protruding breasts with moveable nipples make it easier for our babies to nurse, and their flat faces, lacking a snout, would have found it difficult to suck a nipple while pressed up against a flat chest. It may be that human breasts evolved both to feed human babies and to attract possible mates. In either case, they are a marvel of design and function.

Breast facts: the average breast weighs about one pound. The left breast tends to be larger than the right breast—often, one breast is about 39.7 milliliters bigger than the other. Breasts expand during menstrual cycles. During pregnancy, milk glands grow and expand, then shrink after a baby is weaned. As science reporter Florence Williams has written, "The breast must construct and deconstruct itself over and over again with each pregnancy. It's like Caesar's army, making a camp city and then breaking it down on its relentless march across Gaul."[4]

Breasts are designed to provide milk to infants and breastfeeding benefits to both mothers and children. Breastfeeding shortly after delivery assists in shrinking the uterus back to its original size. Breast milk provides infants with both nutrition and antibodies. The World Health Organization estimates that "about 800,000 child lives" would be saved each year if every child was breastfed exclusively from birth through the first two years of their lives. Yet most children around the world—more than 60 percent—are not breastfed exclusively for the first six months of life. Many women do not breastfeed or do not continue breastfeeding because they lack support, are unable to do so while working, and/or face problems when trying to do so in public.[5]

Some women fear that breastfeeding will make their breasts droop or become ugly. Some find that lactating breasts are not sexy to their partners, or feel coerced to give up the practice. Throughout history, however, some women have relied upon extended breastfeeding to space the births of their children, either because of religious or cultural proscriptions against breastfeeding women engaging in sexual intercourse or because ovulation is normally suppressed while a woman breastfeeds regularly.

Throughout the ages, the human body—or certain aspects of it—has been idealized. Women and men have attempted to conform to the beauty standards of their particular time and place. Breasts have been exposed and covered, enhanced and diminished.

European men who encountered the naked breasts of African and Native American women were excited or repulsed by real or perceived differences in body shapes. Since ancient times, women who have been enslaved, whatever their race, have served as sex objects for their masters. Sex trafficking and slavery still exist, and the breasts of sex slaves belong to the people who "own" the women. Enslaved women have also served as wet nurses for the children of their masters; sometimes these women have been forced to neglect their own infants' needs.

The development of photography in the late nineteenth century, and then the creation of modern advertising and media—movies, magazines, television, and websites—have helped to spread new fads more quickly, as well as ideals about beauty. Women's breasts are used to sell products of all sorts—food, cars, and entertainment. In most cases, the women's bodies have nothing to do with the product being sold; they are there simply to attract viewers and potential buyers. Through the proliferation of these images, the current ideal body type for women is one of large (but perky) breasts on thin frames, small waists, and slightly curvy hips. Seeing these often unrealistic and unattainable images, which are often Photoshopped, some women are dissatisfied with their own breasts and want to change them. Changes in medicine and surgical techniques have made it easier for women to make their breasts larger or smaller. Yet women who have had mastectomies have also had the option of having their breasts reconstructed. Transmen and transwomen can also choose to receive hormonal treatments or surgical procedures to increase or decrease their breast size.

Breasts are not only objects of desire and maternal love. In the United States, few can be unaware of breast cancer. Many of us know at least one person who has had it, and about one in eight women will develop invasive breast cancer sometime in their lifetime. The American Cancer Society estimates in 2013:

- About 232,340 new cases of invasive breast cancer will be diagnosed in women.
- About 64,640 new cases of carcinoma in situ (CIS) will be diagnosed (CIS is non-invasive and is the earliest form of breast cancer).
- About 39,620 women will die from breast cancer.[6]

In the United States, increases in mammography and Pink Ribbon–induced breast cancer awareness have led to early diagnoses of small tumors that would not have been found otherwise. Yet, in many cases, these tumors will not increase or expand beyond their boundaries. Because they have been found, however, they are treated—usually by lumpectomy and radiation. But medical researchers are now debating if these treatments are necessary in all cases, and if they might, in fact, be harmful. It is unclear which cancers will spread; however, and despite the increased number of breast cancer cases found through screening, women with invasive breast cancer die at nearly the same rate as they did fifty years ago. Cancer within the breast is easily treated, but metastatic cancer, or cancer that has spread to other parts of the body, can occur a decade or more after a woman has been treated for early-stage breast cancer.[7]

In many parts of Africa, the rates are grimmer. In Uganda, for example, women are often not treated until they have Stage 4 breast cancer, thus dramatically decreasing their chances of survival. Activists there do not seek increased mammography because there

are not enough technicians to provide or read the X-rays, and treating small tumors that might not develop would divert resources from women who have large invasive growths. Poverty and lack of knowledge about breast cancer and resources often prevent women from seeking treatment. Mastectomies are more common there than in the United States because women do not seek treatment until the tumors are large, and many women cannot get the follow-up radiation or chemotherapy often recommended after a lumpectomy. Women often keep the disease or treatment a secret because many people believe that one-breasted women are witches, or that their cancer has been caused by a witch. The side effects of chemotherapy, such as hair loss, changes in skin pigmentation, and weight loss, are similar to those that people with HIV/AIDS experience, thus producing additional barriers to breast cancer treatment.[8]

In the process of writing and editing this book, I have learned much about breasts. Like most women, I have struggled to find a bra that fits correctly, and I have wished at times that my figure was somewhat different, and my breasts larger or smaller. As most women probably do, I watched my breasts begin to grow at puberty. I watched them grow even more during my two pregnancies, and I was awed by my ability to feed my daughters with the milk that flowed from them on demand. Nature is truly amazing. I was shocked to become a member of the club nobody wants to join, or, as author Judy Blume referred to it, "the Sisterhood of the Traveling Breast Cells."[9] Despite these experiences, I did not really know about breasts until I started working on this book. It is my profound hope that readers are educated and enlightened by what they read in this volume, which expands upon some of the topics I have referred to in this introduction. And if readers also giggle as they read, that is perfectly all right with me.

NOTES

1. Claire Ellicott, "Carved Figurine Dating Back 35,000 Years Oldest-Known Sculpture (. . . and Yes It Is of a Naked Woman), *Daily Mail Online*, May 15, 2009, http://www.dailymail.co.uk/sciencetech/article -1181357/Carved-figurine-dating-35-000-years-mans-oldest-known-sculpture---yes-naked-woman.html (accessed November 5, 2013).

2. Ellen Cole and Esther D. Rothblum, *Breasts: The Women's Perspective on an American Obsession* (New York: Routledge, 2012), viii.

3. See, for example, Michael Thomsen's quest to breastfeed, "Man Milk: My Curious Quest to Breastfeed," *Slate*, May 25, 2011, http://www.slate.com/articles/health_and_science/medical_examiner/2011/05/man_milk.html (accessed November 5, 2013).

4. Florence Williams, *Breasts: A Natural and Unnatural History* (New York: Norton, 2012), 48, 49.

5. World Health Organization, "10 Facts on Breastfeeding," updated July 2013, http://www.who.int/features/factfiles/breastfeeding/en (accessed April 28, 2014).

6. Quoted from American Cancer Society, "What Are the Key Statistics about Breast Cancer?" http://www.cancer.org/cancer/breastcancer/detailedguide/breast-cancer-key-statistics (accessed November 6, 2013).

7. Gayle A. Sulik, *Pink Ribbon Blues: How Breast Cancer Culture Undermines Women's Health* (New York: Oxford University Press, 2012), 159.

8. Denise Grady, "Uganda Fights Stigma and Poverty to Take on Breast Cancer," *New York Times*, October 15, 2013, http://www.nytimes.com/2013/10/16/health/uganda-fights-stigma-and-poverty-to-take-on -breast-cancer.html (accessed November 5, 2013).

9. Judy Blume discussed her breast cancer diagnoses and treatment in a blog post, "!@#$% Happens," *Judy's Blog*, September 5, 2012, http://judyblumeblog.blogspot.com/2012/09/happens.html (accessed November 5, 2013).

CHRONOLOGY OF SELECTED BREAST EVENTS

c. 33,000 BCE	Oldest known piece of sculpture depicts a female with enormous breasts and a large stomach. The figurine was carved from a mammoth tusk and found in a cave in Germany.
c. 1600 BCE	The Edwin Smith Papyrus, one of the oldest surviving medical texts, was written in Ancient Egyptian hieratic script. It discusses breast tumors and abscesses, as well as other ailments. Purchased by American archeologist Edwin Smith in 1862.
460–136 BCE	Hippocrates, the ancient Greek physician and originator of the humoral theory of disease, attributed breast cancer to an imbalance of humors.
c. 129–200 CE	Greco-Roman physician Galen, whose humoral theory of disease was widely accepted through the eighteenth century CE, believed an excess of black bile caused cancer.
640–690	The earliest evidence of surgical intervention to remove "excess" male breast tissue is found in writings by Paulus of Aegineta.
Fifteenth century	Venetian prostitutes display their breasts at the Ponte delle Tette (Bridge of Breasts).
c. 1450	*Madonna and Child (The Virgin of Melun)* painted by Jean Flouquet. The famous beauty Agnès Sorel, mistress of Charles VII, in the guise of the Virgin Mary, has one breast exposed to viewers of the painting.
Sixteenth century	Wilhelm Fabry, the "Father of German Surgery" invents a device to hold the base of the breast during a mastectomy.
1589	Tintoretto paints *The Origin of the Milky Way*. According to Greek mythology, the Milky Way formed from the milk that escaped from the mouth of Hercules as he sucked at the breast of sleeping Juno.
1665	Anne of Austria (wife of Louis XIII of France and mother of Louis XIV) undergoes surgical procedures for breast cancer.
1749–1806	Scots surgeon Benjamin Bell and French surgeon Jean-Louis Petit are the first to remove additional breast tissue and underlying chest muscle in breast cancer patients.
1758	Swedish physician, botanist, and naturalist Carolus Linnaeus first uses the classification "mammal."

c. 1790–1810	The neoclassical style produces changes in fashion, as well as in art and sculpture. The high waist of the "Empire"-style gown means women wear looser corsets with lifted and separated breasts.
1790	Bare-breasted Marianne appears as a symbol of the French Revolution.
1810–1811	Saartje Baartman, also known as the "Hottentot Venus," is exhibited in public shows in London and elsewhere.
September 1811	Frances (Fanny) Burney, Madame D'Arblay, undergoes a mastectomy. Her account of her surgery is published after her death.
1841	Hawaiian Queen Kapiolani, newly converted to Christianity, agrees to allow white doctors to perform a mastectomy. She dies two weeks later from postoperative infection.
1863	*Luncheon on the Grass* by Édouard Manet, depicting a naked woman at a picnic with two fully dressed men, was considered indecent and rejected by the Salon jury.
1872	Folies Trévise in Paris is rebranded as the Folies Bergère, featuring burlesque shows with nude women in lavish costumes and headdresses.
1890	An Austrian doctor, Robert Gersuny, experimentally performs the first breast augmentation surgery by injecting paraffin into breasts.
1890s	The Gibson Girl ideal, with its tiny waist and protruding breasts and buttocks (due to strong corseting), became popular.
1890s	Johns Hopkins surgeon William Stewart Halsted popularized the radical mastectomy.
1896	Emil Grubbe, a medical student, performed the first known treatment of breast cancer using radiotherapy on a patient, Rose Lee.
1908	A faceless Stone Age figurine known as the Venus of Willendorf is discovered in Austria.
1909	First human milk bank opens in Austria.
1914	Mary Phelps Jacob receives a patent for the first modern brassiere.
1920s	"Flappers" create the new Roaring Twenties style: slim, boyish figures, bobbed hair, and cosmetics.
	Josephine Baker (1906–1975) dances bare-breasted at the Folies Bergère.
1925	Breast binding banned in China.
1926	The Maidenform bra, designed by Enid Bissett and Ida Rosenthal, is patented.
1929	Igbo women in southeastern Nigeria, dressed in traditional topless warrior garb, protest and campaign against taxation and demand the British authorities remove the oppressive warrant chiefs.
1933	*Esquire* magazine founded. The men's magazine becomes noted for Alberto Vargas' watercolors of scantily clad women. "Vargas girls" appear on the noses of many U.S. bomber planes during World War II.

1934	Clark Gable removes his shirt in the movie *It Happened One Night*, revealing that he is not wearing an undershirt and shocking theatre audiences.
	Production Code Association (PCA) established to regulate and enforce morality in American movies.
c. 1942	Frederick Mellinger opens his store, Frederick's of Hollywood, with the goal to sell sexy lingerie to American women.
1942	*Yank* magazine, the magazine for U.S. soldiers, is launched. In addition to articles, stories, and poems, the magazine features "pinup" girls.
1946	The bikini is created.
1948	Pushup bras first introduced.
1949	Maidenform Bras begins the "I Dreamed" advertising campaign featuring women dressed only in bras from the waist up in everyday and adventurous situations.
1950s	Era of the "cone bras" and "sweater girls" typified by actresses such as Lana Turner.
1952	Reach to Recovery, the first support program for breast cancer patients, is started by Terese Lasser.
1953	*Playboy* magazine launched by Hugh Hefner. Marilyn Monroe appears on the cover and in the centerfold.
1959	First Barbie doll is created by Ruth Handler.
1960s	Texas surgeons Frank Gerow and Thomas Cronin develop first silicone breast implants.
1962	Timmie Jean Lindsey is the first woman to receive silicone breast implants.
1964	Creation of the Wonderbra by Louise Poirer. The bra becomes very popular in the 1990s.
	The monokini, a topless bathing suit, is designed by Rudi Gernreich.
1965	Helen Gurley Brown becomes the chief editor of *Cosmopolitan* magazine and markets it as a magazine for young, hip, and sexually active women.
September 1968	Bra burning is scheduled to take place during a protest of the Miss America Pageant, but there is no actual burning.
1974	Reach for Recovery adopted in Europe.
1983	Hooters restaurant chain founded in Clearwater, Florida. Female servers wear low-cut tank tops and high-cut short shorts.
1984	Vanessa Williams becomes the first African-American Miss America.
October 1985	National Breast Cancer Awareness Month is started by the American Cancer Society (with funding from the pharmaceutical company Zeneca Group PLC).
1986	Seven women in Rochester, New York, bare their breasts in public and are arrested. They became known as the Rochester Topfree 7 and are later acquitted.

1998	Dow Corning and other implant manufacturers settle a class action lawsuit for $3.2 billion to 170,000 women claiming injury from silicone implants.
1989–2001	Television show *Baywatch* features lifeguards running on the beach. Pamela Anderson and Carmen Electra, who had surgically enhanced breasts, become celebrities.
1990	Breast Cancer Action founded by Barbara Brenner. Dr. Susan Love cofounds the National Breast Cancer Coalition. "Innocenti Declaration on the Protection, Promotion, and Support of Breastfeeding" released by the World Health Organization and UNICEF.
1991	King Goodwill Zwelithini, king of the Zulu nation, reintroduces the Reed Dance Festival in South Africa in which bare-breasted young virgins dance before him.
1992	Avon Foundation launches the Breast Cancer Crusade. Publication of Naomi Wolf's *The Beauty Myth*. The pink ribbon becomes the official symbol of breast cancer awareness. In *People v. Santorelli*, New York judge Vito Titone ruled women in New York could uncover their bodies in the same situations in which men were permitted to do so, for noncommercial purposes.
1996	First breast cancer awareness march in Poland.
1998–1999	Dr. Jerri Nielsen discovered and treated her own breast cancer while stuck at the National Science Foundation research station at the South Pole.
2003	Women of Liberia Mass Action for Peace demonstrate to end the Second Liberian Civil War in 2003. They threaten to strip naked.
2004	Performer Janet Jackson's breast is exposed for a few seconds during the Super Bowl XXXVIII halftime show. It is later referred to as a "wardrobe malfunction."
October 2006	Breast Cancer Pink Ribbon Barbie Doll introduced by Mattel. Many breast cancer advocates were outraged by the doll, which had little connection to breast cancer.
2010	The group Femen, founded in 2006 in Ukraine to protest patriarchy and the large sex industry in Ukraine, begins topless protests.
2011	Matt O'Connor produces an ice cream made of human breast milk to be served in a London restaurant. He calls it Baby Gaga Breast Milk Ice Cream. The ice cream is confiscated as a public health risk. The Susan G. Komen Foundation announces it will stop funding Planned Parenthood. This announcement leads to an investigation of how Komen uses its funds and a backlash against the organization.
2013	Angelina Jolie has a proactive double mastectomy after discovering she carries the BRCA1 gene with an 87 percent chance of developing breast cancer.

A

ADVERTISING

Western society's media saturation is creating advertising saturation with few ad-free physical and digital spaces. Advertisements are present across media platforms, and advertising is a big business. One estimate suggests that across all media platforms, companies spent over $166 billion on advertising in 2013. It is difficult to determine the exact number of people's daily advertisement exposure, but with 24-hour access to media and with consumers using more than one media platform at a time, the exposure is endless. Savvy advertising agencies understand the complexities associated with living in a mass-mediated, consumer-driven culture that promotes idealized lifestyles through the consumption of goods and services. Advertisers must work to attract the attention of a fragmented, distracted audience. Advertisers must also meet the demands of sophisticated, educated consumers socialized in a media-rich environment. Consumers want advertisements that do not reduce their desires to the lowest common denominator. The lowest common denominator has historically centered on the idea that "sex sells." Today, consumers want advertisements that do not feel like sales pitches. However, advertisers have not abandoned the idea that sex sells. Instead, marketers have answered this call by selling idealized lifestyles through the consumption of products. To do this, advertisers have had to tap into current norms, values, and behaviors. In this way, media, and by extension advertisements, simultaneously reinforce and reconstruct existing social, economic, and political structures.

For women, cultural norms dictate an emphasis on appearance that results in an obsession with idealized beauty norms and standards. Idealized beauty standards include large breasts, small waists, and ample hips. Advertisers capitalize on these messages by reinforcing gender roles and norms. Sexualized images continue to be a major component of many advertisements. However, the percentage of sexualized ads has increased over time but in disproportionate numbers and ways. Women are more likely to be portrayed in a light that is both overtly and covertly sexualized compared to advertisements of men. Women's breasts are a central feature in sexualized advertisements. Using breasts in advertisements captures consumer audiences. In this way, marketers use breasts to sell both products and lifestyles. Advertisements are highly suggestible and persuasive elements of everyday life. Consumption is sexualized and is associated with pleasure. Advertisers sell unrealistic expectations, including the idea that consumption equals happiness. Advertising shapes societal desires in hopes of influencing consumer behaviors.

How Breasts Are Used in Advertisements: The primary goal of advertisers is to attract consumer attention by creating desire for their products, in the hopes that that desire manifests into action and ultimately purchase. The purchasing of these products is a marker of desired lifestyles, but it also indicates the belief by consumers that the desired lifestyle can be achieved through consumption. Advertisers have become very adept at targeting and creating loyal audiences. Advertisements featuring breasts are marketed to all audiences, although in nuanced ways. The use of breasts in advertisements is often gratuitous and has little connection to breasts or even most women's lives. Women's bodies are often used by advertisers as means to sell products. In this way, women's bodies are commoditized. Although women's bodies as a whole are used to sell consumer goods, women's breasts are used ubiquitously. Images of women are frequently cropped to fragment women's bodies. Breasts are a preferred feature among advertisers. Women are shown in passive, subordinate positions and are often used as decoration in the background. Women's bodies and the breasts in particular are often positioned in ads for the male gaze.

Women's bodies, and breasts in particular, are frequently used in advertisements for food. Women are seen eating in a sensual manner. This portrayal further sexualizes women and their bodies, and it links women and food and constructs eating with pleasure. This idea is reinforced in advertisements featuring women wearing revealing clothing, low-cut tops, and plunging necklines that eroticize their breasts. Further, women are even pictured eating in bed in a sexualized way, making noises and utterances that are similar to sexual noises.

Some criticisms about breasts in advertisements stem from the gratuitous use of breasts. Advertisements for products such as motor oil, Internet hosting, and orange juice feature women in revealing clothing that sexualizes their breasts. Advertisements using breasts illustrate that women are used as decorative pieces for men and their lives. Advertisements, regardless of the product, often feature women in sexually provocative positions. Women are positioned with exaggerated back arches, opened mouths, and exposed breasts. While some advertisements include women in an active role or position, the majority of them portray women as passive objects. Many advertisements are not explicitly sexual; however, some elements of sexuality are present in subtle ways. In some advertisements, women are presumed to be topless or even fully nude unnecessarily.

Marketers make promises to the public via their advertisements. They promise beauty and sexiness through consumption, suggesting that desirability and attractiveness are things that are purchased. By using breasts in advertisements, advertisers inoculate women into adhering to idealized beauty norms. This reinforces societal obsessions with appearance, youth, and perfection. Women are valued based on their looks, whereas men are valued based on their ability to acquire or attract beautiful women who meet the cultural expectations associated with idealized beauty.

For women, breasts in advertising construct feminine ideals that most women want to emulate even though the depictions are unrealistic for most women. In fact, alterations through software programs like Photoshop support the notion that the depictions of women in the media are unrealistic even among those in the appearance industry. Advertisements of products directly related to breasts, such as bras, are sexually suggestive and minimize the functionality of the product.

Breasts are used to advertise products that are not specifically related to women. An example of this is beer commercials. Women dressed in revealing clothing or even bikinis are often featured in commercials and advertisements directed at men. The relationship between consumption and identity is less straightforward for men. Breasts are used in advertisements directed at men to appeal to primal desires that see women as sexual objects for the viewing pleasure of men. In other words, breasts are used to attract male attention. Once advertisers gain the attention of their audience, advertisers are free to engage in marketing tactics to lure customers.

Feminist critiques of modern advertisements include the increase in the sexualization of women, the objectification and commodification of women and their breasts, and the reinforcement of narrow beauty ideals and attractiveness. Although feminist critiques of breasts in advertisement typically center on arguments against the sexualization of women, others see advertisers as answering the call to see women as sexual subjects and part of women's liberation and empowerment. This new brand of advertising that capitalizes on women's sexuality as a tool of empowerment has been called by some as "commodity feminism," in which women as consumers can purchase or buy their equality through goods and services. This argument fails to consider that products and services marketed toward women are simply new packaging of old gender norms and idealized beauty standards. Although market research continues to explore the relationship between advertisements and purchasing behaviors, social research supports the correlation between the type and frequency of advertisements and product sales.

See also BEAUTY IDEALS, TWENTIETH- AND TWENTY-FIRST-CENTURY AMERICA; BRASSIERE; CELEBRITY BREASTS; MEDIA

Further Reading

Gill, Rosalind. "Supersexualize Me! Advertising and 'the Midriffs.'" In *Mainstreaming Sex: The Sexualization of Western Culture*, edited by Feona Attwood. New York: I. B. Taurus, 2009. Retrieved May 5, 2014, from http://www.awc.org.nz/userfiles/16_1176775150.pdf

Federal Communications Commission. "Obscene, Indecent and Profane Broadcasts." Retrieved May 5, 2014, from http://www.fcc.gov/guides/obscenity-indecency-and-profanity

Rajagopal, Indhu, and Jennifer Gales. "It's the Image That Is Imperfect: Advertising and Its Impact on Women." *Economic and Political Weekly* 37 (August 10, 2002): 3333–3337.

Wade, Lisa, and Gwen Sharp. "Selling Sex." In *Images That Injure: Pictorial Stereotypes in the Media*, edited by Paul Martin Lester and Susan Dente Ross, 163–172. Westport, CT: Praeger, 2011. Retrieved May 5, 2014, from http://lisawadedotcom.files.wordpress.com/2011/02/wade-sharp-2011-selling-sex.pdf

Wallis, David. "The Breast of Advertising: From Hooters to the Cover of 'Time,' Does the Strategy Sell or Repel?" *Adweek*. Retrieved June 4, 2012, from http://www.adweek.com/news/advertising-branding/breast-advertising-140889

Zurbriggen, Eileen L., Rebecca L. Collins, Sharon Lamb, Tomi-Ann Roberts, Deborah L. Tolman, L. Monique Ward, and Jeanne Blake. "Report of the APA Task Force on the Sexualization of Girls: Executive Summary." *American Psychological Association Online*, 2007. Retrieved May 5, 2014, from http://www.apa.org/pi/women/programs/girls/report.aspx

■ AMBER E. DEANE

AGING

The term *aging* refers to the normal transition time that adults experience from their late 20s as they continue the process of growing older or maturing. Many of these experiences indicate that the body is slowing down, and hence it becomes quite susceptible to wear and tear. Slowing down of the body can be linked to the general decline of the physical and mental functioning of the body. Aging can be used as an overall indicator of the health of a country, race, community values and norms, and population—based on gender and geographical region. This process of aging depends on various life expectancy patterns. For example, in many developed nations, life expectancy is between 75 to 90 years; whereas in countries with developing economies, it is from 40 to 60 years. *Life expectancy* refers specifically to the average number of years a person is expected to live and has a gendered angle since in many countries globally, women outlive men. Recent studies reveal that the worldwide life expectancy for all people is 63.4 years for males and 66 years for females. These studies also indicate that there are intergenerational differences, especially between mothers and daughters, in terms of the aging process and thinking about their bodies. These differences highlight that aging as a process is about human bodily changes or loss of certain functions, which can be affected by lifestyle, gender, region, socioeconomic status, and health. Furthermore, human-induced factors like tobacco consumption, obesity, high cholesterol, high blood pressure, famine, wars, disease, and poverty have been known to accelerate the aging process.

Not all people experience the same living conditions; therefore, we note contrasting views related to aging. For some, this process implies becoming less active with an increase in weight, which can require the use of medicine or aided cosmetic surgery. Others, even though active, experience hair loss, gray hair, love handles, memory loss, arthritis, and wrinkles.

For many, one of the key markers of the aging process is reduced skin elasticity. This refers to the ability of the skin to stretch and then go back to normal once the stretching is over. Here, the natural process of cell reproduction slows down as we grow older. *Elasticity* is linked to aging because, when people are younger, their skin is firm and toned. This condition of losing skin elasticity is known as *elastosis*. The skin of people who spend much of their time exposed to the sun appears as worn, weather-beaten, and leathery, especially the face. The San people living in the Kalahari Desert demonstrate some of these features. To slow this process of aging, nutritionists advise regular exercise, a balanced diet, using skin-rejuvenating products, and avoiding habits like smoking.

For women, the aging of the glandular tissues and the reduction of the fatty tissues that produce breast firmness become a reality. Combined by the force of gravity and low skin elasticity, many breasts yield to sagging easily. Hence, women begin to experience sagging of the breast, also known as *breast ptosis*, as they age. Medical experts reveal that breast ptosis for some women can be indicative of age, number of pregnancies, hormonal changes, weight loss history, high body mass index, breast size before pregnancy, large bra cup size, and smoking history. For other women, sagging of the breast, even though a marker of aging, is also hereditary, with other inherited factors like skin elasticity, breast size, and breast density all contributing to the sagging. With the development of the multibillion-dollar plastic surgery industry, which often targets women's breasts, breast ptosis can be addressed. Studies indicate that in 2011, there were 307,100 breast enhancement

procedures for women and 19,766 breast reduction procedures for men. In contrast, for some hunter-gatherer cultures in Papua New Guinea and in parts of Africa, sagging of the breasts is indicative of beauty, fertility, and wisdom.

See also BREAST ANATOMY; BREAST AUGMENTATION; HORMONES; OBESITY; PUBERTY

Further Reading

Ayalah, Daphna, and Isaac Weinstock, *Breasts: Women Speak about Their Breasts and Their Lives*. New York: Simon & Schuster, 1979.

Carlsen, Mary Baird. *Creative Aging: A Meaning-Making Perspective*. New York: W.W. Norton, 1991.

Finigan, Valerie. *Saggy Boobs and Other Breastfeeding Myths*. London: Pinter & Martin, 2009.

Harris, Diana. *The Sociology of Aging*, 3rd ed. Lanham: Rowman & Littlefield, 2007.

Love, Susan, and Karen Lindsey. *Dr. Susan Love's Breast Book*, 5th ed. Philadelphia: Da Capo Lifelong, 2010.

Rowe, John, and Robert Kahn. *Successful Aging*. New York: Pantheon, 1998.

■ FIBIAN LUKALO

AMAZONS

According to legend, Amazons were women warriors whose right breasts had been cut off so that they could better shoot with a bow in battle. The origin of the word *Amazon* is uncertain. It might come from the ancient Greek *a-mazos* (*a* meaning "without" and *mazos* meaning "breast"; hence, "without a breast"). Alternatively, it might be a Proto-Indo-European term meaning "one with no husband," or it might come from an entirely different source.

Amazons were first mentioned in ancient literature by Homer. Quite a number of ancient and classical writers subsequently provided idealized and outlandish variations of Amazon culture and exploits. With the stories becoming ever more embellished, and as the ancient Greeks and Romans placed the Amazon homeland in such diverse locations as Anatolia (an area in modern-day Turkey), Scythia (central Eurasia), the shores of North Africa, the Aegean, the Caucasus, and the steppes of southern Russia and the Ukraine, any truth about who the Amazons might really have been became harder and harder to decipher.

The most common explanation for why a breast was removed is that it would have otherwise impeded the Amazon from pulling back her bow when trying to shoot an arrow. Another explanation is that more energy would have been able to be channeled into the bow-pulling arm. Some Amazons may have fired armor-piercing arrows from a powerful short, composite reflex bow while riding horseback. The draw of this type of bow would have been short and come across the body, so one nipple would have been in the line of fire.

Metaphorically, a single breast could have symbolized women who were half-men. Such women did not need men except for procreation. Not only did they fight like men and against men, but also Amazons are said to have lived within tribal societies that excluded men. They reputedly got rid of male offspring by killing them or giving them away to outsiders—their fathers. The removal of one breast facilitated death, but the remaining breast facilitated life. After a career of violence against men, the remaining breast would have been used to nurse the next generation of Amazons.

Archaeologists have never found a city dominated by female-focused artifacts, or an ancient cemetery filled exclusively with warrior women. Yet, there is concrete archaeological evidence showing that warrior women are more than mere myth. Women's graves containing armor, horseback riding gear, whetstones for sharpening blades, collections of bronze arrowheads, bows and arrows, quivers, iron daggers, and spears have been found in several locations where Amazons were thought to have existed. These archaeological locations include Sarmatia and other areas of Scythia, the Ukrainian steppes, and the Russian steppes. Skeletons of several women in Russia show damage to left arm bones only—archaeologists infer that they blocked adversaries' attacks with raised left arms while counterattacking with weapons on the right. A woman buried in Sarmatia had an impressive iron sword so long it could only have been used while fighting from horseback. And one Iron Age Eurasian woman had been buried with seven horses and enough bronze harness rings to outfit them all.

See also LITERATURE; MYTHOLOGY; WAR

Further Reading

Davis-Kimball, Jeannine. *Warrior Women: An Archaeologist's Search for History's Hidden Heroines.* New York: Warner Books, 2002.

Fraser, Antonia. *The Warrior Queens.* New York: Vintage, 1990.

Wilde, Lyn Webster. *On the Trail of the Women Warriors: The Amazons in Myth and History.* New York: Thomas Dunne Books/St. Martin's Press, 2000.

■ ELIZABETH JENNER

ANCIENT PHYSICIANS

The practices of ancient physicians ranged from recognizable medicine to what we might call "magic" in the twenty-first century. Ancient physicians, folk-practitioners, and healers were variably classified as medical professionals based on their accumulated know-how and community acknowledgment, regardless of socioeconomic status or biological sex. Female physicians, healers, and midwives helped ancient women take an active role in their health, because women generally tended to the medical realities that were female specific (i.e., childbirth, contraception, and general medicine). To this day, careful observation acts as a nonverbal indicator of physical condition, which aids a physician in diagnosis and/or treatment—and few parts of a woman are more telling or more visible than the female breast. Ancient physicians often consulted the female breast to better understand and diagnose a range of medical conditions.

A woman's breasts undergo visible changes over the course of pregnancy because they are preparing to function as a life-giving source of breast milk for their infants. Several ancient treatises from various parts of the world, written by both men and women, confirm aspects of these changes and how they aid in diagnosis. Ancient physicians and midwives could identify a viable pregnancy early on by visibly observing changes of the breasts. Changes in breast firmness as pregnancy nears completion can act as a signal of the pending onset of labor, which was unilaterally dangerous for women in the premodern world. Human breast milk also had variable functions in the accepted and widely

practiced arena of folk medicine. In Roman antiquity, it was considered a uniformly helpful remedy (unlike the other female-particular bodily fluid, menstrual blood), and breast milk was a common antidote for poison and treatment for eye ailments.

Breast cancer was relatively common among women in antiquity. Breast cancer was first identified in writing over 3,500 years ago in Egypt. The visible and tangible nature of tumors and irregular growths associated with the breast were thought to be the result of a buildup of "black bile" caused by a weak liver. Several invasive and noninvasive treatments were practiced in antiquity. Application of cabbage poultices was extremely common. Cruciferous vegetables, like cabbage, have been identified in recent studies of natural cancer treatments as anticarcinogenic, rich in glucosinolates, as well as possessing chemopreventative properties, all of which inhibit tumor growth. The Ayurveda (an ancient Indian medical text) likewise identifies several herbs and spices, including garlic and ginger, which can be used to aid in nonsurgical, symptomatic cancer treatments. Surgical options existed in the ancient world to combat breast cancer also, even though it was generally assumed that the cancer would ultimately return. Full mastectomy, accompanied by high morbidity rates, was achieved by application of ligatures to stop blood flow to the area prior to complete removal. Localized tumor excision was little more than a series of surgical cauterization procedures, which were actually more effective than the ancients could have known since the intense heat also affected residual cancer in surrounding tissues.

See also BREAST CANCER; BREAST CANCER TREATMENTS; BREASTFEEDING; MASTECTOMY AND LUMPECTOMY; PREGNANCY

Further Reading

Baliga, Manjeshwar Shrinath, Jason Jerome D'Souza , Raghavendra Haniadka, and Rajesh Arora. "Indian Vegetarian Diet and Cancer Prevention." *Bioactive Foods and Extracts: Cancer Treatment and Prevention* 2010: 67–86.

Galen. *Method of Medicine*, vols. 1–3, translated by I. Johnson and G. H. Horsley. Cambridge, MA: Loeb Classical Library, Harvard University Press, 2011.

Parker, Holt N. "Women Doctors in Greece, Rome, and the Byzantine." In *Women Physicians and Healers: Climbing a Long Hill*, edited by Lilian R. Furst, 131–150. Lexington: University Press of Kentucky, 1997.

Pliny. *Natural History*, vols. 1–10, translated by W. H. S. Jones, D. E. Eichholz, and H. Rackham. Cambridge, MA: Loeb Classical Library, Harvard University Press, 1949–1954.

Richlin, Amy. "Pliny's Brassiere." In *Roman Sexualities*, edited by J. P. Hallett and M. B. Skinner, 197–220. Princeton, NJ: Princeton University Press, 1997.

■ STEPHANIE LAINE HAMILTON

ANNE OF AUSTRIA (1601–1666)

In 1666, the queen mother of France, Anne of Austria, died of breast cancer. This was a high-profile death from this much-feared terminal illness. Anne of Austria was the wife of Louis XIII and mother of Louis XIV. She herself was Spanish, of the House of Hapsburg. At least one of her relatives, Mariana of Austria, was also to die of breast cancer (in 1696).

According to observers, Anne of Austria was calm and courageous throughout the course of her illness. In 1665, when suffering from advanced cancer, she endured a series of surgical procedures by Pierre Alliot, a surgeon who had a particular interest in treating cancer. These operations, in which he cut at her breast with a razor and removed part of the malignancy, did little to arrest the disease. The operations were performed in public because, as queen, Anne of Austria was always on display.

Anne of Austria's breast cancer was unusually well documented. There are medical opinions, such as in a memoir by M. J.-B. Alliot, the son of the surgeon who operated on her, and also the diaries of Gui Patin, a medical doctor resident in Paris, who records what he heard of her illness. Numerous Catholic clerics wrote accounts of her last illness in the form of funeral sermons, which were published and circulated. Madame de Motteville, Anne's lady in waiting, also wrote a memoir of her years at court, and described Anne's terminal illness in detail. All accounts stress the severity of the symptoms of breast cancer, and the few possibilities of a cure at that time.

See also BREAST CANCER; BREAST CANCER TREATMENTS

Further Reading

Michaux, Gérard. *Un bénédictin lorrain auteur d'un "Traité du cancer" en 1698.* Metz, France: Académie nationale de Metz, 1996. Retrieved May 5, 2014, from http://hdl.handle.net/2042/33743

Taylor, Thérèse. "'Pity and also Horror': Public Mourning, Breast Cancer, and a French Queen." In *Medicine, Religion and the Body*, edited by Elizabeth Burns Coleman and Kevin White, 107–127. Leiden: Brill, 2010.

■ THÉRÈSE TAYLOR

AREOLAE

Areolae (singular, areola) are any small, round (or elliptical), and set-apart (by pigmentation and/or texture) areas surrounding a central feature in the body (e.g., the iris surrounding the pupil in the eye). *Areolae mammae*, or areolae of the breast, surround the nipple and are usually darker than the rest of the breast. Male areolae are on average about 1 inch (2.7 cm), and female areolae are on average about 1.5 inches (3.8 cm), although areolar size is largely dependent on breast size and whether the person is lactating or pregnant. The areolae contain sebaceous glands called *areolar glands* or *glands of Montgomery* that produce oily secretions to protect and moisturize the nipple. The areola and nipple are very sensitive, and when stimulated, the areola contracts, resulting in a bumpier texture caused in part by these glands, the exposed portions of which are called *Montgomery tubercles*.

Although there are a wide variety of colors, sizes, and shapes of areolae, some people may feel that their areolae are abnormally large, dark, or elliptical. This may be most common among people going through life cycle events such as puberty, pregnancy, or weight gain, during which the areolae can change in appearance. For example, during pregnancy and lactation, the areolae may become larger and darker, the tubercles more pronounced, and the texture bumpier. Areolae can be affected by a number of skin diseases as well

as breast cancer. However, most variations in the areolae are not caused by disease or abnormality.

See also BREAST ANATOMY; NIPPLES

Further Reading

Riordan, Jan, and Karen Wambach. "Anatomy and Physiology of Lactation." In *Breastfeeding and Human Lactation*, edited by Jan Riordan and Karen Wambach, 79–116. Sudbury, MA: Jones & Bartlett, 2010.

Sarhadi, N. S., J. Shaw-Dunn, and D. S. Soutar. "Nerve Supply of the Breast with Special Reference to the Nipple and Areola: Sir Astley Cooper Revisited." *Clinical Anatomy* 10, no. 4 (1997): 283–288.

■ ISRAEL BERGER

ART, INDIAN AND AFRICAN

The art of India and Africa highlights the potential power of women through their representations of the female form. Indian art uses the human body to elicit feelings of pleasure and sensuality, while African art emphasizes fertility and sustenance.

India: From the fearsome Kali to the benevolent Devi, and from Parvati to ancient Mother Goddess images, representations of the female form in Indian art display remarkable similarities regardless of culture and time period. Male and female figures are highly naturalized representations of a cultural ideal.

Indian art reflects the feminine ideals sung by poets for centuries. Women's bodies are likened to images of beauty and strength. All of the senses are involved in generating feelings of eroticism and sensuality. A woman's touch is soft and healing. She tastes like the sweetest nectar. The smells of blossoms and fragrant oils waft through the air. The sounds of a woman's jewelry and the tinkle of bells around her waist and ankles herald her arrival. In statues, the senses are involved with the inclusion of elements that highlight the feminine form.

Primarily divine subjects, Indian statuary commonly adorns the entrances and walls of temples. Many figures reflect the underlying eroticism of the Tantric school of Mahayana Buddhism. It is in this tradition that we often see the elegant *tribangha*, or triple flexion pose. Figures are lush and well formed. Female bodies have full, round, high breasts; small waists; and full hips. Clothes are often intimated rather than explicit. They appear to be veil thin, giving the impression of movement and grace, and allow the viewer to fully appreciate the cultural ideal of a large-breasted, small-waisted body. Like clothing, garments and jewels are used to highlight the curvaceous form rather than disguise it. Govardhana, a twelfth-century poet, demonstrates how erotic a piece of jewelry can be when draped across the female breast: "Your necklace, lovely girl, makes my heart all dizzy, just like a rope-bridge in a wild mountainous country: it is dangling from the lofty peaks of your breasts and raised again by your hips, while it spans the impass of your middle." This sensuality is apparent in many Indian statues, but one of the finest examples is that of Parvati and Shiva at the Halebidu Temple in Karnataka, where both figures are draped in garlands and jewels. Parvati's small waist and large, high, round breasts are accentuated

with a rope of pearls. In many Indian cultures, the ideal female figure reflects fertility, pleasure, and power. While adornment is utilized to awaken the senses in statuary, they are even more engaged in court paintings and tapestries.

The painted female body shows the same ideals found in statuary. However, here the sensual symbolism is more pronounced. Lush surroundings such as gardens and jungles allude to maturity, growth, and fertility: the settings mirror the young, ripe feminine ideal of large breasts, small waists, and full hips. The themes of eroticism and love are common. The "Pem Nem," an illustrated sixteenth-century romance, depicts a prince and princess finding love. In contrast to the statuary, the princess and her attendants are fully clothed. Yet, the idealization of their figures is still apparent in soft, short blouses, which highlight a small waist and large bosom.

Africa: African art is less about sensuality and pleasure than Indian art. In the Indian canon, female breasts are high and round and waists are tiny, while the mature female form in African statuary focuses on fertility and motherhood, indicated by protruding navels and elongated, pendulous breasts. Faces, clothing, and jewelry are often secondary or missing altogether, although body scarification is common. The highly naturalized figure in Indian art evokes feelings of pleasure and sensuality, while the more stylized nature of African statuary emphasizes the importance of fertility and reproduction.

In the Upper Niger region, *gwandusu* figures represent a woman's strength and importance. Their long, angular breasts, coupled with a child that often appears to merge with the mother's body, evoke the creative deities Nyale, the master of fire, and Musokoroni, who taught humans agriculture. However, unlike much Indian statuary, the majority of these figures represent flesh-and-blood women. Here, the child held close to large breasts does not arouse feelings of pleasure, but symbolizes the life-sustaining nature of a woman's womb and the nourishment provided by her milk. This is also reflected in the shrines to Ala of the Lower Niger. Ala, the earth goddess, represents fertility. The focus is not on large breasts, but on prominent navels and the children who surround her. Ala, the central figure in the tableaus, is also the largest, representing a woman's importance to social cohesion. Fertility figures are tied not only to families but also to the land. Some cultivator's staffs from western Africa have full-breasted women topping them. The messages of abundance and productivity are again represented by the large-breasted female body.

Female figures are also used in Bamana initiation rituals. *Jonyele* are statuettes carried by young women and men visiting neighboring villages. As these figures represent maidens, there are significant physical differences from the *gwandusu* figures. An epic song from the region describes an ideal young woman:

> A well-formed girl is never disdained, Namu. . . .
> Her breasts completely fill her chest, Namu. . . .
> Her buttocks stand out firmly behind her. . . .
> Look at her slender, young bamboo-like waist. . . .

This woman, with her high conical breasts, firm buttocks, and small waist, represents the potential for fertility, nourishment, and motherhood. When women carry the statuettes, they indicate their maturity and availability for marriage. Young men carry the statuettes to signal that they have passed through the stages of initiation and have entered

manhood. They also use the figures to remind themselves of the importance of finding the ideal wife.

Artistic representations of breasts carry numerous messages. Cultural ideals of physical beauty, sensuality, lust, fertility, and abundance are all represented by a full bosom. Whether clothed or naked, draped in jewels, or bare, the female breast evokes a wide range of emotions.

See also ART, WESTERN

Further Reading

Cole, Herbert M. *Icons: Ideals and Power in the Art of Africa.* Washington, DC: Smithsonian Institution Press, 1989.

Geoffroy-Schneiter, Bérénice. *Asian Art. India, China, Japan.* New York: Assouline, 2012.

Govardhana. *Seven Hundred Elegant Verses*, translated by Friedhelm Hardy. New York: New York University Press, 2009.

Najat Haidar, Navina, and Marika Sardar, eds. *Sultans of the South: Arts of India's Deccan Courts, 1323–1687.* New York: Metropolitan Museum of Art, 2011.

O'Reiley, Michael Kampen. *Art beyond the West.* New York: Henry N. Abrams, 2001.

■ RHONDA KRONYK

ART, WESTERN

There are several subcategories of breast representation in Western art. They can be examined from two perspectives. First is from a temporal perspective, which has the advantage of ensuring a clear diachronic visibility and the disadvantage of neglecting the specificity of meaning of the breast representation (e.g., the ancient breast, medieval breast, or Renaissance breast). Second is from a perspective that takes into account the contents of the representation (mythological breast, maternal breast, etc.). Sometimes, certain subcategories that are detectable by the contents of the representation can be related to specific historical and artistic periods, but that does not mean that a temporal cohabitation, with different weights, of two or several artistic subcategories of the breast is not possible. On the other hand, content-determined subcategories frequently cross several time periods, which results in their being enriched with more meanings.

The maternal sacred breast designates the specific subcategory of the European Renaissance period and is connected to the Nursing Madonna or Madonna Lactans motif, which is ever recurrent in Western art. It is among the strongest breast representation subcategories in art, as both circulation and influence, along with the mythological breast and the erotic breast. Unlike the breast featured by ancient frescoes from the first centuries after Christ, which designate both the living and assumed sexuality, and also its power of transcendence, the sacred breast of the Renaissance is almost always maternal. It is a maternity filtered through the grid of Christian values, which separate motherhood from sexuality, building the paradoxical prototype of the virgin mother. Masterpieces of fine art such as *Madonna Litta* (1490–1491) by Leonardo da Vinci, *Saint Luke Drawing the Virgin* (1435) by Rogier van der Weyden, *Birth of St. John the Baptist* (1569) by Tintoretto, along with many others by artists such as Raffaello Sanzio, Andrea del Sarto, Jean Fouquet,

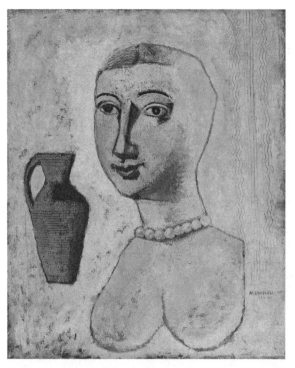

In this 1928 work by Massimo Campigli, who was influenced by modern artists such as Picasso as well as by ancient Etruscan art, the woman is portrayed quite literally as a bust—a face, neck, and breasts. Massimo Campigli, *Bust with Blue Vase*, 1928. Mondadori Portfolio/Electra/Art Resource, NY. © 2014 Artists Rights Society (ARS), New York/SIAE, Rome

and Luis de Morales, depict the breast as a means of establishing a relation between the mother and the child. Unlike works created during the Middle Ages, the Renaissance breast is almost always naked, its fundamental function is that of feeding, and it also connotes other Christian values such as charity, chastity, and hope. The inherent conclusion of all these representations is that the Madonna's existence is legitimized by her son, and not, as would seem logical, the other way around. Her gaze is lowered on her child, in infinite tenderness, while often Jesus, or another saint, is fixing the viewer with maturity. While fifteenth-century Florence was invaded by representations of the Madonna Litta, wet nursing was becoming a common practice among the upper and middle classes. It thus seems that the representations of the maternal sacred breast had a high degree of social idealization. Another explanation offered by researchers is that the suckling Madonna refers to female fecundity in general, and the focus on the breast is due to the inability to render in representation the inner female reproductive system. The maternal sacred breast also can be identified in many Renaissance sculptures.

The mythological breast refers to those representations that place the depiction of a naked breast within a mythological context, regardless if emphasis is placed on the maternal or on the sexual valence of the breast. Over the centuries, especially beginning with the Renaissance, mythological topics were excellent opportunities for painters to approach the female body, a body otherwise prohibited by Christianity and vilified for its eroticism. Tintoretto painted in 1589 *The Origin of the Milky Way*. The Milky Way formed from the milk that escaped from the mouth of Hercules as he sucked at the breast of sleeping Juno. The function of the breast seems to be maternal here, but art critics consider that the painting was meant for the bedroom of Rudolf II. Unlike the maternal sacred

breast, the mythological breast belongs to an almost completely naked body, whether it involves Diana, Danae, the three Graces, characters of the Old Testament, or even the holy women of the First Testament. Another feature of mythological breast representations is that the naked woman is almost never alone, as she is in the case of the erotic breast or the eroticized breast. The category of painters in whose works the mythological breast subcategory plays an important role includes Lucas Cranach the Elder, Tintoretto, Tiziano Vecellio, Francois Boucher, Peter Paul Rubens, Nicolas Poussin, and Guido Gagnacci. The mythological breast can serve pedagogical objectives to demonstrate the vanity of female beauty and eroticism, as with Hans Baldung Grien (*The Three Graces*, 1539), or the triumph of the sacred over the profane, as in the paintings depicting the martyrdom of virgins (e.g., Sebastian del Piombo, *Martyrdom of St. Agatha*, 1520).

The mythological breast subcategory can also integrate those mythological breast representations that stage various political symbolisms. Eugene Delacroix painted *Liberty Leading the People* in 1830. The woman holding the flag and leading the troops has a bare breast, a sign of the social ideology of the Enlightenment that indicated that mothers should breastfeed their children. Babies nursing at the breast symbolized the French Republic, the mother republic of all, feeding its citizens.

The erotic breast has a weak presence prior to the emergence of Impressionism, which rediscovered the naturalness of the breast. The erotic breast subcategory includes those representations of the breast that are not mythological and yet manage to express the sexuality of the female body. In order to bare the breast and to restore its sensuality, painters resort to depicting exotic locations. Such is, for instance, the case of Jean-Auguste-Dominique Ingres, who painted *Turkish Bath* (1859–1863), depicting several women in sensual poses completely naked. In other cases, bygone times are summoned, such as the decadent period of the Roman Empire (e.g., Thomas Couture, 1847; Theodore Chasseriau, 1853). Goya was a very bold artist who revealed the nudity of the female breast and body. *The Nude Maja* (1796–1798), showing a naked woman without the pretense of an exotic space or a past time, would be appreciated by the artists of the following century. Impressionism reveals the beauty and eroticism of the female breast, renouncing mythological or exotic ornaments. Retrieving the normality of the naked breast was not without difficulties. While such trivial art, albeit anchored in mythological narratives, as that of Alexandre Cabanel (*Birth of Venus*, 1863) or William Bouguereau (*Birth of Venus*, 1879) had a resounding success both with the public and with the critics, impressionists were accused of immorality and were denied access to the Salon in Paris in 1863. *Luncheon on the Grass* by Édouard Manet, depicting a naked woman in a relaxed attitude while dining on a blanket with two fully dressed men, was considered indecent and shocked the sense of decency of the painter's contemporaries. Impressionists and Neo-Impressionists (Auguste Renoir, Edgar Degas, Henri de Toulouse-Lautrec, Paul Gauguin, and Henri Matisse), as well as followers of Realism (Gustave Courbet and Jean-François Millet), managed to impose a new type of breast representation: natural, nonidealized, and placed in common contexts.

Expressionism, and later Surrealism, complicated the eroticism of the breast by discovering its thanatic aspect. The erotic breast became ambivalent, being darker with the Expressionists (Edvard Munch, Egon Schiele, and Otto Dix), among whom it is associated with disease, and more abysmal with the Surrealists (Salvador Dali, René Magritte, Paul Delvaux), who exploit the Freudian psychoanalytic vision of sexuality as a

human foundation. Ugly and beautiful at the same time, good and evil, life-giving and death-giving.

The eroticized breast emerged mostly from 1920 to 1930 and is still present today. The eroticized breast involves excessive, intentional, and conscious representations of female eroticism. The emergence of *Playboy*, in 1953, and of such cinema productions as *La dolce vita* (1959) are factors that predict and contribute to the sexual revolution that would erupt in the 1970s and would come to its conclusion by the end of the twentieth century, under the growing influence of the media and of consumerism. Female sexuality is capitalized as an attraction strategy, which is increasingly exploited in art also. Tamara de Lempicka's nudes, painted between 1920 and 1930, express an exuberant sensuality that excludes any trace of motherhood. The eroticized breast is even more common in the growing art of photography (Man Ray and Mel Ramos), illustration (Andre Masson and Hans Bellmer), and collage (Robert Pennekamp). In the artistic productions of recent decades, the eroticized breast has eliminated the ambivalence encountered by early Expressionism and the first years of Surrealism and has acquired pornographic accents (Joe Brockerhoff, Thomas Junior, and Andrew Valko). The aesthetic qualities of the contemporary art manipulated by computer (digitized) are disputed by some and glorified by others. The fact is that, currently, the breast tends to be represented more in its eroticized form, and digital art has something important to say in this respect. The other subcategories also remain actual to a lower extent in the public sphere and to a higher extent within the artistic space.

See also ADVERTISING; ART, INDIAN AND AFRICAN; BREASTFEEDING; FREUD, SIGMUND (1856–1939); ICONOGRAPHY; MEDIA; MOVIES; MYTHOLOGY; PHOTOGRAPHY; *PLAYBOY*; PUBLIC ART; SCULPTURE; VIRGIN MARY

Further Reading

Brown, Petrina. *Eve. Sex, Childbirth and Motherhood through the Ages*. West Sussex, UK: Summersdale, 2004.
Dopp, Hans-Jurgen. *Erotic Works of Genius*. New York: Parkstone Press, 2008.
Eco, Umberto. *History of Beauty*. New York: Rizzoli, 2010.
Eco, Umberto. *On Ugliness*. New York: Rizzoli, 2011.
Maher, Vanessa. *The Anthropology of Breastfeeding: Natural Law or Social Construct*. Oxford: Berg, 1992.
Pitts-Taylor, Victoria, ed. *Cultural Encyclopedia of the Body*. Westport, CT: Greenwood, 2008.

■ ADRIANA TEODORESCU

AVON FOUNDATION FOR WOMEN

In 1995, Avon, the internationally renowned beauty sales company known for its humble beginning in 1886 and its direct marketing strategy (door-to-door sales), launched the Avon Foundation for Women as an expression of its commitment to the empowerment of women worldwide. The foundation stands out as the largest corporate-affiliated philanthropy program, with a remarkable capacity to generate funds for projects focusing on breast cancer, domestic violence, and disaster relief.

The contribution of the foundation has been felt more in the area of breast cancer research, particularly in raising awareness and providing funds to research institutions, private organizations, and clinics. The foundation places enormous emphasis on the need for women to take regular mammograms and undergo clinical breast exams. The Breast Cancer Crusade, a funding program launched by the foundation in 1992, raises funds in support of breast cancer programs operating in three areas: scientific research, safe access-to-care programs for medically underserved and minority groups, and outreach programs focused on education, counseling, and screening. The Avon Foundation for Women operates on a global level, supporting breast cancer programs in more than 53 countries around the world. Avon collaborates with governmental and nongovernmental organizations as well as famous Hollywood stars to raise awareness about its campaign for the empowerment of women. Awareness programs launched by Avon have become known worldwide. The Avon Walk for Breast Cancer is a series of eight weekend-long walks held in different states across the United States. Also, the Avon Walk around the World, which began in 2005, is held yearly and involves over 50 countries; since its inception, the event has generated well over $14 million and mobilized about 1.7 million people to support breast cancer programs. The Avon Foundation alongside other reputable foundations promotes the pink ribbon as an international symbol of breast cancer awareness.

In recent years, the Avon Foundation for Women has turned its attention to another important issue that concerns women around the world: domestic violence. Avon has provided funds to programs on domestic violence through its Speak Out Against Domestic Violence Initiative. In 2012, $60,000 in grants were made available to organizations running domestic violence shelters around the world, including the NSW Refuge Resource Center in Australia, the Canadian Women's Foundation in Canada, the Partnership Against Domestic Violence in the United States, the Hogar de Christo Foundation and the Donne Rete Controla Violenza in Italy, and several others.

Beyond breast cancer and domestic violence programs, Avon has spread its philanthropic reach to other areas that affect humanity, such as national and international emergency relief. The foundation provides material and financial support for victims of human and natural disasters. In the aftermath of the Haitian earthquake in 2010, for instance, Avon donated about $1 million to relief organizations. The organization also moved human and material resources in the aftermath of the 9/11 terrorist attack and Hurricane Katrina.

See also BREAST CANCER; BREAST CANCER TREATMENTS; PINK RIBBON CAMPAIGNS; SUSAN G. KOMEN FOR THE CURE

Further Reading

Avon Foundation for Women. "Working to End Breast Cancer and Domestic Violence." Accessed October 9, 2012, from http://www.avonfoundation.org

Sulik, Gayle. *Pink Ribbon Blues: How Breast Cancer Culture Undermines Women's Health.* New York: Oxford University Press, 2012.

■ TOSIN F. ABIODUN

B

BAARTMAN, SAARTJE (C. 1770s–1815)

Saartje Baartman, or Sara Baartman, also referred to as the "Hottentot Venus," was born to a family of Khoikhoi pastoralists in the mid-1770s. At the time of her birth, the Dutch had already become colonial rulers of the Cape Coast in South Africa. Baartman spent her early childhood on a farm owned by David Fourie. Her parents were indentured servants. Upon the demise of the farm owner, Baartman's family moved to Cape Town, a port city that attracted Europeans of different nationalities. Her exposure to city life came with benefits and challenges. Baartman learned to speak Dutch as well as English. She also worked as a housemaid, first in Michel Elzer's family and then in Pieter Cesars' family. In 1803, she moved from the home of Pieter Cesars to work for his brother, Hendrik Cesars, still as a bound servant.

Baartman's unique bodily features changed the course of her life. Her breasts and buttocks were very large, as was typical for Khoikhoi women. Her physical characteristics aroused the curiosity of many Europeans. Some European naturalists believed large, pendulous breasts were common in primitive beings. Many equated large breasts with sexual licentiousness. Even more exciting to many European men were the elongated inner vaginal lips of Hottentot women, the "Hottentot apron," which some believed was caused by masturbation. Cashing in on this European fascination with African bodies, Baartman's owner, Hendrik Cesars, exploited her for profit. In 1810, when Baartman was in her thirties, Cesars took her to London to participate in freak shows, a form of entertainment that exhibited human beings and animals with features that were considered different and unusual. At these public shows, Baartman would sing and then turn her posterior to spectators. In private viewings, spectators would pay money to touch her buttocks with their hands and even with sticks.

Between 1810 and 1811, Baartman attracted fame but remained a sexualized and commoditized African woman known as the Hottentot Venus. The African Institution, under the leadership of Zachary Macaulay, took up Baartman's cause. Parliament had abolished the slave trade, although not slavery itself, in 1807. Antislavery activists criticized Cesars for using the body of his slave to make money. They also wrote to appropriate legal authorities in a bid to put an end to acts of dehumanization perpetrated by Cesars and his cohorts. The Court of King's Bench reviewed the case and interviewed Baartman to ascertain whether she was compelled to display herself by her owner, or if she participated out of free will.

Among scholars, Baartman's testimony has raised debates on the question of agency. In her response to the court, Baartman claimed that she entertained out of free will, received half of the money accrued from her performance, and preferred to live in London rather than Cape Town. After the case, Baartman settled in Manchester, England. Historians have yet to explain how she survived between 1811 and 1814. No one knows exactly what happened to Baartman until 1814, when she reappeared in France. She died in France in 1815 after suffering from tuberculosis. After her death, her body remained an object of curiosity and a subject of scientific research. French scientists embalmed her body, and dissected and measured her genitalia. In 1995, the Griqua National Conference demanded her body from French authorities. In 1999, participants at the World Archaeological Congress in Cape Town called on the South African government to collect Baartman's remains from the French government. After many years of negotiation, the French government allowed for the removal of her remains on May 2, 2002. Sara's body was finally laid to rest in the Eastern Cape.

Scholars have used Baartman's life as a case study for a number of important historical issues, including: the representation of black women's bodies in mainstream white culture, the intersection of gendered and racial stereotypes in colonial Natal and London in the nineteenth century, and the convergence between European scientific racism and black identity from the nineteenth century onward. African-American scholars such as Suzi Parks-Davis and Lyle Ashton Harris have based their artistic works on the life of the Hottentot Venus. More importantly, scholarly works show that the shape of Baartman's posterior inspired the development of the bustle silhouette, a major fashion innovation for women that emerged in England during the Victorian era. Bustles were used to exaggerate women's buttocks, making them appear larger than usual. Victorian women, out of pressure to conform to an idealized, morally upright femininity, wore bustles and corsets in order to mold their bodies into an hourglass figure.

See also BEAUTY IDEALS, NINETEENTH-CENTURY AMERICA; CORSETS; RACE AND RACISM; SLAVES, AS SEX OBJECTS

Further Reading

Crais, Clifton, and Pamela Scully. *Sara Baartman and the Hottentot Venus: A Ghost Story and a Biography*. Princeton, NJ: Princeton University Press, 2009.

Schiebinger, Londa. *Nature's Body: Gender in the Making of Modern Science*. New Brunswick, NJ: Rutgers University Press, 2008.

Scully, Pamela, and Crais, Clifton. "Race and Erasure: Sara Baartman and Hendrik Cesars in Cape Town and London." *Journal of British Studies* 47 (April 2008): 301–323.

■ TOSIN F. ABIODUN

BARBIE DOLLS

Barbie Doll, whose full name is Barbara Millicent Roberts, was created in 1959 by Ruth Handler and thenceforth manufactured by Mattel, the American toy-manufacturing company. The doll was modeled on Bild Lilli, a German doll depicting a cartoon

character; Bild Lilli was originally intended for adults but over time became a children's toy. Barbie was the first doll for children in the United States that superficially resembled an adult, and it was also the first doll with breasts (although the breasts are void of nipples). Ruth Handler believed that girls await the moment when they grow breasts; they dream of it, and this is the reason behind their desire to play with dolls that really do have adult, womanly bodies and features. Whilst playing with Barbie, girls simultaneously play mature femininity defined through the body, not through household-related responsibilities and child care, as in the case with newborn baby dolls.

Barbie dolls are one of the most popular toys, and concomitantly one of the most preferred collectable objects. Each year, more than a dozen new doll models and hundreds of accessories designed for them appear on the market. Barbie is a global brand associated not only with many commodities such as magazines, movies, and video games but also with enterprises and shops. The doll is considered a cultural icon: in 1976, it was placed in a time capsule to commemorate the bicentenary anniversary of the American Declaration of Independence from the British Empire; and in 1985, Andy Warhol painted her portrait.

Barbie is also considered to be a symbol of femininity, which is in fact a strong exaggeration: she has the height of a supermodel (half of which is taken up with her legs); a long neck; a small nose; large eyes; very thick hair; a slender, virtually boyish

The first Barbie doll (created in 1959) in her original box is displayed during the Barbie Retro Chic exhibition at the Musee de la Poupée in Paris on February 13, 2014. Her long legs and body proportions are completely unrealistic. Getty Images

build; and a very narrow waist, which focuses attention on her disproportionally large, firm, and bouncy breasts. Barbie's figure appears to be unattainable for a real woman (notably the waist), mostly because her "dimensions" are—assuming that she is 5 ft. 9 in. tall—39-18-31.5 inches. A woman of such proportions would suffer from back pain due to her excessively heavy breasts. Barbie completely lacks male elements, and her femininity is beyond dispute. Perhaps for this reason, she inspires girls and adult women alike: Cynthia Jackson, Vicki Lee, and Valeria Lukyanova have all undergone a series of plastic surgeries and cosmetic procedures (including, of course, breast augmentation) only to

become more like Barbie. The corporeality of Barbie has always been heavily exposed—the first doll's apparel consisted of a black-and-white one-piece swimsuit.

In 1975, Mattel developed Growing Up Skipper, Barbie's younger-sister version, who matured when one made any motion with her left hand. As a result of this activity, Skipper's breasts grew, making her waist seem narrower, and the doll became slightly taller.

In October 2006, the Breast Cancer Pink Ribbon Barbie Doll, a collection designed by Robert Best, was introduced to the public. Pink Ribbon Barbie was dressed in a pink dress, and a shawl adorned her arms (the cloth around her neck was primarily intended to represent the symbol of the fight against breast cancer, a pink ribbon; the ribbon was also pinned to her left breast). Last but not least, her long blond hair was formed in a bun on her head. The idea behind the sale of Pink Ribbon Barbie was to support the Susan G. Komen for the Cure Foundation. (The organization received $2.50 for each copy of the doll sold.) The doll was pilloried because it had no association with breast cancer whatsoever, and it did not help children whose mothers, or any other close relatives for that matter, suffered from breast cancer. The trifling sum of money that Mattel spent on supporting the fight against breast cancer was also severely criticized. Members of the Young Survival Coalition designed an alternative doll and published photos of her on the Internet. Their version was bald, with a clearly visible bandage on its chest, and another one placed where a catheter had previously been inserted. The kit also included a drip, medicine, prescriptions, and a pink toilet bowl, indispensable during nausea. In 2012, in response to the demands of a Facebook group, Mattel announced a bald Barbie Doll, provided with wigs, scarves, and hats, which, however, was not issued for sale but was transferred to children's hospitals and foundations.

In 2010, Mattel designed a Barbie series—Back to Basics, The Supermodel Edition. One of the dolls, due to her ample cleavage and a very clear gap between her breasts, received the sobriquet Busty Barbie. Parents mounted a protest against her because they did not want their children to play with a doll whose physical features communicated a message that sexuality should be a woman's priority. Although Barbie Dolls have lost some of their popularity to Bratz dolls, they are still regarded as one of the models that convey significant information about corporeality, femininity, and the currently favored shape of the body.

See also BEAUTY IDEALS, TWENTIETH- AND TWENTY-FIRST-CENTURY AMERICA; BODY IMAGE; PINK RIBBON CAMPAIGNS; SUSAN G. KOMEN FOR THE CURE

Further Reading

Driscoll, Catherine. "Barbie Culture." In *Girl Culture: An Encyclopedia*, edited by Claudia A. Mitchell and Jacqueline Reid-Walsh, 39–47. Westport, CT: Greenwood Press, 2008.

Driscoll, Catherine. *Girls: Feminine Adolescence in Popular Culture and Cultural Theory*. New York: Columbia University Press, 2002.

Peers, Juliette. "Doll Culture." In *Girl Culture: An Encyclopedia*, edited by Claudia A. Mitchell and Jacqueline Reid-Walsh, 25–38. Westport, CT: Greenwood Press, 2008.

Rogers, Mary F. *Barbie Culture*. London: Sage, 1999.

Walter, Natasha. *Living Dolls: The Return of Sexism*. London: Virago, 2010.

■ ALINA ŁYSAK (TRANSLATED BY KAROL MAŚLANY)

BEAUTY IDEALS, NINETEENTH-CENTURY AMERICA

An ideal is a standard of perfection, beauty, or excellence that reflects a particular culture and period of time. It has also been used more specifically to refer to a person or object that exemplifies an ideal and thus provides a model for imitation. In the nineteenth century, it was widely assumed that women were the weaker sex. This was evident early in the century in the growing ideological focus on domesticity and the belief that women's place was in the private sphere.

Since antiquity, female reproductive organs were seen as being the same as male reproductive organs, only inverted. Their positioning in or on the body was a factor in the hierarchy. This meant that female reproductive organs were viewed as inferior to male reproductive organs, as if because of their internal position they were somehow not fully formed.

By the late eighteenth century, there was a shift in how the reproductive organs were viewed. Now they were viewed as different, although this radical shift was not based on scientific discovery, but rather a shift in attitude that reflects the society of the time. Identification with refined moral sensibility was accompanied by a change of attitude toward female sexuality. Now women were taught that they were inherently passionless, and they could derive no pleasure from sex. Part of their role as good wives was to submit to their husbands in the marriage bed. Women who exhibited immodest behavior would have been seen as abnormal.

The ideal wife or "angel of the home" reflects a focus on domesticity. Wives were supposed to make the home a refuge for their husbands who toiled away in the competitive outside world. The ideal wife was expected to be altruistic and solemn in her duty to preserve American culture and to educate her children to become good citizens. These expectations for women are often referred to as the "cult of true womanhood," and they were reinforced through literature, advice books, ladies' magazines, and the visual arts. In general, these standards of womanhood applied to white women of privilege.

American artists who depicted feminine beauty based their ideas on Western European artistic standards. Many would place women in a domestic setting such as a parlor, which reinforced what the ideals promoted in the literature. Images of beautiful women became a common feature of nineteenth-century American print culture, appearing in books, magazines, sheet music covers, and advertising. In the United States, there were two major trends in nineteenth-century beauty: the "steel-engraving lady" and the "voluptuous woman." The image of the steel-engraving lady appeared early in the nineteenth century, as urban life was featured more prominently in representations of American culture. She was pale, frail, and slender. (Upper-class women were also given to eating small amounts of arsenic in an effort to achieve the proper pallor of skin.) By midcentury, this was being challenged by a heavier-legged, hippy, and bustier woman, typified by lower-class women, including actresses and prostitutes. Both ideals share the corseted waistline (ideally, down to an 18-inch circumference). With the rising popularity of the theatre in the United States, voluptuous actresses like Lillian Russell became the standard for beauty. In fact, in the 1880s, young women in the United States worried about being too thin. They used padding, and they ate instead of nibbling or forgoing meals. By the end of the nineteenth century, the voluptuous woman had lost her vogue with the upper classes and returned to her lower-class beginnings.

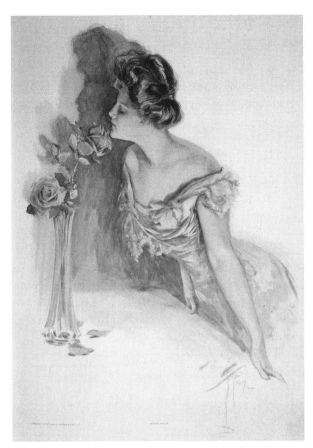

American Beauties, Harrison Fisher, c. 1907. This magazine illustration depicts an ideal woman of the late nineteenth and early twentieth centuries with a full bust displayed by her décolletage and tiny corseted waist. She is slender, but with an hourglass shape. She is elegant and refined as she bends to sniff the flowers. LC-USZC4-10358; courtesy of the Library of Congress

The Gibson Girl, popularized by the American graphic artist Charles Dana Gibson, appeared about 1890. This image of American womanhood retained the slender frame of the earlier "fragile" lady, but combined it with the large bust and hips of the "voluptuous" woman. She piled her hair on top of her head and wore a corset that shaped her chest into a "mono-bosom." The emphasis upon curves produced by the swan-bill corset resulted in the improbable "Grecian bend," in which the breasts and buttocks were so protruded by stays, corsets, and high heels that women who affected the style were unable to sit upright in carriages and had to lean forward and use cushions on the floor to rest their hands. Yet the Gibson Girl was portrayed as an active woman who exercised, went to college, and could make a man do anything she wanted him to do through the force of her beauty and personality. Some authorities believe the Gibson Girl was the first national beauty standard in the United States. As more women entered the workforce during World War I, however, the tightly corseted Gibson Girl style fell out of favor and was replaced by more practical clothing.

See also BEAUTY IDEALS, TWENTIETH- AND TWENTY-FIRST-CENTURY AMERICA; CORSETS; THEATRE; UNDERGARMENTS

Further Reading

Cogan, Frances B. *All-American Girl: The Ideal of Real Womanhood in Mid-Nineteenth-Century America.* Athens: University of Georgia Press, 1989.

Entwistle, Joanne. *The Fashioned Body: Fashion, Dress and Modern Social Theory.* Cambridge: Polity, 2000.

Nead, Lynda. *The Female Nude: Art, Obscenity, and Sexuality.* London: Routledge, 1992.

Nead, Lynda. *Myths of Sexuality: Representations of Women in Victorian Britain.* Oxford: Basil Blackwell, 1988.

■ LORI L. PARKS

BEAUTY IDEALS, RENAISSANCE

During the European Renaissance of the fourteenth through sixteenth centuries, a large belly and thighs were considered more erotic than large breasts. French and English women of the upper classes applied various lotions to their chests to keep their breasts small and firm.

The great masters of the Renaissance painted their Venuses and court beauties as women with small to modest-sized breasts, large hips, and fleshy bellies and thighs. Examples are Giorgione's *Sleeping Venus* (1510), Corregio's *Antiope* (c. 1528), and Titian's *Urbino Venus* (1538). In his famous painting *Birth of Venus* (1484–1486), Sandro Botticelli gave his goddess of beauty a much larger waist and smaller breasts than a modern-day artist would.

This preference for smaller breasts is revealed in the terms used by Renaissance poets to describe their ideal woman. Renaissance poets in England used a variety of fruit terms

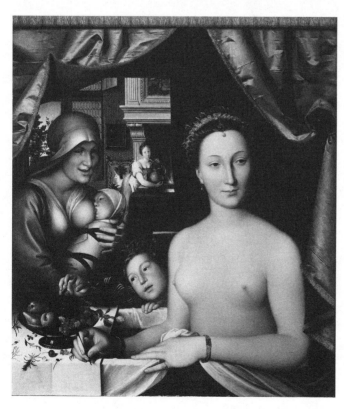

The aristocratic woman of François Clouet's *La Dame au Bath* (*Lady in Her Bath*) is an idealized woman different from the full-busted women of later centuries. Her bare breasts are like those of an adolescent, although she has given birth. To keep her breasts firm, she employs a nurse to breastfeed her baby. The nurse's lower status is indicated by the large breast that is thrust out of her gown for the child to suck upon. *La Dame au Bath* (*Lady in Her Bath*), François Clouet, 1570. National Gallery, Washington, D.C. Album/Art Resource, NY

to describe an ideal woman's breasts. However, unlike the melons and cantaloupes of today's vernacular, strawberries and apples were preferred. According to the French poet François Villon (b. 1431), small breasts and big hips were desirable in a woman.

Large breasts were considered to be ugly and were associated with age and poor women. Because of their size, large breasts sag more, especially with age and multiple children to breastfeed. This was seen as unattractive. Witches and old women (or old women as witches) were painted with large sagging breasts with large nipples. Attractive nudes and noblewomen were shown with very modest chests. This difference can be seen most clearly in the painting *Lady in Her Bath* (c. 1570) by the French artist François Clouet. The noblewoman sitting in her bath in the foreground of the painting has small, firm breasts. Behind her is a wet nurse suckling an infant. This woman has very large breasts like udders. Indeed, "dugs" was a term used in early modern England to refer to the teats or udders of animals as well as to large, sagging breasts.

Women's fashions in the fifteenth and sixteenth centuries were generally designed to minimize a woman's chest, like the gowns popular in the early sixteenth-century Italian city-states, or to practically eliminate the appearance of any breasts whatsoever, such as the tight, high-necked bodices of the Elizabethan court in England. Everywhere, the cut of the skirt and the amount of material were used to emphasize the size of a woman's belly. In a time when food was far less plentiful, a large belly signified health and wealth.

In Renaissance Venice, a modest chest was considered desirable, but fashion allowed a woman's breasts to be more visible than in other areas. Upper-class women and courtesans began to wear undergarments designed as shelves to lift their breasts higher and make them more visible in the new, lower-cut fashions. The courtesans also applied makeup to their nipples and areolae to make them more visible from second-story windows.

The Venetian bridge Ponte delle Tette (Bridge of Breasts) derives its name from the Renaissance prostitutes who used to stand on the bridge and display their naked chests to potential customers in the gondolas passing by underneath. Indeed, during the latter part of the fifteenth century, Venetian laws were relaxed to allow prostitutes to reveal more of their breasts to entice customers, and by the end of the century a law was even enacted that forced them to do so on the Ponte delle Tette. These measures were undertaken to counter the growing concerns with male homosexuality in the city and to make it more difficult for male prostitutes to try to pass as women to avoid the harsh laws against homosexuality. It no doubt also helped to stimulate the Venetian economy, in which catering to the needs of male tourists played a large role.

See also ART, WESTERN; BEAUTY IDEALS, NINETEENTH-CENTURY AMERICA; BEAUTY IDEALS, TWENTIETH- AND TWENTY-FIRST-CENTURY AMERICA; BRASSIERE; PROSTITUTION

Further Reading

Hollander, Anne. *Seeing through Clothes*. New York: Viking Press, 1978.

Paster, Gail Kern. *The Body Embarrassed: Drama and the Disciplines of Shame in Early Modern England*. Ithaca, NY: Cornell University Press, 1993.

Yalom, Marilyn. *A History of the Breast*. New York: Knopf, 1997.

■ TONYA LAMBERT

BEAUTY IDEALS, TWENTIETH- AND TWENTY-FIRST-CENTURY AMERICA

The role of women's breasts has been important for beauty ideals throughout twentieth- and twenty-first-century American history; breasts have been either enhanced and augmented or bound and flattened. Enabled by the growing presence of diverse media, iconic images, movie stars, and fashion models have increasingly influenced women's beauty ideals. The introduction of mass-produced figure-enhancing undergarments and the popularization of diet programs began the twentieth century, later to be supplemented by rigorous exercise regimens and plastic surgeries as women strove to achieve increasingly rigorous standards of beauty. Feminism, hippie culture, and the civil rights movement each challenged cultural values that shaped beauty ideals.

The twentieth century opened with images that, enabled by the influence of a growing print media, would shape women's ideals of beauty in a variety of ways. In the 1890s, Charles Dana Gibson's composite, the Gibson Girl, based on a variety of American women rather than a single model, depicted an independent yet composed and elegant upper-class European American woman. Her hourglass figure, a curvaceous form in which large breasts and hips contrasted with a small waist, was made possible with the aid of a corset and bustle. By contrast, the Brinkley Girl, created in 1908, was a working-class, carefree, feminine woman with loose curls who wore flowing lace. Nell Brinkley's images popularized suffrage ideals and included women of diverse races and backgrounds. Eclipsing the Gibson Girl, the Brinkley Girl remained popular until the 1940s. The 1920s flapper phenomenon challenged conventional morals and femininity; flappers applied newly available cosmetics and cut their hair in short "bobs," using corsets and narrow "hobble"-style skirts to create slim, boyish figures.

In the 1940s and 1950s, the hourglass figure would make a comeback. Film icons Marilyn Monroe and Jayne Mansfield repopularized the hourglass figure, now fully exposing shapely legs as well. Launched in 1953, Hugh Hefner's magazine *Playboy* featured Monroe on the cover and as its centerfold. First produced in 1959, Barbie dolls had tiny waist sizes that emphasized breast size, disproportionately long legs, and little body fat. Raquel Welch, posing in a bikini for the 1966 film *One Million Years BC*, became a sex symbol during the 1960s and 1970s. However, also during the 1960s, the fashion model Twiggy popularized the thin figure that would continue to be popular in fashion. Ideals of sexiness would include ultrathin, androgynous figures of high fashion, such as Kate Moss, as well as the large-breasted, toned-thin bodies of popular singers and actresses. However, more diverse body types have appeared in popular media. Actress Christina Hendricks, singer-actress Jennifer Lopez, and singers Adele, Jennifer Hudson, and Mariah Carey are famous for their curves rather than extreme thinness. Nonetheless, while criticism over excessive slimming continues, large breasts continue to dominate ideals of beauty.

Achieving beauty ideals was made possible by the development of the mass-produced brassiere in the early 1900s and the popularity of girdles through much of the twentieth century. Pushup bras were introduced in 1948; training bras for young girls were developed in the 1950s. During the 1960s, the Wonderbra became famous for "lifting and separating" women's breasts. To achieve increasingly popular slimming effects, women turned to newly invented control-top pantyhose and, later, body shapers. However, thinner ideal bodies required girls and women to diet and exercise, which was popularized by

Jane Fonda videos in the 1980s and the growing availability of gyms and exercise classes. Natural breasts could be augmented with surgical implants to achieve desirable sizes. In the early 2000s, the reality television shows *The Swan* and *Extreme Makeover* documented women undergoing dramatic alterations through dieting, exercise, and plastic surgeries to attain beauty ideals.

Beauty ideals have not gone unchallenged. In the early 1900s, they were based on European skin tones and bodies. African Americans, who were banned from beauty pageants, began their own pageants in the 1920s, and in 1984, African American Vanessa Williams was crowned Miss America, bringing racial diversity, while presenting a conventional body shape, to circulating images of beauty. At the 1968 Miss America Pageant, women protested its narrow ideals of physical beauty by throwing bras and girdles into the trash. In the 1960s, hippie culture encouraged women to dispense with bras, makeup, and shaving. Awareness of rising eating disorders has challenged the emphasis on a low body mass index (BMI) in beauty ideals, pointing to girls' negative feelings about their bodies and self-esteem problems. A fat acceptance movement, started in the 1960s, began to address negative stereotyping of women's bodies. In 1991, Naomi Wolf exposed the devastating effects of beauty ideals on women in her national bestseller, *The Beauty Myth*. Nonetheless, popular media figures with large breasts and highly toned, often extremely thin bodies continue to influence beauty ideals.

See also ADVERTISING; BARBIE DOLLS; *THE BEAUTY MYTH*; BRASSIERE; BREAST AUGMENTATION; CELEBRITY BREASTS; IMPLANTS; MODELING; MOVIES; *PLAYBOY*; WONDERBRA

Further Reading

Bailey, Eric J. *Black America, Body Beautiful: How the African Image Is Changing Fashion, Fitness, and Other Industries*. Westport, CT: Praeger, 2008.

Banner, Lois W. *American Beauty*. New York: Knopf, 1983.

Brumberg, Joan Jacobs. *The Body Project: An Intimate History of American Girls*. New York: Random House, 1997.

Farrell-Beck, Jane, and Colleen Gau. *Uplift: The Bra in America*. Philadelphia: University of Pennsylvania Press, 2002.

Perlmutter, Dawn. "Miss America: Whose Ideal?" In *Beauty Matters*, edited by Peg Zeglin Brand, 155–168. Bloomington: Indiana University Press, 2000.

Robbins, Trina. *Nell Brinkley and the New Woman in the Early 20th Century*. Jefferson, NC: McFarland, 2001.

Sagert, Kelly Boyer. *Flappers: A Guide to American Subculture*. Santa Barbara, CA: Greenwood, 2010.

■ DOROTHY WOODMAN

THE BEAUTY MYTH

Naomi Wolf's bestselling 1991 book, *The Beauty Myth: How Images of Beauty Are Used against Women*, is a key text in American third-wave feminism for its systematic analysis of the ways that the beauty myth damages women's bodies, psyches, and political agency. Wolf defines the beauty myth as "being in the midst of a violent backlash against feminism that uses images of female beauty as a political weapon against women's advancement."

The beauty myth pushes back against the political, legal, and cultural gains of second-wave feminism, and it associates feminism with female ugliness. According to Wolf, industries such as weight loss businesses, cosmetic companies, pornography producers, women's magazines, and plastic surgeons have created a myth that women are not lovable, sexually desirable, effective workers, or indeed truly women unless they uphold an ideal of feminine beauty. Those industries then sell products and procedures to women to service the anxieties they have created. Wolf compares the beauty myth to a nineteenth-century German torture device known as an iron maiden, an iron casket with a female image on top and spikes inside that punctured victims to death when closed. Wolf uses the iron maiden as a vivid metaphor for the painful and punishing treatments that many women undergo in order to conform to unreachable beauty ideals. She tracks its impact on women in their work lives and in cultural texts; shows how beauty rituals such as dieting, skin care, and cosmetic application take on a religious cast; and illustrates how dieting can rob women of life, energy, and libido. The final chapter before the conclusion, "Violence," focuses on cosmetic surgery, including breast enhancement.

Wolf's analysis of the cosmetic surgery industry demonstrates her argument about how the beauty myth harms women physically and emotionally. The Surgical Age, or the specific beauty myth that supports the cosmetic surgery industry, insists that women view their functioning bodies as deformed and in need of correction. Wolf outlines the many possible cosmetic surgeries for women, and she focuses on breast enhancement as a key example of how women may be seriously harmed in pursuit of idealized beauty. Women who have breast enhancement surgery may lose sensation in their nipples or in their breasts generally, scar tissue may form that necessitates removing the implants, some implants deflate and require extraction, silicone implants may leak toxins into the body, and implants make detecting breast cancer more difficult. Wolf argues that the procedure of breast enhancement surgery is itself eroticized and restricts female sexuality to beauty without feeling.

Furthermore, Wolf states that the cosmetic surgery industry's perpetuation of the beauty myth leads to harmful and profit-centered practices. Wolf posed as a potential client for cosmetic surgery, and none of the conversations she had with medical staff included realistic information about the potential risks. The surgery industry is replete with medical professionals who are not specifically licensed or board certified in plastic surgery, and thus they put women at additional risk of pain or lasting body damage. Those who perform cosmetic surgery charge high fees for their services, which insurance does not cover, and reap large profits. Governmental oversight of cosmetic surgery is so minimal, Wolf points out, that extensive reports to the U.S. Congress in the 1980s about women being permanently harmed or dying were received with indifference. Wolf also suggests that the childish language of cosmetic surgery, such as "nip" and "tummy tuck," draws attention away from the serious medical risks associated with expensive and unnecessary surgeries.

Wolf suggests in the conclusion that women fight back against the beauty myth by creating their own cultures of beauty and desire outside of those the beauty myth industries dictate. She suggests that women embrace the beauties of aging and difference, and that they reject the beauty myth's unending demands. That *The Beauty Myth* remains popular more than 20 years after its first publication speaks both to the pervasiveness of the title concept and to its long-term impact on readers.

See also ADVERTISING; BEAUTY IDEALS, TWENTIETH- AND TWENTY-FIRST-CENTURY AMERICA; BREAST AUGMENTATION; BREAST REDUCTION; FASHION; FEMINISM; MEDIA

Further Reading

Orbach, Susie. *Fat Is a Feminist Issue: The Anti-Diet Guide to Permanent Weight Loss.* New York: Paddington Press, 1978.

Valenti, Jessica. *Full Frontal Feminism: A Young Woman's Guide to Why Feminism Matters.* Emeryville, CA: Seal Press, 2007.

Wolf, Naomi. *The Beauty Myth: How Images of Beauty Are Used against Women.* New York: HarperCollins, 1991.

■ DONNA J. DRUCKER

BIBLE

The Bible is a collection of writings considered sacred and authoritative by Christians. It is divided into the Old and New Testaments. A "testament" means a covenant or agreement. Related writings, together called the Apocrypha, were included in the Latin Vulgate and Greek Septuagint versions of the Bible and are still adhered to by the Catholic branch of Christianity. The Protestant branch does not accept Apocryphal writings as holy scripture or authoritative canon, but does sometimes view them as valuable historical documents. The words "breast" and "breasts" occur in the Old and New Testaments 45 times, and in the Apocrypha six times.

In some cases, "breast" refers to the chest area of wild game or livestock as a source of food. For example, in the book of Leviticus, God told Moses to instruct the Israelites to wave a sacrificed animal's breast in the air when making an offering, and then give it to Aaron and his sons—the priests—to eat (Lev 7:30–36). Thus, the priests were well taken care of while serving God.

In other cases, "breast" refers to the chest area of human beings or angels. In the book of 2 Esdras in the Apocrypha, wisdom fills Ezra's breast, or chest, after he drinks a cupful of inspiration given to him by God. And in the book of Luke, a man emotionally beats his own breast, or chest, in lament as he admits to God in prayer that he is a sinner (Luke 18:13). In Revelation, seven angels wear golden sashes around their breasts, or chests.

"Breast" sometimes refers to the mammary glands of animals. Throughout the Bible, the jackal is used as a literary device to symbolize the cruelty of desolation and abandonment. In Lamentations, jackals nurse cubs at their breasts—and are deemed less cruel than Israelite women who have stopped feeding their infants because of famine (Lam 4:3).

In other examples, a woman's mammary gland is being referred to. In Job, oppressors take the fatherless child away from its mother's life-giving breast, thus killing the child (Job 24:9). In Psalms, David declares he has always trusted God—even when just an infant at his mother's breast (Psalms 22:9). In Hosea, the prophet Hosea curses those who defy God—he asks God to give them wombs that miscarry and breasts that cannot produce milk (Hosea 9:14).

A woman's breasts are also referred to as pleasing sexual objects in the Bible. In Proverbs, David compares the breasts of a man's wife to the breasts of a loving, graceful doe

(Prov 5:19); he hopes his sons will be intoxicated by their wives' breasts—and not desire the breasts of other men's wives or of ungodly women. In Song of Songs, a man twice refers to a woman's breasts as twin fawns of a gazelle—they symbolize youthful beauty and virginity (Song 4:5 and 7:3). He celebrates her body, piece by piece—first her feet, then legs, bellybutton, waist, breasts, neck, eyes, nose, head, hair, breath, and mouth (Song 7:1–9). Her breasts are coconuts on a palm he will climb; then they are clusters of grapes, plump and ready to be taken hold of (Song 7:7–8). She later responds, describing her breasts as towers high atop a fortress's wall where they are well protected (Song 8:10). She must be climbed if the man is to gain entry, or she must let him into her fortress herself. She knows her breasts will bring him contentment. In Ezekiel, breasts are associated with sin as prostitutes let their breasts be fondled (Ez 23:3).

See also LITERATURE; RELIGION

Further Reading

Henry, Matthew. *Matthew Henry's Commentary on the Whole Bible*. Peabody, MA: Hendrickson, 2011.
Strong, James. *The New Strong's Exhaustive Concordance of the Bible*. Nashville, TN: Thomas Nelson, 1996.
Yalom, Marilyn. *A History of the Breast*. New York: Knopf, 1997.

■ ELIZABETH JENNER

BODY IMAGE

The concept of body image may refer to the way in which a person perceives his or her own body, but also to the set of body representations produced by a culture. There is a strong connection between the two sides of this concept. Every society attaches meanings, values, and prescriptions to the body, producing an ideal image of it, and determining the attitudes of individuals toward their body and toward the body in general. Many scholars have pointed out that the body is always a sociocultural constructed reality, thus variable in space and time, and that to some extent the body is always a matter of image. In contemporary Western societies, body image and self-image overlap significantly, due to the growing importance of the body within a capitalist and hypervisual culture that is praised by some and criticized by others for its hedonism, its weakening of Christian values, its freedom, its individualism, and its obsession with well-being.

The breast functions nowadays as the central part of the feminine body image. The mass media play an important role in configuring the ideal breast image. Reinforcing the obsession triggered during the Second World War, when many soldiers read magazines revealing the so-called pinup girls, the past decades have endorsed excessively the contradicting image of an ultrathin woman with voluptuous breasts. From the common cleavage of news anchors to the soft-porn images of girls featured in tabloids or video clips, breasts have become the instrument through which women are hypereroticized within the media. Even though we should not mistake the reality of the media for our daily existence, the impact of media images of breasts cannot be ignored. Turned into a standard of femininity by the media, the breast becomes powerful through the media's unquestionable ability to spread, mold, and level the way women regard their breasts. Thus, the breast promoted

by the media, which is fresh, large, upright, and firm, becomes a norm for women, and activates expectations in men of the women in their lives, enhancing the desire but also male anxieties toward femininity. The extensive association of female eroticism with the breasts is not a universal phenomenon. In Latin America and Africa, the buttocks play the role of an erotic symbol; in China, the feet; and in Japan, the neck. The current Western fetishism of breasts, the power of the media, and the cross-cultural context of globalization, however, are resulting in a weakening of cultural differences, crowning the breast as the ultimate erotic symbol.

Massive research has shown that we are far from the feminist activism of 1968, when a famous bra-burning event was scheduled to occur in New Jersey. What might seem a freeing act by exposing the breasts and body in general has actually backfired into a regression of the woman to the state of an object, dissembled through a luxurious slavery. While women are taught how to exploit their erotic potential through exhibition of their breasts in order to achieve fame, admiration, and other emotional or material benefits, they merely strengthen the phallocratic organization of the society, as the real beneficiary will always be the opposite sex. The negative impact of the media hypereroticization of the breasts and the female body in general has been detected in the fact that women's degree of satisfaction with their body is very low. Although, for example, obesity tends to be higher in men than in women, concerns for one's figure and dieting become easily detectable constants of being a woman. Weight variation, morphological, and genetic factors often cause large differences between the breasts that women have and the breasts they would like to have, giving rise to discontentment and diminishing self-esteem. An adjustment to the ideal breast image occurs not infrequently by a surgical procedure of breast augmentation. Performed previously only for reconstructing the breast affected by cancer, breast surgery performed for cosmetic reasons disqualifies small breasts, and, as cultural studies researcher Birgitta Haga Gripsrud observes, employs a medical treatment of the normal breast, which is thus treated as a disease.

The influence of the mass media's breast image is all-pervasive and at the same time very subtle. In his book on the sociology of bare breasts on the beach (i.e., topless sunbathing), Jean-Claude Kaufmann shows that the media-promoted breast image interferes with the formation of the naked breast image and of the operation rules of topless beaches. The freedom and naturalness invoked by the beachgoers turn out to be just an inconsistent veil. People admit to accepting breast nakedness because it has become a commonplace practice in the media, but also they issue basic requirements that the naked breast needs to meet—to be upright, nonbouncing, and so on—and admit their inability to separate the beauty of the breast from its eroticism.

The breast image participates in generating the body image and vice versa. Yet, pregnancy is a special situation when the breast, imbued with sexuality, maintains its positive image and can even be improved—the breasts grow larger—while the body image risks certain alterations due to the extra weight gained by the pregnant woman. During the postpartum period, many women get depressed not only because of their bodily changes but also because they are culturally confronted with a different body image, the idealized image of the good mother. After giving birth, the social imperative of breastfeeding makes the maternal image of the breast to be well integrated in a general body image that is no longer an eroticized one, but a body connected to the baby's necessities. Scholars talked

about this cultural paradox that consists of exposing women to two different body images, a contradiction that some women find very difficult to handle.

French theorists like Jean Baudrillard or David Le Breton emphasized the idea that our contemporary body image is not the image of our body. In fact, they say we are now living in an era of the extreme body, as the image is not bringing to the fore a real body, but rather an idealized image, a super-body. The physical body is devitalized, yet its appearance is reinforced. While this view may be perfectly true from the perspective of the philosophy of culture and image theory, social sciences and gender studies are showing that real women live in constant tension, oscillating between what their society assigns to the ideal breasts and women's desire, ability, efforts, and risks in complying with that ideal.

See also ADVERTISING; BEAUTY IDEALS, TWENTIETH- AND TWENTY-FIRST-CENTURY AMERICA; BREAST AUGMENTATION; CELEBRITY BREASTS; MEDIA; OBESITY; PINUP GIRLS; *PLAYBOY*; *YANK, THE ARMY WEEKLY*

Further Reading

Goldman, Leslie. *Locker Room Diaries: The Naked Truth about Women, Body Image, and Reimagining the Perfect Body.* Cambridge, MA: Da Capo Press, 2007.
Wolf, Naomi. *The Beauty Myth: How Images of Beauty Are Used against Women.* New York: HarperCollins, 1991.
Wykes, Maggie, and Barrie Gunter. *The Media and Body Image: If Looks Could Kill.* Thousand Oaks, CA: Sage, 2005.
Yalom, Marilyn. *A History of the Breast.* New York: Knopf, 1997.

■ ADRIANA TEODORESCU

BRA
See Brassiere

BRA BURNING
Bra burning is a potent image of second-wave feminism. According to author and activist Susan Brownmiller, a reporter for the *New York Post* sparked a rumor that the Miss America pageant in Atlantic City, New Jersey, on September 7, 1968, would include bra burning as a women's protest akin to burning a military draft card. New York Radical Women, the group that organized the protest, targeted the Miss America pageant as a symbol of the artificial standards of femininity and beauty imposed on women in a patriarchal culture. They threw symbols of women's oppression, such as bras, *Playboy* magazines, mops, girdles, makeup, and kitchen equipment, into a "Freedom Trash Can" in front of the convention hall, but they did not light the items on fire because they did not have a permit from the local police department. The protest also included crowning a live sheep and comparing the pageant to a livestock show. The protestors produced a document, "No Miss America!" which contained 10 specific objections to the pageant, including "The Degrading Mindless-Boob-Girlie Symbol," "Racism with Roses," and "Miss America as Military

Death Mascot," in which they describe Miss America as "The Living Bra" who entertained soldiers in the increasingly deadly Vietnam War. While the protest was not shown on TV, it was widely covered in American newspapers, including the *New York Post* with the title "Bra Burners and Miss America." The would-be bra burning received the most lasting attention of all its memorable aspects, as it crystallized how second-wave feminism challenged the beauty ideals inherent in American culture.

Bras and other body-shaping undergarments are central to modern ideas of femininity and how women's bodies should look. The characterization of women as bra burners, or that of second-wave feminism as bra-burning feminism, associates the rejection of bras with women's rejection of cultural ideals of femininity. The bra-burning characterization also suggests that women who destroyed bras were like men refusing to be drafted into the military; both groups were willing to engage in dangerous and potentially violent acts in order to oppose cultural and political demands on their personhood. Furthermore, women rejecting bras symbolize a rejection of pervasive patriarchal ideas about how proper, respectable women should appear in public. In an antifeminist light, the idea of bra-burning feminism associates feminist women with ugliness and lacking true womanhood. The powerful and long-term correlation of feminism with bra burning can make present-day women reluctant to name themselves as feminists for fear that their peers and broader American culture will consider them unattractive or unsexy. Whether seen in a feminist or an antifeminist paradigm, the idea of bra burning remains a powerful symbol of the association of shaping undergarments with women's power and agency.

See also THE BEAUTY MYTH; BRASSIERE; MEDIA; PLAYBOY; TOPLESS PROTESTS; WOMEN'S MOVEMENT

Further Reading

Brownmiller, Susan. *In Our Time: Memoir of a Revolution*. New York: Dial Press, 1999.

Farell-Beck, Jane, and Colleen Gau. *Uplift: The Bra in America*. Philadelphia: University of Pennsylvania Press, 2002.

"No More Miss America!" *CWLU Herstory Archive*, September 7, 1968. Retrieved May 16, 2014, from http://www.uic.edu/orgs/cwluherstory/CWLUArchive/miss.html

■ DONNA J. DRUCKER

BRASSIERE

A brassiere, or bra, is an undergarment designed to support the breasts. A brassiere generally consists of two cups for the breasts, supporting shoulder straps, and an adjustable clasp. Contemporary bras come in a variety of styles, shapes, and colors at retail stores such as Victoria's Secret, but they had very modest beginnings. A recent archeological find has prompted discussion about the origin of the brassiere. Historians found what appears to be a modern-like brassiere from the fourteenth or fifteenth century in Austria, but many still argue that these kinds of breast supporters were rare until the twentieth century. The popularity of corsets began to wane, as women wanted something less confining and easier to wear. As early as 1905, American brassiere manufacturers advertised their products in

Brassieres, more commonly called "bras," come in many colors and styles, including strapless designs and sports bras. RusianOmega, Karen Roach, Chiyacat/ Thinkstock by Getty Images

catalogues such as the Women and Infants' Furnisher. Companies that had manufactured corsets and other undergarments began selling brassieres as their other products' popularity diminished. Before the modern brassiere, however, women wore "bust improvers" that were similar to corsets in that they had boning, but were much shorter and did not cover the bottom half of the torso. These "bust improvers" were the prototype of the modern bra, but created a mono-bosom effect rather than separating the breasts. Brassiere manufacturers began to move away from the mono-bosom in the 1910s, when the two-cup brassiere was developed and popularized because of new fashion trends that highlighted the breast area. Sports bras and strapless bras were also created during this period, but they did not become popular until the 1950s.

Although fashion trends of the 1910s tended to enhance the breasts, women in the 1920s adopted the flapper look that focused on boyish traits, like small breasts. Because of this trend, brassiere designs of the 1920s, such as bandeaux bras, compressed rather than supported the breasts to create the illusion of flat chests. It was not until the early 1930s that lingerie companies came up with the concept of the "uplifted" breast. Bras that uplifted the breasts were meant to correct the damage caused by the flattening bandeaux bras of the 1920s. The "uplifted" breast of the 1930s became very fashionable in the 1950s and again in the 1990s. Standardized cup sizes (A–D), and adjustable elastic straps also came about in the 1930s because brassiere companies wanted to make buying and selling bras easier. Before the sizing system and adjustable straps, brassieres had to be fitted to each individual body.

During World War II, many women entered the workforce for the first time. Women, who had not necessarily needed to wear bras before, needed them for support while wearing the tight-fitting clothes required for factory work. Brassieres manufactured during this period often used less metal for underwires and different fabrics, because most metals and fabrics were reserved for war supplies. In the two decades after the war, Americans were

more financially stable. Women could afford to purchase multiple bras for different outfits that helped them to achieve the pointy, uplifted torpedo effect that was popular in the 1950s. In the 1950s and 1960s, young baby boomers "trained" their breasts to develop perfectly by wearing newly popular training bras. Those baby boomers are often credited with the mythical bra-burning demonstration at the Miss America Pageant in the late 1960s, when the counterculture promoted freedom from the perceived oppression of the brassiere.

The pushup bra, mainly promoted by the Wonderbra Company, grew in popularity in the 1970s because of tight-fitting, low-cut designs for women. During the 1980s, however, the popularity of natural-looking breasts came back, and the bras made during this decade reflect that trend. They were more rounded or padded in the cup area and generally came in earth tones rather than bright colors. In the early 1990s, the pushup bra again became popular, due partly, in fact, to a famous Wonderbra ad campaign. These pushup bras were generally stiff and uncomfortable, prompting women to ask for more comfortable options. From the mid-1990s into the twenty-first century, bra makers have focused on creating a variety of bras to fit every need, including comfort. Bras are now more affordable and comfortable than ever, and can be bought in specialty as well as general retail stores.

See also BEAUTY IDEALS, TWENTIETH- AND TWENTY-FIRST-CENTURY AMERICA; CORSETS; FREDERICK'S OF HOLLYWOOD; JACOB, MARY PHELPS; MAIDENFORM; MAN BRA; SPORTS BRAS; TRAINING BRAS; WONDERBRA

Further Reading

Farrell-Beck, Jane, and Colleen R. Grace. *Uplift: The Bra in America*. Philadelphia: University of Pennsylvania Press, 2002.

Fields, Jill. *An Intimate Affair: Women, Lingerie, and Sexuality*. Berkeley: University of California Press, 2007.

Nutz, Beatrix. "Medieval Lingerie." August 2012. Retrieved May 16, 2014, from http://www.historyextra.com/lingerie

■ MICHELLE FITZSIMMONS

BREAST ANATOMY

The human breast covers the area from the axilla or armpit to the inframammary fold, which is the junction between the bottom of the breast and the rest of the chest skin. The human breast usually extends from approximately the second to the sixth rib. The breast overlies the pectoralis major muscle, and the breast tissue that extends into the armpit is known as the axillary tail (also called the tail of Spence, named for Scottish surgeon James Spence). The breast is composed of mammary glands, adipose tissue (fat), an areola, a nipple, and skin. Mammary glands consist of a network of lobules and ducts. Fibrous connective tissue known as suspensory ligaments (also called Cooper's ligaments, for English surgeon Astley Cooper) connects the inner skin of the breast to the pectoral muscles to support the breast and maintain the shape of the tissue.

The areola (plural: areolae) is the darker circle of skin surrounding the nipple. Small bumps on the areolae are called Montgomery tubercles, which are the external portion of

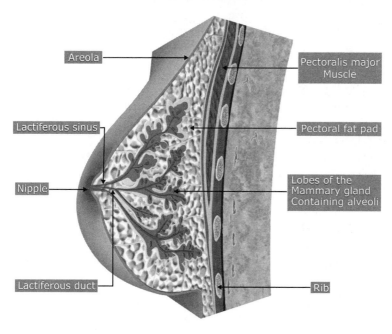

Breast cut

Areola

Pectoralis major Muscle

Lactiferous sinus

Pectoral fat pad

Nipple

Lobes of the Mammary gland Containing alveoli

Lactiferous duct

Rib

Human breasts are made up of mammary glands, fat, areolae, nipples, and skin overlying the pectoralis major muscles. PicologicStudio/ Thinkstock by Getty

the areolar glands (also called the glands of Montgomery, after Irish obstetrician William Fetherstone Montgomery). The Montgomery glands are sebaceous glands that secrete oily lipoid fluid to protect and moisturize the areola and nipple of each breast. Secretions from these glands can also stimulate appetite in nursing infants.

"Female" and "male" breasts have the same basic components, including mammary glands. Adipose tissue can increase in the breast due to a variety of factors, including hormonal changes and obesity. Thus, the presence of adipose tissue is common in both typically female and male breasts.

Blood Vessels: The breast receives blood from several sources: (1) the second, third, and fourth branches of perforating branches and anterior intercostal branches of the internal thoracic artery; (2) the lateral thoracic artery, a branch of the axillary artery; (3) the thoraco-acromial artery, a branch of the axillary artery; and (4) the lateral cutaneous branches of the posterior intercostal arteries in the second, third, and fourth intercostal spaces. Blood drains mainly to the axillary vein, but also to the internal thoracic vein.

Lymphatic System: The lymphatic system is part of the circulatory system. Lymphatic drainage of the breast is complex. First, fluid of the lymphatic system called the lymph passes from the nipple, areola, and lobules into the subareolar lymphatic plexus and then to several groups of lymph nodes after the subareolar lymphatic plexus: the infraclavicular, supraclavicular, interpectoral, parasternal (internal mammary), interpectoral, and axillary nodes. Most of the lymph drainage is to the axillary lymph nodes by way of the pectoral lymph nodes. The axillary lymph nodes can be further divided into apical, lateral

(humeral), central, anterior (pectoral), and posterior (subscapular) groups. During breast exams, examination of the axillary lymph nodes can provide important diagnostic information. The precise locations of lymph nodes and drainage can vary. Sometimes, breasts drain to lymph nodes outside of the immediate area, and some people also have intra-mammary lymph nodes, or lymph nodes within the breast.

Nerves: Sensory nerve supply to the breast originates from the anterior and lateral cutaneous branches of the fourth, fifth, and sixth intercostal nerves. T4 (thoracic spinal nerve 4) supplies the nipple, and its dermatome (sensory innervation pattern) covers most of the breast. The intercostal nerves also supply sympathetic fibers to the breast's blood vessels and to the smooth muscle in the nipple and skin.

Mammary Gland: The mammary gland is an apocrine gland (a kind of exocrine gland). Apocrine glands secrete their products by budding them off through their plasma membrane, sending vesicles of their product into a duct. It is controversial whether human mammary glands are modified sweat or sebaceous (oil) glands, as the mammary glands of different species have evolved in different ways. Swollen mammary glands may be a sign of milk duct blockages, breast infection, or even cancer.

Mature mammary glands contain alveoli (cavities), which form clusters called lobules. Milk (or lactiferous) ducts lead from the lobules to the nipple, where milk is secreted. A nutrient-rich form of breast milk called colostrum is produced by mammary glands toward the end of pregnancy. This particular breast milk contains a variety of ingredients that are essential to the optimal health of a newborn, including growth factors, microbicides, antibodies, and immune cells.

The endocrine system regulates mammary gland development, which occurs only under particular hormonal conditions such as those typical in female puberty and in pregnancy. As a result, people with typically male bodies do not usually have mature mammary glands. Mammary glands in typically male breasts are often described as "vestigial." Medical evidence has documented cases in which steroid use and other factors that cause hormonal changes can lead to mammary gland development and milk production in people with typically male bodies.

See also AREOLAE; BREAST CANCER; BREASTFEEDING; NIPPLES; PREGNANCY; PUBERTY

Further Reading

Anderson, William F., Michelle D. Althius, Louise A. Brinton, and Susan S. Devesa. "Is Male Breast Cancer Similar or Different Than Female Breast Cancer?" *Breast Cancer Research and Treatment* 83 (2004): 77–86.

Moore, Keith L., and Arthur F. Dalley. *Clinically Oriented Anatomy*. Philadelphia: Lippincott Williams & Wilkins, 2006.

Raouf, Afshin, Yujia Sun, Sumanta Chatterjee, and Pratima Basak. "The Biology of Human Breast Epithelial Progenitors." *Seminars in Cell and Developmental Biology* 23, no. 5 (2012): 606–612.

Sinnatamby, Chummy S. *Last's Anatomy Regional and Applied*. Edinburgh: Churchill Livingstone, 2011.

Winchester, David J., David P. Winchester, Clifford A. Hudis, and Larry Norton. *Breast Cancer*. Hamilton, ON: BC Decker, 2005.

■ ISRAEL BERGER AND Y. GAVRIEL ANSARA

BREAST AUGMENTATION

Breast augmentation, also known as breast enlargement or breast augmentation mammoplasty, is a set of related surgical procedures to enhance the appearance of the breast, particularly by increasing the size (or appearance of size) of one or both breasts, make the breasts symmetrical, adjusting the contour of the breast, or reconstructing the breast after mastectomy or lumpectomy. It may be performed under local or general anesthesia and is usually performed as an outpatient surgery. Implants may be made from silicone or saline, which may be chosen for their weight, appearance, and/or safety. Alternatively, subcutaneous fat may be used from another area of the body, for example the abdomen or buttocks. This is most common in breast reconstruction. There are two main locations for artificial implants: in front of the pectoralis major muscle (subglandular) or behind it (subpectoral). A newer technique places the implant in front of the muscle but under the fascia, a layer of tissue that encapsulates the muscle (subfascial). Each technique has benefits and drawbacks for different bodies and lifestyles.

When the implant is placed behind the muscle, it gives the appearance of larger breasts by pushing the muscle and breast tissue outward, giving more cleavage but not actually changing the volume of the breast. This procedure produces a more natural appearance than when the implant is placed in front of the muscle. The latter procedure is the traditional form of breast augmentation, which results in the look that is characteristic of breasts that have been enlarged. It results in a rounder and more mobile appearance than is characteristic of natural breasts. This procedure is also able to produce larger breasts due to the implant being in the breast itself rather than behind it. The exact implant and procedure that are used depend on the existing breast, chest muscles, preference, and lifestyle. For example, highly active individuals may prefer the implant to be behind the muscle, because the breasts will appear larger but will not bounce as much as when the implant is placed in front.

Postoperatively, a surgical support bra or binder is worn to prevent fluid buildup and prevent stretching at the incision sites. Healing times vary for each person, with light activities usually being resumed within a week and heavy activities within 3 months. Stitches, drains (if placed), and dressings are usually removed at one week, and residual swelling usually subsides within one month.

Although breast augmentation has been associated with pornography and large breasts, the majority of procedures result in the equivalent of a U.S. B or C cup. Individuals may choose to have breast augmentation for a variety of reasons, including following mastectomy or lumpectomy. Although it is considered an elective, cosmetic surgery in that it is not medically necessary, it may be socially or psychologically necessary for the person who has it done. Women with particularly small breasts may be treated poorly or mistaken for men, resulting in psychosocial difficulties. This includes women who may consider themselves transgender or intersex and those whom others would consider transgender or intersex. Some women may be satisfied with relatively small breasts, whereas some will seek breast augmentation.

Some studies have linked breast augmentation with various health outcomes, including cancers, whereas other studies have found no link. However, women who have breast augmentation are more likely than others to suffer from sadness, low self-esteem, and body dissatisfaction (sometimes having been diagnosed with depression or body dysmorphic

disorder). Surgeons must consider whether surgery is likely to be an improvement, as the change may not improve the person's state.

See also BEAUTY IDEALS, TWENTIETH- AND TWENTY-FIRST-CENTURY AMERICA; BREAST CANCER TREATMENTS; BREAST RECONSTRUCTIVE SURGERY; IMPLANTS; MASTECTOMY AND LUMPECTOMY; TRANSGENDER/TRANSSEXUAL

Further Reading

Figueroa-Haas, C. L. "Effect of Breast Augmentation Mammoplasty on Self-Esteem and Sexuality: A Quantitative Analysis." *Plastic Surgical Nursing* 27, no. 1 (2007): 16–36.

Jacobson, Nora. *Cleavage: Technology, Controversy, and the Ironies of the Man-Made Breast*. New Brunswick, NJ: Rutgers University Press, 2000.

Solvi, A. S., K. Foss, T. von Soest, H. E. Roald, K. C. Skolleborg, and A. Holte. "Motivational Factors and Psychological Processes in Cosmetic Breast Augmentation Surgery." *Journal of Plastic, Reconstructive and Aesthetic Surgery* 63, no. 4 (2010): 673–680.

Xie, L., J. Brisson, E. J. Holowaty, P. J. Villeneuve, and Y. Mao. "The Influence of Cosmetic Breast Augmentation on the Stage Distribution and Prognosis of Women Subsequently Diagnosed with Breast Cancer." *International Journal of Cancer* 126, no. 9 (2010): 2182–2190.

■ ISRAEL BERGER

BREAST BINDING

Breast binding refers to applying tight wrapping or bandaging around an individual's chest and the wearing of extremely tight clothes. Various materials can be used for breast binding, including bandages and tapes. Breast binding is practiced by both women and men for a variety of reasons. The most common reason is to reduce breast visibility and to achieve a male-looking chest. Adolescent girls may practice binding to reduce the visibility of their early sexual development for modesty reasons. Girls may wear tight sports bras and swimsuits to make their breasts less visible. Some girls may want to remain childlike and bind their breasts to reduce the signs of their sexual maturity. Breast preoccupation at an adolescent age may be a sign of body dysmorphic disorder. In Cameroon and some other African countries, breast binding may follow breast mutilation in order to reduce signs of girls' sexual development.

Breast binding could be practiced for other reasons that are not related to body image issues. Women who decide to stop breastfeeding or to not initiate it may bind their breasts tightly for a couple of days in order to suppress lactation. Breast binding may also be practiced to suppress breast milk production caused by some psychotropic medications. Breast binding is commonly practiced for immobilization reasons postoperatively, including after breast reduction, breast augmentation, and breast cancer surgeries, and as a trauma management procedure, for example to manage rib fractures. Chest binders, which are specially designed orthotic support garments, may be used in postoperative care. Breast binding may be practiced by women participating in sports, and for those performing male character roles on the screen or stage.

Breast binding can be practiced by men with gynecomastia to avoid embarrassment related to enlarged breasts due to obesity, hormonal imbalance during adolescence, the use

of hormonal medicines, and other reasons. They usually wear chest binders and tank tops. Some breast-binding practices could be used by people undergoing gender reassignment surgery, and can be used generally by transsexuals who prefer to hide breasts, considering them as undesirable body features related to the opposite gender.

Breast binding is associated with a number of health risks. Immediate health effects include difficulty with breathing, discomfort due to pressure, backache, excessive sweating, and skin rashes and lesions. Skin lesions may be severe if household tape is used as a binding method. Long-term health effects may include deformity of the ribs, posture problems, and breast flattening. These health effects may affect people who practice breast binding over a long period of time.

As described in the historical literature, breast binding was practiced for various reasons. For example, Saint Joan of Arc practiced breast binding in order to be accepted as a soldier in the French army. The wearing of corsets, fashionable in the Victorian era, was considered a breast-binding method. Corsets were used with the aim of breast flattening and lifting, and creating a small waist. Breast binding by wearing a tight linen top was commonly practiced by Catholic nuns to prevent the distraction of male clergy by their breasts. "Boyishness fashion" and related breast-flattening practices, such as wearing bandeaux, became popular in the Western world in the 1920s. Breast binding by wearing a tight top with multiple buttons was popular in China because women with flat chests were considered beautiful. This practice was banned in China in 1925, as it was considered a harmful traditional practice. There are arguments that bra wearing is also a form of breast-binding practice, which is similar to the breast binding practiced in China. Although there is no epidemiological evidence, some historians suggest that breast cancer could be linked to wearing breast-binding garments, such as bras and corsets.

See also BODY IMAGE; BRASSIERE; BREASTFEEDING; BREAST MUTILATION; CROSS-DRESSING, IN HISTORY; FASHION; FLAPPERS; GENDER AFFIRMATION SURGERY; TRANSGENDER/TRANSSEXUAL

Further Reading

Chin, Angelina. *Bound to Emancipate: Working Women and Urban Citizenship in Early Twentieth-Century China and Hong Kong.* Plymouth, UK: Rowman & Littlefield, 2012.

Fields, Jill. *An Intimate Affair: Women, Lingerie, and Sexuality.* Berkeley: University of California Press, 2007.

Finnane, Antonia. *Changing Clothes in China: Fashion, History, Nation.* New York: Columbia University Press, 2008.

Horowitz, Karyn, Kenneth Gorfinkle, Owen Lewis, and Katharine A. Phillips. "Body Dysmorphic Disorder in an Adolescent Girl." *Journal of the American Academy of Child and Adolescent Psychiatry* 41, no. 12 (2002): 1503–1509.

Kaufman, Randi. "Introduction to Transgender Identity and Health." In *The Fenway Guide to Lesbian, Gay, Bisexual, and Transgender Health*, edited by Harvey J. Makadon, Kenneth H. Mayer, Jennifer Potter, and Hilary Goldhammer. Philadelphia: American College of Physicians, 2007.

■ VICTORIA TEAM

BREAST CANCER

The term "cancer" originated from the Greek *Karkino*, and by the end of the fifteenth century it had acquired the meaning of malignant tumor. The use of this term is explained by the similarity between the structure of a crab and the morphology of a tumor (a central mass from which ramifications start), and it refers to the tumor's adhesion as it clings to neighboring tissues, colonizing them later. Cancer denotes a class of diseases. There are about 200 different types of cancer, which can reach any part of the body. What they have in common is the rapid and uncontrolled proliferation, beyond limits, of cells that change their normal characteristics. The modified cells may include neighboring parts of the body, and can also disseminate to more distant organs in which they form secondary lesions or metastases.

Along with AIDS, cancer is the most common disease of current Western time and a major cause of death in the world (13 percent of all deaths worldwide). The World Health Organization estimates that by the end of 2020, one in four people will die of cancer in developed countries. Although cancer has been known and feared since ancient times, the fight against cancer became more urgent only in the twentieth century. This is because cancer affects mostly people over the ages of 40–50, an age that was harder to reach in previous centuries, when infectious diseases were dominant.

Unlike many other diseases, cancer is a gender-related disease. There are significant differences between men and women. In men, the most common cancers are lung, stomach, prostate, and liver cancer. In women, the most common cancers are breast, lung, skin, and cervical cancer. Nevertheless, men do get breast cancer. Breast cancer is the second most common in women and the second type of cancer-causing death, after lung cancer. Breastcancer.org announced that in 2012 in the United States, there were 190,000 cases of invasive breast cancer and another 60,000 cases of noninvasive breast cancer. There are four stages that are used to describe the development of breast cancer: from stage 0 (or carcinoma in situ), when abnormal cells cluster in the ducts or lobules of the breast, to stage IV, when the cancer cells reach into the bones, liver, brain, or other organs.

The risk for women to develop breast cancer is higher today than in the past. There are several risk factors, although the mechanism causing breast cancer is not completely understood (in fact, there are several types of breast cancer, classified by location, degree of invasiveness, etc.). Simply being a woman is a risk for breast cancer. Men develop only a percentage of less than 1 percent of all breast cancers. White women are more likely to develop cancer than Latino, Asian, or African women, but the death ratio in African-American women is higher than in white women when they get the disease. It is unclear whether this is a genetic predisposition of African-American women, or whether it is a matter of socioeconomic factors. Other breast cancer risk factors include age (over 55), increased breast density, personal history of breast cancer, radiation to the chest or face before the age of 30, first pregnancy after the age of 30, being overweight, the use of hormone replacement therapy, lack of physical exercise, and smoking. It is believed that between 5 and 10 percent of cancers are hereditary. In these cases, the BRCA1 and BRCA2 genes, which everyone has, contain abnormalities and mutations that are transmitted from generation to generation.

Although a woman's risk of getting cancer is ever increasing, numerous medical and pharmaceutical discoveries have been made that have increased life expectancy. As of 2012, there are about 3 million breast cancer survivors. Determining the risk factors has allowed for the development of prevention programs for breast cancer. The programs target factors related to lifestyle, choosing healthy nutrition, weight control, a recommended monthly breast self-palpation, annual ultrasound in the event of family history of breast cancer, and mammography after 40.

Treatment is based on the size and location of the tumor, and on its extensions to lymph nodes or other parts of the body; the sooner the cancer is found in a stage as incipient as possible, the higher the success rate. Treatment may include, in various combinations, lumpectomy (surgery that preserves the breast), mastectomy (the removing of the breast), radiation therapy, chemotherapy, hormone therapy, and breast reconstruction surgery. Since 1990, tamoxifen has been the hormonal drug most commonly used in the world as treatment of breast cancer. When the treatment can no longer cure the illness, palliative care is provided.

Implications of breast cancer and its treatment are numerous for women. Because of medication, radiation, and hormone therapy, many of those affected by breast cancer face infertility and image distortion of their own femininity. Cancer affects not solely the cancer patient but also the family. For women who already have children, the situation may be even worse. Mothers are prescribed by society the roles of dedication, education, and care for others. In this context, the family, prioritized over the disease, can become a burden for the patient. Studies show that there is a negative impact on female adolescents whose mothers have breast cancer, first because they tend to take over the family responsibilities that their mothers held, and, second, because their identifying mechanisms with their mothers make them fear the event of disease and lack confidence in their womanhood. Highly publicized cases of stars like Christina Applegate and Kyle Minogue contribute to enhancing awareness of breast cancer prevention consultation, and help women to understand that there is life after breast cancer.

The cultural history of breast cancer resembles the general history of cancer, and, despite being recent, is characterized by major changes from invisibility and stigma, to being brought to the fore, to acceptance and socially organized fighting against this disease. In 1970, despite the work of anticancer activist groups, cancer was considered a disgrace. In her 1978 book *Illness as Metaphor*, Susan Sontag, herself facing breast cancer, exposed the mechanisms by which cancer undergoes metaphorization. By metaphorization, Sontag meant that an excess of meanings were assigned to cancer, instead of it simply being a disease. In modern society, sick people became "guilty" of having cancer. Sontag denounced the psychological theories according to which cancer happens just to those who want to die, who are not at peace with themselves, who are depressed, or who are going through a divorce, whereas only those with a very strong will are believed to be able to heal. In fact, Sontag argues, such descriptions are no good because much of the human condition requires, up to an extent, all these elements. The psychological interpretations of the disease are due to the absence of a clear cause of the disease and are prompted by the desire to control the disease. Sontag also denounces cultural theories that turn cancer into a metaphor of the advanced capitalist world, a disease of the Other, or war, for example.

Such semantic slippage regarding cancer has always existed. The psychologization of cancer has been recorded since the ancient Greek physician Galen, who noted that cancer was more likely to happen to depressed women rather than to happy women. Studies in the eighteenth and nineteenth centuries are replete with findings according to which psychological factors are critical in triggering cancer. In 1950, it was believed that breast cancer patients had no strength to express anger and inner states, and they were instead stuck in a social mask of aggregation and politeness. Nonconventional personality was, on the contrary, considered to be a protective factor. During the 1970s and continuing through the 1990s, the theory of the personality most likely to get cancer, the so-called type C, was developed. Studies by Caroline Thomas and Karen Duszynski have shown that the inability to express feelings, the breakup of a relationship, and a lack of significant closeness to the parents are the most loyal predictors of getting cancer. According to the medical folklore circulating in contemporary Western space, breast cancer could be the result of unresolved conflict of a woman with her maternal role, or of loss suffered as a mother. Type C is associated with the following traits: sociability, dedication, perfectionism, conventionalism, suppression of emotions, and depression. However, excessive psychologization of cancer was stopped in part by the breast cancer awareness campaigns that have intensified and increased in number since the 1990s.

During recent years, as medicine has been accused of a machinist perspective on the body, which is thus treated as an appendage of the human being, the psychologization of cancer started reemerging. Medically speaking, that happens in the context of the more moderate psychosomatic approach. It is considered that personality itself cannot cause cancer, but there is an openness to include psychological factors in understanding how cancer emerges in a person. There is also an entire industry of self-education, which abounds in tips on how to avoid cancer and which exploits people's fear of it. Despite medical advances, cancer remains in the contemporary imagery related to the idea of incurability.

Global, international, and national breast cancer awareness social movements are characterized by a diversity of manifestations and by the secondary objectives pursued: prevention, support for the ill woman, support for the family, public awareness, prompting public debates, fundraising, and so on. They have contributed greatly to annihilating the collective perception of cancer as a shameful disease. A major challenge was inquiring into the relationship between the ill women and medicine. In the 1970s, journalist Rose Kushner sounded the alarm on the rapidity with which the diagnosis of breast cancer was followed by mastectomy, refusing the automatic one-step surgical removal of her breast following a biopsy that indicated cancer. Kushner wanted to show that there are other solutions and that women should not be deprived of their will in the hands of doctors.

Breast Cancer Action (BCA), founded by Barbara Brenner in 1990, aims to turn breast cancer into a matter of public policy, and to influence legislation in order to adopt preventive measures and effective treatment. In 2002, the same organization noticed that many of the companies that adopted the pink ribbon, a symbol of the fight against breast cancer, manufactured their own products, such as cosmetics, which are suspected of causing breast cancer. The National Breast Cancer Coalition (NBCC), formed in 1991, aims to promote research and improve women's access to screening for breast cancer, establishing national programs to support cancer prevention in low-income women. The Silent

Spring Institute (SSI) and the Toxic Links Coalition (TLC) are organizations that point out the link between the pollution produced by large corporations, women's health, and breast cancer.

Breast cancer remains a serious disease, despite the numerous efforts made to raise awareness for the need to prevent it and for the social responsibility of both corporations and state policies. The cultural history of cancer is one of overlapping and contradictory discourses, some of which are likely to seize the truth from what cancer means. It is therefore still needed to bring to the fore, by means as various as possible, the personal, social, economic, and cultural aspects of breast cancer.

See also AVON FOUNDATION FOR WOMEN; BREAST CANCER SUPPORT GROUPS; BREAST CANCER TREATMENTS; CELEBRITY BREASTS; MAMMOGRAMS; MASTECTOMY AND LUMPECTOMY; PINK RIBBON CAMPAIGNS; SUSAN G. KOMEN FOR THE CURE

Further Reading

Breast Cancer Action. Retrieved May 16, 2014, from http://bcaction.org
Breastcancer.org. Retrieved May 16, 2014, from http://www.breastcancer.org
Cartwright, Frederick, and Michael Biddis. *Disease and History.* Stroud, UK: Sutton, 2004.
Coyne, E., and S. Borbasi. "Holding It All Together: Breast Cancer and Its Impact on Life for Younger Women." *Contemporary Nurse* 23, no. 2 (2006): 157–169.
Kushner, Rose. *Breast Cancer: A Personal History and an Investigative Report.* New York: Harcourt Brace Jovanovich, 1975.
Leader, Darian, and David Corfield. *Why Do People Get Ill: Exploring the Mind-Body Connection.* London: Hamish Hamilton (Penguin), 2007.
Potts, Laura K, ed. *Ideologies of Breast Cancer: Feminist Perspectives.* London: Macmillan, 2000.
Silent Spring Institute. Retrieved May 16, 2014, from http://www.silentspring.org
Sontag, Susan. *Illness as Metaphor.* New York: Farrar, Straus and Giroux, 1978.

■ ADRIANA TEODORESCU

BREAST CANCER SUPPORT GROUPS

For over a century, women in the United States have worked to become empowered when dealing with breast cancer. In 1920, Barbara Mueller wrote letters to her surgeon, William Halsted—the father of the radical mastectomy (a standard but invasive and debilitating treatment for breast cancer that was performed into the 1970s)—seeking information and advice. Three decades later, Terese Lasser started the first support program for breast cancer patients called Reach to Recovery (1952). A mastectomy patient, the group's founder, and its first-ever volunteer, Lasser popularized the program's mission of patients giving practical and emotional support to other patients receiving breast cancer treatment.

The American Cancer Society adopted the Reach to Recovery program in 1969. Concerned that women feared the Halsted treatment more than breast cancer itself, the society's program focused on conciliatory relationships with the medical system and helping women normalize their postsurgical appearance. Program volunteers entered medical settings to share information about the program, but high mortality rates, social mores, and fear that breast cancer was synonymous with a death sentence still made the topic

taboo for many women. Authoritative doctor–patient relationships, inaccessible language and invasive medical procedures, and the predominance of male models of disease further silenced the diagnosed and thwarted the initial viability of comprehensive support.

Women's, patients', and consumers' rights movements of the 1970s were instrumental in destigmatizing breast cancer as well as expanding information and support networks, fostering a patient-centered approach, and advocating for social justice in health care. Organizations offered educational and assistance programs, peer-to-peer counseling, and public policy expertise as women formalized their networks and grew the social movement. Placing women at the center of advocacy helped to politicize the personal experience of breast cancer.

By the 1980s, the term "survivor" empowered diagnosed women to take personal and collective action. National Breast Cancer Awareness Month, which the American Cancer Society started in October 1985 (with funding from the pharmaceutical company Zeneca Group PLC), gave survivor groups a new focus: screening mammography. Though some groups still focused on quality of care, access points in the health care system, research directions, and public policies, screening became the touchstone of the most highly visible breast cancer activities. Awareness month provided a regular timeline for outreach.

By the early 1990s, women's organizing resulted in a successful social movement with hundreds if not thousands of community-based organizations across the nation. After two decades of advocacy, breast cancer was out in the open; support systems were in place, particularly for early-stage women; screening programs were widespread; research programs were infused with money; patient advocates influenced research agendas and medical practice; the pink ribbon became the movement's official symbol (1992); awareness activities, such as the popular Race for the Cure, were common; and breast cancer *awareness* became part of the American mainstream, as well as a profitable item of popular consumption.

Aspects of the American approach to breast cancer have gone global. The American Cancer Society's Reach to Recovery was adopted in Europe in 1974. The largest U.S. breast cancer charity, Susan G. Komen for the Cure, started outreach outside the United States in 1999 and launched initiatives across Eastern Europe, Latin America, and the Middle East in 2007. The extent to which the American approach applies to other settings is a crucial consideration. Breast cancer as a social cause is highly contested in the United States, particularly in terms of the commercialization of the disease and the roles of social movements and culture in promoting or resisting medicalization. American influences in Poland (discussed next) provide an illuminating counterpoint.

American Influences in Poland: Women's organizing around breast cancer in socialist Poland did not occur until the 1980s, when Polish oncologists who had completed medical internships in the United States returned home. Physicians in Poland had been hesitant to have patient involvement in medical settings. After observing the American Cancer Society's Reach to Recovery program in practice, two Polish specialists at the Centre of Oncology in the capital city of Warsaw (Zbigniew Wronkowski, MD, and Krystyna Mika, PhD) started a small rehabilitation-focused support group. Composed of only three women, the group served as a catalyst for the development of additional support groups. Physicians were still slow to accept the peer-to-peer support model that is the core of the Reach to Recovery program until the mid-1990s. At this point, some breast cancer

groups developed cooperative relationships with local hospitals that enabled volunteers who had completed a course in psychology to visit patients. As the practice normalized, breast cancer survivors (referred to as Amazons) started new support groups. By 2010, there were over 200 Amazonian groups in Poland, with over 15,000 members, some of whom volunteer in hospital settings.

There are several obvious American influences in Poland. First, building from the Reach to Recovery model (described above), voluntarism is a feature of women's organizing. Of the registered Amazonian associations, hundreds of members have completed the course that enables them to provide volunteer patient support in Poland's hospitals. Second, the first awareness march (reminiscent of the physical-based awareness events in the United States) was organized in 1996 and is now held each year. And third, like October's Breast Cancer Awareness Month in the United States, October 17 was declared Poland's Day of the Breast Cancer Fight in 1998.

Polish groups did not develop the political bent of the American breast cancer movement. Poland has strong traditions of political demonstrations, but a *feminine* concern such as breast cancer does not fit neatly into the masculine character of Poland's political activism. Thus, the Amazons did not develop a capacity to participate in public debate or take an activist orientation with regard to research or medical practice. The marches are the primary means of public engagement, but even these are aimed at transferring a value system rather than engaging in social change. The October march is even a pilgrimage to a place of religious worship. Significantly older than their American counterparts, the Polish Amazons are firmly embedded within patriarchal medicine, and they do not view this as a problem.

See also AMAZONS; AVON FOUNDATION FOR WOMEN; BREAST CANCER TREATMENTS; FEMINISM; LOVE, SUSAN (1948–); MAMMOGRAMS; MASTECTOMY AND LUMPECTOMY; PINK RIBBON CAMPAIGNS; RECONSTRUCTIVE SURGERY; STEREOTYPES; WOMEN'S MOVEMENT

Further Reading

Kedrowski, Karen, and Marilyn Sarow. *Cancer Activism: Gender, Media, and Public Policy*. Champaign: University of Illinois Press, 2007.

King, Samantha. *Pink Ribbons, Inc.: Breast Cancer and the Politics of Philanthropy*. Minneapolis: University of Minnesota Press, 2006.

Leopold, Ellen. *A Darker Ribbon: A Twentieth Century Story of Breast Cancer, Women, and Their Doctors*. Boston: Beacon Press, 2000.

Lerner, Barron. *The Breast Cancer Wars: Hope, Fear, and the Pursuit of a Cure in 20th Century America*. Oxford: Oxford University Press, 2001.

Sulik, Gayle. *Pink Ribbon Blues: How Breast Cancer Culture Undermines Women's Health*. New York: Oxford University Press, 2012.

Zierkiewicz, Edyta. *Rozmowy o raku piersi. Trzy poziomy konstruowania znaczeń choroby* [*Talks about Breast Cancer: The Three Layers of Meaning Constructing of Sickness*]. Wroclaw, Poland: Atut, 2010.

■ GAYLE SULIK AND EDYTA ZIERKIEWICZ

BREAST CANCER TREATMENTS

Breast cancer is one of the most common forms of cancer, and it affects both men and women. Until the twentieth century, breast cancer treatments were generally ineffective, and there are still risks associated with modern treatments. The concern for breast cancer and its treatments is one that dates back to antiquity. One of the earliest writings on breast cancer comes from the Edwin Smith Papyrus, which was found in Egypt and dates to approximately 1600 BCE. The papyrus includes descriptions of breast tumors, wounds, and abscesses, for which the author knew no cure. In the Classical Greek period (460–136 BCE), the physician Hippocrates wrote of the four humors and the humoral theory of disease. These humors (black bile, yellow bile, phlegm, and blood) were thought to create illness when they became imbalanced. Hippocrates recorded a case of a woman with breast cancer, and he noted that she had a discharge coming from her nipple. He did not mention a cure for the cancer, but instead he insisted that it was an imbalance of humors. During the Greco-Roman period (150 BCE–500 CE), breast cancer treatments expanded to include surgical treatments. Aurelius Celsus (b. 25 BCE) wrote a description of breast cancer and outlined four stages of cancer. He did not give details about causes and cures. The Greco-Roman physician Leonidas is often recognized as the first physician to successfully remove a breast tumor surgically. He created an incision in the breast and removed the tumor slowly, while using cauterization to stop the bleeding. Of all the Greco-Roman physicians, Galen (b. 131 CE) and his continued use and popularization of Hippocrates' humoral theory were by far the most notable. His version of the humoral theory was widely accepted by physicians until the nineteenth century. Galen believed that an excess of black bile was the primary cause of cancer in all forms, and he advocated bloodletting or purging as a cure for the disease. He also believed that he had successfully cured a case of early-stage breast cancer by removing the "roots" of the tumor during surgery. These "roots" were not a part of the tumor, but rather veins filled with black bile that supposedly fed the tumor and led to its growth and the ill health of the patient.

During the Middle Ages, monks played a large role in health care. Physicians were scarce, and only wealthy patrons could afford their services. After the Council of Rheims in 1131 CE, however, clerics and monks were forbidden from practicing any kind of medicine that would shed blood, including bloodletting and surgery. Barber-surgeons and physicians had to take on these roles that once belonged to the clergy. Physicians such as Lanfranc of Milan (b. 1250) wrote medical texts on surgery that described breast cancer and surgical treatments such as mastectomy, or a removal of the entire breast. Renaissance physicians, such as Andreas Vesalius (b. 1514), made great strides in human anatomy and advocated for mastectomy and sutures instead of cauterization. One of the best examples of the progression of breast cancer treatments during the Renaissance is the work of physician Wilhelm Fabry (b. 1560). Fabry created a surgical tool that held the breast in place in order to inflict less pain on the patient and to make the surgery easier. His writings included detailed instructions on how to perform mastectomies and illustrations of the tools he used. Although many medical writings from the medieval and Renaissance period include descriptions of these treatments, they were rarely performed because of the high mortality rate associated with surgery.

During the seventeenth century, European physicians began to shy away from the Galenic model and posed their own theories on diseases, including breast cancer. The United States did not yet have formal medical programs; therefore, most of the advancements in medicine during the seventeenth and eighteenth centuries came from Europe. French physician Henri le Dran (b. 1685) suggested that early stages of cancer were localized, and the spread of cancer to the lymphatic system was a sure sign of progression of the disease. During the eighteenth century, European surgeons performed a greater number of mastectomies because of new theories and surgical techniques. These surgeries decreased again in the latter half of the century because they usually did not produce positive outcomes and maimed many women in the process.

The nineteenth century revolutionized surgery with the advent of anesthesia and the theory of antisepsis. This led to less pain during surgery and less risk of infection. British physician Dr. Charles Moore (b. 1821) wrote a renowned essay in which he emphasized the necessity of surgically removing the breast. Moore hypothesized that cancer returned as a result of cutting the tumor during surgery, which is why he advocated for removal of the entire breast rather than just the tumor. He did not suggest removing the underlying breast muscle (pectoralis major) or lymph nodes, as later surgeons would. This changed around 1875, when German physician Richard von Volkmann (b. 1830) argued that the entire breast, including the pectoral fascia, breast muscle, and axillary nodes, must be removed regardless of tumor size. This technique was coined a "radical mastectomy." Physicians today still use this technique in cases of severe breast cancer that have not responded to less invasive treatments.

The term "metastasis" also entered the medical field in the nineteenth century, when French physician Joseph Récalmier used it to explain the spread of cancer. In the United States, medical programs arose during this century, namely, in Philadelphia and Baltimore. University of Pennsylvania physician Samuel W. Gross (b. 1837) and his father Samuel D. Gross (b. 1805) helped to establish the Philadelphia Academy of Surgery in 1879. Both father and son performed many mastectomies, and the younger Gross examined all excised breast tumors under a microscope. At the Graduate School of Medicine in New York, Dr. Willie Meyer (b. 1854) published a paper that advocated for the removal of the pectoralis minor along with the pectoralis major. Meyer's technique, called the Willie Meyer modification of the Halsted procedure, was considered cutting edge, and it was widely used for nearly 70 years until breast-sparing techniques became popular. In the 1890s, William Stewart Halstead, first chief of surgery at Johns Hopkins, popularized the radical mastectomy, which removed the entire breast, the axillary nodes, and both chest muscles in one bloc, thus helping to eliminate the spread of cancer and infection.

During the twentieth century, cancer research led to further developments in breast cancer treatments. Following Halstead's success, mastectomies began to include the removal of the supraclavicular and internal mammary nodes that had previously been left intact. However, new nonsurgical options, such as radiation therapy, hormonal therapy, and chemotherapy, allowed for less invasive treatments. The first known treatment of breast cancer using radiation therapy occurred in 1895 by Emile Grubbe (b. 1875). In the early decades of the twentieth century, Dr. George Pfahler (b. 1874) advocated the use of radiation therapy after surgery. The idea of combining therapy with surgery is still popular today. Some physicians argued that surgery had become unnecessary and that radiation therapy would produce

the same results. Hormone therapy also became available in the twentieth century. Some physicians as early as 1900 noted that older patients, some of whom were menopausal, had a higher survival rate, and therefore advocated for removal of the ovaries in younger patients. Hormone therapy drugs that prevent the production of estrogen became available in the 1980s. Paul Ehrlich (b. 1854) is sometimes referred to as the "father of chemotherapy." His work on chemical compounds, which was originally used to treat syphilis, was not used for treating cancer until shortly after World War II. Chemotherapy trials in the 1950s and 1960s led to its current popularity and widespread use for treating cancer.

Modern medicine allows for a variety of options for treating breast cancer. Radiation therapy and chemotherapy are often the first steps in treating early stages of breast cancer. Radiation therapy is used after lumpectomies or when the breast cancer tumors are small. X-rays, or energy beams, are directed at the cancerous tissue externally using a large machine. Brachytherapy also uses radiation, but the radioactive material is placed inside the body, unlike the external method of traditional radiation therapy. Patients may experience redness and burning around the radiation site, and some experience swelling and firmness of the breast. Rarely, serious side effects can include swelling of the arm (lymphedema) and injury to the nerves. Chemotherapy is similar to radiation therapy in that it destroys cancer cells without the use of surgery. Instead of using X-rays, chemotherapy uses chemical drugs to gradually shrink cancerous cells. Adjuvant systemic chemotherapy is used when the cancer is at risk of spreading or returning after surgery. Neoadjuvant chemotherapy is used to shrink tumors before they are surgically removed. When cancer has spread to other parts of the body, chemotherapy helps to repress tumor growth and alleviate the patient from symptoms associated with cancer. Side effects of chemotherapy vary depending on the drugs used, but generally include fatigue, hair loss, nausea, and vomiting. Patients using chemotherapy are also more likely to develop infections.

Hormonal therapy is another nonsurgical treatment. This treatment is reserved for breast cancers that are either estrogen receptor positive (ER positive) or progesterone receptor positive (PR positive). There are two different types of hormone therapy drugs: selective estrogen receptor modulators (SERMs) and aromatase inhibitors. SERMs block estrogen from adhering to the estrogen receptor on the cancerous cells, which helps to delay tumor growth and can kill cancerous cells. Side effects resemble menopausal symptoms, such as hot flashes and vaginal dryness. Blood clots, stroke, and cataracts are some of the more serious side effects of SERMs. Unlike SERMs, aromatase inhibitors are used on postmenopausal women. Aromatase inhibitors work to stop the production of estrogen that is essential for the growth of cancerous breast tumors. In cases where neither of these hormone treatments can successfully stop the spread or growth of cancer, the hormones may be eradicated by surgically removing the ovaries. Other treatments include targeted drugs, such as trastuzumab, and clinical trials. Targeted drugs, which target deformities within the cancer cells, are often less effective and more expensive, as most are not covered by insurance policies. Clinical trials use new drugs as well as combinations of established drugs to find new options for treating breast cancer. These trials may or may not be as effective as other established treatments.

Surgical options are some of the most invasive but effective treatments. Lumpectomy and mastectomy remove cancerous tumors and surrounding tissue. Sentinel node biopsy and axillary lymph node dissection help to diagnose how far the cancer has spread. A

lumpectomy, or breast-sparing surgery, consists of the removal of the cancerous tumor and some of the surrounding healthy tissue. This surgery is usually only performed in cases where the tumor is small and not attached to a large amount of surrounding breast tissue. When the tumors are large or connected to breast tissue, a mastectomy is performed. A simple mastectomy is a removal of the entire breast, including the ducts, fatty tissue, lobules, nipples, and areola. Less common, but still performed, is the radical mastectomy, which along with the breast tissue also removes the chest muscle under the breast, and the lymph nodes in the armpit. Skin-sparing mastectomies have become a common option because they leave more of the overlying skin undamaged in order to make reconstructive surgery of the breast a viable option.

To determine if the cancer has spread beyond the tumor in the breast, physicians may opt for a sentinel node biopsy and/or axillary lymph node dissection. In some cases, breast cancer drainage collects in the lymph nodes of the armpit, causing the cancer to spread to other parts of the body. In a sentinel node biopsy, the lymph node that collects this drainage is removed and biopsy tests determine if there are any breast cancer cells within the lymph node. If cancer cells are found, physicians may suggest an axillary lymph node dissection if the tumor is too large to be treated with chemotherapy and radiation. Axillary lymph node dissections, which remove the nodes in the affected armpit, are only performed if necessary because they can cause lifelong side effects like lymphedema, or chronic swelling of the arm.

There are many options available to the breast cancer patient. A physician must first determine the severity and type of breast cancer before deciding with the patient the best treatment options. Some practitioners may advocate for alternative medicine, but there are no alternative medicines that have been proven to effectively fight breast cancer. Most physicians advocate for a second or third opinion before deciding on a specific treatment, as well as talking to breast cancer survivors in order to fully understand the process.

See also ANNE OF AUSTRIA (1601–1666); BREAST ANATOMY; BREAST AUGMENTATION; BREAST CANCER; BREAST CANCER SUPPORT GROUPS; BREAST RECONSTRUCTIVE SURGERY; BURNEY, FANNY (1752–1840); IMPLANTS; MAMMOGRAMS; MASTECTOMY AND LUMPECTOMY; NIPPLES; PINK RIBBON CAMPAIGNS

Further Reading

Bland, Kirby I., and Edward M. Copeland III. *The Breast: Comprehensive Management of Benign and Malignant Disorders*. St. Louis, MO: Saunders, 2004.

Mayo Clinic Staff. "Breast Cancer: Treatments and Drugs." November 29, 2011. Retrieved May 16, 2014, from http://www.mayoclinic.com/health/breastcancer/DS00328/DSECTION=treatments -and-drugs

Olson, James. *Bathsheba's Breast: Women, Cancer, and History*. Baltimore: Johns Hopkins University Press, 2002.

Sulik, Gayle A. *Pink Ribbon Blues: How Breast Cancer Culture Undermines Women's Health*. New York: Oxford University Press, 2011.

Yalom, Marilyn. *A History of the Breast*. New York: Knopf, 1997.

■ MICHELLE FITZSIMMONS

BREASTFEEDING

Breastfeeding is the nourishment of human infants and toddlers with milk from a lactating woman's breasts. Breastfeeding is traditionally thought of as one of the most natural things that a woman and her infant child can engage in. However, for many women, the choice of whether or not to breastfeed a baby is influenced by a number of factors. The factors influencing a woman's choice of whether to breastfeed include the media's portrayal of breastfeeding, or lack thereof; social and cultural perspectives; and medical and health studies. Moreover, although breastfeeding is popularly conceived of as a very private matter, it is a very social practice and involves family, friends, and the community at large.

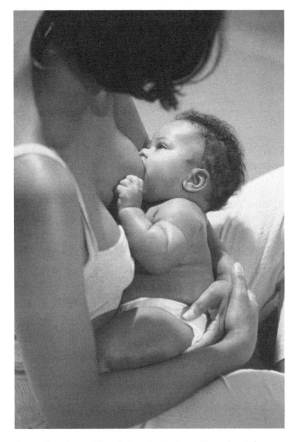

A mother breastfeeds her baby boy. Purestock/ Thinkstock by Getty

The benefits of breastfeeding are well known and established; however, fewer than 25 percent of American women follow the recommendations of the medical community and decide to breastfeed. The World Health Organization (WHO) recommends exclusive breastfeeding for the first 6 months of life and up to age 2 or longer. Even with recommendations from global health organizations and the medical community, only 35 percent of infants are exclusively breastfed for the first 4 months of life worldwide. In the United States, those numbers are even lower. About 72 percent of women report initiating breastfeeding immediately after the birth of a child. At 7 days, that number dropped to 63 percent; at 3 months, it drops to 43 percent; and it drops to 13 percent at 6 months. These rates apply to white, middle-class, well-educated, and older women, who tend to breastfeed more than their contemporaries.

Choosing whether or not to breastfeed is not a simple choice. Researchers have found there is considerable variation geographically in the rates of breastfeeding across the United States, suggesting that social and cultural differences have much to do with whether or not a woman breastfeeds. The choice to breastfeed or not is tied to these social and cultural values, as well as the complexity of other factors tied to modern motherhood, personal choice, and gender role attitudes. In fact, some researchers have found that having nontraditional gender role attitudes is a good predictor of choosing to breastfeed,

while women with traditional gender role attitudes who choose to breastfeed tended to breastfeed longer.

Sociologist Kathryn Pallister has outlined the factors that influence a woman's choice to breastfeed, which include formal policies and educational initiatives; hospitals that are "baby friendly"; community-based support networks; "embodied knowledge," or knowledge based on anecdotal evidence from friends and family; public space availability; and the mainstream media's portrayal of breastfeeding. Beyond simple understanding or awareness of the benefits of breastfeeding, society's perception of breastfeeding can have a strong influence on whether or not a woman decides to breastfeed her infant. In Western societies, in particular, the sexual significance of the breast outweighs the biological function of the breast. The social perception of the breast as a sexual object often translates into a lack of support for public breastfeeding. There are very few public spaces available for women who choose to breastfeed, forcing breastfeeding moms to either remain hidden at home or face possible ridicule for choosing to publicly breastfeed their infants. In fact, there have been a number of public cases where women who were breastfeeding their children were asked to stop or leave the establishment.

Perceptions of breastfeeding are also shaped by societal ideas of bodily functions and fluids. Society views bodily functions and fluids as something that should remain private and out of sight. Because breastfeeding involves both a bodily function and a body fluid, many view it as a dirty and disgusting practice. Breastfeeding women are often relegated to the privacy of their own home or, if in a public space, a bathroom. The choice to breastfeed, especially in public, then leaves a mother with a complex mix of emotions. Studies have found that some breastfeeding mothers worry about breastfeeding in public because it may embarrass them or others, and they may face negative reactions and ridicule. Often, women who publicly breastfeed report that they feel guilty and shameful because of the public perception.

The sociocultural norms and values around breastfeeding can also be internalized by the mother, making the choice to breastfeed all the more difficult. In addition to the internalized emotions attached to breastfeeding, women are also faced with other fundamental challenges. Women who choose to work as well as breastfeed are faced with a very difficult and delicate balancing act. Workplaces often do not have the policies or the means to accommodate a breastfeeding mother. A working woman must try to negotiate a flexible working schedule or find a private place to express breast milk during the time she is away from her baby. This delicate balance is something that many breastfeeding mothers struggle with when returning to work and trying to find a career and family life balance.

Media Portrayals of Breastfeeding: Although public attitudes about breastfeeding have a strong influence on whether a woman decides to breastfeed or continue to breastfeed, the media and its portrayal of breastfeeding can be seen as an equal, if not stronger, influence on both the decision to breastfeed and the public perceptions of breastfeeding. These mediated images present few positive images of the breastfeeding mother; at the same time, they shape the public perceptions of whether it should be done, who breastfeeds, and how it is or should be done. Coverage of breastfeeding is sparse and often highlights the negative aspects. There are few images of breastfeeding in the media; however, the image of a formula- or bottle-fed baby is quite prevalent, creating the impression that bottle feeding is the norm. Specifically, through advertising and sponsorship of programs

by formula companies, many conclude that the media do not support breastfeeding, but rather endorse formula feeding.

One of the reasons that breastfeeding has been largely absent in the media is the sexual objectification of the breast. In Western societies, the breast is inextricably linked to sex. Mainstream sexualized advertising, television programs, music videos, and movies emphasize that the primary purpose of the breast is to sexually stimulate. When the breast is not hypersexualized by the media, oftentimes the media portrayal of breastfeeding is presented in a negative light. Media reports present stories of "undernourished" babies because of breastfeeding without explaining that these are rare occurrences. Additionally, media accounts of extended-breastfeeding or extreme-breastfeeding stories also present breastfeeding in obscure ways. The *Time* magazine cover of May 21, 2012, "Are You Mom Enough?" showed an attractive 26-year-old woman breastfeeding her 3-year-old son, which erupted into a firestorm of controversy and media coverage for the breastfeeding mother. Although media coverage tends to cover the scandalous aspects of breastfeeding, it also presents breastfeeding in a limited and often neutral way.

The alternative presentation of breastfeeding by the media reinforces many of the public perceptions of breastfeeding and tends to leave women more perplexed. The images of the breastfeeding mother still continue to emphasize the privacy of the activity, rather than presenting the challenges of public breastfeeding. The media also characterizes who is breastfeeding and who chooses to bottle feed. Most "ordinary" families are associated with bottle feeding, whereas middle-class and celebrity moms seem to be associated with breastfeeding, suggesting a "type" of woman who breastfeeds. Additionally, most of the women presented as positive examples of breastfeeding mothers tend to be white, attractive, thin, and middle class. The dichotomous message of breastfeeding that the media send creates more confusion for mothers and for the public at large. Many breastfeeding advocates agree that contemporary sitcoms and television programs sometimes frame breastfeeding positively; however, these portrayals are not always realistic regarding the real experience of breastfeeding.

The emerging empowering vision of the breastfeeding mother can help women more realistically understand the demands of breastfeeding, while at the same time understand its benefits. These realistic images have appeared in such programs as *Sex in the City*, *Desperate Housewives*, and *ER* and include references to pumping, higher metabolism, and larger breasts, which help change common misperceptions of breastfeeding. However, the reality is that approximately 72 percent of respondents in one study (as cited in Pallister 2012) still believe that showing a woman on television breastfeeding is inappropriate. Scholars suggest that the incorporation of positive and realistic images of breastfeeding in the media may have the potential to challenge negative perceptions of breastfeeding by society at large.

Public Perceptions of Breastfeeding: Perceptions of breastfeeding have changed over time. Over the past 400 years, changes in attitudes toward nudity, biological urges, and the Western hypersexualization of the breast have proven to be far more influential in perceptions of breastfeeding than the nutritional needs of the infant. In addition, researchers studying changing attitudes toward breastfeeding have found that emotional factors have much to do with a person's perception of breastfeeding. For example, the sight of women publicly breastfeeding often invokes a strong emotional response in observers. Some of these

emotional reactions include, but are not limited to, disgust, perversion, and indecency. Scholars contend that it is likely these strong emotional reactions to breastfeeding are the direct result of the cultural view of the breast as a sexual object combined with the individual's general perspective on sexuality.

Much of the research on perceptions of breastfeeding has found that many people acknowledge and believe in the importance of breastfeeding, but most feel neutral at best. Furthermore, even those who support breastfeeding do not want to see it. That is, most feel that it should be kept out of the public eye. In one study, only 43 percent of respondents said women have the right to breastfeed in public, and only 28 percent thought it was OK to show a woman breastfeeding on television (Li et al. as cited in Acker 2009). Research suggests that women breastfeeding in public are seen as indecent, offensive, rude, and immodest.

Studies have found that low-income women have less positive attitudes about breastfeeding than college students or the population at large. In addition, level of education seems to have some influence on perceptions of breastfeeding, and both college men and women view a breastfeeding mother more favorably than a bottle-feeding mother. However, a gender role expectation seems to be one of the strongest predictors of perceptions of breastfeeding. Private breastfeeding is seen as more favorable than public breastfeeding by both men and women. Traditionally, society perceives the role of women as "stay-at-home moms," which closely matches the idea of private breastfeeding. However, for women who are critical of public breastfeeding, it is not necessarily because they endorse the traditional gender role of women, but rather because they have internalized public perception. It appears women's perspectives of breastfeeding are largely reflective of how they believe it reflects on them as a woman, the anticipated negativity of men's response, and the approval of their male partners.

Medical and Health Perspectives of Breastfeeding: Breastfeeding is commonly viewed by the medical community as the best choice for mother and baby. It provides one of the most immediate mechanisms for mother–child bonding through skin-to-skin contact that cannot be replicated with bottle feeding. But it is more than just about bonding: many health agencies and organizations declare it a matter of public health. The advantages from a public health perspective include nutritional, immunological, developmental, psychological, environmental, social, and economic ones. Scholars have shown that breastfeeding is beneficial for maternal and child health. For the mother, breastfeeding helps her recover from the pregnancy, and it helps delay the next pregnancy until both her body and her child are ready. For the infant, breastfeeding provides the ideal nourishment for the first 6 months as it contains all the nutrients, antibodies, and liquid that the baby needs. It has also been shown to reduce chronic disease and development problems, as well as increase intelligence. However, some scholars believe that the commonly accepted medical endorsement of breastfeeding applies primarily to babies in the developed world and that the benefits are marginal at best.

Many also argue that breastfeeding is the best option ecologically. Breastfeeding reduces the need for the packaging, production, plastics, pharmaceuticals, and energy consumption that go into the manufacture of infant formula and bottles. Moreover, environmentalists liken breastfeeding to the Slow Food movement, which emphasizes knowing where your food comes from and buying local. In this case, breastfeeding is both local and green, as all the factors that contribute to its production are located where the mother and child live.

Breastfeeding Advocacy: The slogan "Breast Is Best" is a common phrase that contemporary mothers have learned. This slogan was part of a larger initiative of the Healthy People 2010 campaign by the U.S. Department of Health and Human Services to increase the proportion of mothers who breastfeed to 75 percent at birth and to 50 percent at 6 months of age. In the 1990s, a number of studies pointed to the importance of breastfeeding, and the global health community responded by creating two main initiatives, the Baby-Friendly Hospital Initiative (BFHI) and the International Code of Marketing of Breast-Milk Substitutes. The BFHI initiated changes in policy, training, and creating community support for breastfeeding based on the "Ten Steps to Successful Breastfeeding," while the International Code of Marketing of Breast-Milk Substitutes put limits on the advertising, production, and distribution of formula. However, many would argue that these campaigns only further marginalize women, putting the needs of the infant above the needs of the new mother. Therefore, many would advocate for more structural changes that would actually promote breastfeeding for all women.

See also ADVERTISING; BREASTFEEDING, IN PUBLIC; BREAST MILK, EXPRESSION OF; CELEBRITY BREASTS; CONTROVERSIES; MEDIA; MOTHER–INFANT BOND; MOVIES; POSTPARTUM BREASTS; SLAVES, AS WET NURSES; TELEVISION; UNICEF; WEANING; WET NURSING

Further Reading

Acker, Michele. "Breast Is Best . . . but Not Everywhere: Ambivalent Sexism and Attitudes toward Private and Public Breastfeeding." *Sex Roles* 61 (2009): 476–490.

Fildes, Valerie. *Breasts, Bottles and Babies: A History of Infant Feeding.* Edinburgh: Edinburgh University Press, 1986.

Forbes, Gordon B., Leah E. Adams-Curtis, Nicole R. Hamm, and Kay B. White. "Perceptions of the Woman Who Breastfeeds: The Role of Erotophobia, Sexism, and Attitudinal Variables." *Sex Roles* 49 (2003): 379–388.

Murthy, Padmini, and Clyde Lanford Smith. *Women's Global Health and Human Rights.* Boston: Jones & Bartlett, 2010.

Pallister, Kathryn. "And Now, the Breast of the Story: Realistic Portrayals of Breastfeeding in Contemporary Television." In *Mediating Moms: Mothers in Popular Culture*, edited by Elizabeth Podnieks, 221–232. Montreal: McGill-Queen's University Press, 2012.

Wolf, Joan B. *Is Breast Best? Taking on Breastfeeding Experts and the New High Stakes of Motherhood.* New York: New York University Press, 2011.

■ SARA SMITS KEENEY

BREASTFEEDING, IN PUBLIC

Breastfeeding in public has become an issue not because of the activity itself, but because of the simple fact that the breast, which is considered to be a private part of a woman's body, is exposed in public; in other words, it may be considered indecent exposure or obscene. As a result of controversies surrounding the matter, it has received different reactions and laws being put in place. In some countries, breastfeeding in public is forbidden; in other areas, it is not even addressed by law; yet in others, there is a granted legal right to breastfeed in public. Countries like Australia, Canada, Germany, Malaysia, Philippines,

Saudi Arabia, Taiwan, the United Kingdom, and parts of the United States have put up laws granting women the right to breastfeed in public because this is considered natural and healthy for the baby. In other countries, like China, breastfeeding in public is seen as embarrassing. In African countries, there are no particular laws addressing women breast-feeding in public.

Public breastfeeding has resulted in controversies over the years in the United States and United Kingdom, especially where magazine covers have babies nursing at a bare breast. For instance, in the August 2006 edition of *Baby Talk* magazine, there were com-plaints from readers about the cover. In 2010, the deputy editor for *Mother and Baby* mag-azine described breastfeeding as creepy. Barbara Walters, a presenter on the U.S. talk show *The View*, expressed a similar view when she said she felt uncomfortable sitting next to a breastfeeding mother during a flight. Facebook, the social media service, added to the controversy when it claimed that they had to remove photos of mothers breastfeeding their children as this violated their decency code by showing exposed breasts, even when the baby covered the nipple. These expressions have been described as hypocritical since there are advertisements all over the place—in social media, billboards, and magazines—that use and encourage photographs of topless models.

The U.S. federal government has laws that protect nursing mothers, and these are based on the recognition of organizations such as the American Academy of Pediatrics, the American Congress of Obstetricians and Gynecologists, the American Public Health Association, UNICEF, and WHO that breastfeeding is the best choice for the health of a mother and her baby. In as much as laws may be put in place to protect women who breastfeed in public, and also regarding the growing awareness of the benefits of breast-feeding, some women may still find it difficult to do so in public. However, certain tips for breastfeeding in public could include the following:

- Wearing clothes that allow easy access to the breast, particularly tops that pull up from the waist or are buttoned down.
- Wearing nursing bras, which are very easy to pull up or unfasten with one hand when there is a need to breastfeed.
- Using a special breastfeeding blanket around the shoulders, although some babies feel uncomfortable with this so it should not be forced.
- Using a baby sling may also be helpful. They are worn over one shoulder and are easily adjustable and comfortable. They form a good support for your baby when the baby is in the cradle position to nurse. The cloth of the pouch can be pulled up over the baby for its protection and that of the mother's skin.
- Visiting a women's dressing room, if available, to breastfeed your baby.
- Also, as the saying goes, "Practice makes perfect." Discreet breastfeeding in public becomes easier with practice; so nursing mothers can practice at home before going out, and the more this is done, the better.

Breastfeeding advocates point out that being too discreet or too private about breast-feeding may actually work against more acceptance of breastfeeding in general, since it tends to keep breastfeeding hidden from most people. Peggy O'Mara suggests in her book *Natural Family Living* that if a breastfeeding woman encounters any curious or

hostile stares, she should smile back benignly, knowing she is contributing to the health of the next generation and setting a beautiful example for other women, young girls, and expectant fathers. As people become more aware of the importance of breastfeeding, breastfeeding in public will become accepted.

See also BREASTFEEDING; BREAST MILK; CONTROVERSIES; NIPPLES; UNICEF

Further Reading

Blincoe, A. J. "The Health Benefits of Breastfeeding for Mothers." *British Journal of Midwifery* 13, no. 6 (2005): 398–401.

Hannan, A., R. Li, S. Benton-Davis, and L. Grummer-Strawn. "Regional Variation in Public Opinion about Breastfeeding in the United States." *Journal of Human Lactation* 21, no. 3 (2005): 284. doi:10.1177/0890334405278490

Pugliese, Anne Robb. "Breastfeeding in Public." *New Beginnings* 17, no. 6 (November–December 2000): 196–200.

■ MARY A. AFOLABI-ADEOLU

BREAST MILK

Breast milk is milk that is made in the small, saclike glands in the human breasts and expressed during infant breastfeeding. Breast milk helps babies meet 100 percent of their nutritional needs. Breast milk changes composition to meet the needs of the growing baby. At the end of pregnancy, the breasts produce about 40 to 50 milliliters of a highly nutritious, yellowish-colored, and sticky form of breast milk called colostrum. Colostrum is produced only in the first 2 to 3 days after birth. The World Health Organization calls colostrum the "perfect food for the newborn." Infants should receive colostrum within the first hour after birth.

Breast milk changes with every feeding. The foremilk, which is secreted at the beginning of a feeding, is bluish-gray in color, high in lactose (milk sugar) and protein, and low in fat. The hindmilk, the milk that is secreted at the end of feeding, is creamy white in color and rich in fat.

The nutritional components of breast milk are properly balanced for and easily digested by the child with few exceptions. Breast milk is made up of 6–7 percent protein, 38–42 percent carbohydrates, and 50–55 percent fat. It also contains water and important vitamins and minerals.

The components of breast milk remain unchanged even if a mother consumes less than adequate calories and protein. However, the mother produces less breast milk with lower nutritional intake. Dehydration and less-than-adequate fluid intake also reduce maternal breast milk volume. Breast milk production (lactation) increases the mother's need for a balanced diet and adequate liquid intake. A mother does not require nutritional supplements unless a deficiency of a particular nutrient exists.

Breast milk has two main forms of protein: 60–80 percent whey and 40 percent casein. Other proteins found in breast milk are lactoferrin, secretory immunoglobulin A (IgA) and other immunoglobulins, lysozyme, and bifidus factor. These proteins protect the infant against bacterial infection, yeast, and inflammation.

Lactose (milk sugar) and oligosaccharides are the carbohydrates found in breast milk. Lactose is a double sugar or disaccharide. It is the main sugar in breast milk. Oligosaccharides are simple or single sugars (monosaccharides) with three to 10 monosaccharide units. Infants cannot digest the oligosaccharides in breast milk. However, bacteria found in the infant's digestive tract can digest the oligosaccharides. These intestinal bacteria boost the infant's immune system and protect the baby against life-threatening infections and conditions.

Fat in breast milk provides calories, allows for the absorption of fat-soluble vitamins, and promotes healthy brain, retina, and nervous system development. The fat in breast milk has docosahexaenoic acid (DHA) and arachidonic acid (AHA), two polyunsaturated fats that are important to an infant's neurological development. DHA and AHA are not found in other types of milk. Also, DHA and AHA fats added to infant formulas may not be as beneficial to babies as the fat that is found in breast milk.

Breast milk contains water, vitamin C, vitamin A, iron, and other important nutrients. The low sodium content is good for keeping fluid needs met and kidney stress at a minimum. Breast milk does not contain adequate vitamin K or D. Iron and zinc are also low in breast milk. However, iron and zinc are highly bioavailable (easily absorbed) to avoid deficiency. Because the amount of vitamin K in breast milk is minimal, infants typically receive a 1 mg injection of vitamin K directly into the muscle within the first 6 hours of birth. Vitamin K prevents hemorrhage (bleeding). Sunlight helps the body make vitamin D. Infants who are not exposed to adequate sunlight require 200 to 400 IU of oral vitamin D drops per day for the first 60 days of life. They may continue to receive vitamin D each day until they reach 2 years of age and begin drinking vitamin D–fortified milk.

Breast milk currently feeds only 34.8 percent of all infants around the world. The World Health Organization reports that 35 percent of child deaths are caused by undernutrition. About 32 percent of children worldwide under the age of 5 who are poorly nourished suffer from stunted growth and development, and wasting. When breast milk is absent or not available in amounts to meet 100 percent of a newborn to 6-month-old infant's nutritional needs, about 1.4 million deaths and about 10 percent of illnesses related to poor health occur in those children. Rates of death in the United States are lowered by 21 percent in infants who consume breast milk.

Studies have shown breast milk reduces the risk of infant death and several infectious diseases and conditions. These conditions include but are not limited to bacterial infections, respiratory tract infections, urinary tract infections, diarrhea, type 1 (insulin-dependent) and type 2 (non–insulin-dependent) diabetes, leukemia, overweight and obesity, high cholesterol, asthma (in older children and adults), and late-onset sepsis (in preterm infants). Breast milk also promotes the correct development of the infant's teeth and jaws.

According to both the WHO and UNICEF, breast milk is encouraged and recommended for all babies. Breast milk is especially important for low-birth-weight infants. Health care providers around the world recommend breast milk for infants up to age 2 and older. Breast milk is the only form of food needed for the first 180 days of a newborn's life. Water and juice should not be provided, because they may expose the infant to contaminants and allergens. For children 6 months and up to 2 years of age or beyond, breast milk is recommended along with other foods.

Breast milk benefits infants in many ways. Breast milk requires no preparation. It is ready for babies at the right temperature and at any time of the day or night. It is safe for infant consumption. Breast milk has the perfect blend of nutrients for the infant—specifically tailored to meet his or her nutritional needs without stressing vital organs.

See also BREAST ANATOMY; BREASTFEEDING; BREAST MILK, AS FOOD INGREDIENT; BREAST MILK, DONATION/BANKING/SELLING; BREAST MILK, EXPRESSION OF; POSTPARTUM BREASTS; PREGNANCY

Further Reading

American Academy of Pediatrics. "Breastfeeding and the Use of Human Milk." *Pediatrics: Official Journal of the American Academy of Pediatrics* 115, no. 2 (February 1, 2005): 496–506. Retrieved May 16, 2014, from http://pediatrics.aappublications.org/cgi/content/full/115/2/496

Kramer, Michael S., and Ritsuko Kakuma. *The Optimal Duration of Exclusive Breastfeeding: A Systematic Review,* WHO/NHD/01.08 and WHO/FCH/01.23. Geneva: World Health Organization, 2001.

World Health Organization. *Infant and Young Child Feeding: Model Chapter for Textbooks for Medical Students and Allied Health Professionals.* Geneva: World Health Organization, 2009.

■ KELLY L. BURGESS

BREAST MILK, AS FOOD INGREDIENT

Breast milk has been reported as being used in cooking as a substitute or an alternative to cow's milk. Some websites advertise dishes prepared with breast milk. The recipes described were for breast milk–based gelato, butter, cheese, and yogurt; cupcakes, breads, and cakes; breast milk and mushroom risotto; breast milk lasagna; and breast milk–fruit shakes. Although some people may use expressed breast milk as a cooking ingredient for personal or family use, the commercial preparation and sale of human milk–based foods are restricted for health and ethical reasons.

The two recently reported cases of breast milk used as a food ingredient for commercial purposes were the production and sale of human milk–based cheese in the United States, and of human milk–based ice cream in the United Kingdom. In 2010, a New York chef, Daniel Angerer, decided to produce cheese out of his wife's breast milk when their daughter was 4 weeks old and their freezer was full of expressed breast milk. He offered this cheese as an appetizer together with figs and Hungarian pepper to his customers at his own restaurant, Klee Brasserie, in Manhattan. The dish was called Mother's Milk Cheese. The restaurant immediately received a warning by the New York City Health Department prohibiting the production and sale of his new product.

In 2011, Matt O'Connor, an ice cream maker from London, prepared a human milk–based dessert, which was served with vanilla pods and lemon zest in London's Covent Garden restaurant. The dessert was called Baby Gaga Breast Milk Ice Cream. The serving price was £14. The dessert was produced from expressed breast milk offered by 200 lactating women at a cost of £15 per 10 ounces. All women attended health checks similar to the health checks recommended by the United Kingdom's National Health Service for blood donors; and the breast milk was pasteurized prior to dessert preparation. After

just a few hours of sale, the Westminster City Council confiscated the product for public health reasons and prohibited its sale. Lady Gaga prosecuted the ice cream parlor for using a name for the product that was similar to her own name.

Generally, breast milk–based products are promoted as natural, organic, and free-range, and also as exotic for customers who want to try out a new product. The public arguments relating to breast milk as a cooking ingredient were usually limited to "yum" versus "yuk" debates. In feminist and anthropological literature, the practice of the production and sale of breast milk–based products was described as one of the ways of commodifying and commercializing body fluids. These processes were described as indicative of the conversion of breast milk from a biological good into a product that has exchange value.

See also BREAST MILK; BREAST MILK, EXPRESSION OF

Further Reading

BBC News London. "Breast Milk Ice Cream Goes on Sale in Covent Garden." *BBC News*, February 24, 2011. Retrieved May 16, 2014, from http://www.bbc.co.uk/news/uk-england-london -12569011

Giles, Fiona. *Fresh Milk: The Secret Life of Breasts*. Sydney: Allen and Unwin, 2003.

Leonard, Tom. "New York Chef Offers Customers Cheese Made from Wife's Breast Milk." *The Telegraph*, March 10, 2010. Retrieved May 16, 2014, from http://www.telegraph.co.uk/news/newstopics/ howaboutthat/7409877/New-York-chef-offers-customers-cheese-made-from-wifes-breast-milk .html

Longhurst, Robyn, ed. *Maternities, Gender, Bodies and Spaces*. New York: Routledge, 2011.

■ VICTORIA TEAM

BREAST MILK, DONATION/BANKING/SELLING

Some women may have an excess of expressed breast milk, which they want to donate to human milk banks. They usually donate their expressed breast milk out of altruistic motives, believing that their milk would help to save the life of a preterm infant. Some women may have used banked breast milk for a certain period of time in the past and want to recompensate the stock. Women who have lost their newborn may donate their breast milk as part of their grieving process. Most donors receive no compensation. Some donors may be offered a free breast pump and/or minimal compensation in the form of a transport allowance. There are some cultural and religious beliefs regarding breast milk donation and the use of banked human milk.

In developed countries, human milk banking is promoted as having the aim of facilitating breast milk feeding for preterm infants, or infants whose mothers are unable to produce milk or any sufficient amount of it. Many human milk banks are not-for-profit organizations. They sell human milk supplies to neonatal intensive care units. The sale prices, however, are very high. These prices are related to the costs associated with donor screening and the collection, processing, testing, storage, and delivery of donated breast milk.

The first human milk bank was opened in Austria in 1909; since that time, more human milk banks opened in Europe, North America, and Australia. With the beginning of the AIDS epidemic in the 1980s, many human milk banks were closed due to the

potential risk of HIV transmission. Currently, they are reemerging. In many countries, human milk bank operation is not specifically regulated; however, most banks follow the voluntary code of practice for milk bank operation. For example, North American and Australian human milk banks follow the *Guidelines for the Establishment and Operation of a Donor Human Milk Bank* developed by the U.S. Food and Drug Administration and Centers for Disease Control and Prevention. The minimum standard for potential donor screening, as recommended by these guidelines, involves screening for the HIV 1 and 2 antibodies, human T-cell lymphotropic virus I and II antibodies, hepatitis C antibody, hepatitis B surface antigen, hepatitis B core antibody, and syphilis antibody.

Human milk markets existed throughout human history. Wet nursing was practiced in ancient Greece and Rome, in America at the time of African-American slavery, and across centuries in European countries. In the modern world, the direct sale of expressed breast milk is discouraged for a variety of ethical, epidemiological, and public health reasons. However, the unregulated sale of human milk has always existed; and the informal sale of human milk through websites continues to rise. Some websites, such as Only The Breast, allow placing human milk sale–purchase advertisements on their pages. The consumer audience of these websites varies from the families of sick and preterm infants to men with fetishistic behaviors who are interested in purchasing expressed breast milk to satisfy their sexual desires. Major sale–purchase websites, such as eBay and Craigslist, have policies banning sales of body fluids, including expressed breast milk.

See also BREASTFEEDING; BREAST MILK, EXPRESSION OF; WET NURSING

Further Reading

Dutton, Judy "Liquid Gold: The Booming Market for Human Breast Milk." *Wired*, 2011. Retrieved May 16, 2014, from http://www.wired.com/magazine/2011/05/ff_milk/all/1

Hartmann, Margaret. "The Breast Milk Black Market." *Jezebel*, 2011. Retrieved May 16, 2014, from http://jezebel.com/5803416/the-breast-milk-black-market

Hassan, Narin. "Milk Markets: Technology, the Lactating Body, and New Forms of Consumption." *Women's Studies Quarterly* 38, nos. 3–4 (2010): 209–228.

Shaw, Rhonda, and Alison Bartlett. *Giving Breastmilk: Body Ethics and Contemporary Breastfeeding Practice.* Bradford, ON: Demeter Press, 2010.

Simmer, Karen, and Ben Hartmann. "The Knowns and Unknowns of Human Milk Banking." *Early Human Development* 85, no. 11 (2009): 701–704.

Woo, Katie, and Diane Spatz. "Human Milk Donation: What Do You Know about It?" *American Journal of Maternal/Child Nursing* 32, no. 3 (2007): 150–155.

■ VICTORIA TEAM

BREAST MILK, EXPRESSION OF

Breast milk expression is a procedure of breast milk removal from the breast either by hand or with the help of hand pumps and electric pumping machines. Lactating women may express breast milk for a variety of health and social reasons. Health reasons that motivate women to express breast milk may relate to their own health conditions, such as sore nipples and mastitis, or to health conditions of their infants that interfere with their

latching on the breast, such as cleft lip and palate. Expressed breast milk can be given to babies with the use of alternative feeding methods, including syringe, spoon, cup, bottle, and finger feeding. Expressed breast milk can be stored for later use, shared, donated to milk banks, or discarded. Most women express breast milk because they want to have an extra amount for emergencies or aim to increase milk production. Some women express excess breast milk before and/or after feeding their infants in order to reduce the fullness of their breasts and to make them softer.

The most common social reason for breast milk expression is maternal return to work. In developed countries, breastfeeding guidelines and regulations require the employer to provide a paid break for a nursing mother and the facilities for breast milk expression. Some women may feel uncomfortable breastfeeding their infants in public and may prefer to feed them expressed breast milk given in the bottle, which is another social reason for breast milk expression. Following the recent social trend for paternal involvement in infant feeding, some women may express breast milk with the aim of allowing the father to experience infant feeding, reducing paternal isolation and promoting father-to-infant bonding.

Studies have found that feeding expressed breast milk to infants does not increase the risk of early weaning and increases the likelihood of breastfeeding until 6 months. The World Health Organization has recommended that all postpartum women be taught expression techniques. However, some anthropologists suggest that breast milk expression and expressed breast milk feeding purely for social reasons may contribute to the erosion of breastfeeding as a natural process.

See also BREAST ANATOMY; BREASTFEEDING; BREASTFEEDING, IN PUBLIC; MASTITIS

Further Reading

Clemons, Sarah N., and Lisa H. Amir. "Breastfeeding Women's Experience of Expressing: A Descriptive Study." *Journal of Human Lactation* 26, no. 3 (2010): 258–265.

Earle, Sarah. "Why Some Women Do Not Breast Feed: Bottle Feeding and Fathers' Role." *Midwifery* 16, no. 4 (2000): 323–330.

Ryan, Kath, Victoria Team, and Jo Alexander. "Expressionists of the 21st Century: The Commodification and Commercialization of Expressed Breast Milk." *Medical Anthropology: Cross-Cultural Studies of Health and Illness* 32, no. 6 (2013): 467–486. doi:10.1080/01459740.2013.768620

World Health Organization and UNICEF. *Baby-Friendly Hospital Initiative. Revised, Updated and Expanded for Integrated Care. 2009. Original BFHI Guidelines Developed 1992.* Geneva: World Health Organization, UNICEF, and Wellstart International, 2009.

■ VICTORIA TEAM

BREAST MUTILATION

Breast mutilation is the physical maiming of the breasts. Breast ironing is a cultural practice performed in Cameroon and, less frequently, in other African countries, including Benin, Chad, and the Togolese Republic. Breast ironing is a breast-flattening practice performed on adolescent girls by applying a firm pressure massage with hot objects, such as stones, coconut shells, pestles, spoons, and even hammers. Application of hot fruit

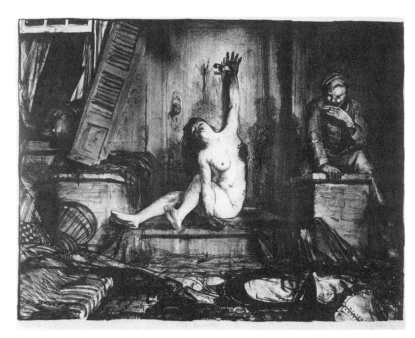

Throughout history, women's breasts have been mutilated both as part of cultural practices and as a type of torture, as depicted here. *The Cigarette*, George Bellows, 1918. LC-USZ62-108361; courtesy of the Library of Congress

peels and tight chest binding to make a girl's chest look flat usually follow the massage. This intergenerational practice is usually performed with the aim to reduce the visibility of the adolescent girl's sexual development. According to Cameroonian beliefs, breast development indicates an adolescent girl's maturity for marriage and parenting. Breast ironing is usually conducted by girls' mothers and later by girls themselves with the aim of reducing their sexual attractiveness. Other female relatives, including aunts, older sisters, and grandmothers, may also be involved. The sociocultural reasons behind this practice include prevention of sexual harassment and rape, protection from early involvement in sexual intercourse and teenage pregnancy, prevention of early marriage, and the development of better prospects in life. The increasing prevalence of AIDS in the country made mothers concerned about their daughters' sexual health, and breast ironing was a practice also aimed at preventing HIV infection. Historically, however, breast ironing was a practice by some African women aiming to increase girls' future milk production.

There are many health effects, both physical and psychological, associated with this practice. The immediate health effects include painful blisters and infection, including breast abscesses; the long-term effects may include disfiguring scars, breast asymmetry, and insufficient breast milk production due to tissue damage. Posttraumatic stress disorder is the most common psychological effect related to breast ironing. Girls and their mothers may naïvely believe that this practice is conducted for their health and social benefit.

Breast ironing is most prevalent in rural areas. In some provinces, the prevalence of this practice reaches 53 percent. Girls as young as 8 years are subject to breast ironing, and girls with early signs of sexual development are at an increased risk of undergoing this procedure. This cultural practice is considered by many as a form of violence against women and is subject to attempts to eradicate it. Although various gender empowerment and health education campaigns have been implemented in Cameroon focusing on the

elimination of breast ironing, to date there is no law in place prohibiting this harmful traditional practice. As part of these campaigns, Cameroonian women and girls were educated regarding the health effects related to breast ironing and upon effective and socially acceptable methods of preventing teenage pregnancy and HIV.

In historical and anthropological literature, various forms of breast mutilation were described, including amputation, cauterization, searing, and pinching. Breast mutilation has been performed for various reasons. It was practiced as a method of female torture with the aim of eliciting crime-related information and as a method of punishment for suspected witches. Breast torture instruments were described as either four- or six-pointed metallic claws.

In ancient military practice, breast mutilation was performed to women primarily to facilitate the efficient use of a bow. According to ancient military culture, only a breast-mutilated woman was considered a real warrior. Breast mutilation was also conducted as a practice of honor for female warriors. In Greek mythology, breast mutilation was conducted as a practice of sacrificial service to Artemis, the mythological goddess of hunting and wilderness. Amazons, the legendary ancient Greek women-warriors, were portrayed as having practiced one-sided breast mutilation by either burning or cutting off their right breast. This practice allowed Amazons to better throw their spears.

Nowadays, the term breast mutilation, or female mammary mutilation, is used much more broadly. This term also includes breast reconstruction surgeries for cosmetic reasons, such as breast reduction and breast augmentation, and nipple piercing, which have become increasingly popular in the contemporary Western world. Some cultural anthropologists argue that contemporary breast modification practices are reinvented traditional practices to control women's bodies.

See also AMAZONS; BREAST AUGMENTATION; BREAST REDUCTION; INTERNATIONAL CULTURAL NORMS AND TABOOS; MYTHOLOGY; MYTHS; PUBERTY; WITCH'S TEAT

Further Reading

Bawe, Rosaline Ngunshi. *Breast Ironing . . . a Harmful Practice That Has Been Silenced for Too Long.* August. N.W. Region, Cameroon: Gender Empowerment and Development (GeED), 2011.

Child Rights International Network (CRIN). "Millions of Cameroon Girls Suffer Breast Ironing." CRIN Network: Children and Violence, June 13, 2006. Retrieved May 16, 2014, from https://www.crin.org/en/library/news-archive/millions-cameroon-girls-suffer-breast-ironing

Karacalar, Ahmet. "The Amazons and an Analysis of Breast Mutilation from a Plastic Surgeon's Perspective." *Plastic and Reconstructive Surgery* 119, no. 3 (March 2007): 810–818.

Vakunta, Peter Wuteh. *Cry My Beloved Africa: Essays on the Postcolonial Aura in Africa.* Mankon, Cameroon: Langaa Research & Publishing.

■ VICTORIA TEAM

BREAST ORGASM

Having their breasts and nipples touched, licked, and sucked sexually arouses many men and women. Physiological changes take place in the body during sexual arousal. Observable changes in the breasts can include swelling of the breasts, nipple erection, and the

development of a darker hue in the nipples. Breast sensitivity varies throughout each woman's menstrual cycle, and a woman's preferences about how and how much she wants her breasts stimulated can also change throughout her menstrual cycle because of breast swelling and tenderness.

Anecdotal reports of women achieving orgasm through breast stimulation alone have long existed. A scientific study published in 2011 confirmed that it is possible. In this small study, each woman was asked to stimulate her own clitoris, vagina, cervix, and nipple. Each body part was stimulated for 30 seconds then there was a rest before the next body part was stimulated. Each participant was instructed to stimulate herself in the same fashion in order to eliminate biased results. For example, the women were asked to use their right hands to tap their left nipples rhythmically. During the process, participants were inside a functional magnetic resonance imaging (fMRI) machine so that researchers could see which areas of the brain were active as each area was stimulated. The researchers were surprised to discover that nipple stimulation activated the genital sensory cortex area of the brain—just as stimulation of the clitoris, vagina, and cervix did. The arousal that many women feel when their nipples are manipulated is enough to cause orgasm in some.

Orgasms result from a combination of factors and interconnections within multiple areas of the brain. Stimulation of the nipples also releases the hormone oxytocin. This hormone is released during pregnancy as well, and it triggers uterine contractions. However, research suggests that the nerves in the nipples appear to link in the brain without going through the uterus, and men who have been studied also seem to feel similar sensations when their nipples are stimulated.

See also BREAST ANATOMY; HORMONES; NIPPLES

Further Reading

Boston Women's Health Book Collective. *Our Bodies, Ourselves*, rev. ed. New York: Touchstone, 2011.
Komisaruk, Barry R., Nan Wise, Eleni Frangos, Wen-Ching Liu, Kachina Allen, and Stuart Brody. "Women's Clitoris, Vagina, and Cervix Mapped on the Sensory Cortex: fMRI Evidence." *Journal of Sexual Medicine* 8, no. 10 (October 2011): 2822–2830.

■ MERRIL D. SMITH

BREAST RECONSTRUCTIVE SURGERY

Reconstructive surgery cosmetically corrects defects incurred during breast cancer surgery and recreates the appearance, if not the sensations, of the removed breast. Offering a renewed sense of wholeness through recreating a socially normative body, reconstructive surgery is seen as an important way for cancer survivors to regain a sense of normalcy. With improvements in reconstruction techniques and results, as well as increasing health insurance coverage, information availability, awareness, and support, increasing numbers of women are choosing this procedure. Some argue, however, that reconstruction contributes to social pressures regarding feminine norms and contest the ideals of beauty that underlie it.

Women's breast reconstructive surgery has been practiced for over 100 years. Starting in Europe, in 1895, Vincent Czerny used autologous (i.e., in which the patient is

both a donor and recipient) tissue to correct postoperative breast defects; in 1906, Louis Ombredanne first used the muscle flap to repair a mastectomy. In 1942, London-based Sir Harold Gilles developed a lengthy reconstruction process, also using autologous tissue. In the United States, the 1963 Cronin–Gerow silicone breast implant improved surgery results, and in 1982 Chedomir Radovan's skin expander increased the available local tissue. The transverse rectus abdominis myocutaneous (TRAM) flap, developed in 1982 by Carl Hartrampf et al., is a popular autologous site; however, tissue from the back (the latissimus dorsi flap) and buttocks is also used. After controversy over alleged correlations between silicone and autoimmune disease, extensive studies cleared the way for silicone implant use. Algorithms and multidisciplinary teams currently enable tailoring procedures to women's unique situations, and are now able to choose immediate or delayed surgeries.

The availability of information on reconstruction and the reducing stigma of breast cancer and reconstructive surgery have resulted in increasing numbers of women requesting this set of procedures. Since the 1960s, women's magazines have helped women become better informed about the process and the possible cosmetic outcomes, and to press for this as their final cancer surgery. As bookseller sites demonstrate, reconstruction has become an important topic. The bestselling *Dr. Susan Love's Breast Book* (now in its fifth edition) and websites by breast centers and cancer societies provide current information, photographs, and videos. The books *Reconstructing Aphrodite* and *Aphrodite Reborn* (following up on 20 of the original women and including new material) affirm reconstruction's successful results and positive effects through photographs and personal statements.

To enable informed consent, doctors and multidisciplinary teams advise potential candidates of the advantages and risks involved during breast cancer treatment discussions. Regardless of advances in breast reconstruction techniques, outcomes may not match initial expectations. Age, breast size and shape, the quality and quantity of donor sites, as well as the state of surgical margins (whether clear of cancer cells or not) determine the feasibility of surgery and its degree of success. Tobacco use is a known problem for reconstructive work, and women are advised to avoid use and exposure prior to and during the process. Ptosis (drooping or sagging) makes achieving and maintaining breast symmetry problematic. Wound infections, fluid buildup, and flap failure, as well as the experience of pain, often require corrective breast surgery. Implants may harden and/or alter in shape, leak, or need replacement. Based on the risks, women may choose to use external prostheses or go breastless.

Not all women opt for reconstructive surgery or use external prostheses for political reasons, questioning cultural assumptions about beauty norms and sexuality, and the profitable business of cosmetic surgeries. In the late 1970s and 1980s, Audre Lorde associated her mastectomy with the Amazon warrior legend, and Deena Metzger tattooed her scar with a tree, producing the iconic "Tree" poster. Both contributed to a movement of empowered postmastectomy women. Compared with the increasing information on reconstruction and its growing popularity, however, there is little available on and by women who forgo reconstructing their breasts. A few websites and blogs provide forums for women to challenge cultural pressures to conform to beauty ideals and to promote and encourage going breastless. Reconstructive surgery has, nonetheless, become a significant issue in breast cancer treatments and women's identities.

See also AMAZONS; BEAUTY IDEALS, TWENTIETH- AND TWENTY-FIRST-CENTURY AMERICA; BREAST CANCER; BREAST CANCER TREATMENTS; LOVE, SUSAN (1948–); MASTECTOMY AND LUMPECTOMY

Further Reading

Benedet, Rosalind. *After Mastectomy: Healing Physically and Emotionally*. Omaha, NE: Addicus Books, 2003.

Crompvoets, Samantha. *Breast Cancer and the Post-Surgical Body: Recovering the Self*. Basingstoke, UK: Palgrave Macmillan, 2006.

Lorant, Terry, Loren Eskenazi, and Helga Hayse, eds. *Reconstructing Aphrodite*. Burlington, VT: Verve Editions, 2001.

Love, Susan M. *Dr. Susan Love's Breast Book*, 5th ed. Cambridge, MA: Da Capo Press, 2010.

Uroskie, Theodore W. Jr., and Lawrence B. Colen. "History of Breast Reconstruction." *Seminar in Plastic Surgery* 18, no. 2 (2004): 65–69. doi:10.10055/w-2004-829040

■ DOROTHY WOODMAN

BREAST REDUCTION

Breast reduction is also known as reduction mammoplasty or reduction mastopexy, and it refers to surgical procedures to reduce the volume of the breast for aesthetic or social reasons, comfort, mobility, and/or especially to reduce symptoms associated with excess breast weight (known as macromastia or gigantomastia) such as back pain and headaches. Macromastia usually develops during puberty but can occur during pregnancy, menopause, or any other period of hormonal change or weight gain. Nonsurgical treatment during puberty is also possible before the breasts have fully developed. Tamoxifen or other medications that reduce the effects of estrogens on breast tissue or reduce estrogen production have been used to stop breast growth and may also reduce breast size. Although this does not guarantee a dramatic reduction in breast size, it may prevent the need for future surgical intervention.

Breast reduction can involve one breast (in order to create symmetry) or both breasts (as is usual). Similar procedures are used in breast reduction, breast lift (mastopexy), and mastectomy. The key considerations in both mastopexy and breast reduction are the placement and appearance of the nipple–areola complex and the possible effects on lactation and breastfeeding. Breast reduction does not involve complete removal of breast tissue and usually involves removal of fat rather than the mammary glands, thereby preserving the ability to produce breast milk. There are two approaches available: liposuction only (lipectomy) and surgery. For surgery, an incision is made around the areola so that it can be moved without affecting the blood and nerve supply. If large portions of tissue are to be removed, the nipple–areola complex may need to be removed and grafted to the new site rather than preserved in place. This option does not preserve the nerves or the ability to breastfeed. A section of the pedicle, the region under the areola to the bottom of the breast, is removed, and many variations exist on the precise incisions made. Two scar configurations are common: lollipop (in which there is a scar around the areola and from the bottom of the areola to the bottom of the breast) and anchor (in which there is an additional scar along the bottom of the breast across the bottom of the "lollipop").

For surgical breast reduction, light activities can usually be resumed within a week and heavy activities after 3 months. Aftercare involves wearing a surgical binder, surgical support bra, or sports bra for 3 months. Most puckering, wrinkling, or residual swelling subsides within 1–3 months, although revisions may be sought after one year. In liposuction-only breast reduction, a small incision is made on the edge of the breast and suction is used to remove fat. The recovery time is much shorter and the scar smaller with liposuction-only breast reduction. However, no adjustment is made to the nipple–areolar complex location, and therefore no "lift" (mastopexy) is provided. In determining the breast reduction approach, the woman's medical history, breast fat, mammary gland size, breastfeeding plans, aesthetic preferences, and breast sagging (ptosis) are considered.

See also BREAST ANATOMY; BREAST AUGMENTATION; MASTECTOMY AND LUMPECTOMY; PREGNANCY; PUBERTY

Further Reading

Cherchel A., C. Azzam, and A. De Mey. "Breastfeeding after Vertical Reduction Mammaplasty Using a Superior Pedicle." *Journal of Plastic, Reconstructive and Aesthetic Surgery* 60, no. 5 (2007): 465–470.

Dancey, Anne, M. Khan, J. Dawson, and F. Peart. "Gigantomastia: A Classification and Review of the Literature." *Journal of Plastic, Reconstructive & Aesthetic Surgery* 61, no. 5 (2008): 493–502.

Mello, Arnaldo A., Neide A. M. Domingos, and M. Cristina Miyazaki. "Improvement in Quality of Life and Self-Esteem after Breast Reduction Surgery." *Aesthetic Plastic Surgery* 34, no. 1 (2010): 59–64.

■ ISRAEL BERGER

BURNEY, FANNY (1752–1840)

Frances Burney, Madame D'Arblay, known as Fanny to her friends, was an English novelist who was residing in France and underwent a mastectomy in September 1811. The following year, she wrote a complete account of the operation in a letter to her sister, Esther. This was published posthumously in the widely read volume edited by Charlotte Barrett, *Diary & Letters of Madame d'Arblay (1778–1840)* (London, 1904). Her account of surgery from the point of view of the patient was an unusual and powerful document, especially as it was written in the descriptive style of an accomplished novelist. As she relates of the final separation of the breast, "Presently the terrible cutting was renewed—and worse than ever, to separate the bottom, the foundation of this dreadful gland from the parts to which it adhered. . . . Oh heaven! I then felt the knife rackling against the breast bone—scraping it!"

Scholars have considered Fanny Burney's letter in comparison with her fiction, which often relies upon a female narrator who exerts herself to overcome obstacles and to maintain poise. This text has also been compared to political literature, and to other patients' narratives, in order to analyze its contribution to notions of the body, of stoicism, and of the female gaze. Fanny Burney's mastectomy letter would be the single most studied account of such surgery. According to literary historian Julia L. Epstein, the wealth of detail in the letter "makes it a significant document in the history of surgical technique, [and] its intimate confessions and elaborately fictive staging, persona-building, and framing make it likewise a powerful and courageous work of literature in which the imagination confronts and translates the body" (Epstein 1986, 131).

Fanny Burney's life and work are honored at the Burney Centre at McGill University, Canada, which is overseeing a detailed, annotated collection of her complete written works.

The original manuscript of the "mastectomy letter" is now held in the Henry W. and Albert A. Berg Collection, New York Public Library, New York.

See also BREAST CANCER; BREAST CANCER TREATMENTS

Further Reading

Epstein, Julia L. "Writing the Unspeakable: Fanny Burney's Mastectomy and the Fictive Body." *Representations* no. 16 (1986): 131–166.

Kaye, Heidi. "'This Breast—It's Me': Fanny Burney's Mastectomy and the Defining Gaze." *Journal of Gender Studies* 6, no. 1 (1997): 43–54.

Olsen, James S. *Bathsheba's Breast, Women, Cancer & History*. Baltimore: Johns Hopkins University Press, 2002.

Pécastaings, Annie. "Frances Burney's Mastectomy and the Female Body Politic." *Prose Studies* 33 no. 3 (2011): 230–240.

■ THÉRÈSE TAYLOR

C

CELEBRITY BREASTS

Throughout history, women have traded on their physical attributes, including their breasts, to advance their social status. Agnès Sorel, for example, became the first officially recognized mistress of a French king after she captured the attention of Charles VII in 1444, when she was about 20 and he was in his forties. Charles bestowed upon her wealth, servants, a castle, and other luxuries. Sorel was called *Dame de beauté*, and she was celebrated for her beautiful breasts, as well as her face and figure. In an age before tabloid news, the Internet, and social media networks, Sorel's celebrity status was spread through letters and gossip. Instead of photographs, her dazzling beauty was captured in portraits, most notably in Jean Flouquet's *Madonna and Child* (*The Virgin of Melun*). In this work, Sorel, in the guise of the Virgin Mary, looks down in a pensive pose. One of her firm round breasts appears to have burst out of her low-cut gown, while the other can be seen through the sheer fabric. The exposed breast is on display for the viewers of the painting. The infant Jesus who sits on the Virgin/Sorel's lap does not appear interested in it at all.

Breasts have helped to turn many movie actresses into sex symbols. Jean Harlow, often referred to as the "original blonde bombshell," was one of the first blonde sex goddesses of American movies. In one of her best movies, the comedy-drama *Dinner at Eight* (1933, dir. George Cukor), Harlow plays a sexy gold digger. In these pre-code movies, she is frequently displayed in or on her bed. In one scene, she jumps up from the bed, and viewers see she is not wearing a bra or panties.

Marilyn Monroe, who died in 1962, remains one of the most famous sex symbols of modern times. Unlike many late twentieth- and early twenty-first-century sex symbols, she was curvy, not simply large-breasted, and she and other movie actresses of the 1950s helped to repopularize the hourglass figure. She was—and still is—exalted as a voluptuous sex symbol. Her cleavage and curves were displayed in her movies and in still photographs. Jayne Mansfield, another blonde "bombshell" who often competed with Marilyn Monroe for movie roles, seemed to revel in her image as a sex symbol. She appeared in *Playboy* (as did Monroe), and became the first major Hollywood actress to appear nude in a movie, *Promises, Promises* (1963). Lana Turner became known as the "Sweater Girl" after she wore a tight sweater in her first major film, but the phrase was applied to other actresses, such as Jane Russell and others in the 1950s who wore tight sweaters over the popular cone-shaped bras of the era.

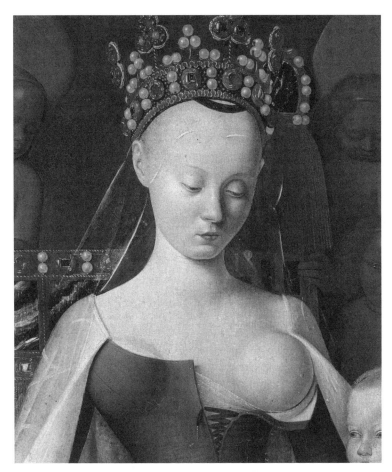

In this detail from a painting by Jean Fouquet, Agnès Sorel, the celebrated beauty and mistress of King Charles VII of France, is portrayed as the Virgin Mary. One of her round, firm breasts appears to have burst from her gown, and the other can be seen through the fabric of her gown. Detail of *Virgin and Child Surrounded by Angels* from *The Melun Diptych*, Jean Fouquet, 1440. Scala/Art Resource, NY

Today, the breasts of female celebrities appear both covered and uncovered on various Internet sites, and in magazines, newspapers, movies, and television. Some, such as Pamela Anderson, owe their celebrity status to large, surgically enhanced breasts. Anderson had appeared in *Playboy* magazine and on the television show *Home Improvement*, but her career really took off after she had breast augmentation surgery and become one of the stars of the television show *Baywatch*. *Baywatch*, a ridiculously campy show about beach lifeguards, was one of the most watched television shows in history, mostly because of the revealing shots of the stars' bodies. Anderson famously ran across the beach several times in each episode in her skimpy red bathing suit with her ample cleavage exposed. Carmen Electra, who replaced Anderson on the show in 1997, also was known for her breasts, which she had had enlarged with double D (DD) implants.

Dolly Parton, the country music singer, actress, and businesswoman, also had breast augmentation surgery. It has been reported that the diminutive celebrity has 40 DD breasts that are insured for $600,000. Parton has been open about her outwardly artificial appearance, but she has frequently commented that she is real inside. In contrast, television and movie actress Jennifer Aniston has a more natural style and appearance. Aniston,

however, is noted for having her nipples show through the fabric of whatever she is wearing. There are even social media pages devoted to Jennifer Aniston's nipples.

Although celebrity breasts are flaunted and used to boost television ratings, uncovered nipples cannot appear on regular U.S. network broadcasts without controversy. During the 2004 Super Bowl halftime show, performer Janet Jackson's right nipple was exposed for about a second when her co-performer, Justin Timberlake, pulled off part of her costume in what was later called a "wardrobe malfunction." The incident led to media discussions and headlines, sparked a network lawsuit, and became known as "Nipplegate."

In addition to using their breasts to achieve fame, female celebrities have also used their status to promote breast causes, such as breast cancer and breastfeeding. Celebrities who have battled breast cancer include Sheryl Crow, Cynthia Nixon, and Christina Applegate, who had a double mastectomy after breast cancer was discovered in one of her breasts because she tested positive for the BRCA1 gene. Applegate has founded an organization called Right Action for Women to promote the spreading of information and education about breast cancer. In an opinion piece in the *New York Times* in May 2013, Angelina Jolie explained her decision to have a proactive double mastectomy after discovering she carries the BRCA1 gene and has an 87 percent chance of developing breast cancer.

Jerri Nielsen Fitzgerald, an American emergency room physician, achieved celebrity status for a time because of her breast cancer. Fitzgerald (known as Nielsen at the time) was spending a year as a doctor at the National Science Foundation's Amundsen-Scott research station at the South Pole, following a nasty divorce. After discovering a lump in her breast in 1998, she performed a biopsy on herself, and when malignancy was confirmed through video transmissions, she treated herself with chemotherapy drugs for several months before she could be rescued. In 2001, she told her story in a book *Ice Bound: A Doctor's Incredible Battle for Survival at the South Pole*, written with Maryanne Vollers. Actress Susan Sarandon played Dr. Fitzgerald in the television movie *Ice Bound* in 2003. Sarandon agreed to the role in the hopes that her celebrity status would help to make more women aware of breast cancer.

Many celebrities have helped to support breastfeeding through their own breastfeeding activities. Angelina Jolie appeared to be breastfeeding in a 2008 cover photo of *W* magazine taken by her husband Brad Pitt. Singer, songwriter, and celebrity Beyoncé was seen breastfeeding her baby, Blue Ivy, while dining in a New York City restaurant. Actress Salma Hayek actively promoted breastfeeding during a humanitarian visit to Sierra Leone in 2009. She made headlines throughout the world and clips appeared on YouTube and other sites after she breastfed a hungry infant who was not her own. (She was still breastfeeding her own baby at the time.) Hayek said she was trying to lessen the stigma against breastfeeding that prevents some women from breastfeeding or keeps them from doing it for very long.

See also ADVERTISING; BREAST AUGMENTATION; FEMALE ACTION HEROES; IMPLANTS; MASTECTOMY AND LUMPECTOMY; MEDIA; MOVIES; MUSIC, POPULAR; PHOTOGRAPHY

Further Reading

Bagley, Christopher. "One Week: Brad & Angelina," *W*, November 2008. Retrieved May 15, 2014, from http://www.wmagazine.com/celebrities/2008/11/brad_pitt_angelina_jolie

Kaplan, Kimberly. "Salma Hayek on Why She Breastfed Another Woman's Baby." *ABC Nightline*, February 11, 2009. Retrieved May 16, 2014, from http://abcnews.go.com/Entertainment/story?id=6854285&page=1#.UXVXv4L-I7A

Jolie, Angelina. "My Medical Choice." *New York Times*, May 14, 2013. Retrieved May 16, 2014, from http://www.nytimes.com/2013/05/14/opinion/my-medical-choice.html.

Jordan, Jessica Hope. *The Sex Goddess in American Film, 1930–1965*. New York: Cambria Press, 2009.

Nielsen, Jerri, with Maryanne Vollers. *Ice Bound: A Doctor's Incredible Battle for Survival at the South Pole*. New York: Hyperion, 2001.

Yalom, Marilyn. *A History of the Breast*. New York: Knopf, 1997.

■ MERRIL D. SMITH

CONTROVERSIES

To Bare or Not to Bare? Several major controversies about the breast revolve around the issue of when and under which circumstances bare chests are considered acceptable or forbidden. Human societies have a variety of societal norms regarding the extent to which chests should be covered and the extent to which gender determines socially acceptable chest coverage. In many societies, bare chests are permitted in some circumstances but not in others. In parts of the United States and the United Kingdom, it is common for men to bare their chests at sporting venues or the beach; it is also not unusual in the United States for shops to bear signs informing customers of a "no shirt, no shoes, no service" policy. Whereas men in these societies are not regularly criticized for baring chests that conform physically to normative expectations, it is not uncommon for women to receive public criticism if an article of clothing slips to reveal a breast. Similarly, men with larger than average breasts are often ridiculed or stigmatized for appearing bare-chested in public spaces. However, these men are rarely criticized on the basis of being sexually inappropriate or engaging in public indecency.

Chest coverage norms also vary based on contextual factors such as geographical region, time period, and culture. In some cultures, the covering or baring of breasts is a social cue for observers. For example, women in Zulu society are expected to cover their breasts after they get married. Although bare chests in public spaces are permitted for men in many parts of the world, men who appear bare-chested in public in Dubai and Bermuda can be arrested for public indecency.

In some countries, young girls do not typically wear clothing, while in other countries girls are expected to cover their bodies and faces. Recent fashion trends that include bikinis for young girls have led to international controversy. U.S. actress Gwyneth Paltrow received criticism for her line of bikinis marketed to girls as young as 4 years old. Paltrow said that the clothing was intended to provide an opportunity for girls and their mothers to wear matching clothes. Critics of the bikinis said that they were inappropriate because they sexualized young girls. Although the bikinis themselves are legal, some legal scholars have noted that taking a photograph of a child wearing the bikini may constitute child pornography in some jurisdictions.

"Topless" or Bare-Chested?: In the statistical minority of the human population that is typically described as Western, the term "topless" is selectively applied to describe the bare chests of women only. Use of the term topless has become increasingly controversial,

with some critics noting that this term constructs a woman's natural bare chest in terms of the absence of a cover in cases where men's bare chests are treated as normative or unproblematic. The term topless is often associated with sexually explicit materials and venues, such as topless bars at which women display their bare chests for the entertainment of paying customers. The negative associations of the term with the sexual objectification of women have led some feminists to call for a shift to terminology that is equally applied to people of all genders. Photographic coverage of the statistical majority of the world that is typically called developing or Southern by minority world photojournalists has often included images of bare-chested women. In recent years, these images have become increasingly controversial. Concerns have been raised about whether such images in high-profile international periodicals such as *National Geographic* are inherently ethnocentric or objectifying to women, and the extent to which the appropriateness of such images depends on the intentions, use, and role of the photojournalist or the viewer.

The debate over topless women has legislative implications. In 1992 in *People v. Santorelli*, New York Judge Vito Titone ruled that police who arrested a woman for appearing bare-chested in public did not provide sufficient justification to support discrimination against women for baring their chests in public as typically permitted for men. Titone ruled that women could uncover their bodies to an equal extent as men when it is done for non-commercial purposes. The ruling applied to all of New York State.

From 2011, the Outdoor Co-Ed Topless Pulp Fiction Appreciation Society in New York has hosted a blog to publicize their public and semipublic events at which women participate bare-chested. The Society's events have the intended dual purposes of increasing public awareness of New York State legislation that permits women to bare their chests in public for non-commercial purposes. The National Go-Topless Day in New York City provides another forum for public education about this legislation. Direct action protests and demonstrations in support of women's equal right to bare their chests have occurred in the New York City subway system and at annual LGBTI Pride Parade events such as the Dyke March.

Mammography Screening for Breast Cancer: The question of whether mammography is a beneficial or harmful method of breast cancer screening has been the subject of fierce debate among health professionals and in the press. Some public health campaigns targeted to women have used fear tactics to advocate for widespread routine screening. However, many health professionals and patient advocates have noted the high numbers of both false positives and false negatives that result from the use of mammography to screen for breast cancer. People who have been called back for follow-up testing have experienced high levels of distress. In addition, both men who were assigned as female and men who were assigned as male have some degree of breast cancer risk. However, men and people with non-binary genders are rarely included in such screening campaigns. Some have questioned if women are being over-treated for growths that are detected in mammograms but would most likely never develop into cancer, or, if cancerous, would never spread.

Controversies have also erupted over Pink Ribbon organizations and campaigns, most notably the Susan G. Komen Foundation. Late in 2011, the organization announced it had stopped funding Planned Parenthood. Then, after a public outcry, the Komen Foundation reversed its decision. Donors and attendance at events plummeted, but CEO Nancy

Brinker received an already planned 64 percent increase in salary, despite the announcement that she was stepping down from her position. Since the organization cancelled several fundraising events because of a decline in funding and attendance, many former supporters of the organization were further disgruntled to learn that Brinker was earning a yearly salary of $685,000—much more than CEOs of comparable charity organizations.

The debacle over management in the Komen organization has increased scrutiny over its emphasis on mammography rather than on funding research for curing breast cancer. In turn, the public inquiry over Komen's handling of its funds and its goals has led to more public debates over Pink Ribbon branding and what the April 28, 2013, issue of *New York Times Magazine* has called "Our Feel-Good War on Breast Cancer." Medical sociologist Gayle A. Sulik has written extensively about Pink Ribbon campaigns and branding, most notably in her book, *Pink Ribbon Blues*.

Breastfeeding in Public: In many countries, breastfeeding in public is controversial. Women have been told to leave restaurants, stores, parks, and other public areas when they begin breastfeeding. In 2006, a Delta Airlines flight attendant asked Emily Gillette to leave the plane after she refused to cover herself with a blanket while breastfeeding her child. Gillette said she was nursing discreetly while sitting in a window seat with her husband in the aisle seat. The airlines apologized, but Gillette sued Delta Airlines; Freedom Airlines, which operated the connecting flight from which she was ejected; and Mesa Air Group, Inc., the parent company of Freedom Airlines. The suit was settled in 2012.

In 2009, Facebook came under attack for removing photos of nursing mothers. Facebook clarified its policy, noting that other Facebook users had flagged most of the photos that had been removed. The company said any photos that show nipples are removed as Facebook policy considers such photos obscene or pornographic.

Whether breastfeeding is appropriate in the workplace has also generated controversy. In August 2012, Adrienne Pine, an assistant professor of anthropology at American University in Washington, D.C., brought her sick one-year-old daughter to her classroom with her. Pine was a single mother. The daycare center would not accept her child while the child was sick. Rather than cancel her lecture, Pine brought her daughter with her to class, and then nursed her when she began to fuss. Later, a student tweeted about it, and debates erupted on the campus and over the Internet over whether Pine's behavior was appropriate for the classroom.

There have also been debates and controversy over breastfeeding children past infancy. *Time* magazine's cover for May 21, 2012, showed Jamie Lynne Grumet breastfeeding her 3-year-old son, who stood on a chair to reach her exposed breast. People all over the United States debated both the cover and the issue of when children should be weaned. The British documentary *Extraordinary Breastfeeding* (2006) featured a woman who was breastfeeding her 8-year-old child. In the United States and many Western countries, breastfeeding past the age of one year is often considered "extended breastfeeding." In India and some parts of Africa, however, children are often nursed until they are 3 or 4 years old.

See also Breastfeeding; Breast Milk; Mammograms; Pink Ribbon Campaigns; Rochester Topfree 7; Susan G. Komen for the Cure

Further Reading

Angell, Catherine. "Bare Necessities: Why Does Society Make Breastfeeding So Complicated?" *The Practising Midwife* 16, no. 3 (2013): 5–5(1).

Boyer, Kate. "'The Way to Break the Taboo Is to Do the Taboo Thing': Breastfeeding in Public and Citizen-Activism in the UK." *Health & Place* 17, no. 2 (2011): 430–437.

Cole, Ellen, and Esther D. Rothblum. *Breasts: The Women's Perspective on an American Obsession.* New York: Routledge, 2012.

Cusack, Carmen M. "Boob Laws: An Analysis of Social Deviance within Gender, Families, or the Home (Etudes 1 2)." *Women's Rights Law Reporter* 33 (2012): 197–375.

Friedman, Lawrence M., and Joanna L. Grossman. "A Private Underworld: The Naked Body in Law and Society." *Buffalo Law Review* 61 (2013): 169–215.

Naidu, Maheshvari. "Indigenous Cultural Bodies in Tourism: An Analysis of Local 'Audience' Perception of Global Tourist Consumers." *Journal of Social Science* 26, no. 1 (2011): 29–39.

Orenstein, Peggy. "The Problem with Pink," *New York Times Magazine*, April 28, 2013, 36–43, 68–72.

Sulik, Gayle A. *Pink Ribbon Blues: How Breast Cancer Culture Undermines Women's Health*, rev. ed. New York: Oxford University Press, 2012.

Ward, L. Monique, Ann Merriwether, and Allison Caruthers. "Breasts Are for Men: Media, Masculinity Ideologies, and Men's Beliefs about Women's Bodies." *Sex Roles* 55, nos. 9 –10 (2006): 703–714.

■ Y. GAVRIEL ANSARA AND MERRIL D. SMITH

CORSETS

A corset is a garment that is worn to shape the body. It usually extends from the chest to the hips, and it is laced and reinforced with bone or metal. Most commonly, it is used to elevate a woman's breasts and decrease her waist size; however, men have also worn corsets. Corsets have been used medically to aid with strengthening the spine and to produce good posture. Some modern-day garments called corsets are tops that resemble corsets but do not actually shape the body. Corsets have also been associated with fetishistic pornography and the sadomasochistic subculture.

Although corset-like garments have existed for centuries, true corsets date from the beginning of the sixteenth century. Most likely, these "whalebone bodies," or *corps à la baleine*, originated in Spain or Italy, and it is possible that Catherine de Medici (1519–1589) brought the fashion of wearing them to France. The bones that were used to reinforce the structure of the garment were known as stays; sometimes corsets are referred to as stays, and corset makers were also known as staymakers.

Corsets' styles and lacings have changed over time, especially as waistlines moved up and down according to fashion. Some eighteenth-century stays, called "jumps," were looser and laced in the front. They were often worn by women who did not have maids to dress them, as well as by pregnant women, and upper-class women who wanted to dress more casually.

In the late eighteenth and early nineteenth centuries, looser, neoclassical high-waisted dresses became the fashion for women, especially French women. They wore shorter and more flexible stays. The "Empire waist" and sheer gowns that were so popular in the time of the French Republic vanished with the return of the monarchy in 1815. Around 1816, the "divorce corset" helped women to achieve the separated-breast look that was then popular. By inserting a padded triangle made of iron or steel into the front center of the

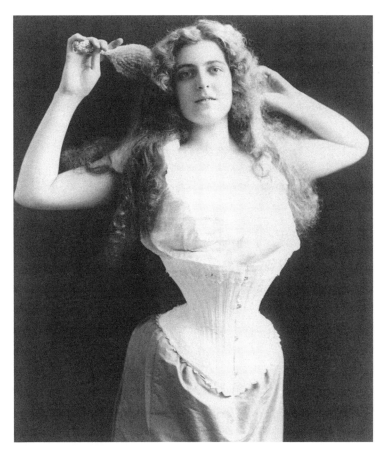

The woman depicted in this glamour shot from about 1899 is wearing a corset that gives her body the distinct "Grecian bend" that was popularized by the Gibson Girl image. Her breasts and buttocks are thrust out due to the corset that makes her waist improbably tiny. *Woman Wearing a Corset, Brushing Her Hair, Half-Length Portrait, Standing, Facing Front*, c. 1899. LC-USZ62-101143; courtesy of the Library of Congress

corset, a woman's breasts were instantly kept apart. Throughout most of the nineteenth century, corsets were long and stiff, and they included gussets at the top that provided shape for the breasts. Falsies and bust pads (available for 25 cents in the 1897 *Sears Roebucks & Co. Catalog*) could be purchased to help women achieve a fuller, rounder breast shape. Most corsets laced in the back, and most were white. Women of all classes wore corsets, especially after they began to be mass-produced in the mid-nineteenth century. However, there were types of corsets designed for a range of activities, including pregnancy and breastfeeding, bicycling, horseback riding, and leisure, and there were even corsets for bathing suits and for sleeping.

Throughout the centuries, some authorities and theologians denounced corsets as immoral because the garments thrust breasts up and exposed them to view. In the nineteenth century, medical doctors and reformers spoke out against corsets because they believed they were unhealthy and harmful to women's bodies. Economist Thorstein Veblen also attacked corsets in his influential treatise, *Theory of the Leisure Class* (1899). He blamed the corset for making women weak and unable to work.

Corsets declined in popularity in the early decades of the twentieth century as a more boyish, flat-chested look became fashionable. By the 1930s, bras and underpants became the staples for most women—sometimes supplemented by girdles, garter belts, and slips.

For the most part, corsets were no longer seen until they reappeared in the punk and goth subcultures of the 1970s—often worn by young men. In her 1990–1991 Blond Ambition Tour, pop singer Madonna wore corsets made by designer Jean-Paul Gaultier, and in 1994, corsets appeared on the runway in the Paris Fall Collection and in *Harper's Bazaar*.

See also BRASSIERE; MUSIC, POPULAR; PORNOGRAPHY; SPORTS BRAS; UNDERGARMENTS; WONDERBRA

Further Reading

Cogan, Frances B. *All-American Girl: The Ideal of Real Womanhood in Mid-Nineteenth-Century America*. Athens: University of Georgia Press, 1989.
Steele, Valerie. *The Corset: A Cultural History*. New Haven, CT: Yale University Press, 2011.
Yalom, Marilyn. *A History of the Breast*. New York: Knopf, 1997.

■ MERRIL D. SMITH

COSMETICS

Cosmetics or makeup refers to the use of products on the body and especially the face to enhance beauty, sexually attract a mate, hide imperfections, or create the illusion of symmetry and harmony. Cosmetics have been a part of civilization for most of human history. Cosmetics were an inherent part of Egyptian hygiene and health. As early as 10,000 BCE, men and women used scented oils and ointments to clean and soften their skin and mask body odor, according to archaeological evidence, such as burial tombs with pots and vessels containing the remnants of fragrant oils. Relief sculpture and paintings reference the use of dyes and paints to color the skin, body, and hair, and indicate that ancient Egyptians rouged their lips and cheeks, stained their nails with henna, and lined their eyes and eyebrows heavily with a dark eyeliner.

Ancient Greek and Roman art and literature also indicate the use of cosmetics. As the Romans became more powerful, cosmetic use became more popular. The influence of the Greeks and Egyptians among other conquests led to Roman use of hair bleaches, eye shadows, body oils, and face powders (made of chalk and white lead). Wealthy Roman women had slaves who acted as personal beauticians. Some Roman women used a "toning" tonic for breasts, most commonly a mixture of plantain, sour castor oil plant, and sour red wine, along with a white lead pigment. This mixture was then applied to the breasts when the moon was descending.

During the Elizabethan period (c. 1558–1603), cosmetics were used in attempts to clear the face and hide the scars of smallpox, especially on the face, neck, and décolletage. The typical thick application made from a combination of white lead, vinegar, and sulfur initially provided the ideal smooth, pale surface, but repeated use caused the skin to become even more ravaged. The skin-bleaching recipe of mercury, water, and ceruse (a derivative of white lead) could affect the body with gastric issues and shakes. Cosmetic use continued to be popular during the eighteenth century, and with it, a rise in medical complications. Tooth decay, skin conditions, and poisonings can be traced to the use of the

dangerous combinations. Lead and sulfur to enhance cleavage, mercury to cover blemishes, and white lead to create a pale complexion were the frequent culprits.

The use of cosmetics in the nineteenth century posed a moral dilemma. Beauty was supposed to be a manifestation of goodness, not artifice. The use of lip color became unusual, although the use of rouged cheeks could still be seen in "good" circles, as with other lightly applied cosmetics. By the 1870s, social mores became stricter, and makeup was only seen on the stage. The first few decades of the twentieth century saw an increase in the visible use of cosmetics. After World War II came an explosion of variety in cosmetics. Now more than ever, makeup is viewed as entrenched in psychological issues of the self and the care of oneself. The cosmetic industry has global reach and profits in the billions. Use of makeup to create the illusion of bigger breasts and cleavage is still prevalent and offered as an inexpensive alternative to breast augmentation surgery.

See also ART, WESTERN; BEAUTY IDEALS, TWENTIETH- AND TWENTY-FIRST-CENTURY AMERICA; FASHION

Further Reading

Chaudhri, S. K., and N. K. Jain. "History of Cosmetics." *Asian Journal of Pharmaceutics* 3, no. 3 (July 2009): 164–167.

Mire, Amina. "Skin-Bleaching: Poison, Beauty, Power, and the Politics of the Colour Line." *Resources for Feminist Research* 28, nos. 3–4 (January 1, 2001): 13–38.

Riordan, Teresa. *Inventing Beauty: A History of the Innovations That Have Made Us Beautiful*. New York: Broadway Books, 2004.

Wolf, Naomi. *The Beauty Myth: How Images of Beauty Are Used against Women*. New York: HarperCollins, 1991.

Woodforde, John. *The History of Vanity*. New York: St. Martin's Press, 1992.

■ LORI L. PARKS

COSMOPOLITAN

Originally a family-friendly literary magazine featuring short stories and book reviews, *Cosmopolitan* did not begin marketing itself as a female lifestyle magazine till the 1960s. The inspiration behind this shift was Helen Gurley Brown, who was appointed as the magazine's chief editor in 1965. Having already enjoyed great success publishing sexually explicit novels and sex guides, most notably her 1962 bestseller, *Sex and the Single Girl*, Brown actively sought to market the new *Cosmopolitan* as a publication for sexually active, forward-thinking young women. Featuring advice columns, fashion guides, and articles on taboo topics such as the birth control pill and rape, Brown's new-look magazine proved incredibly popular, and by the mid-1970s *Cosmopolitan* was reaching more than 2 million readers per month.

In terms of its attitude toward sex, Brown's new-look *Cosmopolitan* adopted an openly liberal attitude, with feature articles and relationship guides that explicitly encouraged women to pursue their own sexual fantasies. Increasingly sexualized photo shoots with both male and female celebrities also began to appear following Brown's arrival, and in

April 1972 the magazine attracted great controversy when it published a near-nude centerfold of actor Burt Reynolds.

In line with this sexually liberated outlook, *Cosmopolitan* continued to encourage its readers to enjoy their own bodies following Brown's decision to step down as chief editor in 1997. In December 2011, for example, the U.S. edition of the magazine ran a feature titled "50 Great Things to Do with Your Breasts," providing readers with advice on everything from how to pose topless in front of the mirror to what sorts of nipple tassels to wear during foreplay. In a similar style, a *Cosmopolitan* "Boob Bible" was published in 2010, whilst the U.S. edition of the magazine has also provided its readers with step-by-step instructions on how to have "boob sex."

Not all of *Cosmopolitan*'s features on breasts have been so sexually explicit, however; recent years have also seen a proliferation of surveys and opinion polls on readers' attitudes toward different issues. In 2010, for instance, the magazine conducted a survey of 100,000 men and women and found that 44 percent of women were "perfectly happy" with their breast size. Indeed, *Cosmopolitan* has consistently tried to encourage women to love their own bodies and has regularly warned of the dangers associated with breast implants and plastic surgery.

In recent years, *Cosmopolitan* has also been an active supporter of the Breast Cancer Care charity and has sought to raise awareness about the disease and its symptoms. For instance, during 2012 the U.S. edition of *Cosmopolitan* featured a 12-part feature written by the Puerto Rican–Dominican author and filmmaker Sofia Quintero about her fight against breast cancer, whilst in September 2012 the UK edition of the magazine featured provocative topless pictures of former Spice Girl Melanie Brown and Hollyoaks actress Jorgie Porter in order to promote the beginning of the 2012 Breast Cancer Awareness Month (held every October).

Although Helen Gurley Brown passed away in August 2012 at the age of 90, the magazine that she resuscitated in the 1960s continues to grow in strength. In fact, in 2013, *Cosmopolitan* was the bestselling women's lifestyle magazine in the world with 64 international editions all continuing to promote *Cosmopolitan*'s sex-centric brand of female empowerment to a new generation of "fun, fearless females" around the globe.

See also ADVERTISING; BREAST ORGASM; CELEBRITY BREASTS; *ESQUIRE*; MEDIA; PHOTOGRAPHY; PINK RIBBON CAMPAIGNS

Further Reading

Landers, James. *The Improbable First Century of Cosmopolitan Magazine.* Columbia: University of Missouri Press, 2010.

Scanlon, Jennifer. *Bad Girls Go Everywhere: The Life of Helen Gurley Brown.* New York: Oxford University Press, 2009.

■ MATTHEW HOLLOW

CROSS-DRESSING, IN HISTORY

Cross-dressing highlights the integral role that clothing plays in shaping identity. It can be an identifier of gender, race, class, and religion. One of the challenges faced by female cross-dressers is disguising their breasts. Today, women have several options, including specialty bras. Historically, breast binding with cloth strips was the most convenient method women had to conceal their figure.

Several medieval women dressed as men to enter monasteries. Hildegund von Schönau joined a Cistercian monastery as Joseph, where she died after only one year. Prior to her entry into the monastery, she had spent several years living as a boy while she traveled to the Holy Land with her father. These women managed to evade discovery because it was common for boys to enter the monastery at an early age; a lack of facial hair and masculine features was not questioned. Von Schönau took advantage of the solitary lives led by monks and the loose cassocks they wore. By binding her breasts with linen strips, she transformed herself into a monk. As with many other women in medieval monasteries, she was so successful that she was not discovered until after death when the monks prepared her body for burial.

There are several examples of nineteenth-century American women who enlisted as sailors and soldiers. The logistics of a woman hiding in public, all-male environments were challenging, particularly for female sailors living in the cramped quarters of an ocean-going vessel where privacy was scarce. There are few reliable accounts of women who chose a life at sea. Yet, even the accounts whose veracity is questionable provide a glimpse into the world of female cross-dressing sailors. In 1815, *The Adventures of Louisa Baker*, a fictional account, was published in Boston. Baker chose to seek a new life by dressing as a man and enlisting as a soldier. She explains how she successfully evaded discovery: "I had taken the precaution to provide myself with a tight pair of under draws, which I had never shifted but with the greatest precaution, which, together with a close waistcoat or bandage about my breasts, effectually concealed my sex from all on board" (Cohen 72). She was aided by the loose shirts, trousers, long hair, and neck scarf favored by sailors. Since many who took to sea were young men, a hairless face, delicate features, and high-pitched voice were not questioned. By adopting the mannerisms of men, disguises were complete. Hannah Snell, a woman who was so successful that she remained at sea for years, kept her male persona until she chose to muster out. Snell took advantage of her natural figure to convince others that she was a man. As with other tall, slender women, Snell did not need to go to great lengths to hide her breasts. Snell's biographer relates the unlikely story of a flogging she received that should have revealed her identity. He claims that because she was turned toward the wall with her arms outstretched and had very small breasts, she kept her secret. At a later date, she maintained her disguise when she was put in irons for five days by standing as upright as possible and tying a handkerchief around her neck, the ends of which covered her breasts. While there are several confirmed cases of female sailors such as Snell, few give details of how they managed to keep their secret. However, female cross-dressers were not found only at sea.

There are several hundred cases of women fighting in the American Civil War. Some women joined the army to follow their husbands, others did so to escape engagements or bad marriages, while still others wanted to experience excitement and adventure. Diary

accounts of female soldiers tell of women cutting their hair, binding their breasts, stuff-ing their pants, lowering their voice, and learning to walk in a masculine manner. Breast binding with cloth strips lined with cotton and waist padding were the most common methods of hiding a woman's figure. Coupled with the ill-fitting thigh-length flannel coats, loose flannel pants, and long overcoats of a soldier's uniform, this was generally sufficient disguise. Janet Velazquez Mitchell's account is unique. Mitchell, a woman of financial means, writes of hiring a tailor to make six wire net devices that were designed to bulk up her shoulders and hide her breasts and small waist. These shields were held in place by chest and shoulder straps. Mitchell glued on a false mustache; was taught to drink, spit, and talk by a male friend; and gathered a contingent of 2,000 men. Mitchell is one of several examples of female soldiers and sailors who were proud of their accomplishments and managed to keep their identities secret until after the war when they published their memoirs.

The primary identifier of these women as men was their clothing. Coupled with breast binding, little more was needed to hide their true identities.

See also BRASSIERE; BREAST BINDING; CROSS-DRESSING, IN LITERATURE

Further Reading

Blanton, DeAnne, and Lauren M. Cook. *They Fought Like Demons: Women Soldiers in the American Civil War.* Baton Rouge: Louisiana State University Press, 2002.

Cohen, Daniel A., ed. *The Female Marine and Related Works: Narratives of Cross-Dressing and Urban Vice in America's Early Republic.* Amherst: University of Massachusetts Press, 1997.

Hotchkiss, Valerie R. *Clothes Make the Man: Female Cross-Dressing in Medieval Europe.* New York: Garland, 2000.

Teorey, Matthew. "Unmasking the Gentleman Soldier in the Memoirs of Two Cross-Dressing Female US Civil War Soldiers." *International Journal of the Humanities* 20, nos. 1–2 (2008): 74–93.

■ RHONDA KRONYK

CROSS-DRESSING, IN LITERATURE

Cross-dressing in literature reflects larger historical practices of and attitudes toward trans-vestitism. Representations of cross-dressing suggest that the activity allows society to more acutely see gender continuums. Some have argued that historically cross-dressing was an attractive means for women to gain entry into otherwise male professions or to travel alone, while contemporary cross-dressing for both sexes is focused on identity and the enjoyment of performance. The accuracy of such a definite shift may be debatable. Cer-tainly, modern analyses of twenty-first-century transvestitism tend to focus on the fluid nature of gendered identity, although nonfiction accounts of women's cross-dressing do note economic gain as a key motivation well into the twentieth century. Furthermore, medieval texts with some frequency used transvestitism to question gender norms; in other words, disrupting conventionally gendered behavior is hardly a modern invention.

Multiple medieval texts make use of female transvestites, often in order to highlight a character's "masculine spirit," although actual cross-dressing in Europe and Britain

was quite rarely noted. The fifteenth-century figure Joan of Arc, who continues to be a popular figure in literature, was depicted in several genres during and immediately after her lifetime. Joan was not attempting to pass as a man, however. In fact, many literary accounts from the fifteenth century mention her lovely features and shapely breasts. Female characters are also depicted traveling as male musicians, as in *Graf Alexander von Mainz* (1493). Male cross-dressing is occasionally a subject in the literature; Guillaume de Blois's twelfth-century text *Alda* is one example. These narratives tend to use cross-dressing to present questions of gendered identity and to resituate assumptions about sexual orientation, often positing that biological sex need not absolutely dictate social roles. Some medieval stories depict women cross-dressing in order to save their husbands. *Ritter Alexander* (1490), for example, sees a woman disguise herself to help her husband escape from jail. The disguised wife then defends her partner at his trial and finally reveals her true identity by showing her breasts. In these narratives, transvestitism allows women to show their wifely devotion and interest in preserving their marriages.

Medieval texts also frequently focused on female saints who dressed as men, living holy lives as hermits or monks, and only revealed to be women after their deaths. These hagiographies often look on female cross-dressing with favor, for the women take on honorable "male" deeds and they move away from less desirable "female" qualities. Such stories can be found in Petrus de Natalibus's *Catalogus sanctorum* (c. 1370–1400) and Aelfric's *Lives of the Saints* (c. 1000). The suggestion has been made that transvestitism is also presented positively in medieval hagiographies because it implies larger feats of spiritual transformation.

This positive treatment had disappeared by the seventeenth century's gender debates, however, as transvestitism by either sex was viewed as a sign of larger social disorder. The authors of the 1620 pamphlets *Hic Mulier* and *Haec-Vir* both connect cross-dressing to eroding gender norms. Cross-dressing on the public stage was a far more easily accepted phenomenon, as boys performed female roles in English theatres until after the Restoration. William Shakespeare's plays often pick up on the mischievous possibilities of disguise: Viola's and Rosalind's disguises as men in *Twelfth Night* (c. 1599) and *As You Like It* (c. 1599) would be especially resonant on the early modern stage, as viewers could enjoy boys playing women playing men. Women have at various times after the Restoration taken on male Shakespearean roles as well. In fact, at least 50 women performed as Hamlet in the nineteenth century alone.

Nineteenth-century women who were revealed to be cross-dressers occasionally profited by selling their stories to newspapers or publishing houses, although the stories were always made to conform to certain generic expectations, presenting the women as cross-dressing out of necessity (to search for a loved one while traveling alone, or to support a family through work in a masculine profession, for example). There are several historical nonfiction narratives about women cross-dressing to enter military and naval service. In their memoirs, writers would recount their efforts to pass in the world of men; while some cross-dressers became modest when opportunities to romance women presented themselves, others flirted or dated happily.

Contemporary society may largely believe that cross-dressing was not recognized prior to the late twentieth century, but transvestitism has actually been a vital part of

various literary genres in several eras. Over 200 pieces on women's transvestitism were printed in *News of the World* and *People* between the early 1900s and 1960 alone; this relative level of frequency would suggest that knowledge of cross-dressing reached at least the middling sort on a regular basis. These newspaper accounts generally have a tinge of the fantastical: they include the language of oddity or marvel in describing the moment when the woman's biological sex was revealed, with particular attention paid to any domestic relationships that she may have enjoyed.

Radclyffe Hall's *The Well of Loneliness* (1928) encouraged connections between transvestitism and same-sex desire in ways that were far less explicit or even considered prior to the twentieth century. On a related note, research suggests that connections between transvestitism and deviance were only firmly established in the postwar period, although this pattern may actually develop out of treatments in nineteenth-century mysteries such as Arthur Conan Doyle's *A Study in Scarlet* (1887). One cannot deny that these connections are firmly established now, however, particularly in detective novels such as P. D. James's *Devices and Desires* (1989). Presentations of transvestitism as criminal or deviant can also be found in several horror films and thrillers, *Psycho* (1960) being one. While the activity has gained some acceptance in recent decades, and several positive examples of cross-dressing exist in contemporary texts, transvestitism is still ultimately seen as countercultural or somewhat shocking, and it continues to be attached to literary characters that more generally defy, question, or distance themselves from gendered norms.

See also CROSS-DRESSING, IN HISTORY; MEDIA; MOVIES; THEATRE; TRANSVESTITE

Further Reading

Bauer, Heike, ed. *Women and Cross-Dressing 1800–1939*, 3 vols. London: Routledge, 2006.

Hotchkiss, Valerie R. *Clothes Make the Man: Female Cross-Dressing in Medieval Europe*. New York: Garland, 1996.

Oram, Alison. *Her Husband Was a Woman! Women's Gender-Crossing in Modern British Popular Culture*. London: Routledge, 2007.

Suthrell, Charlotte. *Unzipping Gender: Sex, Cross-Dressing and Culture*. Oxford: Berg, 2004.

Wheelwright, Julie. *Amazons and Military Maids: Women Who Dressed as Men in the Pursuit of Life, Liberty and Happiness*. San Francisco: Pandora-HarperCollins, 1989.

■ LAURA SCHECHTER

D

DANCE

Because dance uses the human body to express meaning or convey an emotion, breasts are naturally involved. In some forms of dance, breasts are overt because the dancers are topless or the dance itself is sexual. In other cases, the appearance of breasts is more covert, but the overall appearance of the dancers—including the size of their breasts—is important to the dance form. Dancing can be free form, as for example when people dance at social occasions or in clubs, or it can have very stylized and ritual steps and movements, as in classical ballet. It can be part of a religious ritual, a celebration, recreation, or entertainment. Dance has existed since humans first walked on earth, and it can be found in cultures all over the world.

Sexuality is frequently a part of dance, although how it is presented and viewed depends upon the form of the dance, its historical or cultural context, and the point of view of both the participants and those watching. Dance scholar Suzanne M. Jaeger analyzed how breasts were presented in three different dance styles: classical ballet, flamenco, and African dance. In ballet, she found the ballerina's breast was subdued, as she appeared delicate and ethereal, yet in control of her body. If her partner touched her breasts, it was merely to help lift or steady her. In flamenco, the dancer flaunts her breasts, even sometimes caressing them and reveling in the sexuality of the dance. In African dance, breasts are free, and move along with body, in a celebration and exuberance of the body. Whether breasts are displayed or not, some groups, such as Christian fundamentalists and conservative Muslims, oppose both social dancing (especially between men and women) and dance performances because they believe they lead to lustful thoughts and immodest behavior.

Throughout history, some dances have scandalized onlookers. When the waltz was first introduced in the eighteenth century, some considered it immoral because couples danced closely in an embrace. During the dance, a woman's breasts might be pressed against the man, or he might touch them as he moved her around the floor.

In the 1920s, African-American dancer Josephine Baker (1906–1975) thrilled audiences with her signature "banana dance," in which she wore a skirt made of fake banana leaves, but little more. She frequently performed bare-breasted or in revealing costumes. Her comic but dazzling performances at the Folies Bergère were very popular with French audiences, but American racism prevented her from achieving the same popularity in the United States. Baker became a French citizen and received the French

Legion of Honor for her work with the Resistance in World War II. She continued performing until shortly before her death.

In the 1960s, go-go dancers appeared at discotheques and strip clubs. These dancers often appeared topless. In 1964, Carol Doda became famous for dancing topless at the Condor Club in San Francisco. She had her breasts implanted with silicone (changing her bust size from 34 inches to 44 inches), and became one of the most celebrated go-go dancers in the world, dancing at the Condor Club for over 22 years.

In many cultures of the world, dance is used as part of rituals to celebrate fertility or initiate courtship. Sexuality can be explicit or implicit, and dancers may expose their breasts or genitals or engage in thrusting or grinding motions. Such dances can be found all across the globe, from the Tanzanian *phek' umo* rites, done in moonlight and intended to promote fertility, to the narratives of Hindu classical dance. Yoruba men in Nigeria dance the *Gelede*, intended to maintain the goodwill of women and keep them from causing men to become impotent. During the dance, the men dress as women, sometimes attaching covered fish baskets to their hips to mimic a woman's shape and wearing large wooden breasts.

Female ballet dancers are often expected to have long, lean bodies with little body fat and tiny breasts that do not bounce or flap. Alexander Yakoview/ Thinkstock by Getty

In 1991, King Goodwill Zwelithini, king of the Zulu nation, reintroduced the Reed Dance Festival in South Africa. In 2011, more than 30,000 young women dressed in the traditional topless attire participated in this event. The festival is a celebration of chastity, and the king reestablished it in an attempt to combat the spread of HIV/AIDS. Prior to the festival, the young women must undergo traditional virginity testing. During the event, they carry large reeds in a procession led by the chief Zulu princess. If a reed breaks, the woman is deemed to have been sexually active. The women dance bare-breasted before the king and deposit the reeds in front of him.

Throughout history, women have danced in a variety of forms to entertain men. During these dances, their breasts may be exposed, flaunted, or merely hinted at. Women such as the ancient Greek *hertaere* or Japanese *geisha* often performed songs and dances for male clients, who might then later engage in sexual relations with them. Female

dancers in burlesque halls and men's clubs also perform for men. The women may start out clothed and end up nude, in a striptease, or they might be completely nude the entire time. In some places, women are not allowed to show their nipples, so they cover them with "pasties."

Even when breasts are not displayed in a dance, they can be an issue. In the world of classical ballet, the look of a dancer is important. Although dancers must, of course, be able to execute the difficult steps, leaps, and turns in proper form, they must also look like a ballerina. For women, that generally means a very thin frame, long muscles, and extremely small breasts. In an October 2011 interview in the *Wall Street Journal*, former New City Ballet dancer Sophie Flack discusses a character in her young adult novel, *Bunheads*, who is told by an instructor that either she must lose weight from her breasts or she will be dropped from a production. Flack faced similar situations in her own life, and noted that it was rare to find older female dancers who "had breasts" to serve as role models.

Many dancers fear not getting a role or being selected to be in a company. Some dancers even have breast reduction surgery to achieve the required appearance. Many dancers suffer from eating disorders to some extent, although dance schools and companies are now aware of these problems and take measures to educate and help dancers who appear to be suffering from these conditions. Nevertheless, this "cult of slenderness" still has a hold on female dancers, as well as on models and actors. It was depicted in the movie *Black Swan* (2010, directed by Darren Aronofsky). Stars Natalie Portman and Mila Kunis lost twenty pounds or more from their already slender frames to play the roles of ballerinas competing for the role of the Black Swan in the ballet *Swan Lake*. In the movie, Portman's character, Nina, appears both anorexic and bulimic, and her weight loss and vomiting might be factors in a psychotic break she experiences.

See also ADVERTISING; BREAST REDUCTION; EATING DISORDERS; FOLIES BERGÈRE; MEDIA; MODELS AND MODELING; MOVIES; TOPLESS DANCING

Further Reading

Hanlon, Khara. "Making Peace with My Body." *Dance Magazine*, July 2013. Retrieved October 10, 2013, from http://www.dancemagazine.com/issues/July-2013/Making-peace-with-my-body

Hanna, Judith Lynne. "Dance and Sexuality: Many Moves." *Journal of Sex Research* 47, nos. 2–3 (2010): 212–241. Retrieved October 10, 2013, from http://dx.doi.org/10.1080/00224491003599744

Heiland, Teresa L., Darrin S. Murray, and Paige P. Edley. "Body Image of Dancers in Los Angeles: The Cult of Slenderness and Media Influence among Dance Students." *Research in Dance Education* 9, no. 3(November 2008): 257–275. Retrieved October 10, 2013, from http://www.academia.edu/1048476/Body_image_of_dancers_in_Los_Angeles_the_cult_of_slenderness_and_media_influence_among_dance_students

Hollader, Sophia. "Ballet's Gritty Inside Story." *Wall Street Journal*, October 3, 2011. Retrieved October 10, 2013, from http://online.wsj.com/article/SB10001424052970204524604576607280061482452.html

Jaeger, Suzanne M. "Beauty and the Breast: Dispelling Significations of Feminine Sensuality in the Aesthetics of Dance." *Philosophy Today* 41, no. 2 (1997): 270–276.

Jules-Rosette, Bennetta. *Josephine Baker in Art and Life: The Icon and the Image*. Champaign: University of Illinois Press, 2007.

■ MERRIL D. SMITH

DÉCOLLETAGE

Décolletage is the edge or upper part of a low-cut (*décolleté*) dress. It is also used to describe the rounded top parts of the breasts when a woman wears a low-cut dress or blouse. In some cultures, such as those in some areas of Africa and the South Pacific, women have not traditionally covered their breasts. Thus, in these cultures, the breast and its *décolletage* are not given the mainly erotic meaning they have in the West.

Many things seem to hinge on the rise and fall of the breast. Clothing styles have played an important part in the emphasis of the breast. The ideal breasts during the Middle Ages and Renaissance were small, set apart, pale, firm, and round like apples. What had been relatively similar and genderless clothing attire (ankle-length tunics that did not emphasize sexual difference) throughout much of the Middle Ages had, by the fourteenth century, began to change, with men shifting to shorter tunics that extended to mid-thigh and revealed the legs. Women continued to wear the long tunics of the past, but the necklines were now fitted and lowered to emphasize the breasts. Isabeau de Bavière, the powerful mother of France's King Charles VII (r. 1422–1461), is credited with introducing this style that features the *décolletage*.

Displaying breasts became fashionable, despite the view by many that this shift in women's clothing and the increasing exposure of breasts by the rigid corsets and tight sleeves were an overt sexual invitation. Some women got around this by adding a transparent piece of fabric across the *décolletage,* which created a superficial sense of modesty. During the Renaissance, the nude bust became popular in the visual arts and corresponded to the shift in beauty ideals. This shift now viewed the *décolletage* as part of the face. Some courtesans of the period were known to apply cosmetics normally used for faces on their breasts as another way of enhancing and drawing attention to them. Uncovered breasts were generally associated with prostitutes, along with the yellow veils they were required to wear in public to identify them and their profession.

The breast could also be viewed as a visual symbol of a female's "otherness." For many it represented erotic longing, and this is exemplified by the upper-class practice of Renaissance mothers who attempted to preserve the beauty of their breasts by using wet nurses rather than nursing their own children. In contrast the breast could also be a site of society's fear of old age, decay, and death. Many women tried to prevent "ugly" breasts. At the end of the fifteenth century, Eleanor (a favorite mistress of French king Charles VIII, reigned 1470–1498) looked for recipes to enhance the beauty of her breasts. One formula called for poppy water made of rose oil, camphor, and ivy. Another prominent courtesan of the period is said to have used washes made up of gold and rainwater or sow's milk.

Sixteenth- and seventeenth-century beauty manuals list formulas that contain a variety of ingredients such as crushed pearls, lard, toads' eyes, and pigeon droppings. Women also sought out products that were touted to keep breasts small and firm (the ideal). One method called for the pulp of crushed cumin seed mixed into a paste with water and applied to the breasts and décolletage and then bound tightly by a band of cloth that had been dipped in water and vinegar to be worn for three days. This was to be replaced by a paste of crushed lily bulb and vinegar and again wrapped tightly for an additional three days. Some women drew blue veins on their cosmetically whitened *décolletage*.

For the upper classes of the nineteenth century, the clothing style called for exposing the arms, shoulders, and upper part of the breasts on special occasions, although many

disapproved and perceived it as being very near naked. The breasts continued to be the focus in fashion, causing some late nineteenth-century developers to concoct new kinds of bust developers. One kit contained a metal instrument very similar in design to a plunger to be used in conjunction with a jar of special cream and a bottle of lotion.

By the 1920s, the flat-chested figure was popular, but this fashion ended with the crash of the stock market in 1929. During the Great Depression of the 1930s, women put on their girdles and bras again, although for a brief period the erotic focus switched to women's back *décolletage*. The *décolletage* continues to be an area of focus for erotic appeal. Today, cosmetics, bras, lotions, creams, and surgery continue to provide a path for women to achieve the ideal look.

See also ART, WESTERN; BEAUTY IDEALS, NINETEENTH-CENTURY AMERICA; BEAUTY IDEALS, RENAISSANCE; BEAUTY IDEALS, TWENTIETH AND TWENTY-FIRST-CENTURY AMERICA; BRASSIERE; COSMETICS; FLAPPERS

Further Reading

Latteier, Carolyn. *Breasts: The Women's Perspective on an American Obsession.* New York: Haworth Press, 1998.

Steele, Valerie. *Fashion and Eroticism: Ideals of Feminine Beauty from the Victorian Era to the Jazz Age.* Oxford: Oxford University Press, 1985.

Yalom, Marilyn. *A History of the Breast.* New York: Knopf, 1997.

■ LORI L. PARKS

DOULAS

Doulas are women who provide nonmedical, emotional, and active support to expectant women and their families during pregnancy, labor, delivery, and postpartum. They also may be referred to as birth attendants, lay midwives, or direct-entry midwives. Doulas often answer pivotal questions related to pregnancy and childbirth, including changes in the breasts; provide the expectant mother with recommendations related to nutrition, exercise, and stress reduction; and attempt to create a delivery environment conducive to the needs of the expectant mother.

Until the late nineteenth century, most deliveries were considered to be exclusively a woman's enterprise performed at home by women with no formal medical training. However, this trend changed due to the increase of doctors in the field of obstetrics, the shift in public sentiment regarding males being present during births, the increase in the demand for doctors (amongst the upper and middle classes) in order to legally administer painkillers during delivery, doctor recommendations that childbirth was a dangerous process in need of technical skill and proficiency, and relaxed laws that did not hold midwifery to high medical standards.

For some women, having a doula-assisted birth is attractive since it allows for greater autonomy during one of the most important events in a woman's life, the birth of a child. Research suggests that, when compared to mothers who received standard levels of care, doula-supported mothers have more positive birth outcomes. These include but are not limited to an increased likelihood of breastfeeding, greater satisfaction with hospital care,

shorter labors, decreased likelihood of anesthesia use, and lower levels of medical interventions (e.g., caesarean section, vacuum, or forceps).

Despite being associated with positive birth outcomes, not all women are able to exercise their own personal autonomy when it comes to the birth of their children. In countries such as Hungary, home births are illegal unless a neonatologist and an obstetrician with at least ten years of experience are both present, which is highly unlikely; whereas in England, a strong doula movement exists where doulas take pride in their training and skill. Nonetheless, doulas are an increasingly important component of the birthing process worthy of careful attention.

See also BREASTFEEDING; POSTPARTUM BREASTS; PREGNANCY

Further Reading

Campbell, Della, Kathryn D. Scott, Marshall H. Klaus, and Michele Falk. "Female Relatives or Friends Trained as Labor Doulas: Outcomes at 6 to 8 Weeks Postpartum." *Birth* 34, no. 3 (2007): 220–227.

Horn, Angela. "Doula-Assisted Childbirth: Helping Her Birth Her Way." In *Embodied Resistance: Challenging the Norms, Breaking the Rules*, edited by Chris Bobeland and Samatha Kwan, 170–172. Nashville, TN: Vanderbilt University Press, 2011.

Kitzinger, Sheila. "Letter from Europe: Home Birth, Midwives, and Doulas." *Birth* 35, no. 3 (2008): 250–252.

Weitz, Rose. *The Sociology of Health, Illness, and Health Care: A Critical Approach*, 6th ed. Boston: Wadsworth, 2013.

■ TARIQAH NURIDDIN

E

EATING DISORDERS

Eating disorders have an evolutionary and cultural history. Humans filled their bellies with food during times of food availability or feasted, and they fasted without choice during times of famine or food scarcity. During the twelfth and thirteenth centuries, Catholic religious figures in Western culture, such as St. Catherine of Siena, demonstrated the use of severe food restriction or fasting for spiritual reasons. Some scholars see links between this "holy anorexia" and modern-day anorexia nervosa. In early modern Europe, there were numerous accounts of "miracle maidens" who did not eat. The texts attributed the women's ability to live without food to enchantment by witches or prayer, as well as to illness. During the Renaissance, some young women were said to suffer from the "green sickness," or virgin disease, during which they refused food, grew pale, and stopped menstruating. The cure was to have sexual relations with a lusty man. Saints, miracle maidens, and green-sick virgins all lost the physical characteristics of adult women, such as womanly breasts and curves.

In the twentieth century, eating disorders have been linked to processed food, poor dietary nutrition, obesity, poor self-esteem, physical and mental abuse, drug and alcohol addiction, and the rising emphasis on body image. Mental disorders such as depression, bipolar disease, obsessive-compulsive behavior, and anxiety have also contributed to abnormal eating habits. As society idolizes body images of thin or athletic women as beautiful, individuals obsess over striving to achieve what they are led to perceive is the perfect body image.

Eating disorders are medical conditions that disrupt an individual's diet and eating patterns and have a harmful effect on the person's health and life. Several million people are affected by eating disorders. Eating disorders can occur in each sex at any time in a person's life. However, primarily women, adolescents, and young adults (ages 12 to 35) are reported to suffer from the diseases. A 2001 report estimated that 30 percent of high school girls and 16 percent of high school boys suffer from eating disorders. Research in 2002 reported that greater than 50 percent of college women suffer from some degree of disordered eating.

Eating disorders often occur in highly competitive athletes. Individuals involved in sports and activities such as, but not limited to, gymnastics, running, wrestling, ballet, and modeling feel the stress of achieving a targeted weight or body image. Obsessions with

food and body image contribute to dramatic disturbances in eating habits, and thoughts and emotions related to food consumption. Body image or body dysmorphic disorder plays a major role. A 2002 study reported that 46 percent of high school females and 26 percent of high school males were dissatisfied with their bodies. Overweight and obesity were positively associated with dieting and disordered eating.

The embarrassment of obesity and breast tissue development in males (gynecomastia) and excess growth and proportion of breast tissue in women (macrosomia or giganto-mastia) contribute to the development of disruptive eating habits. Obesity may contribute to increased estrogen production and gynecomastia in males. The development of gynecomastia occurs in pubescent males (age 11 to 17). Obesity also causes the early onset of puberty (age 10 to 17) and breast development in young girls. Macrosomia or large breasts are most likely to develop in obese females. The American Association of Pediatrics and the American Psychological Association report that adolescents with gynecomastia and macromastia suffer a higher rate of eating disorders.

The American Psychiatric Association and the American Psychological Association diagnose eating disorders as anorexia

People who suffer from eating disorders often have distorted images of their bodies. For example, they may see their extremely thin bodies as being too fat. Purestock/ Thinkstock by Getty

nervosa, bulimia nervosa, or eating disorder not otherwise specified (EDNOS). Binge eating is categorized as an EDNOS. Eating disorders often coexist with low self-esteem, depression, panic, anxiety, obsessive-compulsive disorders, and/or alcohol and substance abuse. Heredity may also contribute to why some individuals develop eating disorders. Differences in the number of inherited serotonin (pleasure, well-being, and happiness) receptors in the brain may explain the genetic link to eating disorders in families.

Eating disorders are serious but treatable with professional medical care and counseling. Treatment of eating disorders should involve medical care and counseling from family physicians or pediatricians, clinical psychologists and/or psychiatrists, and licensed and registered dietitians. Medical specialists such as cardiologists, gastroenterologists, endo-crinologists, neurologists, and dentists may also need to be involved in patient care if other related health conditions coexist. The American Psychological Association cites research stating that individuals of all ages, and especially up to 13 percent of teens, are not

diagnosed and treated for eating disorders. Left untreated, abnormal behavior can increase the risk of illness and death.

Anorexia nervosa is characterized by the inability to reach or maintain at least 85 percent of a healthy body weight at a particular age and height (emaciation). Anorexia nervosa is reported in 0.5 percent of all women and 0.1 percent of all men. The rate of death with anorexia is 5–10 percent in 10 years, and 18–20 percent in 20 years, of developing the disease. Victims of anorexia nervosa suffer from a distorted body image or body dysmorphic disorder. Individuals with anorexia nervosa are afraid of gaining weight or becoming obese or "fat." They view their body shape as overweight, even when their bodies are emaciated or very thin. Perfectionism, low self-esteem, and self-criticism are common among those who experience eating disorders. Self-esteem is affected by negative perceptions about weight and body shape. Body weight is typically and frequently self-monitored. Those suffering from the condition refuse to accept the serious health risks associated with low body weight. Eating is restricted. Females stop menstruating for at least three menstrual cycles in a row. Breasts will shrink in size as fat deposits diminish. If weight and fat loss causes a halt in female hormone production during the growth and development stage of the female body, the development of ducts and glands in the breasts will also stop, and breasts will not develop.

If weight loss occurs after the growth and development stage of life, breast ptosis (sagging or drooping breasts) may result. Weight gain and loss can contribute to breast ptosis. True ptosis is when the nipple falls below the horizontal level of the breast crease. Pseudo-ptosis is when the breast gland falls below the horizontal level of the breast crease. Weight loss and breast volume loss cause a loss of breast tissue. If skin is not elastic and does not shrink with loss of tissue, breasts will hang. Breast mastopexy or breast lift surgery may be required to lift sagging breasts.

As anorexia nervosa persists over time, individuals may suffer from one or more of the following symptoms: thin and porous bones (osteopenia or osteoporosis), brittle nails and hair, dry and yellowish colored skin, anemia or low blood count, muscle atrophy (wasting) and weakness, constipation, reduced heart function, low blood pressure and pulse, brain damage, organ failure, fatigue, infertility, malnutrition, and starvation. Risk of death from anorexia nervosa is 18 times greater than in individuals without this condition.

Bulimia nervosa is a condition in which individuals consume very large and out-of-control quantities of food, and then purge. About 1–3 percent of women and 0.1 percent of men suffer from bulimia. Individuals with bulimia nervosa may binge and purge several times per day or week. Individuals suffering from bulimia nervosa may be underweight, healthy weight, overweight, or obese. As with anorexia nervosa, individuals exhibiting bulimia nervosa are victims of perfectionism, low self-esteem, extreme self-criticism, and fear of weight gain. Mood disorders, anxiety, impulsive behavior, and other personality disorders may also accompany bulimia nervosa.

Binging occurs when excess quantities of food are consumed within a short period of time (2 hours or less). Foods eaten are typically high in calories, simple or refined carbohydrates, sugar, and fat. The pace of eating is usually fast. Food may be swallowed in gulps and barely tasted. Binging stops when the individual experiences stomach pain from overconsumption, is unexpectedly interrupted by another person, or falls asleep.

Purging is accomplished with vomiting in 80–90 percent of cases. However, purging can also take the form of excessive exercise and/or the use of laxatives, enemas, or diuretics. Bulimics may also fast, or engage in extreme and frequent food restriction or dieting between episodes of binging. Activities are performed in secret. Feelings of shame and disgust accompany purging activity. Negative emotions fade after purging stops and the food has left the stomach.

If symptoms associated with bulimia nervosa are not recognized, the condition may not be noticed. Bulimia nervosa symptoms include an inflamed and/or sore throat, swollen salivary glands in the neck and below the jaw (puffy face), tooth decay and erosion of tooth enamel, gastroesophageal reflux disorder (GERD, or acid reflux), bowel irritation from laxatives, kidney problems from diuretics, heart attack from electrolyte imbalance, and dehydration from loss of fluids. As with anorexia nervosa, bulimia nervosa may result in severe weight loss, disruption of female hormone production, halting of breast development in adolescents, loss of fat deposits in breasts, shrinking of breasts, and breast ptosis (sagging).

EDNOS is, as mentioned, a category of eating disorders that includes binge eating and other forms of abnormal eating habits. Binge eating is described as many episodes of out-of-control eating of excessive amounts of food. Excess intake of food occurs in a short period of time. The individual does not purge the food consumed.

Binge eating occurs in 3.3 percent of women and 0.8 percent of men. Binge eating may start with occasional episodes and then progress over a longer period of time. As body weight increases and poor eating habits persist, binge eating may lead to the development of chronic disease. Morbid obesity, type 2 diabetes, hypertension (high blood pressure), and cardiovascular disease, including heart attack, are potential outcomes of binge eating. Individuals who become morbidly obese may develop gynecomastia or macromastia. About a third of obese individuals who seek counseling are afflicted with binge-eating disorder.

See also DANCE; EXERCISE; GYNECOMASTIA; MODELS AND MODELING; OBESITY; PUBERTY

Further Reading

American Psychological Association. "Eating Disorders." October 2011. Retrieved April 29, 2014, from http://www.apa.org/topics/eating/index.aspx

Bynum, Carolyn. *Holy Feast and Holy Fast: The Religious Significance of Food to Medieval Women*. Berkeley: University of California Press, 1987.

Deans, Emily. "A History of Eating Disorders," *Psychology Today*, December 11, 2011. Retrieved April 29, 2014, from http://www.psychologytoday.com/blog/evolutionary-psychiatry/201112/history-eating-disorders

National Institute of Mental Health. *Eating Disorders*. NIH Publication. No.11-4901, rev. 2011. Bethesda, MD: U.S. Department of Health and Human Services, National Institutes of Health. Retrieved April 29, 2014, from http://www.nimh.nih.gov/health/publications/eating-disorders/eating-disorders.pdf

■ KELLY L. BURGESS

ESQUIRE

An early forerunner to the modern-day "lad's mag," *Esquire* was founded in the United States in 1933 by David A. Smart, Henry L. Jackson, and Arnold Gingrich. Providing a mixture of fashion advice and titillating drawings of scantily clad women, it proved incredibly popular and by 1938 had a monthly circulation of over 700,000. During the 1940s, the magazine started regularly featuring raunchy watercolor illustrations by Alberto Vargas, a Peruvian artist. Designed to be innocent yet provocative, his drawings were especially popular among American servicemen, and during the Second World War "Vargas girls" were regularly used as nose art on American bomber planes.

However, partly due to increased competition from the growing pornography industry, *Esquire* gradually began to move away from the market for erotic imagery from the 1950s onward. Instead, it began to focus much more heavily on providing cutting-edge, experimental journalism and fiction, attracting notable writers and authors such as Ernest Hemingway, William Faulkner, John Steinbeck, and Norman Mailer.

Among the many innovative articles written during this period was a 1972 piece entitled "A Few Words about Breasts" by the acclaimed screenwriter and producer Nora Ephron. Written from an autobiographical perspective, her article sought to provide readers with an insight into the thoughts and feelings of teenage girls during puberty, highlighting in particular how breast size has the potential to affect women's self-confidence. More recently, the American writer and cookbook author Ted Allen was nominated for an American National Magazine Award in 2001 for an article that he had written in *Esquire* about the dangers of male breast cancer and the continuing stigma attached to the condition.

In recent years, *Esquire* has consciously striven to position itself as the lifestyle magazine for sophisticated and intellectually curious men. Priority continues to be given to pioneering journalism and criticism, while, internationally, it has also broadened its scope and now publishes editions in over 20 countries worldwide. Nevertheless, *Esquire* has not completely lost touch with its libidinous roots and continues to run its annual "Sexiest Woman Alive" feature. Likewise, the magazine was also able to generate huge publicity in the summer of 2012 thanks to the publication of a topless photo shoot with the musician Rihanna.

See also ADVERTISING; *COSMOPOLITAN*; MEDIA; PHOTOGRAPHY; *PLAYBOY*; PORNOGRAPHY

Further Reading

Allen, Ted. "This Man Survived Breast Cancer." *Esquire*, June 1, 2001. Retrieved April 29, 2014, from http://www.esquire.com/features/man-survived-breast-cancer-0600

Polsgrove. Carol. *It Wasn't Pretty, Folks, but Didn't We Have Fun: Esquire in the Sixties*. New York: Norton, 1995.

■ MATTHEW HOLLOW

EXERCISE

Exercise is physical activity that is aimed at improving health and maintaining fitness; it also is an important facet of physical rehabilitation. Exercise has many benefits. A study of 25,000 women in Norway reported that exercise for 4 or more hours per week reduced the risk of breast cancer. Researchers show a strong connection between regular physical activity and lower breast cancer recurrence and death. Exercise helps reduce body mass index. Overweight and obesity increase the risk of hormone receptor–positive breast cancer in women. This type of cancer occurs in two-thirds of breast cancer cases. Obesity is associated with a high risk of any type of breast cancer in postmenopausal women.

Exercise cannot improve the shape of breasts. Breasts are external organs. Breasts are made up of fat and glands, not muscle. Lack of participation in upper-body exercise was not found to contribute to breast ptosis (sagging or drooping breasts). Exercise can, however, decrease body weight and breast size. Exercise may reduce the risk of breast tissue development in males (gynecomastia), and excess growth and proportion of breast tissue in women (macrosomia or gigantomastia).

The U.S. Department of Health and Human Services Physical Activity Guidelines for Americans 2010 recommend activity for individuals of all ages. For adults aged 18 to 64, 150 minutes (2 hours 30 minutes) of moderate-intensity or 75 minutes (1 hour and 15 minutes) of vigorous-intensity aerobic activity are recommended per week. A minimum of 10-minute increments of activity is required. As much as 300 minutes (5 hours) per week may be required for weight management and maintenance of a healthy body. Children and adolescents (6 to 17 years of age) should receive 60 minutes or more of physical activity per day. Activity should also include muscle strength-training activities twice per week. Older adults (65 years of age and older) need to assess their health conditions and fitness level for exercise. Older adults should follow adult guidelines if they are physically able to.

Although exercise is beneficial for many reasons—including lowering the risk of breast cancer—too much exercise can be a problem for some individuals. An activity disorder is similar to an eating disorder, and some men and women suffer from both conditions (anorexia athletica). Individuals who suffer from activity disorder cannot stop exercising even when ill, injured, or exhausted, and they will continue exercising even against medical advice to stop.

See also BREAST ANATOMY; DANCE; EATING DISORDERS

Further Reading

Costin, Carolyn. "Is There Such a Thing as Too Much Exercise?" Association for Body Image Disordered Eating. Retrieved April 29, 2014, from http://abide.ucdavis.edu/overexercise.html

National Cancer Institute at the National Institutes of Health. *Factors Associated with Increased Risk of Breast Cancer*. Breast Cancer Prevention. Retrieved April 29, 2014, from http://www.cancer.gov/cancertopics/pdq/prevention/breast/HealthProfessional

U.S. Department of Agriculture and U.S. Department of Health and Human Services. *Dietary Guidelines for Americans 2010*, 7th ed., December. Washington, DC: U.S. Department of Agriculture and U.S. Department of Health and Human Services, 2010. Retrieved April 29, 2014, from http://www.cnpp.usda.gov/dgas2010-policydocument.htm

■ KELLY L. BURGESS

F

FASHION

Fashion refers to a society's accepted style in clothing, hair, and general appearance within a particular period of time. It can also mean the business of creating these latest styles. The origin of clothing can be attributed to the need for protection against the elements, love of decoration and display and its connection with sexual interest, and a desire for modesty.

The view that the creation of clothing was needed to maintain the physiological integrity of the body is somewhat problematic in that there are a number of civilizations, ancient and contemporary (e.g., ancient Egypt and India), where labor is performed with minimal covering. This allows for the heat to evaporate more quickly, thus making work less physically taxing. The use of white or light-colored clothing to reflect the sun is typical of cultures close to the Equator. Tattooing, body painting, and scarification of the body were most likely practiced in many cultures prior to the use of clothing (climate does not seem to make a difference with those groups who dress in pigments alone). In the late nineteenth century, Western anthropologists began to recognize that non-Western and aboriginal peoples used ornamentation and clothing first and foremost to attract—to accentuate rather than conceal or protect the body. Body paint, tattooing, jewelry, and clothing were intended to draw attention to sexual characteristics like the breasts.

There are many different origin myths of dress. Many involve gods who were clothed themselves or gods who bestowed upon their people the essential elements of their culture, which included the ability to make clothes. The Judeo-Christian biblical origin of clothing can be connected to Adam and Eve, who, after having sinned, became aware of their nakedness, felt shame, and covered themselves.

Fashion can reflect and contribute to the ideas that a culture has surrounding the body and its display. Adornment is an important form of communication. It has been used throughout time to indicate occupation, rank, gender, sexual availability, class, wealth, and group affiliation. Dress can be viewed as an important indicator of group identity and by extension reflect socially expected behavior. One's attire can also indicate resistance to the dominant group's dress code. Dress can also reflect cultural ideas and ideals pertaining to class, gender, and ethnicity. Those who do not conform to the dominant style of dress might create their own visual identities either individually or as a separate group or subculture. Their dress can be used to reflect their ideals, which are usually in opposition to those of the mainstream and other subculture groups.

The Western emphasis on modesty, particularly in regard to women and the social value placed on their chastity, has its roots in the Greco-Roman cultures, where the importance of a woman's chastity reflected her position within society as the "property" of her father or husband. Between the sixth and eleventh centuries, the biggest change in Western clothing was the length of the garments. These were similar for both men and women, and were an extension of the tunics worn in Imperial Rome.

Although dress or clothing is common to most cultures, fashion in the modern sense first appeared in Europe in about the fourteenth century. During this period, necklines were lowered and focused more on the décolletage. The sleeves became tight, and the forearm was revealed as well. By the fifteenth century, the focus continued to be on the upper body and breasts. Clothing consisted of padded doublets, tight belts, and larger sleeves. In England, King Henry VI (r. 1421–1471) took offense at the fashion of "baring the breasts" and discouraged such a display at court. Other authorities also disapproved of the new and ostentatious fashions, and they condemned the women for their lack of morals when they bared so much of their breasts.

During the Renaissance, clothing began to become more extravagant, yet the breasts and bodice remained an area of emphasis. Each country interpreted the style differently. For example, northern European countries distorted the natural figure by padding sleeves, doublets, and stockings. Regardless of the region, some of the standard characteristics shared are rich heavy materials used in volume, large sleeves, garments cut close to the body, and an emphasis on the bodice and hips. Colors for this period were jeweled tones: red, green, blue, and gold.

From the beginning of the Elizabethan period (c. 1558), there seemed to be a shift toward more modest dress with an ideal that focused on long slender waists and huge hips from the use of the hoop. This more androgynous image played on the idea that too much femininity (by baring the breasts) could undermine the queen's authority, just as an overly masculine appearance might make her seem monstrous. The wealthy used sumptuous fabrics, many of them brocaded. The starched white, ruffled collar and greater use of jewels to embellish the outfit were added at this time. Yet the gowns seem more like armor, with stiff and elongated waists and the flattened breasts hidden by collars.

The ruff disappeared and fashions changed rapidly after the Elizabethan period. By the time of the Restoration (c. 1660–1700), there was a new focus on clothing and ornamentation. Ribbons, flounces, and feathers returned to clothing wherever they could be attached. Collars were still present, although now they were cut wider across the shoulders, and necklines were again low to emphasize the breasts. Women continued to wear an underdress. Lower-class women often wore different colors for the skirt and bodice, which were separate pieces of clothing. Aprons became popular and were viewed as an extension of the skirt, rather than an accessory.

During the eighteenth century, France was seen as the arbiter of taste. This is the period when wigs became fashionable. Women's wigs grew to astonishing proportions, and it is said that hairdressers had to stand on ladders to dress their ladies' hair. Bodices were made to a corseted shape, making the ideal tightly fitted and long-waisted. Colors for the early part of the period were delicate and pastel, much like the fashionable rococo style, which began as an architecture and interior style and soon moved into the other fine arts. Hoops returned to fashion again, making the skirts into wide, distended bells.

The hoop grew in size up to 6 feet wide before becoming slimmer in the later part of the century. In the 1780s, the chemise dress first appeared. The light fabric and loose fit contrast with the earlier rigidity of the heavy corsets and fabric. Simpler forms reflect the neoclassical influence of the ancient Greek and Roman civilizations, and were meant to signal a more egalitarian society.

The nineteenth century brought a variety of necklines; some came up above the pit of the throat, whereas others, usually worn for formal occasions, threatened to slip off the shoulders and reveal the breasts, leaving very little to the imagination. Most of this period focused on the shoulders and small waist. There was also the shift from the crinoline to the bustle. Clothing became more standardized, and the difference between classes less overt and a result of the superior skill of one's tailor. The late Victorian corset pushed up the bust and pressed tightly on women's ribs and diaphragm, cruelly pressing upon their internal organs.

At the turn of the twentieth century, Paris remained the world's fashion center. Characteristics of women's dress were tiny fitted bolero jackets and sweeping skirts that fit over the hips and buttocks. Evening dresses would again focus on the low-cut décolletage. Corsets extended down over the hips to allow for the fitted skirts that would go over them. The most admired figure became known as the "Gibson Girl," who was created by Charles Dana Gibson, an American graphic artist. This ideal held in high esteem the mono-bosom and S-shaped figure created by a tiny waist and enhanced buttocks region. By 1912, fashion looked to many styles from the past. Inspiration was found in Asian, antique, and medieval styles. "Turkish" or harem trousers came from the near East; this did not last long due to the still-prevalent notion that women should not be wearing trousers. The hobble skirt enjoyed a moment of popularity before the First World War. This essentially prevented women from walking except by little shuffling steps.

During World War I, fashion shifted to a shorter, full skirt, and led to an increase in the demand for silk stockings, although they were still considered a luxury item. As more women led active lives, the corset became less prevalent. By 1924, the Spring Paris collection focused on the short skirt (reaching the calf). The waist was on the hips, and the bust and hips seem to disappear. This style was easy to mass produce and allowed for fashion to come one step closer to the general public.

The early 1930s saw a return to a more feminine silhouette. Waists now hit at a natural or slightly higher line, and skirts hit mid-calf or longer. Evening gowns were typically in chiffon, velvet, or satin, with a draped décolletage and the torso in a clingy and diagonally cut material. World War II brought a clothing style that was connected to utility. Clothing was simple and a variation on the theme of button dresses, flared skirts for easy movement (reaching just below the knees), waists that were well defined and belted, and short dress sleeves to save fabric. At the end of the war, Paris went to great efforts to revive its fashion trade and reestablish its leadership in this industry. The "New Look" was presented by Christian Dior, although it seemed to draw inspiration from the past. Dior lengthened skirts, padded the skirts with petticoats, rounded the shoulder line, and emphasized a tiny waist and the breasts.

The 1950s brought a return to luxury. Gowns were lavishly created with beautiful fabrics and trims. The low necklines inspired Dior to create a line of costume jewelry so women could afford to decorate their décolletage, and the breasts were firm, pointed, and

prominent. This was also a period that brought innovation with fabrics like cotton and synthetics, particularly those with stretch. By 1962, skirts were slender and had reached the mid-calf. The early 1960s saw an interesting shift to a more uninhibited style that seemed to be suited toward the youth. The miniskirt made its sensational appearance in 1965. Shorter skirts revealed the legs and brought a new prosperity to the manufacturers of underwear and tights. The 1960s and early 1970s also viewed the bra as oppressive, and some feminists accused lingerie designers of focusing on styles that reflected men's desires rather than those of women. The small-breasted, waiflike form became popular by models like England's Twiggy and the American Penelope Tree.

From this point on, fashion was being influenced and invented by middle- and working-class people, films, television, musicians, and other cultural icons. Because clothing is such an important aspect of the body, its representation, and its physicality, it can be playful and used to break rules and redefine oneself. From the late 1960s on, fashion introduced a unisex style that both sexes could wear. Skirt lengths moved up and down according to designers' whims, flamboyance and freedom were embraced, and blue jeans became a popular and standard piece in the wardrobe of both sexes. By the end of the 1970s, fashion looked to street wear and reflected increasing social unrest and unemployment issues. Clothing became aggressive and, in contrast to past standards, it was viewed as "anti-fashion" and ugly (punk style).

By the 1990s, the term "trendy" was used to describe a new style phenomenon. This contrasts the notion that "fashion" is something created by designers using high-quality and durable fabrics. "Trendy" clothing is usually worn for a short time and is not meant to be durable; rather, it is easily discarded to make room for the next "trendy" item. The breasts continue to be an aspect of the body that is emphasized in fashion. Pushup bras, halter tops, transparent fabrics, and lingerie-inspired designs all continue to focus attention on the breasts. Fashion has a long and influential part in human history. It is a visual manner of communicating one's affiliation to a group, oneself as an individual, and one's status (economically), philosophical or religious beliefs, gender, and age.

See also ADVERTISING; BEAUTY IDEALS, NINETEENTH-CENTURY AMERICA; BEAUTY IDEALS, RENAISSANCE; BEAUTY IDEALS, TWENTIETH- AND TWENTY-FIRST-CENTURY AMERICA; BRASSIERE; CORSETS; DÉCOLLETAGE; FLAPPERS; MODELS AND MODELING; UNDERGARMENTS

Further Reading

Arnold, Rebecca. *Fashion, Desire and Anxiety: Image and Morality in the 20th Century*. New Brunswick, NJ: Rutgers University Press, 2001.

Entwistle, Joanne. *The Fashioned Body: Fashion, Dress and Modern Social Theory*. Cambridge: Polity, 2000.

Rubinstein, Ruth P. *Dress Codes: Meanings and Messages in American Culture*. Boulder, CO: Westview Press, 2001.

Steele, Valerie, *The Corset: A Cultural History*. New Haven, CT: Yale University Press, 2011.

Steele, Valerie. *Fashion and Eroticism: Ideals of Feminine Beauty from the Victorian Era to the Jazz Age*. Oxford: Oxford University Press, 1985.

■ LORI L. PARKS

FEMALE ACTION HEROES

The female action hero exploded onto the screen in the 1970s blaxploitation films that directly responded to the gender and race politics of the time. The two biggest blaxploitation stars were Pam Grier, who starred in films including *Coffy* (1973), *Foxy Brown* (1974), and *Sheba, Baby* (1975); and Tamara Dobson, who starred in *Cleopatra Jones* (1973) and *Cleopatra Jones and the Casino of Gold* (1975). Both women were statuesque beauties, and their films capitalized on their breasts, both in the film narrative and in the framing of shots. Dobson and especially Grier used their breasts to both distract and seduce bad guys, repurposing the black female breast as a site of both pleasure and danger. This portrayal responded to previous racist depictions of black women in film, whose bodies were treated as the property of others; the blaxploitation hero sometimes revealed her breasts, but she did it on her terms and for her own personal gain. The success of these films led to the introduction of the female action hero on television in *Policewoman* (1974–1978) and *Charlie's Angels* (1976–1981). The television hero was white, and her breasts were no longer a site of danger; instead, the female action hero breast was recuperated as purely a site of pleasure, pandering to the male gaze in an effort to compensate for the activity the female hero was allowed to engage in.

The next surge in female action films occurred in the late 1980s and early 1990s, and it directly responded to the feminist backlash that occurred during Reaganism, the term used to describe the ideological underpinnings of Ronald Reagan's presidency (1981–1989). Part of the backlash ideology included the belief that women could achieve equality by acting like men, sometimes by adopting masculine dress and attitudes. This was made iconic in films such as *Aliens* (1986), *Terminator 2: Judgment Day* (1991), and *Silence of the Lambs* (1991). Female action hero breasts at this time were no longer sites of danger or pleasure, but rather concealed and dismissed by both the narrative and the framing of shots. These female action heroes were muscular, and their small breasts were hidden underneath loose-fitting tank tops and played no role in the success of their missions. This dismissal and minimizing of the female action hero breast indexed that there was no room for femininity in the action genre (or Reaganism), reasserting the action genre as a "male" genre.

The Girl Power female action hero is made iconic by Lara Croft (Angelina Jolie) in *Lara Croft: Tomb Raider* (2001) and *Lara Croft: Cradle of Life* (2003), and, like the new Angels in *Charlie's Angels* (2000) and *Charlie's Angels: Full Throttle* (2003), she relies on her breasts instead of her firearms. The (narrative and shot) focus on Jolie's breasts in *Tomb Raider* is so extensive that Jolie was repeatedly questioned about her breasts during interviews about the franchise. (Jolie wore a 36C bra, and her padded bra increased the size to 36D.) The Angels use their breasts—instead of weapons—to get the upper hand. Shifting the focus from violent spectacle to sexual spectacle, the focus on the breast of the Girl Power hero skews the focus from her heroics to her body, reminding us that she is primarily and ultimately a sexual object of desire, thus lessening her threat as an action hero and active woman.

See also CELEBRITY BREASTS; FEMALE SUPERHEROES; MOVIES

Further Reading

Brown, Jeffrey A. *Dangerous Curves: Action Heroines, Gender, Fetishism, and Popular Culture.* Jackson: University Press of Mississippi, 2011.

Dunn, Stephane. *Baad Bitches and Sassy Supermamas: Black Power Action Films.* Chicago: University of Illinois Press, 2008.

Holmlund, Chris. *Impossible Bodies: Femininity and Masculinity at the Movies.* New York: Routledge, 2002.

■ CRISTINA LUCIA STASIA

FEMALE SUPERHEROES

Female superheroes in comics, cartoons, and *anime* share with their male counterparts an exaggeration of the body. Whereas exaggerations of the bodily form in male characters focus on superhuman strength, for example Superman's alien superpowers or Wolverine's mutant healing factor, female characters are often portrayed with exaggerations of body parts connected to their sexuality, which is often visually displayed as exaggerated or prominently displayed breasts. This was not always the case. The original Wonder Woman, created by psychologist William Moulton Marston in 1941, was an Amazon warrior princess who fought for love, justice, peace—and equal rights for women. In 1972, *Ms.* magazine debuted with Wonder Woman on its cover. In the 1970s, Lynda Carter portrayed Wonder Woman in the TV series. Her long legs and large breasts, as well as her signature pirouette as she transformed into the superhero, made her the iconic Wonder Woman.

Mirroring the change in women's roles following World War II, the strong, independent Wonder Woman of the 1940s gave way to a more traditional woman in the postwar 1950s. During this period, psychiatrist Fredric Wertham led a sustained attack on comic books. In 1954, he published *Seduction of the Innocent,* in which he claimed that comic books were corrupting the youth of America. Among the features of the comic books that he criticized were the large, protruding breasts of the female characters. According to him, teenage boys called them "headlight comics," and they were a great source of sexual stimulation. Wertham also attacked Wonder Woman for being a lesbian, and Batman and Robin for their supposed homoerotic relationship. Though Wertham may have had good intentions, scholars have demonstrated that much of his work was based on faulty, manipulated, and falsified information.

In the 1980s, comic book characters underwent a transformation. Male characters began to sport unrealistically large muscles, thick necks, and huge chins. Female characters had enormous balloon breasts, tiny waists, and impossibly long legs. They appeared in seductive poses with their breasts or rears thrust out. In comparison to the armor and protective clothing worn by male superheroes, the costumes of female superheroes, such as those of Wonder Woman, Supergirl, She Hulk, Power Girl, and the ambiguous villain Cat Woman, exposed and emphasized their sexuality. The 1989 incarnation of the She Hulk broke the fourth wall in a postmodern fashion and often addressed the issue of scantily clad female superheroes, interacting with an assumed teenage male audience. Racially diverse female superheroes, such as Shuri, who took over her brother's mantle as the Black Panther; Storm of the X-Men; and Vixen are often hypersexualized as well as racially and sexually stereotyped. These issues are also noted in film adaptations such as

The Avengers (2012), where Scarlet Johansson as Black Widow was often depicted in more sexually suggestive poses than male counterparts.

Manga and Anime: *Manga* (comic books) and *anime* (animation) are based on Japanese warrior traditions. The hero's commitment to his or her cause is more important than success or failure. Female heroes are an important feature of *manga* and *anime*. One important character is the *miko*, a Shinto priestess. In *manga* and *anime*, they are often associated with the supernatural. Only a woman can become a *miko*, and her power comes to her through her female ancestors. They are often pictured as bare-breasted, especially when they enter battle. Although this is partially to titillate the audience, it also demonstrates the *miko's* womanhood. It is her gender that gives her power.

Some *anime* and *manga* images focus on sexualized female characters. Some cater to those attracted to underage girls, and the images are of childlike females who are erotic-cute. Sometimes they are dressed as schoolgirls. *Hentai* is the term that describes pornographic *anime*, and *bakunyū* is a subgenre that focuses on images of women with large breasts. *Bakunyū* can be translated as "exploding breasts."

Although Western animation has traditionally been seen as for a juvenile audience, Tex Avery's "Red Hot Riding Hood" created humor from a character's exaggerated reaction to breasts; the 1970s animations of Ralph Bakshi included overtly sexual representation of female characters; and the depiction of Jessica Rabbit in *Who Framed Roger Rabbit?* (1986) also alluded to her breasts.

See also ADVERTISING; BARBIE DOLLS; FEMALE ACTION HEROES; MOVIES

Further Reading

Bukatman, Scott. "X-Bodies (the Torment of the Mutant Superheroes)." In *Uncontrollable Bodies: Testimonies of Identity and Culture*, edited by Rodney Sappington and Tyler Stallings, 92–129. Seattle, WA: Bay Press, 1996.

Inness, Sherrie A. *Action Chicks. New Images of Tough Women in Popular Culture*. New York: Palgrave, 2004.

Guevara-Flanagan, Kristy, dir. *Wonder Women! The Untold Story of American Superheroines* [documentary]. *Independent Lens*, PBS, first aired March 1, 2013.

Robinson, Lillian S. *Wonder Women: Feminisms and Superheroes*. New York: Routledge, 2008.

Wright, Bradford C. *Comic Book Nation: Transformation of Youth Culture in America*. Baltimore: Johns Hopkins University Press, 2001.

■ LORCAN MCGRANE AND MERRIL D. SMITH

FEMINISM

Feminism takes a critical stance against many of the current cultural hypostases of the breast, especially within the Western area. However, there are many nuances to feminist criticism, which are sometimes contradictory. This is due to rapid transformations in the meanings of events such as abortion and bra usage in recent history, as well as to their complex, deeply interpretable nature, which makes one talk in terms of *feminisms* rather than feminism.

Currently, much of feminist criticism takes into account the process of how breasts should be confined, shaped, and covered. If the feminist movements of the 1960s

campaigned against the bra, as it restricted the free movement of the breast (although it was a relative improvement compared to the Victorian corset), causing discomfort in order to align to the standards of beauty, later feminists had to change their attitude. The bra has become a central component of fashion and of a woman's daily life, while bra producers have become increasingly aware of the needs of women, improving and creating several types of bras that women can wear for varied activities such as for breastfeeding and sports, and for women who have had mastectomies. While the bra as an item of female clothing has become common and its usage normal, if not even mandatory, another issue that raises feminist debates is the plastic surgery of the breast.

The correct-incorrect criterion according to which breasts used to be judged against a beauty ideal is now replaced by the healthy-ill criterion. Feminists have highlighted how small and normal breasts—and, more rarely, very large breasts—are regarded as a disease, and they have further shown that this process is due to an unequal division of power, as doctors have been mostly men, but the plastic surgery patients are mostly women. Science in general and medicine in particular have fervently been accused of androcentrism. Thus, feminists have argued that women must regain possession of their bodies, regardless if it is about contraception, abortion, assisted human reproduction, or breast surgery. But this taking into possession has been understood differently, depending on various ideas about feminism. Critics of cosmetic breast augmentation, especially of the use of silicone implants, have argued significantly that such breast surgery may increase the risk of cancer, and that it forces women to align to abusive standards of beauty that are generated and promoted by misogynistic attitudes. Feminist scholar Sheila Jeffreys, for example, believes that the decision to undergo a cosmetic breast surgery is never an individual choice, rooted in what the woman feels, but it is triggered by cultural pressure, which identifies breasts as a fundamental attribute of femininity and postulates certain characteristics of shape and size. Thus, Jeffreys believes cosmetic surgery is a veiled form of violence against women. Feminists who believe that women have the right to adjust their body according to their ideals have regarded the medicalization of the female body and breasts as a means through which women can surpass depression and unhappiness. They argue that plastic surgery gives women the chance to finally regain their bodies, contributing to general female empowerment. Moreover, pro-surgery militants claim vigilance against the attempt of some Western policies to limit or condition the access of women to breast augmentation, believing that every woman must have the first and the last word on her body.

Controlling the shape and size of breasts through undergarments or cosmetic surgery is an effect of the broader cultural paradigm of the eroticized breast. Feminist criticism has been virulent over the extreme eroticization of the breast, and the differences of opinion are fewer here. There seems to be a general agreement: within the Western world, promoted by the stereotypes of the mass media, the breast became an erotic fetish with pornographic nuances, through which women are reduced to the status of sex objects. The much-desired unleashed body in early feminism took a false turn in the contemporary era: although a woman can do much more with her body, society imposes a new set of rules on how a woman should "own" her body.

Exasperated by the artificialization of the breast and its instrumentation in the benefit of industries that perpetuate gender differences, many feminists have identified in the maternal breast an opportunity to retrieve naturalness. Breastfeeding is the expression

of that naturalness, and it marks, according to feminists, a breaking with medical science and the dairy industry, which, by perfecting the milk powder formula, caused an increase in the bottle-feeding trend. Yet the de-medicalization of the maternal breast raises other issues. Powerful organizations such as La Leche League International (which had Catholic founders) and UNICEF treat motherhood only in terms of its natural aspect, ignoring its culturally constructed character and putting pressure on women. There is an intractable conflict between their militancy and the socioeconomic situation of women as they are increasingly involved in working outside their homes. For example, Massimo de Angelis, a left-wing feminist, has denounced the injustice of the capitalist system, which, although it needs a woman's reproductive labor, does not recognize and does not remunerate her. On the other hand, Judith Warner believes that the naturalistic approach to motherhood overstrains women in their role as mothers and exempts fathers from responsibility.

The diversity in feminist criticism of the cultural representations of the breast continues to challenge the association between women and any simplified cultural meaning of the breast.

See also BEAUTY IDEALS, TWENTIETH- AND TWENTY-FIRST-CENTURY AMERICA; BRA BURNING; BRASSIERE; BREAST AUGMENTATION; MEDIA; PORNOGRAPHY; RECONSTRUCTIVE SURGERY; WOMEN'S MOVEMENT

Further Reading

Davis, Kathy. *Reshaping the Female Body: The Dilemma of Cosmetic Surgery.* New York: Routledge, 1995.

De Angelis, Massimo. "Production and Reproduction." In *The Beginning of History: Value Struggles and Global Capital.* London: Pluto Press, 2007.

Dugdale, Anni. "Beyond Relativism: Moving On—Feminist Struggles with Scientific/Medical Knowledges." *Australian Feminist Studies* 5, no. 12 (1990): 51–63.

Jeffreys, Sheila. *Beauty and Misogyny: Harmful Cultural Practices in the West.* New York: Routledge, 2005.

Pitts-Taylor, Victoria, ed. *Cultural Encyclopedia of the Body.* Westport, CT: Greenwood, 2008.

Warner, Judith. *Perfect Madness: Motherhood in the Age of Anxiety.* New York: Riverhead Trade, 2006.

■ ADRIANA TEODORESCU

FERTILITY SYMBOLS

The fertility of women, game animals, livestock, and agricultural land was of utmost importance for the continuity of prehistoric and ancient cultural groups. These groups therefore addressed fertility in their religious myths, ceremonies, and rituals. Symbols were created to communicate concepts, stories, ideals and values, and realities related to fertility, and these symbols may have had religious or ritual significance.

Across thousands and thousands of years, figurines meant to symbolize fertility in women were created from clay, stone, bone, and ivory. Such figurines, frequently called Venus figurines, have been found throughout Europe and Eurasia. Many are shaped like pregnant or lactating women—with enlarged breasts and bellies. These figurines may have been viewed as goddesses, or as magical or sacred objects that could promote and protect fertility and even the ability to lactate.

To prehistoric and ancient people, a high amount of body fat would have indicated that a person had consistent access to highly nutritious food sources. But since such access was generally limited, few people would have had much body fat. Women with high amounts of body fat could have survived and breastfed their children much longer during times of famine than those without high amounts. For women, fat bodies would therefore have been viewed as optimal. Thus, Venus figurines with fat breasts, bellies, and buttocks could have represented an ideal woman—fertile, able to breastfeed, and able to survive harsh conditions.

One of the most famous of these figurines is the Venus of Willendorf, discovered in Austria in 1908. This obese-looking Stone Age female figurine carved from limestone has a head but no face, and therefore represents the fertile woman in general. The lack of a face is a feature shared by many Venus figurines. The Venus of Willendorf's hair is detailed, as are her breasts and vulva, and she appears to have originally been covered in red ochre—a natural pigment—which may have symbolized menstrual blood or blood from childbirth.

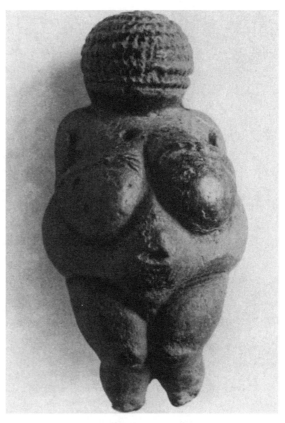

Because of its exaggerated breasts, buttocks, vulva, and belly, scholars believe the faceless "Venus of Willendorf" may have been used as a fertility goddess. It is estimated that the limestone statuette was carved sometime between 28,000 and 25,000 BCE. Photos.com/Thinkstock by Getty

Other figurines and images of women with breasts bared are known to depict specific goddesses from the past. For example, clay idols of Astarte, a fertility goddess worshipped from the Bronze Age through Classical times in the Eastern Mediterranean, were shaped as women holding up their breasts with their hands, seemingly offering the breasts to the viewer. Another example is Artemis, the ancient mother goddess of the Greek Ephesians who was petitioned for support and protection. She was viewed as a patroness of fertility, childbirth, and the ability to breastfeed. Two famous life-sized statues of Artemis of Ephesus, from the first and second centuries CE, appear to depict a many-breasted goddess who was abundantly able to nourish all creatures. More than 20 udder-like globes dangle from her chest. Although many scholars interpret these globes instead as eggs or the testicles of ritually sacrificed bulls—both symbolizing fertility—later versions of Artemis of Ephesus clearly show the goddess breastfeeding children from them.

Female breasts were sometimes associated with a male deity who controlled an aspect of fertility in a culture. An example is the ancient Egyptians' male Nile River god, Hapi, who was portrayed with a bearded chin, female breasts, and a large belly. This beneficial god was believed to annually overflow the otherwise parched desert banks of the Nile. Thus, he fertilized the land alongside the river with rich river sediment and irrigated it, making it perfect for growing enough crops to sustain an entire civilization.

At some prehistoric sites, objects depicting women's breasts only—no bodies associated—have been discovered. At a Neolithic village in Switzerland, for example, a pair of breasts carved out of a set of antlers was found. In Turkey, the walls of a Neolithic religious shrine had clay breasts plastered onto them. And Iron Age vases decorated with breasts have been uncovered in Germany. The meaning of such objects is uncertain.

Scholars have many interpretations of prehistoric and ancient art that shows women's breasts, but in general they believe the art is related to fertility. Some objects created during those timeframes were clearly worshipped as fertility deities, while others may simply have been a celebration of fertility, or may have been used in religious ways to protect or enhance fertility. Fertility-related art has continued to be created post antiquity, but preoccupation with it has decreased as modernization has increased. Since today's modern societies have scientific methods for enhancing and controlling fertility, there is very little need among their peoples for fertility-related art.

See also ART, INDIAN AND AFRICAN; ART, WESTERN; KOUROTROPHOS CULTS; MYTHOLOGY; PREGNANCY; RELIGION; SCULPTURE; VIRGIN MARY

Further Reading

Rudgley, Richard. *The Lost Civilizations of the Stone Age.* New York: Simon & Schuster, 2000.
Taylor, Timothy. *The Prehistory of Sex: Four Million Years of Human Sexual Culture.* New York: Bantam, 1997.
Yalom, Marilyn. *A History of the Breast.* New York: Knopf, 1997.

■ ELIZABETH JENNER

FLAPPERS

Flapper girls symbolized popular culture during the Roaring Twenties, a decade characterized by postwar malaise, a booming economy, jazz, and Prohibition. As young, unattached women experienced a sharp increase in their freedom of speech and movement, they developed an individualism no longer defined by family, marriage, or children.

Although originally a British term for young birds flapping their wings and learning to fly, it also came to refer to the style of wearing unfastened galoshes that flapped. The most famous flappers were French fashion designer Coco Chanel, silent film star Clara Bow, and cartoon character Betty Boop. Who were these flappers? As the popular writer H. L. Mencken exclaimed in 1915, "She is youth, she is hope, she is romance."

Not one single type or style, flappers exhibited a range of unconventional behaviors. Many of them drank alcohol, smoked in public, sunbathed, and danced to the Charleston.

This woman models a 1920s flapper-inspired gown. She is uncorseted and flat-chested, and has no discernable waistline. The image is of a woman who is youthful and unbound from confining undergarments and social conventions. *Evening Gown in All Its Splendor*, c. 1921. Gown by Lucile. LC-USZ62-100835; courtesy of the Library of Congress

They cut their hair short into a "bob." A rapid expansion of the beauty industry accompanied an increased use of makeup. They also showed much more skin than previous iterations of women, with shorter skirts, sheer stockings, bared arms, and the occasional exposed leg. This sexual revolution included necking and petting, too.

Flappers represented youthful rebellion by women who rejected the styles and stereotypes of their mothers. They replaced the Gibson Girl style of their mothers, which had accentuated curves with a large bosom and wide hips separated by a tiny corset-bounded waist. They were slender with flat chests and hips, not full-figured. Flapper fashions deemphasized large breasts and the curvaceous figure in favor of flat chests and straight dresses that minimized the bust line, waist, and hips. Smaller breasts became popular and associated with a youthful appearance. The style began with teenagers, but many older women soon adopted it.

Flappers often wore strapless brassieres known as bandeaux that covered the breasts and bound them downward. The cloth was fastened to the corset and held the breasts downward. Some of these bras were merely covers and did not offer support. This resulted in a straight and slim look with minimal breast definition. They wore a new style of slimmer corsets that went over the hips and not the chest.

The flapper style mirrored women's expanding economic role. The First World War brought women into areas and occupations that were previously the domain of men,

so loose-fitting clothes and bandeaux covering the bust befitted an active lifestyle and enabled women to work more comfortably. Although the bandeaux cloth covering the breasts had replaced the full-length stiff corsets of previous decades, they soon evolved into the modern iteration of the brassiere with shoulder straps and well-defined breasts of varying sizes, including the introduction of cup sizes. Larger bust lines came back into style with the development of the modern bra, often worn with a girdle.

The stock market crash of 1929 followed by the Great Depression ended this era of sexual rebellion. The flappers' carefree, almost hedonistic lifestyle could no longer be sustained. They had challenged the religious and cultural roles of women and planted the seeds for future generations to expand their boundaries. Intriguing to many, their behavior and style were still too risqué for most women to adopt, yet this youthful counterculture foreshadowed the modern independent woman.

See also BEAUTY IDEALS, TWENTIETH- AND TWENTY-FIRST-CENTURY AMERICA; BRASSIERE; CORSETS; FASHION

Further Reading

Fitzgerald, F. Scott. *Flappers and Philosophers*. New York: Vintage Books, 2009 [1920].

Hix, Lisa. "'The Great Gatsby' Still Gets Flappers Wrong." *Collectors Weekly*, May 3, 2013. Retrieved October 30, 2013, from http://www.collectorsweekly.com/articles/the-great-gatsby-still-gets-flappers-wrong

Johnson, Russell L. "Flappers." American History for Australasian Schools. Retrieved September 14, 2012, from http://www.anzasa.arts.usyd.edu.au/ahas/flappers_overview.html

Mencken, Henry L. "The Flapper." *The Smart Set: A Magazine of Cleverness*, February 1915, pp. 1–2.

Zeitz, Joshua. *Flapper: A Madcap Story of Sex, Style, Celebrity, and the Women Who Made America Modern*. New York: Broadway Books, 2007.

■ MATHEW WILSON

FLASHING

Flashing is a type of indecent exposure or exhibitionism. It involves a momentary display of the breasts, buttocks, or genitals, with the breasts being the most common body part revealed. Typically, women expose their breasts by quickly lifting and lowering their shirt, bra, or swimsuit top, giving a brief flash of bare skin. In the United States, flashing is often done for the enjoyment of spectators in public locations and gatherings, such as festivals, parades, and sporting events.

This kind of display is generally not considered to be a pathological or psychosexual disorder, nor is it regarded as threatening to others. On the contrary, flashing is often seen as good-natured and fun. As a rule, flashing is provocative and titillating rather than aggressive in intention. Women who flash may do so for a number of reasons: to draw the attention of onlookers, to solicit vocal confirmation of their own attractiveness, for shock value, or to invite sexual attention from members of the opposite sex.

As a cultural phenomenon, flashing has roots in collegiate party culture. Spring Break is one such protracted period of intense partying. There are often tens of thousands of young adults gathered together, engaging in binge drinking and wearing little more than

their swimwear. Inhibitions are lowered, and an atmosphere of sexual permissiveness abounds. The same is true for the raucous Mardi Gras celebrations that take place in the French Quarter of New Orleans, Louisiana.

Where the act of flashing is institutionalized, as during Mardi Gras, there may be an item of negligible value offered by onlookers in exchange for the act of flashing, such as a string of beads. Items distributed by the *Girls Gone Wild* franchise in exchange for flashing are typically minimal as well, ranging from trucker hats to T-shirts and tank tops. The incentives themselves offer little reason for women to engage in flashing, pointing to a more complex reason than a simple profit motive. In interviews, women have articulated the idea that the *Girls Gone Wild* franchise is an access point to celebrity and stardom. Popular culture provides plenty of examples of fame gained through similar avenues: by nude modeling, reality television, online video blogging, and the leaking of sex tapes.

There can be a darker side to the act of flashing, especially when extreme intoxication or coercion is involved. At public events, women may feel pressure to expose themselves or risk being accused of prudishness. Still others may find themselves faced with long-ranging consequences by being caught on camera. Their likenesses may be used for advertising or in promotions without further remuneration to the women involved. Joe Francis, the CEO of *Girls Gone Wild*, has been involved in numerous lawsuits where the plaintiffs sought damages for use of their images on video boxes and advertisements. Despite these legal troubles, the phenomenon of flashing shows no signs of abating anytime soon.

See also MEDIA; TOPLESS BEACHES; WET T-SHIRT CONTESTS

Further Reading

Hoffman, Claire. "Joe Francis: 'Baby, Give Me a Kiss.'" *Los Angeles Times*, August 6, 2006. Retrieved January 9, 2013, from http://www.latimes.com/features/la-tm-gonewild32aug06,0,6367343.story#axzz2jECpm1w0

Levy, Ariel. *Female Chauvinist Pigs: Women and the Rise of Raunch Culture*. New York: Free Press, 2005.

Navarro, Mireya. "The Very Long Legs of 'Girls Gone Wild.'" *New York Times*, April 4, 2004. Retrieved January 6, 2013, from http://www.nytimes.com/2004/04/04/style/the-very-long-legs-of-girls-gone-wild.html?pagewanted=all&src=pm

■ ERIN PAPPAS

FOLIES BERGÈRE

The Folies Bergère music hall popularized modern burlesque shows to a growing urban culture in Paris, France. Colorful and kitschy, its reputation and format spread and spawned many imitators from the Moulin Rouge to Las Vegas showgirls. It defied conventional morality and became famous for its nudity in an era of Victorian modesty. Bare breasts and thighs were displayed, if only as part of an extravagant song-and-dance routine. The new attitude epitomized the French *joie de vivre* from the Belle Époque to the Roaring Twenties (1880s–1920s). It appealed to a diverse group of Parisians during an era in which most socioeconomic classes kept their distance and had their own forms of entertainment. The hall featured many famous performers over the years, from Maurice Chevalier to Charlie

Chaplin and from Ella Fitzgerald to Benny Hill.

Opening on May 2, 1869, as the Folies Trévise in Paris, it rebranded itself as the Folies Bergère in 1872 because the Duc de Trévise wanted his named disassociated with the hall's obnoxious reputation. *Folies* derives from the Latin term for "leaves," implying "fields." The term *folie* also means "folly," and its use indicated a "house of pleasures." *Bergère* refers to a neighborhood street. Originally, the Folies Bergère resembled a contemporary gentlemen's club where patrons could sit at a table, drink, smoke, and socialize. The famous 1882 impressionistic painting by Édouard Manet, *A Bar at the Folies-Bergère*, contrasts a sullen barmaid with a display of libations and a festive crowd. Presumably a prostitute, she stands alone and separate from the crowded hall reflected in the large mirror behind her. According to legend, prostitutes frequented the bar, and many even worked there.

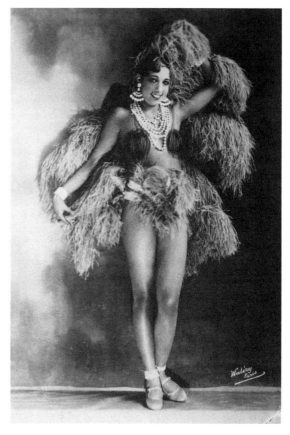

Josephine Baker in an exotic and revealing costume at the Folies Bergère, Paris, c. 1925–1930. CCI/The Art Archive at Art Resource, NY

Comedy and musical acts dominated the performances, as did circus shows featuring animals and acrobats. Despite this variety, sensual routines have always typified the Folies, specifically cabaret and striptease. Prior to 1867, restrictions on public nudity, erotic dancing, and revealing costumes had prevented risqué performances, yet nudity and sumptuous costumes would come to symbolize the Folies. Alluring advertising and lavish revues prevailed over the humbler acts while beautiful dancing girls became the centerpiece of the shows. Their costumes often included feather plumes, headdresses, corsets, or flowing gowns. Women walked through the hall, enticing men with their brightly colored makeup, large smiles, floral perfumes, and tight blouses. Their raw sexuality could not be outdone in those days.

Paul Derval took control in 1918 and enlarged the shows while showcasing celebrities and, most importantly, increasing the amount of nudity. His *petites femmes nues*, or "small naked women," became the centerpiece of his grandiose productions. He also used the new inventions of colored lights with projectors and mirrors to illuminate the female figure and mesmerize the crowd. In 1926, Derval presented Josephine Baker, known as the Black Pearl, who epitomized the Jazz Age in Paris. The black American began performing

exotic African-inspired routines with little clothing, most famously with only a skirt made from fake bananas. Baker's silly costumes and shows were never authentic, but were meant to make the audience laugh while they ogled the erotic movements of her *danse sauvage*. Later, she received the French Legion of Honor for her help during the Second World War, because she had served in the Red Cross and had performed for troops at a time when many French celebrities were afraid to do so.

Today, the Folies Bergère continues to entertain Parisians and tourists with concerts. Although it remains a Parisian institution and a cultural icon for grand revues, its glamour and originality have faded. A Western culture accustomed to hedonism has replaced Victorian values, and nudity is no longer a novelty. The Folies Bergère has lost its monopoly on public sexual performances, but its influence in the revolution of sexual mores lives on.

See also DANCE; PASTIES; PROSTITUTION; STRIPTEASE; TOPLESS DANCING

Further Reading

Castle, Charles. *Folies Bergère*. Manchester, NH: Franklin Watts, 1985.
Folies Bergere. Retrieved May 31, 2014, from http://www.foliesbergere.com
Jules-Rosette, Bennetta. *Josephine Baker in Art and Life: The Icon and the Image*. Champaign: University of Illinois Press, 2007.

■ MATHEW WILSON

FREDERICK'S OF HOLLYWOOD

Best known as the originator of the pushup bra and the "dream corset," Frederick Mellinger changed how American women thought about their bodies and undergarments when he opened Frederick's of Hollywood (c. 1947). Despite changes in trends and shifting perceptions of the brand, Frederick's continues to be one of the most recognized lingerie brands in the world.

Mellinger was inspired to open Frederick's upon his return from participation in World War II for three reasons: (1) recent exposure to radically different mid-twentieth-century European lingerie conventions, (2) the scarcity of such undergarments in the United States, and (3) his GI buddies thought their girlfriends would appreciate these daring styles as much as they did. Mellinger was right in his longheld assumption that "sex appeal is always in style"—and the real aim of Frederick's was to enhance a woman's best body parts, especially her breasts. Mellinger became well known as a purveyor in black undergarments when most manufacturers supplied only white. Frederick's became an instant hit in Hollywood, increasingly known as *the* place to purchase unique and eye-popping lingerie. Known for pushup bras and the dream corset, Frederick's expanded its line through the 1950s and 1960s to include shoes, wigs, and eveningwear. Through the 1970s, 1980s, and 1990s, the brand continued to push the envelope beyond what was considered merely provocative. The American public increasingly associated Frederick's with crotch-less panties, sexy costumes, and barely-there shelf bras.

Declining revenues over the 1980s and 1990s resulted in the brand filing for bankruptcy in 2001. Despite financial upsets and subsequent business mergers, however,

Frederick's survives to this day. Rebranding has been ongoing for some time, and these efforts seek to restore the popular image of Frederick's in line with the heritage of quality and class that originally made the brand a household name 70 years ago. Past Frederick's models include Betty Page, Pamela Anderson, and Brooke Burke-Charvet.

See also BRASSIERE; CORSETS; FASHION; JACOB, MARY PHELPS; MAIDENFORM; MODELS AND MODELING

Further Reading

Kazickas, Jurate. "Frederick's Philosophy: Women Dress for Men, Men like Sexy Women." *Free Lance-Star*, October 10, 1973, p. 9. Retrieved May 14, 2014, from http://news.google.com/newspapers?id=2ftNAAAAIBAJ&sjid=o4sDAAAAIBAJ&dq=frederick's%20of%20hollywood&pg=7130%2C1259290

Mydans, Seth. "After the Riots: Confessions of a Star-Struck Looter." *New York Times*, May 6, 1992. Retrieved May 14, 2014, from http://www.nytimes.com/1992/05/06/us/after-the-riots-confessions-of-a-star-struck-looter.html

■ STEPHANIE LAINE HAMILTON

FREUD, SIGMUND (1856–1939)

Sigmund Freud is considered the founding father of modern psychoanalysis. His theory of development divided human sexuality into five distinct stages: oral, anal, phallic, latent, and genital. These diffuse drives form the libido, which initially lacks structure. A particular form of the libidinal drive characterizes each of these stages, although they may overlap in terms of duration.

According to Freud, the mother's breast plays a crucial role in the oral stage of psychological sexual development. He considered her approach to feeding foundational in the development of the child's ego and superego. Similarly, an infant experiences both the termination of feeding and the process of weaning as punishments. These are thus the first experiences of social rules, however nebulous.

The oral stage, in Freud's typology, spans a time period from birth until approximately 2 years of age. During this time, the child interacts with the outside world by breastfeeding, thumb-sucking, and placing objects in the mouth indiscriminately. Of these, the mother's breast is the most natural and effectual object for satiating the oral libidinal impulse. Within this framework, Freud postulated that the prototype for all subsequent sexual gratification could be found in the act of breastfeeding. Similarly, the pleasure inherent in the activity of sucking could itself be detached from the need for nourishment, as when an infant sucks its thumb or a dummy object.

In a more complex process, desire for the breast may also be displaced onto the mother, which turns her into the child's first love object. Lastly, the mother generally, and her breast specifically, serve as organizing objects for the Oedipal complex. In these later stages of sexual development, the breast and especially the nipple take on an erotic charge precisely because of their forbidden or taboo status.

See also KLEIN, MELANIE REIZES (1882–1960)

Further Reading

Felluga, Dino. "Modules on Freud: On Psychosexual Development." In *Introductory Guide to Critical Theory*. January 31. West Lafayette, IN: Purdue University, 2011. Retrieved December 15, 2012, from http://www.purdue.edu/guidetotheory/psychoanalysis/freud.html

Freud, Sigmund. *Introductory Lectures on Psycho-analysis*, edited by James Strachey. New York: W. W. Norton, 1989.

Freud, Sigmund. *On Sexuality: Three Essays on the Theory of Sexuality*. London: Penguin, 1991.

■ ERIN PAPPAS

G

GENDER AFFIRMATION SURGERY

Gender affirmation surgery is also called gender alignment surgery or gender-confirming surgery. Terms such as sex reassignment surgery and gender reassignment surgery are increasingly considered to be archaic and inaccurate, as they imply that surgical status determines someone's authentic sex or gender. In contrast, terms such as gender affirmation surgery and other more recent terms are derived from an understanding that people's knowledge about their gender prior to any surgical intervention motivates them to seek surgery, but that surgical status and anatomical configuration do not determine authenticity.

People who were assigned as "female" at birth may seek more conventionally male bodies through surgery, whereas people who were assigned as "male" at birth may seek more conventionally female bodies through surgery. However, surgery and hormone replacement therapy are not pursued by everyone due to personal preference, medical conditions, religious beliefs, and/or gatekeeping and access issues. Some people who seek gender affirmation surgery do not identify as women or men and may wish to align their bodies with their nonbinary identity. Some such people who wish to have bodies closer to a conventional female configuration identify as "transfeminine" but not as women. Similarly, some people who wish to have bodies closer to a conventional male configuration identify as "transmasculine" but not as men. Some intersex people seek gender affirmation surgery to correct the effects of "normalizing" surgeries to which they were involuntarily or coercively subjected as infants, adolescents, or adults. Distinct surgical techniques are needed to address the specific needs of these different constituencies, and they are likely to use distinct terms to describe their surgical experiences. Although some medical systems attempt to impose a rigid order of medical intervention, a wide variety of pathways through gender affirmation have been documented in clinical and research literature. This includes accounts of people who report having undergone successful gender affirmation surgeries prior to going on hormones or living their public lives fully in their affirmed gender.

Men and Transmasculine People: Men who were assigned as female at birth and transmasculine people may take testosterone, which causes masculinization of the body, including body and facial hair growth, fat redistribution, enlarged genital tissue, and breast tissue atrophy. Among these men and transmasculine people, genital surgery is usually called

bottom surgery or lower surgery. Various forms of bottom surgery can involve removal of the gonads, uterus, and vagina; metoidioplasty (lengthening of the external genital tissue by releasing the suspensory ligament and lengthening the urethra); and/or phalloplasty (construction of a new penis). Many men and transmasculine people refer to their external genital tissue as their phallus or penis, regardless of whether they have had bottom surgery. Such men and transmasculine people have created sexual cultures that use terms associated with stereotypically male bodies, such as "cock" or "dick," instead of "clit" or "clitoris." Surgery to remove breast tissue is usually called chest surgery or top surgery. Male chest reconstruction is distinct from breast reduction surgery and mastectomy. Male chest reconstruction involves tissue contouring and other techniques to create a typically "male" chest structure, elements that make it distinct from breast reduction surgery or mastectomy. Most men have top surgery prior to any lower surgery, and some even have top surgery prior to taking testosterone. For some men who were assigned as female, top surgery is an essential precursor to being able to live safely in public as a man.

Some surgeons require candidates for male chest reconstruction to consent to multiple surgeries that include a full hysterectomy and possibly further genital surgeries in a single continuous session. Benefits include not having to undergo multiple surgeries. However, this results in a long surgery that will incapacitate the man for a longer time. The practice of conducting multiple surgeries can increase recovery time, the risk of blood clots, and the risk of anesthesia-related surgical complications. Additionally, ethical and human rights concerns have been raised regarding the coercive nature of this surgical requirement.

Although some surgeons require patients who were not assigned as male at birth to stop testosterone in the period prior to surgery on the grounds that testosterone reduces blood clotting, this instruction is increasingly considered negligent. The abrupt cessation of hormones carries numerous risks to the patient, including severe mental health consequences and immunosuppression. Testosterone levels in these patients are comparable to those of the general male population, and the logic behind the recommendation would thus imply that nobody with functional testes should ever have surgery. The instruction to cease hormones prior to surgery is one form of medical discrimination against patients who seek gender affirmation surgeries.

Women and Transfeminine People: Women who were assigned as male at birth and transfeminine people may take estrogen and progesterone, which cause feminization of the body, including softer skin, fat redistribution, and breast growth. They may also take additional medications, such as spironolactone, to promote breast growth or suppress androgens. Spironolactone is a competitive antagonist of the aldosterone receptor, which gives it antiandrogenic effects as well as some weak progesteronic and estrogenic effects, promoting breast growth.

Breast growth is often satisfactory with well-controlled hormone replacement therapy. However, for those who are unable to achieve their desired breast growth, some do opt to undergo breast enlargement surgery using silicone or saline implants. Some people seek one or more forms of facial feminization surgeries. Genital surgery typically involves orchiectomy (removal of the gonads) and vaginoplasty. Vaginoplasty involves construction of a neovagina either from the large bowel or by inverting the soft tissue of the penis. Erectile tissue is trimmed to form a new clitoris. The neovagina will require daily dilation for several months, with regular lifelong dilation necessary to retain vaginal depth

and vaginal wall integrity. The gonads are removed either at the time of surgery or prior to surgery. Removing the gonads causes the erectile tissue, and thus the skin, to shrink, which can result in less depth if the inversion technique is used. However, if the surgical candidate lacks the funds for a large operation, removing the gonads first can reduce her need for synthetic hormones and androgen blockers and make women's clothing more comfortable.

There has been enduring controversy over whether estrogen should be stopped prior to surgery to decrease the chance of deep venous thrombosis (DVT). When making recommendations to patients, surgeons should conduct a balanced assessment of risks and benefits that considers both individual risk factors for DVT and likely adverse effects of stopping estrogen treatment. As is the case for testosterone cessation, abrupt cessation of estrogen can have detrimental effects on mental health, blood cell counts, and the immune system.

See also BREAST AUGMENTATION; BREAST REDUCTION; HORMONES; INTERSEX; MASTECTOMY AND LUMPECTOMY; PUBERTY; TRANSGENDER/TRANSSEXUAL

Further Reading

Ainsworth, Tiffiny A., and Jeffrey H. Spiegel. "Quality of Life of Individuals with and without Facial Feminization Surgery or Gender Reassignment Surgery." *Quality of Life Research* 19, no. 7 (2010): 1019–1024.

Allison, Rebecca. "Aligning Bodies with Minds: The Case for Medical and Surgical Treatment of Gender Dysphoria." *Journal of Gay & Lesbian Mental Health* 14, no. 2 (2010): 139–144.

Berry, M. G., Richard Curtis, and Dai Davies. "Female-to-Male Transgender Chest Reconstruction: A Large Consecutive, Single-Surgeon Experience." *Journal of Plastic, Reconstructive & Aesthetic Surgery* 65, no. 6 (2012): 711–719.

Rachlin, Katherine, Griffin Hansbury, and Seth T. Pardo. "Hysterectomy and Oophorectomy Experiences of Female-to-Male Transgender Individuals." *International Journal of Transgenderism* 12, no. 3 (2010): 155–166.

Spade, Dean, Gabriel Arkles, Phil Duran, and Pooja Gehi. "Medicaid Policy & Gender-Confirming Healthcare for Trans People: An Interview with Advocates." *Seattle Journal of Social Justice* 8 (2009): 497.

Thomas, James P., and Cody MacMillan. "Feminization Laryngoplasty: Assessment of Surgical Pitch Elevation." *European Archives of Oto-Rhino-Laryngology* (2013): 1–6.

Weyers, Steven, Petra De Sutter, Piet Hoebeke, Stan Monstrey, Guy T'Sjoen, Hans Verstraelen, and Jan Gerris. "Gynaecological Aspects of the Treatment and Follow-Up of Transsexual Men and Women." *Facts, Views & Vision in ObGyn* 2, no. 1 (2010): 35–54.

■ Y. GAVRIEL ANSARA AND ISRAEL BERGER

GYNECOMASTIA

Gynecomastia is a medical term for the benign growth of glandular breast tissue in people who are medically classified as male. The term gynecomastia comes from the Greek word for woman or feminine and *mastos*, meaning "breast." The first use of this term dates back to the second-century CE Greek-born Roman physician and philosopher Galen. However, Galen's use differed from that of modern medicine because he used gynaecomastia

to describe an abnormal increase in fat in a male breast and considered an increase in glandular tissue as a different condition.

Gynecomastia is frequently misused in popular media to describe pseudo-gyneco-mastia, the medical term for benign growth of adipose (fatty) breast tissue. Although the concept of gynecomastia as a medical condition is widely accepted in many parts of the world, the concept of gynecomastia contains a number of cultural assumptions about what constitutes a healthy male body and overlooks cross-cultural variations in physical norms.

According to medical research, at least one-third of men will experience gynecomastia during their lifetime. As in people classified as female, breast development in males may be a hereditary trait. In such cases, gynecomastia typically occurs as a result of hormonal changes associated with puberty. Naturally occurring gynecomastia rates also vary substantially across cultures. Gynecomastia can result from a variety of natural physical variations, such as aging and puberty, and from a variety of internal and external stimuli, such as malnutrition, prescribed medications, or street drugs. Although gynecomastia is typically benign, it can in some cases be a sign of breast cancer; an adrenal, pituitary, or testicular tumor; hyperthyroidism (overproduction of thyroxine by the thyroid gland); or kidney or liver failure. Gynecomastia can also be associated with an XXY or 47XXY karyotype (the number and appearance of chromosomes).

The leading external cause of gynecomastia is anabolic steroids. Gynecomastia is common among competitive athletes who use performance-enhancing steroids. Overuse of testosterone leads to the conversion of excess testosterone into estrogen. This conversion process is called aromatization. In bodybuilding communities, gynecomastia is often described using the pejorative term "bitch tits," a term that conveys a misogynistic disdain for anatomical characteristics associated with bodies classified as female and suggests anxiety about the potential similarities between bodies that are often constructed as "opposites." The term "moobs," a portmanteau of the words "man" and "boobs," has also become a popular term to describe breast tissue in males.

Historical evidence documents the presence in the ancient world of what modern medicine would label as gynecomastia, such as in statues of Pharaoh Seti I and in the writings of Aristotle. The earliest evidence of surgical intervention to remove "excess" male breast tissue is found in writings by Paulus of Aegineta (640–690 CE). Islamic surgeon Al-Zahrawi or Albucasis (936–1013 CE) detailed his own surgical methods for dealing with gynecomastia in the Muslim medical text *A-Tasrif*. Modern surgical interventions often involve the removal of glandular breast tissue in gynecomastia by using variations of liposuction and peri-aeriolar or "keyhole" surgery for tissue excision.

Gynecomastia has featured as a plot thread in popular television shows. For example, in "The Doorman," the 104th episode of the U.S. television series *Seinfeld* on NBC, the entrepreneurial character Kramer invents "a support undergarment specifically designed for men." Highlighting cultural anxiety about potential similarities between female and male bodies, Kramer asserts that "a bra is for ladies. Meet the bro." When Kramer discusses his idea with his friend George's father, Frank Costanza, Mr. Costanza suggests that the new men's undergarment be called the manssiere, a play on the word brassiere. In this episode, George and Mr. Costanza pitch their idea for marketing this undergarment to

bra salesman Sid Farkus. The episode's premise relies on the assumption by the writers and the characters that men's gynecomastia undergarments do not already exist. Despite this premise, the invention of the manssiere or bro was unnecessary given the already thriving men's gynecomastia undergarment industry in the United States. The terms most commonly used to describe the undergarments in this industry are "gynecomastia vest" and "compression shirt." Although these undergarments come in a range of styles, a typical gynecomastia undergarment is in the form of a tight-fitting sleeveless shirt that covers the abdominal region. This style renders the gynecomastia undergarment as distinct from a brassiere.

See also BRASSIERE; BREAST ANATOMY; BREAST AUGMENTATION; BREAST REDUCTION; MAN BRA; OBESITY; TELEVISION

Further Reading

Al-Benna, Sammy. "Albucasis, a Tenth-Century Scholar, Physician and Surgeon: His Role in the History of Plastic and Reconstructive Surgery." *European Journal of Plastic Surgery* 35, no. 5 (2012): 379–387.
Huber, Wesley Blake. *Gynecomastia, Hegemonic Masculinity, and Stigma: Researching Male Corporeal Deviance.* PhD dissertation, Kent State University, 2012. Retrieved May 14, 2014, from http://etd.ohiolink.edu/view.cgi/Huber%20Wesley%20Blake.pdf?kent1349640475
Laqueur, Thomas Walter. *Making Sex: Body and Gender from the Greeks to Freud.* Cambridge, MA: Harvard University Press, 1990.

■ Y. GAVRIEL ANSARA

H

HIDING PLACES

Breasts—or, to be more precise, clothing and especially bras covering breasts—have been used to hide objects for centuries. Evidence comes mostly from police or custom records. The purpose of hiding things in bras is related to espionage, theft, and (probably most commonly) to smuggle things, either because they are forbidden to be exported or imported or to avoid paying taxes on them. The use of breasts or bras as a place for hiding things is helped by the real or imagined taboo of searching through such places, especially by male custom or police officials.

During and after the two world wars, the black market and smuggling among frontiers transformed breasts and bras into popular hiding places. Especially small valuable objects (precious metals, diamonds, etc.) were smuggled via bras, for example from East Germany to West Germany during the Cold War period. Until quite recently, (untaxed) gold coins, money, and bills were smuggled this way to and from tax havens like Luxembourg and Switzerland into neighboring European countries. Nowadays police and newspaper reports about illegal drugs smuggled via breasts and bras are quite common. To give two officially documented examples: German custom officials at Düsseldorf Airport identified a push up-bra of a female traveler from the Caribbean as a hiding place for cocaine in October 2012. A similar case was discovered at Bangkok airport in Thailand in September 2012 with apparently 271 designer drug capsules concealed in this way.

In espionage, breasts and bras were mostly used in the same way as for non-espionage-related smuggling, but there were notable variations from this use of breasts and bras. The intelligence agency of East Germany (i.e., the "Stasi") developed bras with an integrated camera to take clandestine photos of the capitalist enemy. The equipment catalog to outfit British agents during World War II contained bras, but the only thing that had to be hidden from the enemy was the British origin of the clothing during service in Nazi-occupied continental Europe. In spy fiction, bras are mostly used for the opposite of hiding purposes, as for example in the iconic scene in the 1962 James Bond film *Dr. No* with Ursula Andress in a white bikini emerging from the sea (a scene repeated in the 2002 film *Die Another Day* with Halle Berry in an orange bikini).

See also BRASSIERE

Further Reading

Hemmerle, Joachim. "Eine entwaffnende Waffenschmugglerin. Was Tante Susi unter der Bluse trug." In *Wenn Quadrate Kreise ziehen: Feuilletons eines Mannheimer Journalisten*, 98–99. Ludwigshafen: Pro Message, 2012.

Seaman, Mark. *Secret Agent's Handbook of Special Devices: World War II*. Richmond, UK: Public Record Office, 2000.

■ OLIVER BENJAMIN HEMMERLE

HOLLYWOOD

In Hollywood, the female breast is a commodity that is highlighted, shaped, enhanced, and celebrated. From the days of Lana Turner, Marilyn Monroe, and Jayne Mansfield, Hollywood producers have developed and exploited the image of the femme fatale. Hourglass figures sporting large breasts, tightly cinched waists, and full hips are accentuated with clingy fabrics, daringly cut necklines, and form-fitting clothes. Hollywood's impact on women was swift. In the 1940s, sales of breast pads increased as women attempted to achieve the look of Lana Turner. In the 1950s, sales of bras, girdles, and corsets increased quickly as women strove to emulate Jayne Mansfield and Marilyn Monroe. These images were designed to get men into the theatre and women to buy into the ideal.

Actresses who are not naturally endowed can undergo breast augmentation surgery or resort to other means to land roles that require enhancements. In order to play Erin Brockovich in the movie of that name, Julia Roberts had to undergo a physical transformation. Avoiding surgery, Roberts had a number of undergarments made to create a large bosom and noticeable cleavage. The trailers for the movie regularly featured Brockovich saying, "They're just boobs, Ed." Interviewers, critics, and reviewers often focused more on Roberts' new bra size than the importance of the story or the quality of her acting. The constant references to breasts implied that the movie was better with their inclusion.

Another form of boob sensationalism is found in movies with seemingly strong female characters. Masquerading as independent, tough women, Angelina Jolie as Lara Croft and Halle Berry as Cat Woman employ the language of female empowerment and liberation. Yet this is belied by their comic-book outfits, which clearly define large bosoms, muscular forms, butts, thighs, and crotches. Couple this with close-ups of breasts, constant shots of the gun strapped to Jolie's thigh, provocative poses, and double-entendres, and it becomes clear that Lara Croft and Cat Woman have nothing to do with female liberation, and everything to do with fulfilling male fantasies of highly sexualized women.

Hollywood regularly associates breasts with sexuality, extroversion, and assertiveness. This exploitation of the female body continues to draw audiences.

See also ADVERTISING; BRASSIERE; CELEBRITY BREASTS; FEMALE ACTION HEROES; MOVIES; RUSSELL, JANE (1921–2011)

Further Reading

Kord, Susan, and Elisabeth Krimmer. *Hollywood Divas, Indie Queens, and TV Heroines: Contemporary Screen Images of Women.* Toronto: Rowman & Littlefield, 2005.

Meyers, Marian, ed. *Mediated Women: Representations in Popular Culture.* Cresskill, NJ: Hampton Press, 1999.

■ RHONDA KRONYK

HOOTERS

Hooters is the name of a restaurant chain founded in Clearwater, Florida, in 1983. While the company's large-eyed owl logo is widely recognizable, the business is best known for employing scantily clad waitresses known as "Hooters' Girls." Brand recognition hinges on the slang meaning of the term "hooters" as a reference to women's breasts. Marketing the sex appeal of the female body, the restaurant chain outfits waitresses in standardized uniforms consisting of low-cut tank tops and high-cut short-shorts that draw attention to the women's ample cleavage and curvaceous figures. Although Hooters has expanded to include hundreds of locations, the chain has not escaped controversy. Critics suggest that by creating a dining experience that revolves around gazing at the company's beautiful, large-breasted waitresses, Hooters both objectifies and exploits women. Proponents argue that "Hooters' Girls" are unfairly stigmatized and that women should be allowed to celebrate the beauty of their bodies, breasts, and sexuality without fear or harassment. However, the restaurant chain has been the repeated target of lawsuits by former "Hooters' Girls" who contend that the highly revealing uniforms, nearly all-male management and clientele, and overly sexualized atmosphere create an environment where verbal and physical sexual harassment runs rampant. In 1995, the Equal Employment Opportunity Commission charged that by employing only female waitresses, Hooters engaged in gender discrimination against men who sought work as servers. Hooters has emerged relatively unscathed from these attacks, and the chain's business model remains largely intact. The Hooters brand has expanded to include a yearly calendar, clothing line, and even swimsuit pageant. Spawning a wide array of look-alike restaurants, including the Tilted Kilt, Twin Peaks, and Mugs & Jugs, the popularity of Hooters and its clones has earned the burgeoning industry of eateries centered on large-busted waitresses the nickname "breastaurants."

See also ADVERTISING; MEDIA; SLANG

Further Reading

Becker, Mary, and Patricia A. Casey. "Sex Discrimination: Does Refusing to Hire Men as Food Servers Violate the Civil Rights Act?" *ABA Journal* (February 1996): 40–41.

Brizek, Michael. "It's More Than Just the Perceived Exploitation of Women: Contemporary Issues Facing Hooters Restaurants." *Journal of Case Research in Business and Economics* 3 (August 2011): 1–9.

■ JENNIFER RACHEL DUTCH

HORMONAL THERAPY

Unlike hormone replacement therapy (*see* Hormones), hormonal therapy for breast cancer aims to reduce hormone activity in the body. Estrogens and progesterone can cause breast cancer to grow more rapidly. If tests on a removed tumor or metastases (new tumor growth) show that the cancer has hormone receptors (proteins where hormones can attach and be used by the cancer), hormonal therapy might be a viable treatment method. Cancers with hormone receptors are known as hormone-sensitive or hormone-dependent. Approximately 70 percent of breast cancers have estrogen receptors, and most of these also have progesterone receptors. Hormonal therapy may also be given as a preventative medication to people who are at high risk of developing breast cancer. Ovarian ablation, which involves removing ovaries or preventing ovarian function, is a treatment method that reduces or slows the progression of breast cancers by reducing estrogen and progesterone in the ovaries or blocking their effects through hormone blockers. Currently, hormonal therapy is given after surgery as adjuvant therapy, a term for treatments given after primary treatment to prevent future recurrence. Current clinical trials are underway to determine whether hormonal therapy before surgery (called "neoadjuvant therapy") is effective in reducing the size of tumors before surgery. All hormonal therapy carries the risk of side effects due to hormonal changes. In addition to common side effects, such as hot flashes, night sweats, and dry mucous membranes, hormonal therapy also disrupts the menstrual cycle.

Ovarian ablation can be done with radiation or by surgically removing the ovaries (oophorectomy), and it is usually permanent. It can also be done temporarily using medications called gonadotropin-releasing hormone (GnRH) agonists or luteinizing hormone-releasing hormone (LH-RH) agonists, for example goserelin (Zoladex®) and leuprolide (Lupron®). Agonists are substances that bind to cellular receptors (the parts of cells that receive information used to trigger cellular changes) and act like the hormone that is normally used by that receptor. The agonists used in hormonal therapy block signals from the pituitary gland to the ovaries, preventing the production of estrogens. Ovarian ablation side effects include bone loss, mood disturbances, and loss of libido.

Selective estrogen receptor modulators (SERMs) such as raloxifene (Evista®), tamoxifen (Nolvadex®), and toremifene (Fareston®) are estrogen antagonists (blockers). These antagonists work by binding to estrogen receptors and blocking the cancer's receptors from using estrogens. Tamoxifen has been used for over 30 years and is commonly prescribed when patients have early stages of breast cancer as well as metastatic breast cancer (i.e., new breast cancer growth). Because SERMs work on cells throughout the body, acting as an antagonist on cancer cells and as an agonist on uterine tissue, there is an increased risk of endometrial cancer. Endometrial cancer can be detected early through annual pelvic exams. Patients are advised to report any unexplained vaginal bleeding to a doctor. SERMs' effectiveness can be reduced by certain medications, especially selective serotonin reuptake inhibitors (SSRIs, which are antidepressants). SERM side effects may also include an increased risk of blood clots, cataracts, bone loss (pre-menopausal), changes in mood, impotence or loss of libido, headaches, nausea, vomiting, and rashes. SERM side effects appear largely related to their estrogen agonist effects. Some medications, such as

fulvestrant (Faslodex®), act like SERMs as antagonists but have no agonist effects. Fulvestrant side effects include loss of strength, pain, and gastrointestinal disturbances.

Rather than blocking estrogens at the cancer receptors, aromatase inhibitors (e.g., anastrozole [Arimidex®], exemestane [Aromasin®], and letrozole [Femara®]) prevent the conversion of androgens into estrogens. Aromatase inhibitors are given to postmenopausal women, women who have undergone permanent ovarian ablation, or men with primary breast cancer, and clinical trials are being done to evaluate their effectiveness for metastatic breast cancer. They may be given instead of tamoxifen or after 2 or more years of tamoxifen or temporary ovarian ablation. They are not given to people with full ovarian function because functional ovaries produce too much aromatase to suppress. Aromatase inhibitor side effects include increased risk of high cholesterol, heart attack, angina, and heart failure; bone loss; mood disturbances; and joint pain.

See also BREAST CANCER; BREAST CANCER TREATMENTS; GYNECOMASTIA; HORMONES

Further Reading

Goss, Paul E., James N. Ingle, José E. Alés-Martínez, Angela M. Cheung, Rowan T. Chlebowski, Jean Wactawski-Wende, et al. "Exemestane for Breast-Cancer Prevention in Postmenopausal Women." *New England Journal of Medicine* 364, no. 25 (2011): 2381–2391.

Mauri, D., N. Pavlidis, N. P. Polyzos, and J. P. Ioannidis. "Survival with Aromatase Inhibitors and Inactivators versus Standard Hormonal Therapy in Advanced Breast Cancer: Meta-Analysis." *Journal of the National Cancer Institute* 98, no. 18 (2006): 1285–1291.

National Cancer Institute. "Hormonal Therapy for Breast Cancer." 2012. Retrieved May 2, 2014, from http://www.cancer.gov/cancertopics/factsheet/Therapy/hormone-therapy-breast

■ISRAEL BERGER AND Y. GAVRIEL ANSARA

HORMONES

Numerous hormones are produced in the breast or have an effect on breast anatomy and physiology. Many, but not all, are termed "reproductive hormones" and often labeled as "sex hormones." Although some of these hormones are typically associated with women or men and with bodies labeled as female or male, these hormones are present in most people in varying concentrations, and some play a role in human sexual response. Physiological factors such as pregnancy and age affect the quantities of these hormones in the body. High levels of hormones that increase growth of breast tissue, such as those in hormone-based birth control, can increase the risk of breast cancer.

Reproductive Hormones: Estrogens stimulate growth and differentiation of the milk ducts (known as lactiferous ducts), and high levels inhibit lactation. Levels rise during pregnancy and fall at delivery. Low levels of estrogens also regulate sperm production and mood. A higher balance of estrogens over androgens can cause breast growth in people with conventionally "male" bodies. High systemic estrogens in utero can lead to newborn breast growth and galactorrhea, a medical term that is typically applied to all milky breast secretions of men and of women who are not breastfeeding. This gendered use may contribute to a medical culture that overlooks human biological diversity and excludes men such as those who were assigned the label "female" and who may seek medical guidance

about breastfeeding or chestfeeding, a term sometimes preferred by such men. People with ovaries typically have estrogen production in these gonads prior to the permanent end of the monthly menstrual cycle during a process that is medically termed menopause. Estrogens are also produced in adipose tissue (fat), including the adipose tissue of the breast. They can also be produced through the conversion of androgens to estrogens in a process called aromatization.

Progesterone stimulates growth of the mammary glands, and high levels inhibit lactation. Levels rise during pregnancy and fall at delivery. Progesterone is produced in the ovaries (pre-menopause), fat (and thus breast), and skin. Despite limited medical attention to progesterone in conventionally "male" bodies, progesterone secretion and serum progesterone levels in typical adult males are generally similar to those of typical adult females except during the luteal or secretory phase of the menstrual cycle. Despite the widespread cultural association of progesterone with typical female bodies, progesterone has been shown to play an important role in the physiological processes and sexual behavior of typical human males.

Testosterone inhibits differentiation of the milk ducts and mammary glands. High levels prevent breast growth in typical males despite the presence of estrogens. Testosterone is produced in both the ovaries and testes, and other "androgens" are produced in the adrenal cortex. Androgens are precursors to estrogens, and the enzyme aromatase facilitates this conversion. Although culturally associated with typical males, testosterone plays a role in physiological processes and has been linked to the sexual response of typical human females.

Luteinizing hormone (LH) also stimulates estrogen production, and a surge in LH causes ovulation to occur. LH levels are low during full-time breastfeeding, contributing to breastfeeding's contraceptive effects by preventing ovulation. In the testes, LH stimulates testosterone production and spermatogenesis. LH is produced in the pituitary.

Oxytocin causes milk to be released into the milk ducts by contracting the smooth muscle layer in the mammary glands. Oxytocin is essential for the milk ejection (letdown) reflex, in which the physical suckling of the infant causes oxytocin to be produced in the hypothalamus. In addition to its effects during infant nourishment, oxytocin is involved in a number of pleasurable feelings in the body as well as dilation of the cervix during childbirth.

Mammary Hormones: Human placental lactogen (HPL) is important for breast, nipple, and areola growth and is released by the placenta during pregnancy.

Parathyroid hormone–related protein (PTHrP) is secreted in utero and begins differentiation of the mammary bud that will continue, dependent on hormones, throughout the life span.

Prolactin increases growth and differentiation of the mammary glands as well as differentiation of the milk ducts. Prolactin regulates milk production by regulating osmosis in the ductal epithelium, the tissue that lines the milk ducts. It remains high during breastfeeding and falls during weaning. It is also considered a "reproductive" hormone. Prolactin is produced in the pituitary, uterus, breast, and prostate, and in white blood cells.

Leptin is involved in the development of the duct system and lactation. It is also influential in promoting energy balance in the breastfeeding infant and can affect breast cancers. It is produced throughout the body primarily in fat but is also produced in

the ovaries, mammary glands, skeletal muscle, bone marrow, pituitary, liver, stomach, and placenta.

Metabolic Hormones: Growth hormone (GH) and adrenocorticotropic hormone (ACTH) are structurally similar to prolactin and serve similar functions in promoting lactation. They are both produced in the pituitary.

Glucocorticoid and other corticosteroids are important in regulating osmosis in the ductal epithelium. They are produced in the adrenal cortex.

Thyroid-stimulating hormone (TSH) increases lactation and may increase breast growth in individuals with hyperthyroidism. It is produced in the pituitary.

See also BREAST ANATOMY; BREAST CANCER; BREAST CANCER TREATMENTS; BREASTFEEDING; HORMONAL THERAPY; PREGNANCY; PUBERTY

Further Reading

Baratta, M. "Role of Leptin in the Mammary Gland Development, Lactation and in Neonatal Physiology." In R. M. Hemling and A. T. Belkin, *Leptin: Hormonal Functions, Dysfunctions and Clinical Uses*, 89–106. Hauppauge, NY: Nova, 2011.

Ben-Jonathan, N., J. L. Mershon, D. L. Allen, and R. W. Steinmetz. "Extrapituitary Prolactin: Distribution, Regulation, Functions, and Clinical Aspects." *Endocrine Reviews* 17, no. 6 (1996): 639–669.

Blackless, M., A. Charuvastra, A. Derryck, A. Fausto-Sterling, K. Lauzanne, and E. Lee. "How Sexually Dimorphic Are We? Review and Synthesis." *American Journal of Human Biology* 12, no. 2 (2000): 151–166.

Brisken, C., and B. O'Malley. "Hormone Action in the Mammary Gland." *Journal of Mammary Gland Biology and Neoplasia* 7, no. 1 (2002): 49–66.

Miralles, O., J. Sánchez, A. Palou, and C. Pico. "A Physiological Role of Breast Milk Leptin in Body Weight Control in Developing Infants." *Obesity* 14, no. 8 (2006): 1371–1377.

Oettel, M., and A. K. Mukhopadhyay. "Progesterone: The Forgotten Hormone in Men?" *Aging Male* 7, no. 3 (2004): 236–257.

Porterfield, S. *Endocrine Physiology*, 2nd ed. Philadelphia: Mosby, 2000.

■ ISRAEL BERGER AND Y. GAVRIEL ANSARA

HYGIENE

Hygiene is the preservation of health and the practice and principles of cleanliness. The concept of dirt is intimately entwined with the evolution of human notions of public and personal hygiene. As groups of people began to live in more permanent settlements, the issues of public health became more complex. Disease is a major force that can affect the growth and health of an individual and his or her community. From this premise, collective beliefs and practices regarding the presence of disease and the goal of attaining and maintaining good health emerge among the general populace.

The ancient Greek Hippocratic *corpus* broadly explains the body in health and illness through its humors. Illness was a result of the body's humors being out of balance. Health (balance in the body) might be restored by causing the body to sweat, vomit, or defecate, or through bloodletting. The female body has stereotypically been viewed as overly leaky and prone to pollution because not only does it have basic functions (like the male body),

but also it has the potential to give birth, menstruate, and lactate. While menstrual blood is usually considered a pollutant, breast milk in contrast is generally regarded as quite "pure." Ancient texts have recommended the use of breast milk for treatment of a number of maladies such as cataracts, burns, and eczema.

The milk of Greek goddesses had the potential to confer infinite life to those who drank of it. In Western Christian art, the Virgin Mary nursing the Christ child became a popular image from the fourteenth century onward. As sacred fluid, the Virgin's milk is second only to the blood of Christ, as many a reliquary boasting to contain vials of the Virgin's milk can attest. Although lactation is a basic biological function, it has been metaphorically transformed into the quintessential female elixir. Ancient theories posit that a woman's personality could influence for good or bad the character of the child who drank from her breast. Suckling not only could ruin a beautiful bosom but also it disturbed the aesthetic illusion. Wives and wet-nurses were not supposed to have intercourse while breastfeeding for it was believed that breast milk was formed in the uterus from the menstrual blood. Medieval and Renaissance texts show the female body with a duct that connected the uterus and breasts. By having intercourse, it was believed that menstruation would be triggered and could taint the flow of the milk to the infant.

See also Breastfeeding; Mythology; Religion; Virgin Mary; Wet Nursing

Further Reading

Angier, Natalie. *Woman: An Intimate Geography*. New York: Anchor Books, 2000.

Karlen, Arno. *Man and Microbes: Disease and Plagues in History and Modern Times*. New York: Simon & Schuster, 1995.

McNeill, William H. *Plagues and Peoples*. New York: Anchor Books, 1976.

Sivulka, Juliann. *Stronger Than Dirt: A Cultural History of Advertising Personal Hygiene in America, 1875 to 1940*. New York: Humanity Books, 2001.

■ LORI L. PARKS

I

ICONOGRAPHY

The depiction of covered and naked breasts as part of political iconography derived from Greek and Roman mythology; however, the message of these images has altered since the eighteenth century. Traditionally, the iconographic use of breasts has been linked to women and motherhood. Depiction of mutilated breasts (as for the Amazons) implicated a militarization of females as opposed to traditional role models. The iconographic volume of breasts in early modern times had a clear social meaning: small breasts for noble and upper-class women and larger breasts for women from lower ranks. After breastfeeding by the actual mother (and not by a wet nurse) was propagated during the Enlightenment period, this social distinction by volume changed or lost its importance. Voluminous breasts now symbolized health and a natural way of life. Even so, breastfeeding by wet nurses for social reasons survived in some parts of society well into the nineteenth century. This change of attitude to breastfeeding during the Enlightenment shaped the iconographic value and significance of breasts in modern times, thereby allowing breasts to become a symbol in revolutionary times.

Probably the most important depiction of the breasts in modern political iconography is the French revolutionary Republican female "Marianne," who became the symbol of France and a role model for other female Republican icons (in the Americas, etc.). The exact origin of this female figure is unclear; it emerged as a symbol for the French Revolution and the Republic shortly after 1789, but the Marianne figure probably predates the outbreak of the Revolution. Marianne has a number of changing attributes (Phrygian cap, crown, and spear), but the naked breast or breasts are quite common. These images were modeled on Greek or Roman goddesses and in the beginning were often labeled as representations of "Liberty" or "Reason." Whereas goddesses from Antiquity (like Minerva) vanished from the French public imaginary during the nineteenth century, Marianne as a national symbol prevailed. It has been argued that the bare breast(s) of Marianne emerged with the radicalization of the Revolution in the early 1790s, but it is difficult to prove a consistent and politically motivated pattern of covered or bare breasts. Especially since the famous painting by Eugene Delacroix of the French Revolution of July 1830, the bare breasts are permanently linked to Marianne. Although the title of the picture identifies the female with bare breasts, a tricolor flag, and a rifle with a bayonet as "The Liberty Guiding the People" ("La Liberté guidant le peuple"), she is usually interpreted as Marianne.

Since the French Third Republic (from 1870), busts of "Marianne" became quite popular in official buildings. It has to be said that usually the breasts were covered by the artists of the busts produced for display in town halls and schools, but the bare breast(s) reappeared constantly in other representations of this female icon. Modern Marianne busts for official display often get inspiration from the faces of prominent singers, actors, or models (in the last decades, Mireille Mathieu, Catherine Deneuve, Laetitia Casta, and other prominent French women). In some cases, for example a Marianne modeled after Brigitte Bardot, the cover of the depicted breasts in the bust is existent, but minimal.

In counterrevolutionary imagery from the 1790s, the bare breasts of Marianne were—like the female figure in general—depicted in most unpleasant ways. Often breastfeeding was ridiculed, and Marianne was portrayed as an elderly prostitute nourishing suburban scum. This tradition started probably in English caricatures during the revolutionary wars of the 1790s and was used throughout the nineteenth century by French counterrevolutionaries and anti-Republicans. Use of Marianne in caricatures sympathetic to the Republican cause only emerged much later, but it is nowadays quite common and popular. From the 1970s, there were occasional feminist discussions concerning the sexist implications of a bare-breasted Marianne, but these debates never seriously questioned the Republican symbol in the general public. Probably the identification of the Republic with a female, in contrast to a male king—or, today, a male president—and the active role of Marianne in urging the nation to action helped to diminish feminist protests. From the late nineteenth century, there are rare examples of nonpolitical, pornographic images of Marianne in photos, postcards, or adult magazines. Late in the nineteenth century some images supplemented Marianne with a red flag, thereby making her a symbol of socialism or communism. Bare- or covered-breast depictions of this leftist Marianne were used as within the more traditional Republican Marianne imagery throughout the twentieth century. During the world wars, Marianne was often portrayed in a more militaristic way (with armor), or as a caring mother on the battlefield comforting dying soldiers, thereby interpreting the function of Marianne as a secularized Madonna. Sometimes, the motherhood aspect of Marianne (with the breasts as a symbol for that) was highlighted in the iconography of the state and of patriotic groups, as the French from the defeat in 1870–1871 to the Second World War feared the strategic consequences of German fertility. For this motherhood propaganda purpose, the breasts were usually depicted as covered, but voluminous.

See also ADVERTISING; ART, WESTERN; MYTHS; POLITICS; PUBLIC ART; SCULPTURE

Further Reading

Agulhon, Maurice. *Marianne into Battle: Republican Imagery and Symbolism in France, 1789–1880*, trans. Janet Lloyd. Cambridge: Cambridge University Press, 1981.

Hunt, Lynn. *Politics, Culture, and Class in the French Revolution*. Berkeley: University of California Press, 1984.

Renault, Jean-Michel. *Fées de la République*. Paris: Pélican, 2004.

Yalom, Marilyn. *A History of the Breast*. New York: Knopf, 1997.

■ OLIVER BENJAMIN HEMMERLE

IMPLANTS

A breast implant is a prosthesis consisting of gel or fluid material in a flexible envelope. It is inserted behind or in place of the breast in cosmetic or reconstructive surgeries.

An Austrian doctor, Robert Gersuny, experimentally performed the first breast augmentation surgery in 1890, injecting paraffin into breasts to determine if such a procedure would result in breast enlargement. This type of augmentation led to infections and hardening of the breasts, and it was abandoned by 1920. Doctors also constructed early implants from polyurethane foam, animal fat, ivory, glass, rubber, Teflon, sponges, steel, soy bean oil, and human tissue, all of which resulted in a variety of health complications for patients.

Two American plastic surgeons, Frank Gerow and Thomas Cronin, created the first contemporary breast implants in 1961 with silicone gel. In 1962, Timmie Jean Lindsay would become the first woman to receive a silicone gel implant. Cronin was issued a patent for the implant in 1966 with production rights assigned to the Dow Corning Corporation. As silicone was already used in a variety of other medical devices without evidence of serious health risks, plastic surgeons generally celebrated Gerow and Cronin's innovations.

Although early versions of silicone implants gained popularity among women throughout the 1970s and 1980s, health concerns began to arise involving implant ruptures, breast pain, connective tissue and neurological diseases, cancer, and suicide. In response to these concerns, the U.S. Food and Drug Administration (FDA) restricted the use of silicone implants between 1992 and 2006. During this time, saline implants, also developed in the 1960s, were marketed as an alternative to silicone implants.

In 1997, U.S. Congress commissioned a report from the Institute of Medicine (IOM) to examine health concerns associated with breast implants. The IOM report found no definitive evidence that silicone implants are associated with disease, but that many women do suffer significant complications and side effects. In 1998, Dow Corning and

Silicone breast implants. Benis Arapovic/ Thinkstock by Getty

other implant manufacturers settled a class action lawsuit for $3.2 billion to 170,000 women claiming injury from implants.

Feminist scholars, bio-ethicists, and women's health advocates continue to debate the regulation of breast implants. Issues surrounding choice and informed consent are among the most discussed. Some scholars argue that the decision to undergo cosmetic procedures, such as breast augmentation, can be a reasonable choice for women in certain instances. Others, however, question concepts of choice and agency in a patriarchal culture that normalizes and fetishizes certain breast ideals, which may cause women to view their breasts as deficient or inadequate.

See also BEAUTY IDEALS, TWENTIETH- AND TWENTY-FIRST-CENTURY AMERICA; BREAST AUGMENTATION; BREAST CANCER; CELEBRITY BREASTS; MASTECTOMY AND LUMPECTOMY

Further Reading

Bruning, Nancy. *Breast Implants: Everything You Need to Know*, 3rd ed. Alameda, CA: Hunter House, 2002.

Davis, Kathy. *Reshaping the Female Body: The Dilemma of Cosmetic Surgery*. London: Routledge, 1995.

Jacobson, Nora. *Cleavage: Technology, Controversy, and the Ironies of the Man-Made Breast*. New Brunswick, NJ: Rutgers University Press, 2000.

Zimmerman, Susan M. *Silicone Survivors: Women's Experiences with Breast Implants*. Philadelphia: Temple University Press, 1998.

■ CHRIS VENDERWEES

INTERNATIONAL CULTURAL NORMS AND TABOOS

The term *culture* in anthropology refers to the cumulative deposit of knowledge and practices through experience, beliefs, values, norms, hierarchies, religion, notions of time, roles, spatial relations, and concepts of the universe. It also points to the material objects and possessions acquired by a group of people in the course of generations through individual and group striving. Culture is not static but is subject to changes in the behavior, values, symbols, norms, and taboos that are communicated from generation to generation. Accordingly, cultural norms are agreed-upon expectations and rules of different cultural groups that guide the behavior of its members in given situations. Sociologists view cultural norms in terms of laws, taboos, morality, and customs. These four aspects are critical to the internalization of community boundaries and socialization toward the celebration, condemnation, or exploitation of the breast. Using varying cultural templates, communities are selective about which breasts to celebrate and which ones to condemn. Men's breasts the world over are not as sexualized as women's breasts. When they grow bigger, they become an attractor or detractor of male appeal.

In Africa, women's breasts are viewed with great pride since they symbolize fertility and motherhood. Consequently, many images abound of African women exposing their breasts, and this is not viewed as nudity but as celebrating the female body. Exposed breasts are the norm among many indigenous communities like the San, Himba, and Nama of Namibia. In East Africa, there are the Masaai, Acholi, Nuer, Pokot, Borana, and Rendille. In the annual *umhlanga* or reed dance for the Swazi king, many young virgins bare their

breasts as they pay homage to the Swazi queen mother. In recent years, the king of Swaziland has used these dances to get a wife. The girls' bodies, particularly their breasts, are of importance when the king chooses one of them as his bride.

The popular African proverb "Looking at a king's mouth, one would never think he sucked his mother's breast" points to how the culture views fertility and childcare as tied to the mother. Linked to this is the limitation of milk provision by the breast: "She who gives birth to triplets cannot ask for a third breast." The felicitous nature of the mother–child relationship is bounded around the breast as one purpose of existence for the mother, as the following proverb shows: "A child can play with its mother's breasts but not with its father's testicles." To contradict this position is the cultural view of breasts as sexually dangerous objects that can lead one to peril. Captured in the South African proverb is this danger: "Do not desire a woman with beautiful breasts if you have not money." In another proverb from Kenya, the symbol of the breast is used to depict impossibility: "He will marry the one who has a bone in her breast." The rationale and value behind this are that marriage is impossible for the man involved.

Meanings of the breast are constructed within women's social and cultural contexts, and in some of these contexts breasts are associated with sex and being concerned about breasts is considered inappropriate. Breasts may also be seen as a menace or ill to society. In some African cultures, a mother can curse her children or anyone who offends her by tapping her bare breast. Elsewhere, the cultural practice of ironing the breasts as girls grow up is practiced in a number of African countries. It is mainly carried out by mothers who compress the breasts of their daughters to lessen the chance of them being raped or forced into early marriages. This involves using a wooden pestle and banana leaves to compress the breasts and stop them from enlarging. Cameroon is notorious for this practice. Other countries where breast ironing is practiced include Benin, Ivory Coast, Guinea Bissau, Kenya, Togo, and Zimbabwe.

Perceptions toward breasts are changing and have varied from society to society. Before 1927, women in China were involved in the tradition of breast binding, and those who wore low-cutting clothes that exposed some skin were arrested. Revealing of the breasts, no matter how small, was seen to lead to moral decay and degradation. Upon marriage, many husbands would continue to bind their wives' breasts with cloth pieces. This cultural practice was noted to weaken the chests of women and interfere with the natural growing process of the body. In the early 1930s, actress Ruan Lingyu was one of the first Chinese women to wear a bra, hence emancipating the breast and changing the way women's body were understood. In Chinese culture, which attaches importance to female chastity, breasts are idealized according to their shapes and sizes. Examples include the round-plate type (*yaunpan xing*), hemispherical type (*banqui xing*), conical type (*yuanzhui xing*), and hanging type (*xiachui xing*). Of all these types, the conical type is seen to measure up to a respectable, untainted, and well-behaved girl. The "unused quality" that these breasts point to is a benchmark for female chastity.

In 1858, in India amongst the tribes in Kerala, all women were allowed to cover themselves in public. Before then, only the higher-caste women like the Brahmins covered their chests. This example was matched by others in most parts of the Asian subcontinent: women's breasts were exposed unless they belonged to higher castes. In countries like Laos, evidence exists of women breastfeeding their babies in public. In Indonesia before

the introduction of Islam, women and girls exposing their breasts was the norm. In some cases, if the size of the breasts interfered with work, women were encouraged to cover them. In extreme cases, some women's breasts have been known to smother their partners to death.

In Ukraine, a female group of protesters known as FEMEN has achieved popularity by staging topless demonstrations to draw attention to the plight of impoverished communities. In 2012 during the world economic forum at Davos, they staged another protest demanding economic redress to the plight of the poor. This exposure of the breasts or bare chest is seen as indecent exposure, but for the protesters it is a way of using their bodies to highlight societal concerns. August 26, 2012, was the fifth anniversary of "Go Topless" day. On this day, women and men throughout the United States were involved in a women's rights campaign called "the right to bare breasts." During this time, women throughout cities in the United States were able to bare their breasts while men supported them by wearing bras. The event in part was to draw attention to the inequality in topless rights between men and women.

Among the Aboriginal Papunya community of the western desert region in Australia, decorating the body includes women's breasts. Women's body paintings emphasize the breasts and their relationship to the fertility of the land, which they show off in their traditional dances performed by elderly women. In 2004, they were ordered by the government not to perform their dance at Alice Springs since it was deemed offensive to the public.

In many Westernized countries, the controversial topic of breastfeeding children in public has given impetus to the exposure of breasts in these circumstances to be a *taboo*. In the United Kingdom, the taboo related to the direct emissions of milk from the breast can be traced to medieval times. During this time, the practices of wet-nursing and withholding of colostrum to infants were rife. However, a decline occurred in these two practices when the perception of transmission of personality via breast milk was high. Consequently, socially it became a taboo to breastfeed another's child.

Women today are concerned about how their breasts look, and some would do anything to get the "perfect" shape. This concern has seen many go to lengths to use surgical procedures performed on them to enhance the image of their breasts. In some extreme cases, this enhancement has led to more medical problems for the women. Exposure of the breasts or toplessness has been encouraged by the topfreedom movement. However, this movement has come under great legislative challenges for the recognition of its activities. In other areas, toplessness has created fuss over the issues it has exposed. For example, Kate Middleton, duchess of Cambridge, and the topless images of her sold by paparazzi caused a wave of fury from Buckingham Palace. Breasts are sexualized in the national collective psyche, making nudity and part of the duchess's body taboo subjects not to be exposed to the public. In contrast, cities like New York annually play host to the naked bike ride and the famous "no pants subway ride." Also in 2012 during the *Thailand's Got Talent* television show, one female contestant elicited a morality debate by painting a canvas with her bare breasts. The three judges were split on the morality of the act, with two expressing their opinion that 23-year-old Duangjai was artistically expressing her talent, and the third judge labeling it as immoral. For the artist, her defense was that the program producers could have edited out parts they deemed inappropriate for children since her act was art in practice.

Unlike the male breast, the female breast is part of her private world and one part of a woman's body that has been subjected to a lot of judgment. Exposing one's breasts, particularly the areolae and nipples, publicly is seen as indecent exposure in the United States and elsewhere, and one can be held liable and fined. A case in mind is Janet Jackson's 2004 Super Bowl "Nipplegate" in which indecent exposure of her breast was met by complaints to the Federal Communications Commission. Many parents watching the event cited morality and inappropriateness of the exposure to their children. In Canada, no complaints were launched over this incident, and even in Europe there seemed to be no fuss around this incident. After the event, Congress passed legislation that increased the maximum fines in indecency claims to $325,000 per station violating the law. In contrast, when Lady Gaga wore her gun-toting brassiere, which she first wore in 2010, in Canada in 2012 after the Sandy Hook, Connecticut, elementary school massacre, her performance using this costume was deemed as being insensitive at a time when gun laws were under focus in the United States. Her rifle-breasts costume crossed the line from harmless to harmful, making this a moral question. However, some critics defended Lady Gaga and saw this as a case of mixing art with politics.

Linked to the breast is the taboo against women seeking treatment for breast cancer. Studies conducted on women from South Asia revealed an ambiguity over discussions of the breast, and symptoms of cancer were ignored because of their reference to the breast as the chest. The women declined to directly name the breast because of a cultural view of cancer as a stigma and a taboo subject. It stopped women from seeking medical attention. In Vietnam, the cultural beliefs related to the cause–effect nature of cancerous or lumped breasts make women live in fear of stating their problems. Discussing the "flower-buds" or breasts is considered immodest, and there is a common belief among Vietnamese that "cancer leads to death" and of questioning what the women did that led to them contracting cancer. This belief that cancer is a punishment from the gods is one that runs true in many African countries, making it a taboo to claim that one's breast is sick. The linkage of breasts and cancer as a taboo subject is highly pronounced in the Middle East, where issues of gender—male doctors and technicians administering treatment to women in hospitals—make it impossible to address the high numbers of women succumbing to breast cancer.

See also BREAST BINDING; BREAST CANCER TREATMENTS; BREAST MUTILATION; CONTROVERSIES; POLITICS; RELIGION; TOPLESS BEACHES; TOPLESS PROTESTS

Further Reading

Bawe, Rosaline Ngunshi. *Breast Ironing . . . a Harmful Practice That Has Been Silenced for Too Long.* Bamenda, Cameroon: Gender Empowerment and Development. Retrieved August 24, 2011, from http://www2.ohchr.org/english/bodies/cedaw/docs/cedaw_crc_contributions/Gender EmpowermentandDevelopment.pdf

Fretté, Juliette. "The Meaning of Breasts." *Huffington Post.* Retrieved April 6, 2010, from http://www .huffingtonpost.com/juliette-frette/the-meaning-of-breasts_b_527740.html

Mabilia, Martha, and Mary Ash. *Breast Feeding and Sexuality: Behavior, Beliefs and Taboos among the Gogo Mothers in Tanzania.* New York: Berghahn, 2006.

Mbiti, John. *Introduction to African Religion,* 2nd ed. Oxford: Heinemann, 1991.
McMillan, Joanna. *Sex, Science and Morality in China.* New York: Routledge, 2006.
Mey, Jacob. *Pragmatics: An Introduction.* Malden, MA: Blackwell, 2001.

■ FIBIAN LUKALO

INTERSEX

Intersex is an umbrella term that describes the physical experience of having one or more biochemical, genetic, or anatomical variations that differ from typical medical expectations of "female" or "male" bodies. The term "intersex" is the most widely preferred term internationally by people with bodies that fit this description. People who are intersex may have medical diagnoses associated with their biological differences, but their physical variations are natural biological variations and not medical problems in themselves. Intersex is widely misunderstood and conflated with "trans" (short for transgender or transsexual) in popular culture, in news media, and even among some medical and mental health professionals.

Intersex people have been (and often still are) objectified as sources of fascination, ridicule, or curiosity. Caricatured images of intersex people have been used in numerous circus advertisements. For example, the popular image of the "hermaphrodite" in circus marketing is depicted as a half "male" and half "female" body divided vertically. Although a minority of intersex people identify with the term "hermaphrodite," most intersex people and many health professionals now consider this term to be pejorative and inappropriate. Circuses often feature a "bearded lady" who has typically "female" breast development combined with hair growth that is usually considered more typically "male." Although a small group of professionals have attempted to claim a consensus to use pathologizing language such as "disorders of sex development" to describe intersex people's bodies, such a consensus does not actually exist within or outside of the medical community.

In popular media, the presence of visible breasts is usually assumed to correspond with genetic, genital, and gonadal characteristics that are associated with typically female bodies. However, intersex people may have one of many possible combinations of physical characteristics. Intersex people with any physical characteristics may identify as any gender and have any sexual orientation. People who are intersex may or may not have breasts. For example, intersex people with XXY chromosomes may have larger breasts than people with typically male XY chromosomes. Some studies have found that breast cancer rates among people with XXY chromosomes are similar to rates among people with typically female bodies. Although medical literature often assumes that all people with XXY chromosomes identify as men, this assumption overlooks the variety of gender identifications held by people with XXY chromosomes. People with XXY chromosomes are often labeled as having Klinefelter's syndrome, although some people with XXY chromosomes consider this terminology unnecessarily pathologizing. People with typically female breast development and who were raised as girls may experience the descent of their testicles at puberty, a physiological phenomenon known as *guevedoces* (also known as "testicles at 12") in the rural areas of the Dominican Republic where there have been many such cases. These people were often called *machihembras* (first women, then men).

People with *guevedoches* have been subjected to scrutiny and disrespectful approaches in some medical journals.

Spanish painter José de Ribera's 1631 painting *La Mujer Barbuda* (*The Bearded Woman*) depicted bearded woman Magdalena Ventura breastfeeding her infant; her husband, Felici de Amici, stands next to her. Ribera, who spent his career in Italy, was commissioned to paint this work by his patron, Duke Ferdinand II of Alcalá, viceroy of Naples. According to text on the stone tablet in the painting, Magdalena grew a beard late in her 30s and appeared visually to others to have an appearance more similar to that of a gentleman than a woman. The stone tablet entreats viewers to admire this unusual occurrence in its first sentence: "Look, a great miracle of nature." In recent years, several medical journals have published articles in which endocrinologists have attempted retrospective diagnosis of Magdalena. The stark contrast between artistic celebration and medical pathologizing illustrates the shifting views of intersex people across disciplines and time periods.

Intersex people may or may not seek medical or surgical interventions to limit or enhance the size of breast tissue. Prior to surgery, it is necessary to ensure that breast tissue is not still growing, thereby preventing regrowth or overgrowth of breast tissue. Medical interventions to prevent or increase breast growth would usually include hormone replacement therapy and may include similar medications as required by trans people. This similarity may contribute to some of the confusion between people of trans experience and intersex people.

Although human breast development follows the same stages regardless of physical characteristics, hormonal changes affect whether breasts grow in a certain way. "Female" puberty and pregnancy are typical instances of when hormones promote breast growth. Intersex people may experience breast growth at different times than would be expected in other populations. Puberty may be early or delayed, and puberty may involve changes associated with either or both female and male maturation. For example, a person who has a penis and no vaginal opening may have a uterus and internal opening, resulting in menstruation through their rectum. Similarly, breast growth may occur in intersex people who otherwise appear typically "male" as well as those who appear typically "female."

For many years, pediatric endocrinologists and urologists have performed surgeries on intersex infants' reproductive and sexual organs, usually to attempt to give them typically "female" bodies and to ensure that they will be able to have vaginal intercourse with men as adult women. Professionals who use this approach often fail to determine intersex people's genders accurately, impose heterosexist assumptions, and perpetuate surgeries that often result in permanent damage. Some damage done by these involuntary or coerced procedures include major scarring and dysfunction that require numerous revisions throughout infancy, childhood, and adulthood. Many of the same surgeries imposed on intersex infants are considered genital mutilation when performed on infants who are recognized as female at birth. These involuntary or coerced "normalizing" surgeries conducted by licensed medical professionals in Australia, the United Kingdom, the United States, and elsewhere are often legally permitted by the same governments that publicly condemn and promote criminalization of virtually identical procedures when they occur in African and South Asian countries to babies labeled as female. Intersex adolescents are often given unnecessary feminizing hormone treatments to make them develop breasts without their own informed consent.

Some jurisdictions around the world have legislated to protect intersex people from medical mistreatment and criminalized discriminatory practices that some medical professionals have claimed were therapeutic. Some medical professionals and human rights authorities have proposed an end to the involuntary or coerced normalizing medical interventions to which intersex infants are routinely subjected in many countries. Intersex rights efforts have targeted these human rights issues, and the UN Special Rapporteur on Torture has issued a report that designates these involuntary or coerced medical and surgical interventions on intersex people as torture. UN member states are encouraged to legislate against them.

See also ART, WESTERN; BREASTFEEDING; GENDER AFFIRMATION SURGERY; HORMONAL THERAPY; HORMONES; PUBERTY; TRANSGENDER/TRANSSEXUAL

Further Reading

Davis, Georgiann. "'DSD Is a Perfectly Fine Term': Reasserting Medical Authority through a Shift in Intersex Terminology." *Advances in Medical Sociology* 12 (2002): 155–182.

de María Arana, Marcus, and HRC Staff. *A Human Rights Investigation into the Medical "Normalization" of Intersex People.* San Francisco: Human Rights Commission of the City and County of San Francisco, 2005. Retrieved May 31, 2014, from http://www.sf-hrc.org/ftp/uploadedfiles/sfhumanrights/Committee_Meetings/Lesbian_Gay_Bisexual_Transgender/SFHRC%20Intersex%20Report(1).pdf

Holmes, Morgan. *Critical Intersex.* Aldershot, UK: Ashgate, 2009.

Karkazis, Katrina. *Fixing Sex: Intersex, Medical Authority, and Lived Experience.* Durham, NC: Duke University Press, 2008.

National LGBTI Health Alliance. *Inclusive Language Guide: Respecting People of Intersex, Trans and Gender Diverse Experience.* May. Newtown, CT: Author, 2013.

Swiss National Advisory Commission on Biomedical Ethics. "On the Management of Differences of Sex Development," Opinion no. 20/2012. Berne: Author.

United Nations Human Rights Council. "Report of the Special Rapporteur on Torture and Other Cruel, Inhuman or Degrading Treatment or Punishment, Juan E. Méndez," Document no. A/HRC/22/53. Geneva: Author.

■ Y. GAVRIEL ANSARA AND ISRAEL BERGER

J

JACOB, MARY PHELPS (1891–1970)

At age 19, socialite Mary Phelps Jacob from New Rochelle, New York, created the first modern brassiere, or bra, the design of which was granted a patent in November 1914. She patented it under the name of Caresse Crosby, and called it the "Backless Brassiere."

Jacob's invention began when she was preparing to get dressed for a dance. Women wore corsets underneath their clothing at that time, but these garments were notoriously uncomfortable. They were tight, stiff, and heavy, and their supportive whalebones and metal rods forced the body into an awkward position. Jacob's corset visibly stuck out through the sheer fabric of her dress and up beyond its plunging neckline. Annoyed, Jacob and her French maid sewed two silk handkerchiefs and pink ribbon with cord into a simpler, softer, lightweight supportive garment that was more comfortable for Jacob to wear. It fit wonderfully, delightfully separating the breasts—unlike the corset, which forced the breasts together into a mono-bosom.

Jacob showed her new undergarment to female friends, and they quickly began asking her to make the light and risqué item for them as well. A stranger asked her to make her one for a dollar. Jacob recognized the potential of her creation, and she patented it.

At first, Jacob sold the product herself. Then, in 1915, after disappointing sales, she sold her patented rights to the Warner Brothers Corset Company in Bridgeport, Connecticut, for $1,500. Sales of her invention picked up greatly after she sold it, especially during World War I when the U.S. government called for women to stop purchasing corsets in order to conserve metal. At that time, her invention became the most widely used brassiere in the country, eventually earning Warner Brothers $15 million. Jacobs died in 1970 at the age of 78.

See also BRASSIERE; CORSETS; MAIDENFORM; UNDERGARMENTS

Further Reading

"Breast Supporting Act: A Century of the Bra." *The Independent*. Retrieved December 1, 2012, from http://www.independent.co.uk/news/uk/this-britain/breast-supporting-act-a-century-of-the-bra-461656.html

"Mary Phelps Jacob: Inventor of the Modern Brassiere, Publisher." Phelps Family History in America. Retrieved December 1, 2012, from http://www.phelpsfamilyhistory.com/bios/mary_phelps_jacob.asp

Yalom, Marilyn. *A History of the Breast*. New York: Knopf, 1997.

■ ELIZABETH JENNER

K

KLEIN, MELANIE REIZES (1882–1960)

An Austrian-born British psychoanalyst, Klein extended Freudian psychoanalysis to children and was an important innovator of object relations theory.

While Sigmund Freud assigns much significance to the father in childhood development, Klein emphasizes the maternal role and the infant's relationship with the breast. Drawing from Freud's understanding of life-and-death instincts, Klein suggests that from an early age, infants feel both intense love and extreme hatred toward the primary object, the mother, but in particular the mother's breast. The love and hate felt by the infant for the mother stem from the mother's ability to both provide and withhold comfort and nourishment. Rather than viewing the mother as a whole object, the infant splits the mother into part objects: the "good breast" and the "bad breast." The good breast comforts, gratifies, and nourishes, satisfying the infant's life instincts and stimulating feelings of love and creativity. The bad breast stimulates the death instinct, generating feelings of frustration, hatred, and destruction as the breast is withheld or withdrawn.

For Klein, the infant's fantasies and impulses around the mother's breast permanently become part of the individual's unconscious, affecting all subsequent mental processes and experiences. In this view, a person's notions of good and bad, and of right and wrong, develop during the oral stage, not the phallic stage as both Sigmund and Anna Freud had posited.

See also BREASTFEEDING; FREUD, SIGMUND (1856–1939); MOTHER–INFANT BOND

Further Reading

Holder, Alex. *Anna Freud, Melanie Klein, and the Psychoanalysis of Children and Adolescents*. London: Karnac, 2005.

Klein, Melanie. *The Writings of Melanie Klein I: "Love, Guilt, and Reparation" and Other Writings*. London: Hogarth Press, 1975.

Klein, Melanie. *The Writings of Melanie Klein II: The Psycho-Analysis of Children*. London: Hogarth Press, 1975.

Klein, Melanie. *The Writings of Melanie Klein III: "Envy and Gratitude" and Other Works, 1946–1963*. London: Hogarth Press, 1975.

Klein, Melanie. *The Writings of Melanie Klein IV: The Narrative of a Child Analysis*. London: Hogarth Press, 1975.

Segal, Hanna. *Introduction to the Work of Melanie Klein*. London: Karnac Books, 2008 (originally published in 1968).

■ CHRIS VANDERWEES

KOUROTROPHOS CULTS

The polytheistic tendency of the ancient Greek mind means that although it is impossible to outline a definitive interpretation of the term *kourotrophos*, the word can be translated as a term for a children's nurse or teacher, either human or animal, who, as the manifestation of motherhood and nursing, inspired special cults, rituals, and offerings in the ancient Greek religion. For example, in Crete, pregnant women would present offerings to Artemis, and water taken from a site thought to be especially blessed would be added to the bath taken after a woman gave birth. In Brauron, Artemis was worshipped as the *kourotrophos* responsible for birth, children, and young people, especially girls. Artemis was thought to be responsible for their journey from childhood to adulthood as well as an influence on fertility, and as such she was presented with votive offerings.

The *kourotrophos* is usually presented as a multidimensional deity predominantly connected with childrearing. This can be seen, for instance, in her association with motherhood, as in the filial cults of Demeter; or she can care for children as Gaia the great mother of all things; or she can be a virginal child-rearer as Athena. It is notable that in Greek art and literature, the *kourotrophos* who raises the child is not always the mother. For example, Athena acts as the *kourotrophos* to Erichthonius, whom she fostered after he was born from Gaia. Zeus has many *kourotrophos* as he was believed to have been raised by various figures, including nymphs, a goat, Melissa, and Gaia; and Hermes raised Dionysus after he was given into his care by Zeus.

Kourotrophos cults differ from the fertility cults of other religions as these other cults tended not to stress the importance of the nursing and childrearing elements of motherhood.

See also ART, WESTERN; FERTILITY SYMBOLS; MYTHOLOGY

Further Reading

Fischer-Hansen, Tobias, and Birte Poulsen. *From Artemis to Diana: The Goddess or Man and Beast*. Copenhagen: Collegium Hyperboreum and Museum Tusculanum Press, 2009.

Hadzisteliou Price, Theodora. *Kourotrophos: Cults and Representations of the Greek Nursing Deities*. Leiden: E. J. Brill, 1978.

Koloski-Ostrow, Ann Olga, and Claire L. Lyons. *Naked Truths: Women, Sexuality and Gender in Classical Art and Archaeology*. London: Routledge, 2004.

■ VICTORIA WILLIAMS

L

LA LECHE LEAGUE

La Leche League is an international nonprofit breastfeeding support organization that was founded in 1956 by seven Catholic mothers in Illinois. Based on their own experiences with childrearing and their frustrations with the information available to mothers about breastfeeding, Mary Ann Cahill, Edwina Hearn Froehlich, Mary Ann Kerwin, Viola Brennan Lennon, Betty Wagner (Spandikow), Marian Leonard Tompson, and Mary White came together to organize a group that would promote the practice of breastfeeding by educating and assisting women on a mother-to-mother basis. The organization was founded at a time when breastfeeding rates in the United States had fallen to roughly 20 percent and most women were taught to feed their children by bottle with infant formula. The organization spread quickly beyond the United States and became La Leche League International (LLLI). The organization is now present in over 60 countries around the world, and its publications are available in numerous languages. The organization works closely with the American Medical Association and the World Health Organization.

Goals and Philosophy: LLLI functions on a local level by holding small-group meetings led by mothers who are experienced in the practice of breastfeeding. The organization emphasizes the importance of transmitting knowledge and experience from mother to mother with the goal of helping women achieve confidence and a sense of purpose as mothers. LLLI believes that breastfeeding is the most natural way to fulfill the physical and emotional needs of a baby and that devotion to breastfeeding will promote positive parent–child bonds. Mothering should be child-centered and responsive to the needs of the infant, rather than driven by the medical profession. Furthermore, the philosophy of the organization views breastfeeding as one facet of a broader ideology of motherhood and holds that empowering women as mothers will ultimately have a positive impact on families and society.

Publications: In addition to mother-to-mother assistance, LLLI promotes its vision in publications such as *The Womanly Art of Breastfeeding*, first issued as an unbound volume in 1958, and *The Breastfeeding Answer Book*, first published in 1991. These publications address a range of pragmatic topics, from returning to work after having a baby to dealing with breast abscesses. *The Womanly Art of Breastfeeding* also focuses on breastfeeding not only as a way of providing the best nutrition for an infant, but also as a form of human connection, explaining, "Breastfeeding is a connection as well as a food source, a baby's

first human relationship, designed to gentle him into the world with far more than just immune factors and good nutrition."

Criticism: By the 1960s and 1970s, the organization had garnered considerable support from women who sought a more natural understanding of childbearing and mothering in opposition to prevailing notions of scientific motherhood, which taught women to feed their children precisely measured formula on a rigid schedule. Rates of breastfeeding rose from roughly 20 percent in the 1950s to around 60 percent in the mid-1980s, attesting to the fact that pro-breastfeeding attitudes resonated with many women. Yet LLLI also received considerable criticism, particularly from second-wave feminists who believed that the organization's maternalist philosophy restricted women's autonomy by insisting that motherhood was a natural role for women and that their most important place was within the family. Feminist critics rejected the notion that women should stay at home with their children, forgoing a career outside of the home. Moreover, they saw the idealization of motherhood as a dangerous move that reduced women to their reproductive biology, marking them as radically different from rather than equal to men. The organization also garnered criticism for primarily addressing the concerns of a narrow range of white, middle-class, Christian women. LLLI continues to receive criticism for implying that women who do not breastfeed are "bad" mothers, irrespective of the economic, medical, and personal circumstances that contribute to women's decisions about infant feeding.

See also BREASTFEEDING; BREASTFEEDING, IN PUBLIC; WOMEN'S MOVEMENT

Further Reading

Bobel, Christina G. "Bounded Liberation: A Focused Study of La Leche League International." *Gender and Society* 15, no. 1 (February 2001): 130–151.

La Leche League International. 2008–2011. Retrieved May 15, 2014, from http://www.llli.org

Ward, Jule DeJager. *La Leche League: At the Crossroads of Medicine, Feminism, and Religion.* Chapel Hill: University of North Carolina Press, 2000.

Weiner, Lynn Y. "Reconstructing Motherhood: The La Leche League in Postwar America." *Journal of American History* 80, no. 4 (March 1994): 1357–1381.

■ NORA DOYLE

LINNAEUS, CAROLUS (1707-1778)

Carolus Linnaeus was a Swedish physician, botanist, and naturalist. Often called the "father of taxonomy," Linnaeus established the universally recognized binomial system of naming biological species that is still in use today. Linnaeus first implemented his binomial classification system to plants in *Species Plantarum* (1753), and extended it to the zoological world in the tenth edition of *Systema Natura* (1758)—which is where the designation of *mammal* appeared for the first time.

At least six unique characteristics could differentiate mammals as a generic order, but mammals are called such because they possess breasts. The term derives from *mamma* (*mammae*, pl.), the common Latin term for the female breast (which includes associated milk-producing structures, or mammary glands). All mammals, it could be argued, are

nourished in infancy by lactiferous teats (or breasts) of varying number, but only those of the female are functional—albeit on a part-time basis, after the viviparous birth of off-spring. The term gained almost immediate acceptance despite its female specificity.

Trends in naming anything are often affected by political, cultural, and social realities. This is certainly reflected in our classification as *mammal*, since shifting religious and cultural associations with the female breast are ever present. The practice of breastfeeding places humans squarely within the broader mammalian order, but it simultaneously separates us because human reason explicitly connects the practice to the propagation of our species. The practice of wet nursing, and associated infant mortality rates, were at their height at the time of Linnaeus' writing. In fact, Linnaeus also penned a polemic treatise against the practice of wet nursing in 1752. With our designation as mammals, the function of the female's lactiferous teats was explicitly linked to mammalian success and propagation, regardless of biological sex. History suggests that science is not a value-neutral endeavor, and our eighteenth-century biological classification as *mammal* acts as a case in point.

See also Breast Anatomy; Breast Milk

Further Reading

Quammen, David. "Linnaeus the Name Giver: A Passion for Order." *National Geographic*, June 2007. Retrieved October 21, 2012, from http://ngm.nationalgeographic.com/2007/06/linnaeus-name-giver/david-quammen-text

Schiebinger, Londa. "Why Mammals Are Called Mammals: Gender Politics in Eighteenth-Century Natural History." *American Historical Review* 98, no. 2 (1993): 382–411.

■ STEPHANIE LAINE HAMILTON

LITERATURE

The breast has been featured prominently in almost all world literatures from ancient times to the present. Poets and writers were and are still fascinated by the female breast. It is seen as the bed of life; a site of beauty and aesthetics; a source of inspiration; a divine site of worship; a symbol of femininity, motherhood, and human tenderness; and, last but not least, a site of medication, medical research, and financial profit.

Rarely has a female body part engaged the minds and hearts of writers and readers more than the breasts. Female parts such as the eyes, lips, neck, hair, waist, vagina, legs, thighs, and posterior have received their share in literary texts, but none has been acclaimed more than the breasts and their peripheries: the nipples.

In Greek mythology, the goddess Hera's breasts are depicted, in addition to their beauty, whiteness, and firmness, as the source material of the Milky Way, a galaxy that adorns the sky with millions of heavenly bodies. Hera's breasts are seen as a source of life, as they generate milk to nourish the people on earth. Hence, Hera is closely associated with the cow.

In classical Arabic literature, poets saw the breast as a site of femininity, beauty, and sexual excitement. The breast is compared with pomegranates in its roundness, with ivory in its whiteness, with pigeons in their fluttering, and with marble stone in its firmness. The breast is even dubbed "the fruit of the necks," as it hangs under the neck the way exotic

fruits dangle from the branches of trees. Furthermore, a few female Arabic proper names are derivatives of the breast's shape and form: *Nahid* is a female proper name indicative of a big breast, while *Kaab* is another female name signifying a small budding breast. Such is the importance of the breast in the Arabic tradition that Arabs name their daughters after it and its phases.

The breast also appeared in the writings of Ottoman, Persian, and modern Turkish poets. Omer Khayam, Baki, and Nazim Hikmet, among many others, wrote lasting poems about the beauty and charms of the breast. Baki, for instance, compared breasts to Ali's double-bladed sword; Ali bin Abi Talib is the fourth Muslim caliph and the prophet Mohammad's cousin, and his sword supposedly has two sharp scissors-like cutting blades.

In Yoruba literary texts, the fullness and erectness of the breasts, along with other bodily features, are signs of perfect femininity. The traditional *Ifa* poetry accentuates the virtue of the breast in the making of a beautiful woman.

In the modern literary tradition, the breast is additionally seen as a threat to the phallocentric world. In lesbian literature, the breast, among its other functionalities, is celebrated as a site of war tactics. It is used as a decoy to thwart man's attempts at invading female territory. The Amazon fighters, Diane Griffin Crowder reports, "bare their breasts aggressively before a besieging male army. Taking this as an act of sexual submission, the men advance close to the women and are annihilated." In a similar vein Malika Mezzane, a Moroccan poet and feminist, turns the breasts into a metaphor for revolution against the oppressive patriarchal regimes, and into a trap of death for the male enemy: "Before yearning to my breasts / First, identify your features among the corpses" (translation is mine). Along the same line, many feminist scholars see the breast as a site of opposition between feminist discourses and the phallocentric logos.

Although the breasts are frequently described in novels and poems in connection with female nudity in ways that titillate the readers and pave the way to eroticism, a discursive look at the way the breast is viewed in literary texts shows that the breast is seen as a site of:

1. Play and tinkering, as in Willis Barnstone's "Letter to My Fingers": "Enough. Get off the keys. Go home and hold / a glass of tea and think of tinkering / with apples, tits, cognac."
2. Danger and challenge, as in e.e. cummings's "between the breasts," where cummings warns: "Hooray / hoorah for the large / men who lie / between the breasts / of bestial Marj."
3. Motherhood, milk, and feeding. In Dante's corpus, the breast is mentioned frequently in association with feeding and weaning. In eighteenth-century England, Samuel Richardson's novels, including *Pamela*, associated the breast with womanhood and breastfeeding as opposed to the prevalent characterizations of upper-class women as wives rather than mothers.
4. Pleasure and happy memory, as in the writings of American poet Adrienne Rich: "My mouth hovers across your breasts / in this bed we are delicate / and touch so hot with joy we amaze ourselves."
5. Beauty, aesthetics, and admiration, as in sixteenth-century English poet Edmund Spenser's "Amoretti": "Her brest lyke lillyes, ere their leaves be shed; / Her nipples

lyke young blossomed jessemynes"; and Serbian American poet Charles Simic's "Breasts": "I love breasts, . . . / Pearly, like the east / An hour before sunrise, / Beads of inaudible sighs, / Vowels of delicious clarity / I spit on fools who fail to include / Breasts in their metaphysics / I insist that a girl / Stripped to the waist / Is the first and last miracle."

6. Phantasmagoria, as in Philip Roth's novel *The Breast* (1972), where David Kepesh, the protagonist of the novel, metamorphoses into a huge breast.

7. Femininity and selfhood, as in twentieth-century American poet Anne Sexton's "The Breast": "Later I measured my size against movie stars. / I didn't measure up. Something between / My shoulders was there. But never enough."

8. Worship and glory, as in Robert Herrick's "Upon Julia's Breasts": "Display thy breasts, my Julia, there let me / Behold that circummortal purity; / Between whose glories, there my lips I'll lay, / Ravished in that fair Via Lactea." Such exaltation of the breast to the point of divinity comes most likely from what medieval scholars describe as the cult of the Virgin's milk, which was a widespread cult in medieval Europe.

9. Humor and tongue-in-cheek remarks, as in American poet Jill McDonough's "Breasts like Martinis": "One's not enough. Okay; we can do better than that. I like my breasts / Like I like my martinis, we say: Small and bruised or big and dry. Perfect. / Overflowing. Reeking of juniper, spilling all over the bar."

10. Sickness and nostalgia, as seen in Anne Sexton's "Dreaming the Breasts": "Mother . . . in the end they cut off your breasts / and milk poured from them / into the surgeon's hand / and he embraced them / I took them from him / and planted them."

Not all the breasts represented in literature are beautiful, sexy, and erotic. Not all of them are sites of aesthetics, femininity, admiration, and motherhood. There are also the big breasts of aggressive and intimidating women seen by critics as a signification of the Destructive Mother or the castrator. In such narratives, the breasts are no longer seen as erotic or productive. An example of this is Nurse Ratched, the nurse with big breasts, in Ken Kesey's *One Flew over the Cuckoo's Nest*.

See also ART, WESTERN; BREASTFEEDING; MYTHOLOGY; RELIGION; THEATRE

Further Reading

Barnstone, Willis. "Letter to My Fingers." *Boundary 2* 10, no. 3 (1982): 177.

Crowder, Diane Griffin. "Amazons and Mothers? Monique Wittig, Helene Cixous and Theories of Women's Writing." *Contemporary Literature* 24, no. 2 (1983): 117–144.

Cummings, E. E. *Complete Poems, 1913–1962.* New York: Harcourt, 1972.

Herrick, Robert. *The Poetical Works of Robert Herrick.* Oxford: Clarendon Press, 1915.

Kesey, Ken. *One Flew Over the Cuckoo's Nest.* New York: Signet, 1962.

McDonough, Jill. *Where You Live.* London: Salt, 2012.

Mezzane, Malika. *Mutamaredan Yamur Nahduka min Hona* [*The Arrival of the Rebellious Breasts*]. Rabat, Morocco: Ryad Press, 2005.

Rich, Adrienne. "My Mouth Hovers across Your Breasts." In *Love's Witness: Five Centuries of Love Poetry by Women*, edited by Jill Hollis. New York: Carroll and Graf, 1999.

Roth, Philip. *The Breast.* New York: Vintage, 1995.

Sexton, Anne. *The Complete Works.* New York: Mariner Books, 1999.

Simic, Charles. *Selected Poems, 1963 to 1983.* New York: Braziller, 1990.

Spenser, Edmund. "Amoretti." In *The Norton Anthology of English Literature*, 5th ed., edited by M. H. Abrams. New York: W. W. Norton, 1986.

<div align="right">■ VISAM MANSUR</div>

LOVE, SUSAN (1948-)

An American surgeon, professor, author, and advocate of breast cancer research, Love is the president of the Dr. Susan Love Research Foundation (formerly the Santa Barbara Breast Cancer Institute) and a clinical professor of surgery at the David Geffen School of Medicine at University of California, Los Angeles. Love's work was influential in the creation of the breast cancer prevention movement that began in the 1990s. She is widely considered the United States' foremost authority on breast cancer.

Born to Irish Catholic parents in Long Branch, New Jersey, Love was educated at parochial schools and spent 2 years in premed courses at the College of Notre Dame. Following a brief career as a nun, she enrolled at Fordham University and received a bachelor's degree. She initially worked for the State University of New York's Downtown Medical Center in Brooklyn, and completed her surgical residency at Beth Israel Hospital in Boston. Love became chief breast surgeon at the Dana Farber Cancer Institute in 1982. In 1988, she founded the Faulkner Breast Center in Boston. In the same year, Love became pregnant through artificial insemination with her life partner and surgical colleague, Helen Cooksey. After an extended legal battle, the couple formally adopted their daughter, Katie, and became the first to win Massachusetts Supreme Court recognition for their status as co-mothers. In 1990, *Dr. Susan Love's Breast Book* became a bestseller, and, during the same year, Love cofounded the National Breast Cancer Coalition (NBCC), an umbrella organization for more than 180 breast cancer advocacy groups. In 1992, she was recruited to found and operate the UCLA Breast Center. President Bill Clinton appointed Love to the National Cancer Advisory Board in 1998.

Love's work was influential in shifting the medical and political focus on breast cancer from traditional methods of surgery, radiotherapy, and chemotherapy to the development of research and funding that would more closely examine the progression of the disease and produce new prevention strategies. Love has argued that mammography and self-examination are limited in their effectiveness for early detection of breast cancer, maintaining the necessity for strong funding programs for breast cancer research. She is also known for her critical approach to the role of gender in science and medicine. Love has expressed concerns that white, middle-aged men conduct the majority of breast cancer surgery and research. In multiple interviews during the 1990s, Love argued that breast cancer had largely been ignored in the United States because it was a disease of women. Her efforts with the NBCC led to the passing of the Breast and Cervical Cancer Treatment Act under President Clinton, guaranteeing treatment for uninsured women with low incomes.

The Dr. Susan Love Research Foundation has recently partnered with the Avon Foundation for Women to recruit 1 million women of all ages and ethnicities for the Army of

Women project. This project's aim is to partner women with breast cancer researchers to conduct and promote research that will encourage the scientific community at large to support breast cancer prevention research conducted on healthy women.

See also AVON FOUNDATION FOR WOMEN; BREAST CANCER; BREAST CANCER TREATMENT; MAMMOGRAMS

Further Reading

Gover, Tzivia. "Dr. Love and the Politics of Disease." *The Advocate* 728 (1997): 38–40.

Love, Susan M., with Karen Lindsey. *Dr. Susan Love's Breast Book*. Philadelphia: Da Dapo Press, 2010.

Love, Susan M., with Karen Lindsey. *Dr. Susan Love's Menopause and Hormone Book*. New York: Three Rivers Press, 2003.

Olson, James S. *Bathsheba's Breast: Women, Cancer, and History*. Baltimore: Johns Hopkins University Press, 2002.

■ CHRIS VANDERWEES

M

MAIDENFORM

In 1922, Enid Bissett and Ida Rosenthal began making bras in Enid's dress shop in New York City. The women believed bras that provided more support and enhanced women's figures, rather than the current bandeau-style bras, would improve the fit of the dresses they made. Maidenform was designed to be the opposite of the "Boyish Form" brand that was then popular. The women first gave away bras with their dresses, but as the bras themselves became popular, they stopped making dresses and turned to full-time brassiere manufacturing. Ida's husband William Rosenthal helped design the bra, and a patent was issued in 1926.

During World War II, supplies of silk and nylon went mainly toward making parachutes. The Maidenform Company manufactured parachutes, as did many other companies. It also designed and developed the "pigeon vest." This vest allowed paratroopers to carry homing pigeons with them as they parachuted behind enemy lines.

Maidenform's bra, the Chansonette, introduced in 1949, became its most popular model. It became known as "the bullet bra." Like other bras of this era, it was designed to make each breast look like a cone-shaped projectile.

In 1949, the Maidenform Company initiated its now famous "I Dreamed" advertising campaign. In these ads, women were dressed in clothing from the waist down, but wore only bras above the waist. The women were featured in a variety of everyday situations and in more unusual settings, such as a bullfighting ring. The first ad displayed the words "I dreamed I went shopping in my Maiden Form bra." The campaign ran for 20 years. In 1962, *Mad* magazine ran a spoof of the ads with the line "I dreamed I was arrested for indecent exposure in my Maidenform Bra." More recently, in 2008, the company and its campaign were referenced in the popular television series *Mad Men*, which is about a 1960s-era advertising firm.

The company remained a family business for much of its history, but it became a publicly traded company in 2005. It is still one of the top shapeware brands in the United States, and Maidenform bras are sold in stores all over the world.

See also ADVERTISING; BRASSIERE; BEAUTY IDEALS, TWENTIETH- AND TWENTY-FIRST-CENTURY AMERICA; FLAPPERS; JACOB, MARY PHELPS; WONDERBRA

Further Reading

Deutsch, Claudia H., "Dreaming of Bras for the Modern Woman." *New York Times*, September 28, 2005. Retrieved May 15, 2014, from http://www.nytimes.com/2005/09/28/business/media/28adco .html

Yalom, Marilyn. *A History of the Breast*. New York: Knopf, 1997.

■ MERRIL D. SMITH

MAMMOGRAMS

In a modern-day context, mammograms or X-rays of the breast have existed since the 1970s as a medically approved screening technique for breast cancer. Although ages may vary, mammograms are generally recommended annually or biannually for women 40 years of age and older in order to detect any type of abnormal growth (benign or malignant) among breast tissues and the surrounding lymph nodes utilizing minimal-dose X-ray imagery. Despite concerns regarding the small level of radiation emitted during the mammography, the health gains of the test are thought to far outweigh the risks associated with it. In fact, mammograms are considered to use less penetrating X-rays since they are only designed for soft-tissue use (the breast) as opposed to other X-ray machines that are geared to examine bones and other dense objects. Medical technology has vastly improved the accuracy of mammograms. Currently, studies suggest that new procedures such as dual-energy contrast-enhanced mammography and 3D mammography may improve diagnostic accuracy even further.

Mammogram Types: Mammography exams are generally of two types: (1) screening mammograms and (2) diagnostic mammograms. Screening mammograms can potentially detect changes deep in the breast and surrounding tissues much sooner than they can be identified through physical touch. In contrast, diagnostic mammograms are generally recommended if an abnormality or problem is already known to exist or if conditions are present where it may be difficult to capture a sufficient picture, such as when there are breast implants. Screening mammography exams tend to only include two image captures per breast, comprising a view from above (cranial caudal) and an angled view (mediolateral oblique). This process has been described as more cost effective, since it does not have the added technical and interpretation fees associated with diagnostic mammograms. Subsequently, the diagnostic mammography takes longer since more pictures of the breast are captured, which are more costly. Besides front, angled, and side views, diagnostic mammograms may include spot compression and views with higher levels of magnification to capture detail.

Breast Abnormalities: If a breast abnormality is detected through mammography, a radiologist or other specially trained doctor usually medically classifies it. Such abnormality classifications include, but are not limited to, terminology such as palpability, malignant or benign designation, early stage, in situ (confined to location), laterality (right or left), and mass type (asymmetric, distortion, and intramammary node). Depending on the mammography results, additional testing may be necessary, including an ultrasound, a biopsy, magnetic resonance imaging (MRI), or electrical impedance imaging (EIS or T-scan), in

order to be more conclusive about the nature of the problem. These tests collectively aid in understanding both the type of breast cancer and the level of metastasis (spread) in the organs and tissues of the body, if any.

Breast Self-Examinations and Non-cancerous Breast Concerns: Monthly breast self-exams are highly encouraged as part of a home care regimen. Likewise, an annual breast self-exam performed by a gynecologist or doctor in the office is also an important component of breast health management, especially in women who are previous survivors of breast cancer. These self-exams may help an individual identify what is normal to one's body in contrast to what is out of the ordinary. Some potential warning signs that something might be wrong may include changes in the skin around the breast, nipple discharges that soil clothing or bedsheets, and the discovery of a lump or hardening of the breast. Mammograms may also be used to detect other noncancerous breast concerns. Although it is more common to

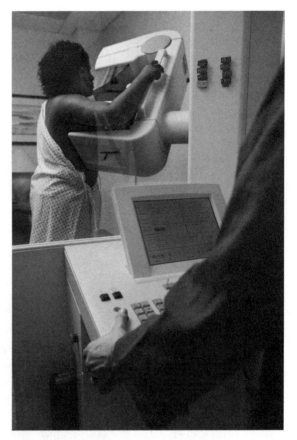

This image shows a woman getting a mammogram of her right breast. The technician carefully positions the woman and her breast in order to get a clear image. Jupiter Images/Thinkstock by Getty

hear about breast cancer in the media (especially since breast self-exams are so heavily encouraged), it must be noted that nine out of ten women have breast conditions that are benign or noncancerous in nature. Among them include cysts, nipple discharge, mastitis (breast inflammation), papillomas (wart-like growths that are noncancerous), and fat necrosis (swelling of the breast fat). Although these conditions are non-life-threatening, they still carry with them pain and discomfort.

Risk Factors of Breast Cancer and Media Attention: Breast cancer is the fifth leading cause of death among women ages 40 and older in the United States and the ninth leading cause of death among women living in the most economically developed nations. Research suggests that the risk factors for breast cancer development include later age at first or any birth, late menopause, nulliparity (not bearing offspring), early age at first menstrual period, late menopause, and affluent background. More recently, celebrities (i.e., Christina Applegate, Sheryl Crow, Guiliana Rancic, and Robin Roberts) who have battled breast cancer have spoken out about the importance of early detection and treatment. Early detection of cancer before it metastasizes is one of the best methods of combating breast

cancer to date. Both treatment and chances of survival improve dramatically through early detection.

See also BREAST ANATOMY; BREAST CANCER; BREAST CANCER SUPPORT GROUPS; BREAST CANCER TREATMENTS; PINK RIBBON CAMPAIGNS

Further Reading

Bray, Freddie, Peter McCarron, and D. Maxwell Parkin. "The Changing Global Patterns of Female Breast Cancer Incidence and Mortality." *Breast Cancer Research* 6 (2004): 229–239.

Breen, Nancy, and Martin L. Brown. "The Price of Mammography in the United States: Data from the National Survey of Mammography Facilities." *Milbank Quarterly* 72, no. 3 (1994): 431–450.

Dromain, Clarisse, F. Thibault, F. Diekmann, E. M. Fallenberg, R. A. Jong, M. Koomen, et al. "Dual-Energy Contrast-Enhanced Digital Mammography: Initial Clinical Results of a Multireader, Multicase Study." *Breast Cancer Research* 14 (2013): R94 1–17.

"How Mammography Is Performed: Imaging and Positioning." *Imaginis*, 2013. Retrieved May 15, 2014, from http://www.imaginis.com/mammography/how-mammography-is-performed-imaging-and-positioning-2

National Breast Cancer Awareness Month. Retrieved May 15, 2014, from http://nbcam.org/.

Schapira, Marilyn M., Timothy L. McAuliffe, and Ann B. Nattinger. "Underutilization of Mammography in Older Breast Cancer Survivors." *Medical Care* 38, no. 3 (2000): 281–289.

■ TARIQAH NURIDDIN

MAN BRA

Also referred to as a male bra, compression bra or vest, gynecomastia vest, manssiere, or "bro," a man bra is a brassiere worn by men. Typically, man bras function as a form of breast binding, compressing male breasts so as to conceal and support them. These bras allow boys and men to give the appearance of a flatter, more masculine chest. Male athletes may also use man bras to prevent sweat-soaked garments from chafing nipples during exercise.

Man bras are most commonly used to conceal and support breasts that develop as a result of obesity or gynecomastia. Gynecomastia (or enlargement of the glandular tissue of the breast) is often caused by hormone imbalance between free estrogen and free androgen actions in the breast tissue. The condition is common among adolescent boys during puberty as the testes and peripheral tissues may produce relatively more estrogen before testosterone reaches adult levels. In adolescents, gynecomastia is usually temporary, but an estimated one-third of all boys and men may experience this condition at some point in their lives, especially as testosterone levels decline in old age. Although gynecomastia is usually asymptomatic, man bras are frequently sold and marketed as an alternative to cosmetic surgery for men who suffer from temporary or permanent gynecomastia. Man bras aid in concealing gynecomastia to avoid ridicule and embarrassment that might occur as a result of bullying.

Man bras are famously featured in "The Doorman," an episode of the NBC television series *Seinfeld*. In this episode, Kramer invents a bra for overweight men, which he calls the "bro." George's father, Frank, however, prefers to call it the "manssiere."

See also BRASSIERE; GYNECOMASTIA; OBESITY; PUBERTY; TRANSGENDER/TRANSSEXUAL

Further Reading

Braunstein, Glenn D. "Gynecomastia." *New England Journal of Medicine* 357 (2007): 1229–1237.
"The Doorman." *Seinfeld*, episode 104. First aired February 23, 1995.
Yost, Merle James. *Demystifying Gynecomastia: Men with Breasts*. Novato, CA: Gynecomastia.org, 2006.

■ CHRIS VANDERWEES

MASTECTOMY AND LUMPECTOMY

Mastectomy and lumpectomy are surgical procedures involving the removal of breast tissue, and they are typically performed under general anesthesia. Lumpectomy is the removal of a small portion of the breast in order to remove a tumor. Mastectomy can be performed in a variety of ways and involves removal of larger portions of breast tissue and possibly surrounding structures such as lymph nodes. Mastectomy may be performed because of a diagnosis of breast cancer, to prevent breast cancer in people with a strong family history, or in order to improve the appearance of the chest due to breast growth in men (male chest reconstruction). Mastectomy can be performed with or without nipple–areola reconstruction, in which nipples and areolae are created from other skin and grafted into the site. Mastectomy for male chest reconstruction may or may not involve removal and subsequent relocation of the nipples depending on the amount of tissue removed. Mastectomy can involve one or both breasts.

Three basic incisions are in common use for mastectomy: peri-areolar (key hole), anchor, and single (or double if involving both breasts) incisions. Peri-areolar incisions are used when there is little mammary tissue compared to fat, the nipple and areola will not be moved or removed, and the skin is sufficiently elastic. Peri-areolar incisions are primarily used for male chest reconstruction and not for surgical cancer treatment. Anchor incisions involve incisions that run from the areola to the base of the breast, and then horizontally to create an inverted T-shape. The use of anchor incisions usually includes relocation of the nipple and areola. Single (or double) incisions involve one incision per breast along the base and usually include relocation of the nipple and areola. Commonly, anchor and single- (or double-) incision mastectomies are performed using a cauterizing scalpel that reduces bleeding. However, all surgeons have their own particular style and preferences that give their best results.

For all types of mastectomies involving the removal of significant amounts of tissue, it is usual for the surgeon to insert a drain following removal of the tissue. The drain collects fluid that builds up due to the sudden empty space between the skin and deeper tissues. The most common type of drain currently in use is called a Jackson–Pratt drain, which uses gentle suction. A flexible tube is rolled and inserted into the surgical site with one end exiting through a separate incision, usually slightly lower than the incision and under the patient's arms. A detachable bulb is attached to the end of the tube and is squeezed before placement in order to exert the gentle suction necessary to collect fluids from under the skin. The bulb or tube may be attached to a surgical binder, a thick piece of elastic material that goes around the chest and back to compress the surgical site and prevent fluid buildup. The bulb is emptied, and the amount of fluid recorded. Once the amount collected falls below a certain point, the surgeon removes the tube with local anesthesia. Stitches may also be removed at this appointment. For procedures

not involving significant amounts of tissue (e.g., revisions on previous mastectomies), the surgeon may only apply a binder.

Swelling in the chest, particularly along the incisions, is normal and decreases as the skin and deeper tissues heal. It is not uncommon for some swelling to remain for several weeks. Resumption of all normal activities, including heavy lifting, can usually occur after 6 weeks, and light clerical duties after 2 weeks. However, the resumption of activities can be very individual and depends on the patient's healing.

The skill of the surgeon, location of incisions, and style of stitches used can affect aesthetic satisfaction. People who have had mastectomies may seek additional surgeries to improve their appearance after approximately 12 months. Women who have had mastectomies due to cancer or family history of cancer may choose to wear prosthetic breasts, although not all do so. Women who have had mastectomies due to family history of breast cancer may in some cases have implants, although this is uncommon due to fear that the implant may increase the risk of breast cancer.

See also BREAST ANATOMY; BREAST CANCER; BREAST CANCER TREATMENT; BREAST REDUCTION; IMPLANTS

Further Reading

Hussain, M., L. Rynn, C. Riordan, and P. J. Regan. "Nipple-Areola Reconstruction: Outcome Assessment." *European Journal of Plastic Surgery* 26, no. 7 (2003): 356–358. doi:10.1007/s00238-003-0566-x

Laronga, C., B. Kemp, D. Johnston, G. L. Robb, and S. E. Singletary. "The Incidence of Occult Nipple-Areola Complex Involvement in Breast Cancer Patients Receiving a Skin-Sparing Mastectomy." *Annals of Surgical Oncology* 6, no. 6 (1999): 609–613. doi:10.1007/s10434-999-0609-z

Simmons, R. M., M. Brennan, P. Christos, V. King, and M. Osborne. "Analysis of Nipple/Areolar Involvement with Mastectomy: Can the Areola Be Preserved?" *Annals of Surgical Oncology* 9, no. 2 (2002): 165–168. doi:10.1007/BF02557369

■ ISRAEL BERGER

MASTITIS

Mastitis is an inflammation of the breast. It is most commonly associated with breastfeeding, although it can occur when the breast is infected for other reasons. The condition also occurs in mammals, such as cows, goats, dogs, and pigs that nurse their young. The symptoms include localized inflammation along with flulike symptoms, such as fever, chills, and discomfort. The infected breasts become very tender and may display a red wedge-shaped area.

Risk factors for lactation mastitis include poor breastfeeding techniques in which milk ducts do not get drained and/or nipples become cracked or fissured. Studies have also suggested that postpartum stress and sleep deprivation can lower women's immunity and increase the risk of mastitis. Mastitis often occurs in the first few weeks postpartum, but cracked or sore nipples are much more common than mastitis.

Mastitis in breastfeeding women can often be prevented by ensuring that milk ducts are emptied entirely. It is important that the infant latches onto the nipple properly, and sometimes changing the baby's position during breastfeeding sessions aids in emptying

all areas. Some women, however, may vary nursing positions before they have mastitis because they have cracked or sore nipples. Women are also advised not to wear tight-fitting bras, and to air-dry their nipples whenever possible.

Throughout history, some women have suffered from painful breasts while nursing. Occasionally, abscesses develop. Late eighteenth-century Maine midwife Martha Ballard treated sore breasts with various poultices, including some made from sorrel or wheat bread. In one case, she applied yellow lily roots, but that appeared to make the woman's pain worse. She also lanced some women's breasts to relieve fluids in an abscess when she thought it was necessary to do so.

Today, warm compresses can help to aid the discomfort of sore and engorged breasts, but health care providers might recommend acetaminophen or ibuprofen for pain. In some cases, doctors or midwives might prescribe antibiotics to get rid of the infection. It is important that women continue breastfeeding even when breasts are sore and they are in pain, as stopping can make the infection worse, and the infection does not harm the breast milk. Warm showers as well as compresses are helpful in relieving the pain of engorged breasts. Breastfeeding women are also advised to drink extra fluids and to try to get extra rest.

See also AREOLAE; BREAST ANATOMY; BREASTFEEDING; NIPPLES

Further Reading

Foxman, Betsy, Hannah D'Arcy, Brenda Gillespie, Janet Kay Bobo, and Kendra Schwarz. "Lactation Mastitis: Occurrence and Medical Management among 946 Breastfeeding Women in the United States." *American Journal of Epidemiology* 155, no. 2 (2002): 103–114. Retrieved May 15, 2014, from http://aje.oxfordjournals.org/content/155/2/103.full

Spencer, Jeanne P. "Management of Mastitis in Breastfeeding Women." *American Family Physician* 78, no. 6 (September 15, 2008): 727–731. Retrieved May 15, 2014, from http://www.aafp.org/afp/2008/0915/p727.html

Ulrich, Laurel Thatcher. *A Midwife's Tale: The Life of Martha Ballard, Based on Her Diary, 1785–1812.* New York: Knopf, 1990.

■ MERRIL D. SMITH

MEDIA

Mass media are a powerful agent of socialization that shapes social and cultural ideas about women and men, bodies, and contemporary gender norms. Mass media reflect, construct, and reinforce these ideas and norms by depicting women in traditional roles or as objects through sexualization and commodification. Although women's bodies are sexualized in general, many images focus specifically and sometimes exclusively on the breasts. Images that portray women as sexual objects transmit the message that women are socially valued for their bodies, attractiveness, and usefulness for the benefit of others' desires and needs. In contrast, images that center on other aspects of breasts such as breastfeeding, women's sexual freedom, aging, or disease are absent from popular media imagery.

Some of the cultural themes about breasts disseminated through mass media include the following: breasts are fundamentally sexual objects, exposed breasts are enticing yet

controversial, and exposed breasts for the purposes of feeding infants are obscene. Social constructions are often conflicting. In Western society, exposed breasts are simultaneously viewed with disdain and titillation. For example, during the live Super Bowl XXXVIII halftime show, Janet Jackson experienced a "wardrobe malfunction." The malfunction occurred when Justin Timberlake ripped open her shirt, exposing her breast on national television. The event caused a great deal of controversy and criticism. Yet many of the advertisements featured during that same Super Bowl broadcast used breasts to promote products, but did not garner any negative attention. Another example of the contradictions surrounding breasts is the May 2012 cover of *Time* magazine that featured a young, attractive mother breastfeeding a 3-year-old male child. The woman is wearing a thin-strapped tank top, and the male child is standing on a stool to reach his mother's exposed breast. Both mother and child are looking directly into the camera. The title of the cover reads, "Are you mom enough?" Media images of mothers breastfeeding their children, a natural function of the breast, are few. However, this image received staunch criticism. Many believed that the image was provocative, unnecessarily sexualized, and to some extent obscene.

Representations of women throughout all forms of mass media are highly sexualized, even hypersexualized and objectified. "Sexualized images" are images that are sexual in nature. Images that are hypersexualized go one step further in that they are created to sexually arouse viewers. Women are objectified in the media when their bodies are positioned or featured as objects devoid of life. For example, in all media platforms, there are countless images of women with arched backs, full breasts, erect nipples, and revealing clothing. Sexual images make up about 20 percent of all magazine and web content and 10 percent of all television content. These margins seem small given the sheer of amount of media Western society views, but these numbers are substantial. Although the primary consumers of mass media are women, the majority of media images are constructed using a male gaze. The "male gaze" is an angle or view that sexualizes and objectifies women and their breasts for the primary purpose of heterosexual male satisfaction and consumption.

In Western society, breasts represent traditional womanhood and femininity because the budding of breasts signals a girl's transition into womanhood and traditional gender roles such as a wife and mother. As such, maintaining femininity is socially constructed as a woman's primary pursuit. Media construct images of women based on dominant ideologies of how women should look and behave. Mass media serve as an additional, influential layer of social pressure to encourage women to conform to these expectations. Mass media reflect and reproduce norms about beauty, attractiveness, and women's desirability. In particular, breasts are part of accepted gender displays. The increased focus on breasts teaches young girls and women to police their bodies to maintain idealized femininity and attractiveness.

Sexualized images of women and their breasts also socialize men to see girls and women primarily as sexual objects. For example, media images often position women to appear sexually available and ready regardless of the situation. Women are more likely to be dressed provocatively in revealing clothing. Further, women's bodies are more likely to be objectified by showing portions of their bodies, typically the breasts, often with their faces covered or obscured. The sexual attraction associated with breasts is culturally specific and socially constructed. Although most images are constructed using the male gaze, women are not passive in the construction and promotion of sexualized images of their

bodies and breasts. Some women accept sexualized images disseminated through media to ensure conformity with idealized standards of beauty and attractiveness. These images serve to support the idea that women are to maintain sexual availability for others' desires.

There are few studies that look specifically at breasts in the media; however, there are numerous studies that look at the sexualization of women in the media and point to the cultural preoccupation with breasts as sexually arousing. Most women presented via media images represent the heterosexual male's "fantasy woman" with a large bust, a narrow waist, and proportional hips and thighs. However, although this sexual-fantasy female figure is unrealistic, women are held to and hold themselves to these idealized standards. Due to the media construction of the universal preference for large breasts, some women feel inadequate and resort to unnecessary elective cosmetic surgery. Technological advances in medicine give women the option to enlarge or reduce their breasts to conform to idealized or standard notions of beauty and attractiveness. These standards are racialized, class based, and gendered. Breast augmentation is the number one requested cosmetic surgical procedure among women. The cosmetic surgery industry buys into media depictions of large breasts as the ideal and views the natural variation in breast size as pathological and in need of surgical enhancement. The narrow representation of breasts in media suggests that only those who are proportionate, supple, young, and readily available are desirable, attractive, and, therefore, normal.

The social meanings associated with women's breasts are contradictory and conflicting. Breasts are viewed with disdain and deemed obscene when used for breastfeeding, yet the sexualization of breasts for advertisements is normalized. Sexualized images of breasts are commonplace; however, images that show breasts in relation to their biological function are seen as obscene and inappropriate for public view. Breast images in the media reflect societal expectations of beauty, youth, and desirability. Images of breasts in the media are airbrushed and manipulated to perfection. Rarely do media images include breasts that are disproportionate, have loss of firmness and elasticity, or are small or very large. Breasts in the media are unrealistic and do not reflect the normal variations of women's breasts, yet these images are presented as authentic.

The sexualization of women and girls is harmful on a number of fronts, including negative effects on cognitive functioning, physical and mental health, and sexuality as well as destructive attitudes and beliefs. Sexualization of women through the media reinforces idealized notions of femininity and sexuality. Media images may not have an immediate impact on viewers; however, the cumulative impact is clear. Numerous studies point to the relationship between media consumption and destructive behaviors like eating disorders, increases in body dissatisfaction, and women's disproportionate use of unnecessary cosmetic surgery. The effects of sexualization of women and their breasts seem obvious, yet they are difficult to document. Objectifying and sexualizing women via mass media is correlated with negative attitudes regarding women. Without critical examination of the way that society interprets media messages, breasts will continue to be sexualized and objectified via the media. Counterexamples of women are needed.

See also ADVERTISING; BREAST AUGMENTATION; BREASTFEEDING, IN PUBLIC; CELEBRITY BREASTS; CONTROVERSIES; EATING DISORDERS; INTERNATIONAL CULTURAL NORMS AND TABOOS; MODELS AND MODELING; TELEVISION

Further Reading

Faludi, Susan. *Backlash: The Undeclared War against American Women*. New York: Three Rivers Press, 1991.

Gill, Rosalind. "Supersexualize Me! Advertising and 'the Midriffs.'" In *Mainstreaming Sex: The Sexualization of Western Culture*, edited by Feona Attwood. New York: I. B. Taurus, 2009. Retrieved May 15, 2014, from http://www.awc.org.nz/userfiles/16_1176775150.pdf

Rajagopal, Indhu, and Jennifer Gales. "It's the Image That Is Imperfect: Advertising and Its Impact on Women." *Economic and Political Weekly* 37 (August 10, 2002): 3333–3337.

Wade, Lisa, and Gwen Sharp. "Selling Sex." In *Images That Injure: Pictorial Stereotypes in the Media*, edited by Paul Martin Lester and Susan Dente Ross, 163–172. Westport, CT: Praeger, 2011. Retrieved May 15, 2014, from http://lisawadedotcom.files.wordpress.com/2011/02/wade-sharp-2011-selling-sex.pdf

Wallis, David. "The Breast of Advertising: From Hooters to the Cover of 'Time,' Does the Strategy Sell or Repel?" *Adweek*, June 4, 2012. Retrieved May 15, 2014, from http://www.adweek.com/news/advertising-branding/breast-advertising-140889

Wolf, Naomi. *The Beauty Myth: How Images of Beauty Are Used against Women*. New York: HarperCollins, 1991.

Zurbriggen, Eileen L., Rebecca L. Collins, Sharon Lamb, Tomi-Ann Roberts, Deborah L. Tolman, L. Monique Ward, and Jeanne Blake. "Report of the APA Task Force on the Sexualization of Girls: Executive Summary." *American Psychological Association* online, 2007. Retrieved May 15, 2014, from http://www.apa.org/pi/women/programs/girls/report-summary.pdf

■ AMBER E. DEANE

MODELS AND MODELING

Models are hired to display and promote commercial goods and services and to make products or an artist's work visible to the general public. Female models have been used throughout history as the subjects of visual images. Beginning as models for paintings and sculpture, women later became models for photographers. Images of women became key elements of modern advertising. The fashion industry relies heavily on idealized images of women. As cultural ideals and fashion trends shift, so too do the preferred shape and size of models' breasts.

Illustrations of fictional women first appeared in magazines and can be seen as a precursor to contemporary modeling. Beginning in 1886, *Life* magazine featured illustrations by Charles Dana Gibson (1867–1944) known as "Gibson Girls" that depicted the New Woman of the time, wearing a corset to create a trim waist and buxom figure. Alberto Vargas (1896–1982) illustrated imaginary pinup-style women for *Esquire* magazine. Unlike Gibson's illustrations, Vargas Girls often wore clothing that revealed the breast, or they were seminude and posed in provocative reclined positions. Alfred Cheney Johnston (1885–1971) photographed the Ziegfeld Girls, showgirls and dancers who performed with the Ziegfeld Follies, for standard advertisements in their full costumes, but Johnston also photographed the performers fully nude and topless throughout his career, perhaps for artistic or personal reasons.

Runway and haute couture fashion modeling began in Paris in the 1850s as designers asked women to wear their clothing as a method of display. The first modeling agencies came into existence in the early 1920s as photography continued to develop. Slim models were pictured wearing the boyish flapper fashions of the day, often wearing bandeau bras to flatten their bust. During the 1930s, 1940s, and 1950s, well-known models Lisa

Fonssagrives (1911–1992), Dorian Leigh (1917–2008), and Suzy Parker (1932–2003) did not bare their breasts in images. Instead, they sported streamlined and industrially influenced clothing and bras, which promoted sleek lines and aesthetically referenced the planes, automobiles, and weapons of the period.

By the 1950s, pinup models like Betty Page (1923–2008) and celebrities like Marilyn Monroe (1926–1962) were featured in *Playboy* magazine as centerfolds and cover models. The magazine included fully nude photographs that emphasized curvaceous bodies, large breasts, and the hourglass figure. Page was also often photographed by Irving Klaw (1910–1966) in bondage scenes and in burlesque films, but was always in costumes or lingerie that covered her breasts in these films. Since the early days of *Playboy* magazine, there has been a preference for models with large breasts both as pinups and in swimsuits and lingerie advertisements. Celebrity models like Monroe often cross between various styles of modeling, appearing in high-fashion shoots and commercial advertisements. There is much debate over

This fashion model is depicted with full breasts and a slender body. Her legs are elongated by high heels. Ervin Usman/Thinkstock by Getty

Monroe's actual measurements. It is clear her weight and size fluctuated, but she continually retained hourglass proportions with a small waist and a large bust line.

The emergence of arguably the first supermodel, Twiggy (born Lesley Hornby Lawson in 1966), drastically changed the fashion landscape and ushered in an era of thin fashion models with boyish figures. Twiggy, at age 17, 5 feet 6 inches tall, and 91 pounds, measured 31-22-32. Unlike models of the previous decade, Twiggy had underdeveloped breasts and an androgynous look that was unique and suited the miniskirts and mod clothing she often modeled. During the height of her fame, her style was emulated by girls and women, which started a continuing debate on the influence of unattainable and unhealthy body images and ideals.

Models and pinups of the 1970s and 1980s returned to a more natural body type with womanly breasts influenced by the aerobics and fitness trends popular at the time. The term "supermodel" was widely used during this period, and many models gained celebrity status and name recognition by posing for the *Sports Illustrated* "Swimsuit Issue" while also walking the runway and being the faces of national advertising campaigns. Models like Christie Brinkley, Cheryl Tiegs, and later Cindy Crawford, Stephanie Seymour, and Naomi Campbell appeared in the issue and also on the runway. The "Swimsuit Issue," like *Playboy* magazine, utilizes models with large breasts and traditional hourglass figures. The issue often shows the models in various styles of revealing bikinis or topless with their hands or objects covering their breasts. Many of the images feature visible nipples seen through the swimsuits. Kate Upton, a voluptuous model whose body type harkens back to the 1950s models, was featured on the 2013 *Sports Illustrated* "Swimsuit Issue" with her breasts partially exposed.

Victoria's Secret models came into prominence as the brand developed and spread into malls in the 1980s and 1990s. The Victoria's Secret Fashion Show began airing in 1995 and features models, also known as "Angels," sporting a range of cup sizes who walk the runway in thematic lingerie. The catalog and ad campaigns feature the models in pushup bras and lingerie that create cleavage.

In a shift away from the naturalistic, tanned, tall, and buxom models of the 1980s, Kate Moss became the face and body of a fashion movement dubbed "heroin chic" in the 1990s. With smaller breasts and a thin frame, styled with dark eye circles, Moss was often criticized for her waifishness. There has been consistent criticism of the fashion industry for using thin models who appear emaciated and underweight. These models typically have little to no cleavage because of their extreme thinness. Critics question what effect visual images of thin models have on women and girls who view these bodies as ideal.

Models, particularly in commercial advertising or in pornography and adult films, may have breast augmentation surgery to increase their cup size. Breast augmentation surgery was reported as one of the most popular cosmetic surgery procedures both in the United States and worldwide in 2012. There is debate on the effects of viewing images of surgically enhanced models on women's self-esteem and body image.

Photo-editing software such as Adobe Photoshop is used to digitally enhance models' bodies by creating thinner waists and thighs while also enlarging the breasts. The actress Keira Knightley's breasts were digitally augmented for the U.S. movie poster for the film *King Arthur* (2004), while the actress Jennifer Love Hewitt's breasts were reduced for the print advertisements for the Lifetime series *The Client List* (2012). Victoria's Secret is also known for its heavy use of digital editing to slim models, create curves, and enhance cleavage.

Transgendered models are becoming more widely used in runway shows and fashion photography. Some transgendered models, like Isis King and Lea T, have fully transitioned and have had breast augmentation and sex reassignment surgery. Andrej Pejic, an androgynous male model who has not undergone breast augmentation surgery, has been featured in runway shows, in topless fashion editorials, and in bra advertisements.

Breast size is also considered important in specialty modeling, including plus-size modeling, fitness modeling, and promotional modeling. Plus-size models are heavier models who wear larger sized clothing and have proportionately larger breasts. Fitness models

with particularly muscular physiques often have breast implants to retain a feminine look. Promotional models perform at conventions or interact with the general public. Their look and breast size are dependent on the brand and the audience, but often fall into the large breast–small waist standard for promotions related to a typically male audience, including car shows, beer sales, and video game conventions.

In modeling, the preferred breast size is dependent on many factors, including the genre or category of modeling, with commercial advertising favoring large-breasted models with a traditional hourglass figure and runway fashion shows favoring thin, androgynous, and small-breasted models. The pendulum of fashion trends also factors into what type, size, and shape of breast are in style and desirable for models during a given time period.

See also ADVERTISING; ART, WESTERN; BEAUTY IDEALS, NINETEENTH-CENTURY AMERICA; BEAUTY IDEALS, TWENTIETH- AND TWENTY-FIRST-CENTURY AMERICA; BODY IMAGE; BRASSIERE; CELEBRITY BREASTS; CORSETS; *ESQUIRE*; FASHION; FLAPPERS; IMPLANTS; PINUP GIRLS; PHOTOGRAPHY; *PLAYBOY*; TRANSGENDER/TRANSSEXUAL

Further Reading

Buszek, Maria Elena. *Pinup Grrrls: Feminism, Sexuality, Popular Culture.* Durham, NC: Duke University Press, 2006.

English, Bonnie. *A Cultural History of Fashion in the 20th and 21st Centuries: From Catwalk to Sidewalk,* 2nd ed. New York: Bloomsbury 2013.

Gross, Michael. *Model: The Ugly Business of Beautiful Women.* New York: William Morrow, 1995.

Koda, Harold. *Extreme Beauty: The Body Transformed.* New York: Metropolitan Museum of Art, 2004.

■ RACHELLE BEAUDOIN

MODESTY

Modesty applies differently to each gender. In terms of modesty related to the covering of specific parts of the body, rather than its meaning as the opposite term for boastfulness, modesty refers predominantly to women. Clothing is expected to cover those body parts considered sexually arousing, such as breasts, in order to dampen women's sexual allure. This practice results from a view held in most Western societies that women, almost exclusively, hold the role of the seductive temptress. Initially, the category of modesty was introduced to gain control over female sexuality in order to prevent male transgressions, a regulatory practice characteristic of patriarchal societies. In patriarchal societies, being modest and bashful for a woman translates as hiding her sexual needs in the pursuit of good reputation and taking good care of her body, which is achieved primarily by hiding it from others in order to keep it pure. In this respect, modesty and shame often intersect, for the feeling of shame in women indicates a supposed transgression from the norm of appropriateness. For instance, women who wear sexually alluring clothes and expose their breasts are considered to offend modesty and are often perceived as shameless. Having shame indicates an appropriate behavior in women, as qualities such as shyness, modesty, and bashfulness are a required norm of a so-called respectable woman.

Although the standards of modesty vary across societies and cultures, women are generally expected to keep their breasts covered in public; however, certain traditions or contexts allow more breast to be exposed. The notion of modesty relies heavily on the attitudes toward nakedness. Not all cultures see nakedness as shameful or view naked female breasts as inappropriate or embarrassing. Australian aborigines, for instance, are indifferent to their nakedness, whereas they would feel ashamed while being seen eating. In Western cultures, naked breasts have ambiguous significance since they are connected to equally maternal and sexual qualities. Church and religious ideologies have played a major part in establishing the norms of exposure of the female body and its significance in Europe, the United States, and many other Western countries.

Between CE 100 and 500, Church fathers defined the fundamental characteristics of seductive attire and, in opposition, modest ways of dressing. The consequence of indicating styles of dressing, as well as which specific body parts should be covered or can remain uncovered, is that all parts of the female body have been objectified and sexualized. The rules about how much breast is appropriate for a modest woman to show have been changed throughout time and place, although showing the nipples and areolae has almost always been considered immodest, and in some instances is viewed as lewd or indecent behavior. In the period between the Renaissance and the nineteenth century, in many parts of Europe, wearing low-cut dresses that displayed and emphasized breasts appeared more acceptable than today. In some aristocratic circles, the exposure of breasts was at times regarded as a symbol of social status and wealth.

In contemporary Western society, the extent to which a woman may expose her breasts in public—or, in other words, the standards of modesty—depends on the social and cultural context. From the 1960s onward, greater sexual permissiveness led to increasing displays of cleavage in films, on television, and in everyday life, and low-cut dress styles became very common, even for casual wear. Though displaying cleavage can be permissible in many settings, it may be prohibited by dress codes in settings such as workplaces, churches, and schools, where exposure of any part of female breasts may be considered inappropriate or immodest.

The category of modesty became somewhat devaluated in contemporary modern societies where women reject the socially imposed restraints regarding their outfit and behavior; this attitude reflects the change of gender roles. In modern societies, the category of modesty was nevertheless replaced by shame about the body's imperfections, which acts as a regulatory factor of body exposure for women. The consumerist culture subjects women to perfection, where any apostasy from the ideal makes women want to hide their body or surgically alter their appearance. Breasts, due to the widespread accessibility of pornographic images and their ensuing sexualization, are a particular reason for women's dissatisfaction and shame. This includes the sexualization of lactation, which makes many women feel embarrassed to breastfeed their infants in the presence of others, in order not to be stigmatized as having no shame. In addition, because breasts are inextricably intertwined with sexuality and femininity, women frequently have ambiguous feelings about their breasts or even a sense of inadequacy.

See also ADVERTISING; BREAST AUGMENTATION; BREASTFEEDING; BREASTFEEDING, IN PUBLIC; CELEBRITY BREASTS; DÉCOLLETAGE; FASHION; MEDIA; MOVIES; PORNOGRAPHY

Further Reading

Bouson, J. Brooks. *Embodied Shame: Uncovering Female Shame in Contemporary Women's Writings*. Albany: SUNY Press, 2009.

Laver, James. *Modesty in Dress: An Inquiry into the Fundamentals of Fashion*. Boston: Houghton Mifflin, 1969.

Lindisfarne, Nancy. "Gender, Shame, and Culture: An Anthropological Perspective." In *Shame: Interpersonal Behavior, Psychopathology, and Culture*, edited by Paul Gilbert and Bernice Andrews, 246–261. New York: Oxford University Press, 1998.

Rubinstein, Ruth P. *Dress Codes: Meanings and Messages in American Culture*. Oxford: Westview Press, 1995.

■ ANETA STEPIEN

MOTHER–INFANT BOND

The social construction of the mother–infant bond relies on notions of essentialism, that women have *inherently* "feminine" qualities that constitute the "mother," such as nurture and compassion. Essentialism conflates biology and gender, which further renders "mothering" to describe affect and care in relation to guardianship. The word "mother" is synonymous with "look after, care for, protect, nurse, tend," whereas the word "father" is synonymous with solely reproduction: "sire, beget, and source." There are further assumptions made about the mother–infant bond beyond the human species. Although the relationship between mother and infant is constructed through the gendering of *mothering*, there are salient examples that substantiate the notion that infants form a unique relationship with their mothers. One critical element to the mother–infant bond relies on the breasts and breastfeeding. The breasts provide both comfort and sustenance to infants of all mammals.

Although ecofeminists have long denounced charges of essentialism, they have written on the relationship between mothers and their offspring. Ecofeminists such as Greta Gaard, Marti Kheel, Carol Adams, Josephine Donovan, and pattrice jones have written on the importance of connectedness, care, and compassion. Specifically, they have theorized about the role of breasts and breastfeeding in forming and sustaining the mother–infant bond in mammals. To this end, ecofeminists place great importance on the agency of female mammals to be able to breastfeed. Livestock animals, however, are bred and kept in various forms of captivity and denied access to breastfeeding. For example, cows are kept in a continuous state of lactation in order to commodify their breast milk into dairy products. Calves are removed from their mothers, despite their emotional and physical need for their mother's milk, in order to artificially extract the milk for humans. Female pigs are bred in order to produce more pigs for slaughter. The female pigs are often kept in small confined crates, even when giving birth. The piglets immediately attempt to suckle their mothers' breasts before being separated. The breast is an integral part of the mother–infant bond for all mammals (aside from the platypus which secretes milk from ducts in the abdomen).

The agency of mammals to engage in breastfeeding is an important part of creating and sustaining the mother–infant bond. Human mothers exercise their agency both through

the utilization of support organizations such as La Leche League and local breastfeeding centers, and through the proliferation of infant formula. Female mothers are presented with options, whereas many other mammals are denied agency in their reproduction and infant bonding by humans. From agribusiness' use of female animals to reproduce to the poaching industry globally that separates mothers from offspring, the closeness that the breast facilitates is denied. The conditions in which other species are able to form connections with their offspring are pertinent when considering the many benefits that are scientifically proven with regard to breastfeeding and skin-to-skin contact.

Studies have interrogated the ways in which breastfeeding impacts the relationship between a mother and her infant, including nonbiological children. Studies have found that breastfeeding mother–infant dyads report significantly higher postpartum interactions on the Barnard's Nursing Child Assessment Feeding Scale (NCAFS) than mothers who weaned breastfeeding or never tried. Research indicates that not only breastfeeding but also placing a newborn child immediately on the mother's breast after birth for skin-to-skin contact have positive implications. The scientific support of breastfeeding is the result of extensive research on the multitude of benefits for both mother and infant.

The breasts are an important part in the process of forming strong mother–infant bonds. Although not all human mothers are physically able to lactate and not all human mothers choose to breastfeed, the breast is still an important source of comfort. The breast is located over the heart, the source of calming sound and vibration. The important value of breasts in both mothering and infant development is not solely for humans. The mother–infant bond in mammals is enriched by the breast when the agency of the mother to make decisions is not constrained or manipulated by others. *Other-than-human* mammals are often constrained by humans based on speciesist beliefs and desires (capitalist incentive to commodify offspring to agribusiness, desire to consume breast milk from other species, etc.). The ability for human mothers to make empowered decisions about breastfeeding is also constrained by capitalism through the lack of postpartum economic support. Vanity and sexuality also influence the decision to breastfeed, despite the promotion of breastfeeding through scientific research.

See also Breastfeeding; Breastfeeding, in Public; Linnaeus, Carolus (1707–1778); Pregnancy; Weaning

Further Reading

Adams, Carol. *The Sexual Politics of Meat: A Feminist-Vegetarian Critical Theory.* New York: Continuum Press, 1990.

Adams, Carol, and Josephine, Donovan, eds. 2007. *The Feminist Care Tradition in Animal Ethic: A Reader.* New York: Columbia University Press, 2007.

Brandt, Kristie A., Claire M. Andrews, and Jan Kvale. "Mother-Infant Interaction and Breastfeeding Outcome 6 Weeks after Birth." *Journal of Obstetric, Gynecologic, & Neonatal Nursing* 27, no. 2 (2006): 169–174.

Gaard, Greta, ed. 1993. *Ecofeminism: Women, Animals, Nature.* Philadelphia: Temple University Press, 1993.

Kheel, Marti. *Nature Ethics: An Ecofeminist Reader.* Lanham, MD: Rowman & Littlefield, 2008.

■ JENNIFER D. GRUBBS

MOVIES

From the beginning of the film industry, movies have included female as well as male nudity. In an early study of moving film from 1884 to 1887, Eadweard Muybridge (b. 1830) experimented with the human figure in film by having both naked men and women perform everyday tasks in order to better show motion. Muybridge had famously used the technique of stop-action photography with animals, most notably horses, before moving on to human subjects. His female model in the early human figure study appears fully nude while walking up and down a staircase. This is most likely the first instance of female nudity in movies. Muybridge's use of nudity was not meant to be erotic, but erotic nudity in movies appeared shortly after his experiments.

From the 1890s to about 1922, female nudity in film was common. The French pornographer Eugene Pirou is often credited with bringing pornographic imagery to the movie screen. In 1896, Pirou helped produce *Le Coucher de la Marie* (*Bedtime for the Bride*), which features the first known female striptease on film. Some French films portrayed nudity in a less erotic sense as early as the 1890s. *Après Le Bal* (*After the Ball, the Bath*, dir. Georges Méliès, 1897), for example, depicts a maid undressing a woman in preparation for her bath. This theme of women undressing in an erotic or nonerotic manner was popular in short films in the first decade of the twentieth century. *From Show Girl to Burlesque Queen* (1903) and *Peeping Tom in the Dressing Room* (1905) are some examples of the popular erotic short films from this decade. Some actresses, like Theda Bara, became famous for their nudity in movies. Bara was known for wearing sheer costumes that exposed her bare breasts. One notable example is her infamous Cleopatra costume that exposed most of her breasts, only covering her nipples. Movies that featured nudity became increasingly difficult to produce in the second decade of the twentieth century because of moral protests against nudity by members of the Temperance Movement, particularly those from the influential Women's Christian Temperance Union. Films such as *Hypocrites* (1915) and *Purity* (1916) received scathing reviews, and their production was often stalled because of nude scenes. Nevertheless, female nudity in movies continued into the 1920s despite the new movie codes that sought to restrict it.

The moral objections of some moviegoers in the first two decades of the twentieth century led to the formation of the Motion Picture Producers and Distributors of America (MPPDA) in 1922 in order to clean up Hollywood's perceived nudity problem. Several states and cities implemented censorship bills, but many still argued that a larger institution needed to control the film industry. William H. Hays was selected to head the MPPDA and "clean up" Hollywood. Hays constructed lists of themes that were deemed unacceptable and themes that should be avoided when possible. Nudity was one of several themes that were to be avoided, but it continued because of a lack of enforcement on the part of the MPPDA. Most movie studios simply ignored the codes because nudity drew customers to the movies. Even films depicting biblical themes during the 1920s continued to include nudity. One famous example comes from *Ben-Hur: A Tale of the Christ* (1925), in which girls draped in only flowers dance bare-breasted around a procession. In Hollywood during the 1920s, actress Clara Bow, known as "The 'It' Girl," continued to show her breasts in movies throughout the decade. *Glorifying the American Girl*, the first feature-length film to depict full female nudity in color, was also produced at the end of the decade in 1929, when censorship was still lax.

The MPPDA started enforcing censorship in the 1930s. But until 1934, many films still depicted female nudity or at least alluded to it. *Tabu: A Story of the South Seas* (1931) featured women in revealing bathing suits, half-naked women swimming, and bare-breasted dancers in hula skirts. Foreign films, such as the Czech film *Ecstasy* (1933), still prominently displayed female nudity, but were often confiscated by U.S. Customs as movie codes became enforced. Even up until 1933, public movie posters showed female leads in silky, breast-baring tops and nightgowns. In 1934, however, movie censorship and the Hays Code went into full effect. MPPDA officials had to approve all movie scripts, and these scripts had to receive Production Code Administration (PCA) approval in order to be produced and released. Any studio that failed to comply was fined $25,000, and therefore many studios came up with new ways to include female nudity. Nudity itself was not prohibited, but the Hays Code stated that the nudity must not be sexually suggestive. Many studios got around this in a number of ways. Actress Jean Harlow was known for putting ice on her nipples before dressing in her thin, silky costumes that revealed her braless breasts underneath. When Harlow starred in *China Seas* in 1935, her silky nightgown clung to her bare breasts after becoming drenched in seawater, clearly showing her erect nipples.

During the 1940s, especially during World War II, the phenomenon of female pinups appeared. Famous female actresses posed for these seductive and usually scantily clad photographs, which helped to increase their popularity without the worry of movie censorship. Movies during the 1940s had to adapt to the Production Code, producing films with less nudity and more sexual innuendos. Even animated films like *Fantasia* (1940) had to be approved by the MPPDA. The cartoon centaurettes, who often appear bare-breasted or lightly covered in floral garlands, were considered controversial when the film was released. Actress Jane Russell, who starred in Howard Hughes's *The Outlaw* (1943), wore tops that were deemed too revealing, causing the film to be delayed and its seal of approval denied. Despite the film's lack of approval from the MPPDA, San Francisco movie theatres screened the film for a week in 1943, and then it was widely released in 1946.

Censorship waned after World War II, and in 1952 the U.S. Supreme Court case of *Burstyn v. Wilson* declared strict film censorship unconstitutional. The French auteur theory, which claimed that film was an art form that should be free from restriction, also helped to fight against movie censorship in the 1950s. Because of the decline in censorship, actresses like Marilyn Monroe and Sophia Loren were able to gain popularity during the 1950s, and often prominently displayed their breasts, either bare or barely covered. Loren had shown her bare breasts in multiple Italian films, such as *Due Notti Con Cleopatra* (*Two Nights with Cleopatra*, 1954), before becoming popular in the United States. Loren's American film roles included more subtle breast-baring scenes. In 1957's *Boy on a Dolphin*, Loren does not appear topless but, rather, emerges from the water in a clingy, drenched blouse that clearly shows the outline of her breasts. Monroe appeared nude, but wrapped in bedsheets, in *Niagara* in 1953, only months after the U.S. Supreme Court case declared censorship unconstitutional. Monroe's famous scene in *The Seven Year Itch* (1955) shows her clad in a low-cut white dress that flies up, exposing her legs as she uses her arms to keep the dress down and push her cleavage together. Also in 1953, the first film of Betty Page's Burlesque Trilogy, entitled *Striporama*, was released in adult-only theatres. All three of her feature-length films included stripteases and burlesque performances. Perhaps the

most controversial film to include female nudity was *The Garden of Eden*, which was produced in 1954. The movie takes place at a nudist camp and prominently features nude women, and it was therefore banned on the grounds that it was obscene. In 1957, however, after three years of legal conflict, the New York Court of Appeals ruled that the film was not obscene and should not be censored.

Films produced in the 1960s continued to push the boundaries in regard to female nudity. The genre of "nudie cuties" like *Boin-n-g* (1963), which were nonerotic nude films, was popular from about 1959 to 1966 and often included many topless female actresses. Foreign films, such as the popular Federico Fellini movie *La Dolce Vita* (*The Sweet Life*, 1960), featured nudity and sexuality, and they were not subject to U.S. movie codes. In 1963, Jayne Mansfield was the first A-list actress to appear nude in the controversial film *Promises! Promises!* In this film, she exposed her bare breasts and derrière. The film was considered indecent and was banned in many cities, including Cleveland. The film *The Pawnbroker* (1964) was the first American film featuring topless women to receive the Production Code seal of approval because it was considered necessary to the scene. The scene depicted Nazi soldiers in the process of raping the main character's wife and was therefore considered historically significant. In the later years of the 1960s, the counterculture movement greatly affected the amount of nudity seen in movies. More movies from 1966 to 1969 included cleavage, topless scenes, or naked women than in the previous years of the decade. This happened in part because the use of the Hays Code was discontinued in 1968 after struggling to control the movie industry. A few notable examples from this period are *One Million Years BC* (1966), *The Graduate* (1967), *Rosemary's Baby* (1968), and *Easy Rider* (1969).

By the 1970s and 1980s, the Hays Code had been replaced by the rating system of the Motion Picture Association of America (MPAA), making it easier for directors to include female nudity. Instead of being banned, films like *Woodstock* (1970) that included female nudity were given an R rating. One segment of Woody Allen's R-rated comedy *Everything You Always Wanted to Know about Sex but Were Afraid to Ask* (1972) featured a giant runaway breast that terrorizes people in the countryside.

Female nudity in horror films also became increasingly common during the 1970s and 1980s. One famous example is the shower scene in *Carrie* (1976), in which Sissy Spacek and other young women shower naked in the locker room. In a scene from *Rocky Horror Picture Show* (1975), a musical comedy horror film, Susan Sarandon's character Janet has her dress ripped off, exposing her bra and panties. In a close-up shot, Rocky, the Frankenstein-like creation, gropes Janet's breasts before having sex with her. Also, in the classic 1980s horror franchise, *Friday the 13th*, many female characters, especially those who end up as victims, are seen topless or naked before they are murdered by the villain, Jason.

By the 1990s, female nudity in film became banal. Even A-list actresses and pop stars, like Demi Moore and Madonna, exposed their breasts in movies. Demi Moore is shown topless during a sex scene in *Indecent Proposal* (1993). Also in 1993, pop star Madonna exposed her bare breasts during many sex scenes in *Body of Evidence*. In a famous nonerotic scene from *Titanic* (1997), the female lead, played by Kate Winslet, has her nude portrait drawn while lying on a couch. (Winslet won the 2009 Academy Award for best actress in

the English movie *The Reader*, in which she also appeared nude.) By the early 2000s, the stigma once associated with appearing topless or nude on film began to dissolve. Actresses who appeared topless were viewed as dedicated to their roles. In 2002, when Halle Berry won an Academy Award for her role in *Monster's Ball* in which she exposed her breasts, all five nominees for best actress had appeared nude or topless in a movie at some point in their career. Along with Halle Berry, that list included Nicole Kidman, Sissy Spacek, Helen Mirren, and Kate Winslet. Film franchises in the 2000s, like the *American Pie* series, capitalized on the popularity of topless scenes. The original *American Pie* was released in 1999, with three sequels from 2003 to 2012 and four spin-off movies from 2005 to 2009, all of which include topless actresses.

Many popular foreign films shown in the United States have also featured nudity. Federico Fellini's *Amarcord*, which featured several scenes showing bare breasts, including one memorable scene in which a buxom woman pushes her breasts into the face of a younger man, won the Best Foreign Film award at the 1974 Academy Awards. The 1992 Spanish-language comedy-romance film, *Jamon, Jamon*, with Penelope Cruz, included a scene in which a man licks a woman's nipples and compares one to ham and one to eggs. Ang Lee's 2007 espionage thriller set in World War II–era Shanghai, *Lust, Caution*, includes several scenes with nudity and sexuality that show bare breasts. More recently, the Swedish movie *The Girl with the Dragon Tattoo* (2009), based on the late Stieg Larsson's wildly popular novel, and its English-language remake (2011) featured nudity, including bare breasts, along with explicit sexuality and violence. *Chico & Rita*, a 2010 animated Spanish film, includes scenes with bare breasts.

Movies today continue to use female nudity as more and more big-name actresses are willing to expose their breasts and bodies. Actresses like Kristen Stewart, who appeared topless in 2012's *On the Road*, are now able to use these kinds of roles to further their dramatic acting careers. But female nudity is not confined to dramatic movies. Breasts are shown in all genres of film, from horror to science fiction. Some breasts are shown bare, while others are only prominently displayed through camera angles, heavy breathing, and sheer clothing. Breasts have been a part of movies since the 1880s and will continue to be a prominent feature in movies across the globe.

See also ADVERTISING; CELEBRITY BREASTS; MEDIA; MODELING; PINUP GIRLS; PHOTOGRAPHY; PORNOGRAPHY; TELEVISION; THEATRE

Further Reading

Benshoff, Harry M., and Sean Griffin. *America on Film: Representing Race, Class, Gender, and Sexuality at the Movies*, 2nd ed. Hoboken, NJ: John Wiley & Sons, 2011.

Dirks, Tim. "Sex in the Movies: An Illustrated Cinematic History." Retrieved May 15, 2014, from http://www.filmsite.org/sexinfilms-index.html

Jordan, Jessica Hope. *The Sex Goddess in American Film, 1930–1965*. New York: Cambria Press, 2009.

Pennington, Jody W. *The History of Sex in American Film*. Westport, CT: Praeger, 2007.

Williams, Linda. *Screening Sex*. Durham, NC: Duke University Press, 2008.

■ MICHELLE FITZSIMMONS

MUSIC, POPULAR

Like many aspects of capitalism, the music industry has made much of the breast. This is most notable not in the lyrics or content of the recorded music it produces, but in the visual material it uses to market it. The breast, especially the female breast, has been emphasized and sexualized on the cover art of Western music releases since the late 1940s. Although fashions, styles, taboos, and standards of appropriateness have changed in line with the wider culture, the principle of female objectification has remained at the core of musical marketing, with the breast as its frequent focus. Subtle and blatant examples are found across all forms of product design, developing in line with music technology: women have been sexualized on the covers and publicity material for 78s, LPs, 45s, tapes, and CDs and on the icons that accompany digital formats. Similarly, the female breast has been emphasized in the many live performances, promotional appearances, videos, films, and advertisements that have increasingly become the substance of the popular music industry.

There is a long history of women being used as visual proxies for male artists in such material. Indeed, when a male artist or bandleader does not possess an easily marketable public persona, a sexually attractive woman, often in a state of undress, is used in their stead. These publicity shots, known to American audiences as "cheesecake," developed on covers from the mid- to late 1940s. They are particularly prevalent on albums focusing on certain instruments (e.g., the Hammond organ), as well as compilation releases from diverse artists or unknown studio bands (e.g., the United Kingdom's notorious *Top of the Pops* series of releases from 1968 to 1985, collecting covers of popular hits). As a general rule, the more marginal the record company, the more explicit the imagery it used on its releases, which could contain actual sexual content ("stag" party material and risqué comedy) or typical cheesecake fare. A good example of the latter would be *Speak Low* by Hal Otis and His Orchestra, illustrated by Jayne Mansfield, her breasts barely contained by her evening dress.

One of the first cheesecake models was Virginia Clark (of Earl Carroll's Theater, Hollywood) who appeared on the cover of Harry Revel, Leslie Baxter, and Dr. Samuel J. Hoffman's *Music out of the Moon: Music Unusual Featuring the Theremin*. This was released in 1947 on shellac, a year before the debut of the vinyl LP, the format on which such covers thrived. It was also an early example of "exotica," a musical genre fascinated by the sensual other. Unlike ethnographic recordings, which displayed the naked breast as a "scientific" illustration of native life, exotica dressed the American breast with a foreign allure that was profoundly sexual. Virginia Clark, for example, was depicted supine and distracted with sumptuous fabric covering her loins and breasts. Sandy Warner, model for many of Martin Denny's albums, was photographed standing waist deep in water for the cover of *Primitiva*, her deep cleavage clothed in torn fabric. This was the breast tempting the consumer into buying a ticket to a wilder America, where standards of probity were relaxed and fantasy made flesh. As a symbol, the breast is thus equated with the hedonistic promise of the contents on the record. This is an intensification of the relationship on purely cheesecake covers (where a sexualized woman is used as a visual proxy for a male artist, compilation, or collection of covers). Here the breast is an explicit manifestation of the music on the record. Genres of music that emphasize hedonism (e.g., disco, hard rock, hip-hop, and house) thus became associated with the breast, not just on album covers but also in all the visual material and performances that comprise the product.

Niagara's self-titled debut was released in a cover showing a large pair of sweat-covered breasts. This was both cheesecake and hedonistic in that it was the work of imageless studio musicians playing intense drum-focused explorations. It was also released in 1970, at the highpoint of explicit nudity on major label releases. The permissiveness of the late 1960s had not yet absorbed feminist critique, leading to such covers as Jimi Hendrix's *Electric Ladyland* (1968) and Roxy Music's *Country Life* (1974). More notorious were the naked pubescent girls on Blind Faith's self-titled debut (1969) and Scorpions' *Virgin Killer* (1976). A few releases attempted to emphasize the breast in a more progressive context, most notably John Lennon and Yoko Ono's *Unfinished Music No. 1: Two Virgins* (1968).

In general, however, the popular music industry has enforced the conditions of patriarchy by constituting the consumer's gaze as that of a heterosexual male, without regard to their actual sexuality or gender. Of course, there are challenges to this standard from individual artists and movements, but in general, mainstream popular music products have become increasingly sexualized from the 1950s onward, in line with the wider culture. As discussed, this trend is intensified in particular genres that emphasize hedonism, such as hip-hop and rock, with the female breast being an especially frequent focus in the latter. Since the 1970s, for example, hard rock and heavy metal performers have often encouraged female audience members to expose their naked breasts for the consumption of the crowd.

This is illustrative of an important principle: popular music products encourage identity work in their audience. Since many of the products of popular music are highly sexualized, it follows that their audience might be highly sexualized too. However, it must be remembered that the audience members are not passive in the way they consume products. While they may enact the sexualization of music marketing, they may well adapt, comment on, or disagree with them too. Janet Jackson and Justin Timberlake's infamous "wardrobe malfunction" at the American Super Bowl in 2004 was significantly criticized by sections of the public and the media. Note here that much of the criticism was directed against Jackson: Timberlake's part in the controversy was downplayed, perhaps because he was enacting acceptable norms of dominant male sexuality.

That the incident was framed as an accident is unusual, because it highlights a crucial aspect of how female breasts and sexuality are framed in contemporary popular music. Beginning in the 1980s with Madonna, mainstream Western female performers have become more proactive in sexualizing themselves. Whilst in the past the breast has been used by the popular music industry as a proxy and lure, the emphasis, post Madonna, has been on female artists sexualizing themselves, taking charge of their bodies and careers. There are few contemporary international female artists who have not emphasized their own breasts as postfeminist weapons in the battle to establish themselves as a brand. As British philosopher Nina Power has noted, capitalism divides and rules, encouraging women to disembody their own breasts from their bodies and use them as resources. This can be seen whether women are performers or audience members, and often before the processes of puberty have begun on their own bodies.

See also MEDIA; MOVIES; PHOTOGRAPHY; TELEVISION; THEATRE

Further Reading

Dibben, Nicola. "Representations of Femininity in Popular Music." *Popular Music* 18, no. 3 (1999): 331–354.

Krenske, Leigh, and Jim McKay. "'Hard and Heavy': Gender and Power in a Heavy Metal Music Subculture." *Gender, Place & Culture: A Journal of Feminist Geography* 7, no. 2 (2000): 287–304.

Power, Nina. *One Dimensional Woman.* Winchester, UK: Zero Books, 2009.

■ MATTHEW CHEESEMAN

MYTHOLOGY

The first known objects of worship related to a Great Mother figure who was associated with fertility, natural cycles, and bounty. By the Proto-Neolithic period (c. 9000–7000 BCE), agricultural practices seem to have consciously included an element of worship to fertility goddesses or other feminine deities. Early sculptures and idols overwhelmingly present images of female fecundity: the female figures' large breasts, exaggerated hips, and swollen bellies all suggest life-giving powers. As much as these goddesses were associated with crops and birth, however, they were also connected to fallowness and death. All were necessary, inextricable parts of life, and the Great Mother controlled them in equal measure.

These early explicit connections between female deities and the land likely distill into Greco-Roman goddesses' companion or associative animals. For example, Venus is regularly depicted with doves and Diana with deer or bears. The powers of the Greco-Roman goddesses are also subordinated to those of the male gods, their abilities or traits more accurately seen as *aspects* of a complete masculine whole. The Greco-Roman goddesses were each also associated with specific elements of the natural world, rather than with life or the earth in a holistic sense: Venus becomes the goddess of sexual love and Hera the goddess of marriage, rather than a single goddess figure being responsible for giving and taking away all aspects of fertility and death. Hera's special connection to marital unions may speak to her mythical roles prior to becoming Zeus's queen, for she was first associated with a more overarching guidance of both heaven and earth, with all natural seasons and cycles part of a larger whole overseen by her. Hera's breast milk was said to be the origins for the Milky Way; in fact, the word "galaxy" takes its root from *gala*, which is Greek for "mother's milk." According to the myths, Hera unknowingly nursed Zeus's son Herakles while she slept (thus granting him immortality), but she rebuked him when she awoke. As she removed the infant from her breast, her milk shot into the sky and created the star system. Further evidence of Hera's earlier, more universal role can be gleaned from the fact that the goddess was associated with all stages in life and was able to offer protection to women both before and after childbirth.

Mother–child relationships are depicted with some regularity on surviving pots: Demeter and Persephone are perhaps the most common pairing, but Thetis and Achilles, and Eos and Memnon, are often offered in visual arts as well. Pot sculptors also took some interest in portraying myths involving violent pursuit: Theseus' kidnapping of Helen, Thetis struggling with Peleus, and Eos absconding with either Tithonos or Kephalos are all familiar narratives regularly depicted in ceramics. Despite the misogyny of ancient Greco-Roman

culture, goddesses and mortal women do play central roles in several important myths, and their places in the narratives are memorialized in text and ceramic.

While the place of gender in myth has become a more carefully considered topic in recent decades, many classicists still focus on structural elements of myth and the connections between ritual worship and myth. The Greco-Roman narratives in general operate according to frameworks based on human desires and wish fulfillment, not probability. The gods and goddesses of the Pantheon represent and experience urges, anxieties, and desires that might otherwise have been too abstract or frightening for the Greco-Roman mind. Certain social codes and systems remain, however, which keep the myths from being in an entirely imaginative or fantastical realm. Gods head up mythological family lines in

The goddess Diana is often depicted with one or both breasts bare and with her bow and arrow. Denys Kronylov/Thinkstock by Getty

ways that are basically patriarchal, for example. At the same time, myths do frequently take up issues of gender conflict and the violent possibilities inherent in sexual relationships. When human sacrifice occurs in myths and classical drama, virginal women are usually killed by men in service of a larger social need, a pattern that speaks to both the misogyny and the gender difference often noted in the narratives.

Many classicists assumed for years that Greek women had little involvement in the world outside the home, with Roman women faring only slightly better. Cult-based worship of deities was often limited to one sex, although it should be noted that cults and festivals did offer women access to the public world. The Eleusinian Mysteries involved ritual leadership by priests and priestesses, for example, while the Thesmophoria was exclusively for female worship of Demeter. Because women were connected to childbirth

and fertility (more so than men were), they were also given special responsibilities for agricultural festivals and celebrations intended to promote crop propagation. Additionally, some rituals associated with the household required women to make daily offerings at a temple (e.g., worshiping deities connected to childbirth when the women were pregnant), whereas others were more occasional (e.g., offerings by a mother when a daughter was getting married). The fact that they could go to temples to pray to deities, and that they could take part in organized celebrations or ceremonial worship of gods and goddesses, suggests that women in the classical world did have some presence in the public sphere, even if their involvement was limited and did not explicitly influence civic concerns such as politics or economics. The often positive portrayal of goddesses and mortal women in the myths is another indicator that the Greco-Roman world left some possibility for female authority and development.

See also ART, INDIAN AND AFRICAN; ART, WESTERN; BREASTFEEDING; BREAST MILK; ICONOG-RAPHY; PREGNANCY; RELIGION; SCULPTURE

Further Reading

Doherty, Lillian E. *Gender and the Interpretation of Classical Myths*. London: Duckworth, 2001.
Dowden, Ken, and Niall Livingstone, eds. *A Companion to Greek Mythology*. Chichester, UK: Wiley-Black-well, 2011.
Downing, Christine. *The Goddess: Mythological Images of the Feminine*. New York: Continuum, 2000.
Goff, Barbara. *Citizen Bacchae: Women's Ritual Practice in Ancient Greece*. Berkeley: University of California Press, 2004.
Lyons, Deborah. *Gender and Immortality: Heroines in Ancient Greek Myth and Cult*. Princeton, NJ: Princeton University Press, 1997.

■ LAURA SCHECHTER

MYTHS

Myths about breasts and breastfeeding abound in every culture. Some have been prevalent over many centuries, like the widely held belief that the first milk produced after child-birth, colostrum, is not good for the infant. Many myths and old wives' tales about breasts involve plant medicines, cultivated or wild herbs, fruits, and vegetables. We now know the exact and effective chemical compounds in these galactagogues, or breast milk–stimulat-ing plants, like fenugreek or fennel, which have been recommended to women for hun-dreds of years but were considered "superstitions" by eighteenth- and nineteenth-century physicians.

There are many myths about breasts, breast milk, and breastfeeding in Greek and Roman mythology. According to these myths, the Milky Way—the Via Lactea in Latin—was created from the spilt breast milk of Hera, who was breastfeeding Hercules. According to Greek mythology, the first wine glass was molded from the breasts of Helen of Troy. Centuries later, it was rumored that Marie Antoinette changed the shape of wine glasses by having them molded from her breasts. The ferocity of the mythical twin brothers of Rome, Romulus and Remus, is attributed to their having been suckled by a wolf. Other

ancient myths also involved breastfeeding: images of the Egyptian goddess Isis show her breastfeeding her son, Horus, as a powerful symbol of a belief in rebirth.

There were also early Christian myths: for example, the robin (*Erithacus rubecula*) got its red breast because as the bird removed a thorn from the crown of Christ during the crucifixion, its breast was pierced by the sharp point, staining it with blood. Other myths involve the breast milk of the Virgin Mary, who was often depicted in early and classical art as *Maria Lactans*, breastfeeding the Christ child.

From the classical period until the eighteenth century, breast milk was thought to be menstrual blood that changed color in the womb during pregnancy and flowed through the breasts after childbirth. In some cultures, colostrum is still considered a taboo food for infants. Infants may not be allowed to breastfeed from 24 hours to 5 days after birth. This delay in breastfeeding has been common in Europe and North America, where the custom of giving sugar water persists to this day. In some Pacific Islands cultures, an older woman, as official milk tester, puts a sample of the new mother's milk in a dish with a little water and hot stones. If the milk curdles, it is declared poisonous and suckling delayed. However, a suitable gift to the milk tester is likely to yield a favorable test result. In West Africa, a test of milk quality is to pour the breast milk on an ant. If the ant dies, that proves the milk is bad.

There are other common myths about breasts and breastfeeding:

- Do not breastfeed around strangers as an envious woman can simply look at a nursing mother and cause her milk supply to stop.
- If you eat cabbage, you will grow large breasts.
- When you are pregnant, it is a girl if your left breast is larger than your right breast. If it is a boy, your right breast is larger than your left.
- The location of a birthmark on the chest determines if the person will enjoy good luck; over the left breast means success, over the right breast means fortune, and center of the chest means neither.
- Ogling women's breasts is good for a man's health and can add years to his life.
- Moss People are dwarves who ask humans to give them breast milk to feed their young.
- To increase the supply of milk, rub the mother's back with warm oil that has had the bones of a swordfish steeped in it.

See also BREASTFEEDING; MYTHOLOGY; RELIGION

Further Reading

Jackson, Deborah. *With Child: Wisdom and Traditions for Pregnancy, Birth and Motherhood*. San Francisco: Chronicle, 1999.

Radbill, Samuel X. "Medical History: Infant Feeding through the Ages." *Clinical Pediatrics* 20, no. 10 (October 1981): 613–621.

Wickes, Ian G. "A History of Infant Feeding Part I, Primitive Peoples: Ancient Works: Renaissance Writers." *Archives of Disease in Childhood* 28 (1953): 151–158. doi:10.1136/adc.28.138.15

■ CLAUDIA J. FORD

N

NIPPLES

In humans, a nipple is a projection on the breast through which breast milk can be delivered to an infant who sucks on it. The nipple is surrounded by the areola, a round or oval area that is darker than the rest of the breast skin. It contains areolar glands, also called "glands of Montgomery," that produce oily secretions that moisturize and help to protect the nipple. The nipple and areola are very sensitive to touch and temperature. When stimulated, the areola contracts, and the surface becomes bumpy. In contrast, nipples that are cold or stimulated by touch become erect due to small muscles that respond to the autonomic nervous system.

Recent research has determined that women have between 17 and 27 milk ducts with 5–9 milk duct orifices in the nipples through which milk is released. Two or three holes are usually located in the center of the nipple, with three to five arranged around them. There are tiny sphincters in the holes that close to prevent milk from leaking out when a baby is not nursing. The milk ducts serve as transport conduits, rather than storage areas for breast milk. During breastfeeding, the stimulation of the nipple triggers hormones that produce contractions, which eject the breast milk through the milk ducts.

Nipples often become sore during breastfeeding, and some women discontinue breastfeeding because of pain in their nipples. Improper positioning of the baby or the baby's mouth sometimes causes sore nipples. Infections and allergies can also cause nipples to become irritated or sore during breastfeeding. Often, warm or cool compresses applied to the nipples and breasts or expressing some milk if the breasts are engorged can help in cases of nipple soreness.

Nipples in both women and men are highly sensitive, and they are often stimulated as part of sexual activity. In many countries, a woman's nipples (but not necessarily a man's) must be covered to escape obscenity charges, even if most of the rest of the breast is exposed.

In the past, entire breasts, including the nipples, were removed during mastectomies. In recent decades, many surgeons have begun performing nipple-sparing mastectomies to provide patients with a more aesthetically pleasing appearance. The nipple-sparing procedure is technically challenging, but it appears to be oncologically safe. Most women who have had the procedure are satisfied with the appearance of the breast postoperatively, even though sensation in the nipple may take months to reappear or may never return.

Some tattoo artists now work in medical micropigmentation. Working with plastic surgeons and dermatologists, these tattoo artists can create three-dimensional nipples as well as enhance the areolae on reconstructed breasts. Each procedure is done with colors and shading designed specifically for a particular individual so that it looks natural. For those with translucent skin, veins can even be tattooed onto the skin.

Nipple piercing has been a part of many cultures over the ages. A widely cited 1993 study is based on responses from a questionnaire administered to 292 men and 70 women. The respondents ranged in income, but the majority had at least some college education. Although the sample was skewed because the majority of respondents were involved in sadomasochism (S/M), most did not believe the nipple piercing was part of their S/M roles or activities. Nearly all respondents reported that they had their nipples pierced to enhance sexual responsiveness; most answered that they did not regret the piercing, even if they suffered from side effects, such as irritation, pain, redness in the nipples, or discharges from the nipples.

In the late twentieth and early twenty-first centuries, nipple piercing became something of a fad in Western societies, since many celebrities have displayed nipple rings. Some women and men claim that piercing the nipple enhances its sensitivity and sexual arousal. Most authorities indicate that women can continue to breastfeed after they have had their nipples pierced, but rings and other hardware should be removed before a child is put to the breast. This will help to prevent complications for the mother and accidental swallowing of hardware by the child.

See also AREOLAE; BREAST ANATOMY; BREASTFEEDING

Further Reading

Martin, Jahaan, "Nipple Pain: Causes, Treatments, and Remedies," *Leaven* 36, no. 1 (February–March 2000), 10–11. Retrieved May 15, 2014, from http://www.lalecheleague.org/llleaderweb/lv/lvfeb mar00p10.html

Moser, Charles, Joann Lee, and Poul Christensen. "Nipple Piercing: An Exploratory-Descriptive Study," *Journal of Psychology & Human Sexuality* 6, no. 2 (1993). Retrieved May 15, 2014, from http://www .tandfonline.com/doi/abs/10.1300/J056v06n02_04#preview

Yalom, Marilyn. *A History of the Breast*. New York: Knopf, 1997.

■ MERRIL D. SMITH

O

OBESITY

Obesity is defined as having a body weight that is higher than what is considered standard or ideal for height. It is also when excess fat exists throughout, or in one or more areas of, the body. To measure obesity, health care professionals calculate the relationship of weight to height or body mass index (BMI). A BMI of 30 or higher is considered obese. A BMI of 40 or higher is classified as morbidly obese.

Two types of fat exist: essential and storage. Essential fat helps the cells, tissues, and organs in the body function normally. For men, 3 percent of body fat is essential. For women, 12 percent is essential. Women require more essential fat for normal sex-specific functions. Sex-specific essential body fat is stored in the breasts, pelvic area, and thighs.

Storage fat is located under the skin, and it surrounds internal organs. It is used for energy, insulation, and warmth. Storage fat is also involved in growth, reproduction, and stages of life. For good health, essential and storage fat levels for men are between 8 and 24 percent. For a woman, they are between 21 and 35 percent. Body fat that exceeds healthy levels is associated with increased risk of preventable disease and death.

Genetics determines where body fat is deposited. Excess body fat in obese individuals is classified as excess subcutaneous truncal-abdominal fat (android or apple-shaped obesity) or excess gluteofemoral fat (gynoid or pear-shaped obesity). Android obesity is excess fat in the belly area. Gynoid obesity is excess fat in the thighs and buttocks region.

According to the U.S. Department of Health and Human Services Centers for Disease Control and Prevention, 35.7 percent of U.S. adults and 16.9 percent of youth in 2009 and 2010 were considered obese. Adult women 60 years of age and older had an obesity rate of 42.3 percent. The Institutes of Medicine report that obesity increases the risk of many diseases, including insulin resistance, cancer, and gynecological abnormalities. Breast cancer risk, cancer recurrence, and death in menopausal and postmenopausal women are directly related to obesity. Excess body fat is the main source of estrogen (the female reproductive hormone) in the body. Women who gain more than 20 pounds from 18 years of age to midlife have two times the risk of developing breast cancer. Women who gain weight after breast cancer diagnosis are also at an increased risk of poor recovery from breast cancer.

Obesity is related to early onset of puberty and breast development in young girls. Early breast development results from higher estrogen levels. Contributing factors to early breast

development include excess body fat, higher levels of blood insulin, and activation of leptin (the energy balance and appetite regulation hormone) in the hypothalamic-pituitary part of the brain. According to a *Journal of Pediatrics* 2010 study of 1,239 girls, 10 percent of Caucasian girls, 15 percent of Hispanics, and 23 percent of African-American girls developed breasts at age 7. At the age of 8 years old, the percentages increased to 18 percent for Caucasian girls, 31 percent for Hispanic, and 43 percent for African-American girls.

Obesity may contribute to increased estrogen production and breast tissue development (gynecomastia) in males. Gynecomastia occurs in puberty and is embarrassing for males. Breast reduction is usually recommended only after weight loss is achieved and maintained if an individual is obese.

Macromastia or gigantomastia refers to excess growth and proportion of breast tissue. Obesity and/or glandular hypertrophy are the main causes. Very large breasts may cause long-term discomfort and reduced quality of life. The American Association of Pediatrics reports that adolescent girls with macromastia suffer from self-esteem and eating disorders. Breast reduction is usually recommended only after maturity, and/or achieved and sustained weight loss.

See also BODY IMAGE; EATING DISORDERS; EXERCISE; GYNECOMASTIA; HORMONES; PUBERTY

Further Reading

Glickman, Dan, and the U.S. Institute of Medicine Committee on Accelerating Progress in Obesity Prevention. *Accelerating Progress in Obesity Prevention: Solving the Weight of the Nation.* Washington, DC: National Academies Press, 2012.

National Institutes of Health, Obesity Education Initiative. *Clinical Guidelines on the Identification, Evaluation, and Treatment of Overweight and Obesity in Adults,* NIH publication no. 98-4083, September. Washington, DC: National Institutes of Health, Obesity Education Initiative, 1998. Retrieved May 30, 2014, from http://www.nhlbi.nih.gov/guidelines/obesity/ob_gdlns.pdf

Ogden, Cynthia L., Margaret D. Carroll, Brian K. Kit, and Katherine M. Flega. *Prevalence of Obesity in the United States, 2009–2010,* NCHS data brief no. 82, January. Hyattsville, MD: U.S. Department of Health and Human Services, Centers for Disease Control and Prevention, National Center for Health Statistics, 2012. Retrieved May 30, 2014, from http://www.cdc.gov/nchs/data/databriefs/db82.pdf

■ KELLY L. BURGESS

P

PASTIES

Pasties are circular coverings used to conceal the nipples, and they are most commonly worn in pairs. They may have tassels attached to the ends, which the performer can twirl using her pectoral muscles. Particularly in modern striptease, anything affixed to and obscuring the nipple can be considered a pasty. The first pasties appeared on the breasts of performers in the Parisian dance halls of the 1920s. Rules and regulations set out by censors of the time dictated that breasts could not be bared in their entirety.

In the United States, public indecency codes requiring that dancers wear pasties have varied according to time and place. Some municipalities continue these restrictions, which generally fell out of favor in the mid-twentieth century. Today, pasties are worn by burlesque artists, performers, and exotic dancers who are required to do so by local laws. They may also be worn in lieu of a bra when a woman is wearing backless or see-through clothing, or wishes to sunbathe without noticeable tan lines.

Characteristically, pasties stand alone, and are set apart from other kinds of breast coverings in that they do not involve straps. Pasties also require a fixative or glue to stay in place. Gum arabic or spirit gum is most commonly used, although modern burlesque performers have been known to make use of tape, liquid latex, and even eyelash glue to ensure that their pasties adhere firmly.

The pasty has appeared in popular culture on female artists such as Rihanna, Pink, Lil' Kim, Lady Gaga, Britney Spears, Nicki Minaj, Dita von Teese, and—controversially, during the 2004 Super Bowl halftime show—Janet Jackson. Actresses who have donned pasties for roles include Marilyn Monroe (*Some Like It Hot*, 1959), Lanie Miller (*The Graduate*, 1967), and Diane Lane (*The Big Town*, 1987).

See also BRASSIERE; FOLIES BERGÈRE; STRIPTEASE

Further Reading

"Pasties." Bikini Science. Retrieved May 10, 2014, from http://www.bikiniscience.com/costumes/soutien-gorge_SS/pasties_S/pasties.html

Tease, Frankie. "Applying Your Pasties." Examiner.com, Clarity Digital Group, March 15, 2011. Retrieved May 10, 2014, from http://www.examiner.com/article/how-to-burlesque-applying-your-pasties

Weldon, Jo. *The Burlesque Handbook*. New York: It!, 2010.

■ ERIN PAPPAS

PHOTOGRAPHY

The naked body has been associated with gods, nature, and perfection in several cultures, and it has been a source of inspiration for human beings throughout history from prehistoric times to the contemporary world. The female body has aroused interest in painters, sculptors, poets, and other artists for both erotic and non-erotic reasons, and the breast has been deified in masterpieces by different art movements in multiple representations, such as breastfeeding, fashion, and nudes.

Between Instrument, Art, and Desire: During the earliest days of photography in the mid-nineteenth century, several pioneers in this field took pictures of bodies with scientific purposes: on one hand, to capture features of the body such as locomotion and expressions, and, on the other hand, with anthropologic purposes to portray native cultures overseas, including their body features. During this time, photography was not considered an art itself; it was only an instrument to aid other sciences and arts. Throughout the nineteenth century, photography of the female body coincided with art and social changes that detached it from other activities and expressions. First, photographic equipment (lenses) and procedures (chemicals) improved, producing better quality and definition standards in pictures and improving the brightness of the human body's images in black and white. Second, the predominance of Great Britain in the world scenario spread Victorian-era moral codes, including rigid norms about sexuality and the exposure of the female body in public. This situation generated a more sexual connotation for female nude photography and aroused a great demand for these types of pictures by men in underground markets. Third, late nineteenth-century photographers developed *pictorialism*, a movement that encouraged photography as an authentic and independent art expression, showing female nude models in an atmospheric environment with sensual features. Some of the well-known photographers of this movement were Robert Demachy and Edward Steichen.

From Surrealism to the Second World War: The twentieth century was the age of photography, and during the first half of this period several gadgets that extended photography to multiple uses and activities were invented or popularized. Some of the most relevant were roll film, color photography, the 35 mm format, portable cameras, and the flash. Evolution in cameras permitted both artists and ordinary people to capture images in an easy way, although developing pictures was complex and expensive. Moral codes and conduct about sexuality and nudity stopped the free exposure of photographs with nude content. In that period of time, images of female nudity were associated with prostitution and the underworld; therefore, nude photographers were not famous celebrities. After the First World War, and particularly during the Belle Époque in France and the Weimar Republic in Germany, pictures of topless female dancers, such as Josephine Baker, became very popular. In the United States, however, authorities banned such pictures. Surrealism became one of the most relevant art movements. Man Ray, the most notable photographer of this artistic expression, took explicit photographs of bare-breasted women, emphasizing the light effect over the body. This technique influenced many artists afterward. In the prewar years, several magazines such as *Vogue* and *Harper's Bazaar* published pictures of naked women, mixing avant-garde ideas and fashion style. Two of the most notable artists were Erwin Blumenfeld and Paul Horst. During the Second World War, young soldiers in the

frontline demanded magazines that included drawings and pictures of pinup girls, some of them with one bare breast.

From Pinup to Glamour: The postwar period was characterized by economic prosperity; a boom in reflex cameras made by Kodak, Fuji, Contaflex, Canon, and Nikon; and explicit full-color photographs of bare breasts in men's magazines. There can be no doubt that Hugh Hefner's *Playboy* magazine was the pioneer. Founded in 1953, its first issue published pictures of Marilyn Monroe, who exposed her breasts over a red chamois. *Playboy* combined photographs of young women with articles about sexuality and other vanguard topics. This magazine marked the difference in the postwar era, because Hefner managed to publish pictures of bare-breasted women in suggestive poses, despite legal restrictions that banned this in the United States. After a legal battle over First Amendment rights, *Playboy's* editor achieved the legalization of these kinds of pictures in a mainstream magazine. Several magazines around the world imitated *Playboy* or modified its style to respond to men's increasing demand for this kind of publication, among them *Modern Man* (United States; published before *Playboy*), *Best for Men* (United States), *Adan* (Argentina), *Oui* (France), *Mayfair* (England), and *FIB Aktuellt* (Sweden). This situation permitted both professional and underground photographers to publish their pictures in these magazines without restrictions. During the 1950s and 1960s, many photographers took pictures of nude women, emphasizing the bare torso more than the pubic area. Two of them exceling over others were Bunny Yeager, who defined the pinup style of taking pictures of hundreds of models for American men's magazines, and Bill Brandt, a controversial artist who scandalized 1960s society with his perspective about female nudity by means of his book *Perspective of Nudes*.

Between Frontal Nudity and the Bare Breast: At the turn of the 1970s, the transnational Revolution of 1968 influenced Western societies in cultural, political, and social issues. The feminist movement criticized the exploitation of women in magazines and in the entertainment industry. Nevertheless, the expansion of fashion, glamour, and photography of women became more relevant in this decade and in the 1980s than in previous years owing to popular cultural interests and the mass consumption society. One of the best examples was Benetton advertising, which included massive campaigns in which models uncovered their breasts. Although female nudity in magazines became quite explicit, including a combination of pictures showing breasts and the pubic zone, these types of pictures were marketed to the adult public. Perhaps the best known photographers who captured the essence of this trend were Helmut Newton and Patrick Demarchelier, both of whom transformed this explicit style into a glamorous representation. Throughout the 1970s and 1980s, tabloid newspapers, such as *The Sun* (Great Britain), *Bild-Zeitung* (Germany), and *Interviu* (Spain), included photographs of topless women. Tolerance toward bare-breast photographs in periodical publications allowed many of the models to become celebrities in their countries; equally, some photographers, such as Mike Crowley and Beverley Goodway, achieved popularity from scouting and taking pictures of these women.

Digital and Internet Era: Two inventions have transformed photography radically in the 1990s and the first years of the twentieth century: digital cameras and the Internet. Digital cameras, ranging from compact to digital single-lens reflex (DSLR) devices, include

several technological advantages. DSLR cameras have interchangeable lenses, manual and automatic modes, and professional options to create artistic works. Their price has dropped in recent years, making them affordable options for photographers.

The Internet was and is one of the most important technological achievements in recent years. It has transformed social interaction and connected people regardless of place or time. Websites, email, Facebook, and other web developments have changed people's lives. Therefore, digital photography along with the Internet has allowed the widespread distribution of artistic work throughout websites. New technologies and people's interest in erotic images have created an enormous demand for pictures of models in different poses, and a boom in photographers taking pictures of nude women. The Internet has permitted old-school nude photographers such as Peter Linberg and website photographers such as Peter Hegre to coexist and share fans across the globe. Moreover, the Internet has sponsored a cultural movement for freedom of expression, which has led to a renewed interest in men's magazines in Latin America and South Asia, including bare-breasted pictures of local models, and a progressive demand for soft-core images of topless models.

See also ART, WESTERN; CELEBRITY BREASTS; CONTROVERSIES; *COSMOPOLITAN*; *ESQUIRE*; MEDIA; MOVIES; PINUP GIRLS; PORNOGRAPHY; *YANK, THE ARMY WEEKLY*

Further Reading

Baetens, Pascal. *Nude Photography: The Art and the Craft.* New York: Dorling Kindersley, 2007.

Brandt, Bill. *Perspective of Nudes.* New York: Amphoto, 1961.

Cole, Ellen, and Esther D. Rothblum. *Breasts: The Women's Perspective on an American Obsession.* New York: Routledge, 2012.

Fraterrigo, Elizabeth. Playboy *and the Making of the Good Life in Modern America.* New York: Oxford University Press, 2009.

Hand, Martin. *Ubiquitous Photography.* Cambridge: Polity, 2012.

Kroll, Eric, ed. *Bunny's Honeys: Bunny Yeager, Queen of Pin-Up Photography.* Cologne, Germany: Taschen, 1994.

Marien, Mary Warner. *Photography: A Cultural History.* London: Laurence King, 2006.

■ SAUL M. RODRIGUEZ

PINK RIBBON CAMPAIGNS

The Susan G. Komen Breast Cancer Foundation (now called Susan G. Komen for the Cure, or just "Komen") is largely associated with the color pink. Currently the largest U.S. breast cancer charity, Komen started giving pink visors to breast cancer survivors in its Race for the Cure fundraiser in 1990. In the fall of 1991, the foundation gave pink ribbons to every participant in its signature New York City race. However, the pink ribbon did not become the *official* symbol for breast cancer awareness until 1992 through a collaboration between Evelyn Lauder of Estée Lauder Companies and Alexandra Penney, then the editor of *Self* magazine. Lauder was the guest editor for the magazine's first breast cancer awareness issue in 1991, and they decided that the focal point for the second

The ubiquitous pink ribbon is often displayed with "inspirational" messages and entreaties to fight cancer. Enterline Design Services LLC/ Thinkstock by Getty

edition would be an awareness ribbon. Lauder agreed to distribute the ribbon at her company's cosmetics counters around the country. All they needed was a color.

A *peach* ribbon related to breast cancer was already in small circulation. A 68-year-old woman named Charlotte Haley had several family members diagnosed with breast cancer and was concerned about the lack of federal funding for cancer prevention. To bring attention to the issue, Haley made peach ribbons by hand and attached a card saying, "The National Cancer Institute annual budget is $1.8 billion, only 5 percent goes for cancer prevention. Help us wake up our legislators and America by wearing this ribbon." Haley gave out the ribbons and cards to people in her community and also contacted public women to spread her message. After learning of the peach ribbon, *Self* magazine contacted Haley to ask permission to use it for their second annual awareness campaign. Haley declined. She was concerned about what would happen to her activist message should a commercial enterprise be involved.

Penney and Lauder forged ahead, using a different color for their awareness ribbon: pink. Pink was soft and delicate, pretty and sedate, soothing and comforting, and stereotypically feminine—everything breast cancer was not. Pink quickly took hold as the color of breast cancer awareness and, more specifically, "breast health and early detection." *Self* magazine's breast cancer awareness edition expanded every year. Estée Lauder cosmetics counters distributed 1.5 million ribbons in 1992, and the Breast Cancer Awareness Campaign that Lauder launched in conjunction with the *Self* collaboration distributed more than 115 million pink ribbons worldwide. Another leading global beauty company, Avon,

launched the Avon Breast Cancer Crusade (1992). The beauty–fashion–femininity link to breast cancer awareness was made, tied to a pink ribbon.

Due to women's organizing in the 1970s and 1980s, breast cancer had already shifted from something taboo to a topic of polite conversation. Activists helped to destigmatize the disease, expand information and support networks, and foster a client-centered approach. As breast cancer gained the public's interest, support and awareness merged into an overarching "culture of survivorship" oriented toward optimism, personal empowerment, and the "survivor" as an identity category. Imagery and discourse emphasized women's place in society, the centrality of beauty and women's bodies, and the accessories that women needed to fit the ideal. Imbued with femininity and a sense of virtue appealing to corporate sponsors, pink ribbon campaigns began to blend with popular culture and commercial enterprise.

The American Cancer Society established National Breast Cancer Awareness Month (NBCAM) in October 1985 (with funding from a pharmaceutical company, Zeneca Group PLC) to promote the "early detection of breast cancer." The program still promotes large-scale mammography screening despite changing protocols and an extensive body of scientific evidence demonstrating the limitations and risks associated with the technology. Beyond its public service potential, however, NBCAM functions as a gateway to industry. Pinktober (i.e., the common referent for NBCAM) is a commercial adaptation of public health promotion that disseminates upbeat, simple messages about breast cancer and encourages people to participate in the "war" against the disease through consumption and participation in pink ribbon culture.

Breast cancer has become a multibillion-dollar industry, a brand name with a pink ribbon logo. Between federal funding and the top five private foundations, the United States spends at least $1 billion annually on research. The nonprofit sector raises an estimated $2.5 to $3.25 billion for breast cancer programs in a given year. Komen received $420 million in revenues in 2011, with $175 million coming from contributions and grants. And all of those pink ribbon products and fundraising activities off the formal grid have not been tracked. Since the pink ribbon is part of the public domain, anyone may use a generic pink ribbon to associate their cause with breast cancer, so it is nearly impossible for consumers to know how much money is raised or where it goes. Some companies and nonprofits trademark stylized ribbons and phrases to set themselves apart. Komen applied or registered for 197 trademarks (more than many large corporations) associated with iterations of the phrase "for the cure" and took legal action against more than 40 breast cancer charities since 1996 for trademark issues. Komen also trademarked its "running ribbon" in 2007.

Since 1996, breast cancer has been the cause of choice for companies striving to build reputations as corporate citizens, deepen employee loyalty, and increase sales while donating to charity. Now, with nearly 1,400 registered breast cancer nonprofits in the United States, companies have a variety of cause-marketing options. The lighthearted and festive ribbon has morphed into everything from human ribbons holding glowing pink candles to bagels, rock concerts, fried chicken, and gear for the U.S. National Football League. A new genre of *boobies* campaigns uses objectifying language, sex, and women's bodies (or parts of them) to lure younger consumers to the cause. The Avon Breast Cancer Crusade has grown into a global initiative with programs operating in 58 countries. The most

prevalent deliverables appear to be pink ribbon gadgets such as cups, spoons, bags, and teddy bears. To increase visibility of the ribbon worldwide, Evelyn Lauder launched a Global Landmark Illumination Initiative in 2000, in which 26 landmarks in 22 countries, including the Empire State Building and the Sydney Opera House, were lit up with pink lights. By 2012, more than 200 landmarks worldwide were illuminated in pink.

In the last two decades, pink ribbon campaigns have, perhaps inadvertently, forged a profitable pink ribbon industry in which *breast cancer awareness* has given way to *pink ribbon visibility*. Investigations into products, companies, and charities have found little transparency, accountability, or evidence-based practice. Yet the industry spends billions to promote the pink ribbon while marketing products and services, some of which involve the production, manufacturing, and/or sales of products linked to the disease (i.e., "pink-washing"). With the general populace still unaware of the complexities of breast cancer or barriers to ending the epidemic, many pink ribbon campaigns profit from hope while selling the image of the courageous warrior to anyone who buys, displays, or thinks pink. Some activists and groups within the breast cancer movement continue to resist commercialization, and instead promote evidence-based information and analyses of the systemic factors influencing breast cancer.

See also ADVERTISING; AVON FOUNDATION FOR WOMEN; *THE BEAUTY MYTH*; BREAST CANCER; BREAST CANCER SUPPORT GROUPS; LOVE, DR. SUSAN (1948–); MAMMOGRAMS; MEDIA; RECONSTRUCTIVE SURGERY; SUSAN G. KOMEN FOR THE CURE

Further Reading

Kedrowski, Karen, and Marilyn Sarow. *Cancer Activism: Gender, Media, and Public Policy*. Champaign: University of Illinois Press, 2007.

King, Samantha. *Pink Ribbons, Inc.: Breast Cancer and the Politics of Philanthropy*. Minneapolis: University of Minnesota Press, 2006.

Peril, Lynn. *Pink Think: Becoming a Woman in Many Uneasy Lessons*. New York: W. W. Norton, 2002.

Sulik, Gayle. *Pink Ribbon Blues: How Breast Cancer Culture Undermines Women's Health*. New York: Oxford University Press, 2012.

Zierkiewicz, Edyta. *Rozmowy o raku piersi. Trzy poziomy konstruowania znaczeń choroby* [*Talks about Breast Cancer: The Three Layers of Meaning Constructing of Sickness*]. Wroclaw, Poland: Atut, 2010.

■ GAYLE SULIK AND EDYTA ZIERKIEWICZ

PINUP GIRLS

With roots in dance halls, burlesque, and early Hollywood, the iconic pinup girl image coalesced in the United States during World War II. The name also dates from this time, as American servicemen "pinned up" pictures to the walls of their quarters, plane cockpits, and lockers. These images could be illustrations or pictures of real-life actresses, film stars, or the servicemen's own girlfriends. The most popular pinup image was a rear-facing photograph of Betty Grable taken in 1943. Clad in high heels, a white swimsuit, and a dazzling smile, her head is turned to wink at the camera.

Alberto Vargas y Chavez produced illustrations for *Esquire* and later *Playboy* in a distinctive watercolor style. Known as "Varga girls," these images were not only pinned up

A marine shows a picture of a "pin-up girl" to other marines on a barge approaching the Japanese-held island of Tarawa, 1943. *Where Marines Go, Their Pin-Ups Go*, 1943. LC-USZ62-98192; courtesy of the Library of Congress Prints and Photographs Division

by servicemen in their barracks, but also painted onto airplanes and bombers as nose art. These illustrations showcase a changing attitude toward female nudity and the depiction of women's breasts.

Vargas' pictures from wartime are notable for containing only implied nudity. The breasts may be covered by clothing, lingerie, a swimsuit, or diaphanous material; however, the shape of the breast is clearly accentuated. If a woman is topless, then her figure is generally portrayed from the back: her breasts are left to be imagined by the viewer.

In postwar culture, the pinup transformed with the times. Though they retained an old-fashioned softness, Vargas' illustrations grew increasingly more explicit and showcased ever more female flesh. In his illustrations for *Playboy* from the 1960s and 1970s, full-frontal toplessness is common. Here, the bare breasts are showcased in their entirety, including the nipple. Drawings and paintings were ousted as the medium of choice and replaced by photographs, such as Marilyn Monroe's nude centerfold for *Playboy* in 1953.

See also ESQUIRE; PHOTOGRAPHY; *PLAYBOY*; *YANK, THE ARMY WEEKLY*

Further Reading

"Alberto Vargas." The Pin-Up Files. Retrieved May 10, 2014, from http://www.thepinupfiles.com/vargas1.html

Buszek, Maria Elena. *Pin-up Grrrls: Feminism, Sexuality, Popular Culture*. Durham, NC: Duke University Press, 2006.

"The History of Pin-Up Art." Art History Archive. Retrieved May 10, 2014, from http://www.arthistory archive.com/arthistory/pinupart/

Meyerowitz, Joanne. "Women, Cheesecake, and Borderline Material." *Journal of Women's History* 8 no. 3 (Fall 1996): 9–35.

■ ERIN PAPPAS

PLAYBOY

Founded in 1953 by Hugh Hefner, *Playboy* was the first men's magazine to bring full female nudity to the mass market. It enjoyed spectacular growth during the 1950s and 1960s, and by the mid-1970s over a quarter of all male American college students were buying the magazine every month.

Beginning with Marilyn Monroe—who posed as the centerfold for the magazine's first issue—*Playboy* has consistently sought to attract the most high-profile female celebrities and has, over the years, featured topless and fully nude photo-shoots of a host of famous film and sports stars, including Jane Fonda, Ursula Andress, Drew Barrymore, Madonna, Denise Richards, Pamela Anderson, and Amanda Beard. A number of prominent photographers have also shot centerfold spreads for *Playboy*, including Stephen Wayda, Ron Harris, and Russ Meyer. Although international editions have been released around the world (including ones for Brazil, Russia, Japan, Mexico, Hong Kong, and Greece), the magazine still remains banned from many Asian countries due to its sexual content.

Stylistically, *Playboy* has always been explicit in its depictions of the female body. The first photo-shoot to reveal clearly visible pubic hair was published in January 1971, and just over a year later in 1972, Marilyn Cole became the first model to pose for a full-frontal nude centerfold. Body measurements pertaining to the general physique of the featured models and celebrities (including bust size, waist size, and hip size, as well as height and weight) have also been routinely published since 1977, whilst in recent years special editions featuring "Big Boobs" and "Big Boob Aerobics" have also been released.

In 1965, Sue Williams ushered in a new era for *Playboy* when she became the first featured Playmate with breast implants. Subsequent decades since have seen a dramatic rise in the number of centerfolds with implants, and in 2011, former Playmate Holly Madison took out insurance worth $1 million on her 36D surgically enhanced breasts. Indeed, thanks in part to the increasing availability of such surgical procedures, the average size of breasts featured in *Playboy* has grown progressively bigger since 1953 (despite the fact that—as recent research has proved—waist and hip sizes in the general U.S. female population have actually been declining).

In recent years, *Playboy* has been more active in raising awareness of breast cancer. In October 2011, it launched the "Bunnies for the Cure" initiative, pledging to donate 10 cents to breast cancer research for every new Twitter follower it received during October. On top of this, 15 *Playboy* Playmates—including the 2008 Playmate of the Year, Jayde Nicole—also agreed to take part in the Susan G. Komen Race for the Cure in Los Angeles.

Although increased competition from other adult and "lad's" magazines—combined with the spectacular growth of online pornography—has seen the magazine's circulation

decline in recent years, it still remains hugely popular with over 1.5 million readers world-wide. Recently, efforts have also been made to enhance the brand's online profile with the introduction of an uncensored web-based archive and an online edition of the magazine. Other innovations include the launch of the magazine's "Smoking Jacket" website, which for the first time provides readers with a censored "breast-free" version of the magazine that can be safely read in the workplace.

See also BREAST AUGMENTATION; CELEBRITY BREASTS; *COSMOPOLITAN*; *ESQUIRE*; IMPLANTS; PHOTOGRAPHY; PORNOGRAPHY; SUSAN G. KOMEN FOR THE CURE

Further Reading

Edgren, Gretchen. *The Playmate Book: Six Decades of Centerfolds.* London: Aurum, 1996.
Pitzulo, Carrie. *Bachelors and Bunnies: The Sexual Politics of Playboy.* Chicago: University of Chicago Press, 2011.

■ MATTHEW HOLLOW

POLITICS

Throughout human history, the female body has been regularized by rules, norms, and procedures enacted by governments, many of them responding to religious, social, or cultural beliefs. In the Western world, the female breast has generated admiration and rejection depending on the society and historical period. The displaying of breasts has also been marked by different policies regarding women's bodies. According to the French intellectual Michel Foucault, the body has been historically linked to power, and there have been a myriad of political arguments exercised over the body to control it in private and public areas. Related to this perspective, during the 1970s, the second wave of the feminist movement minted the concept of "body politics" to point out the policies and practices related to the regulation of the human body, particularly the female body. This situation motivated the struggle of feminists against the subordination and objectification of women's bodies through laws and codes.

History and Social Codes: For ancient Greeks and Romans, the breast represented beauty and fertility. It could be exposed without restriction in different areas and situations. This point of view was very similar to that of native societies' perspectives around the world, including those in the Americas, Asia, and Africa. With the dawn of the Christian era, the breast became associated with sexuality, and attempts were made to cover it in public sce-narios under a symbiosis of political and religious norms. In general, it was acceptable to expose breasts only for breastfeeding. These norms arrived in the Americas with European conquerors and missionaries during the fifteenth and sixteenth centuries.

During the Renaissance, a new perspective about breasts emerged; breastfeeding was considered to be a vital practice, and for that reason, art, literature, and poetry deified it. At the same time, the breast became a fashionable object of desire, particularly in some cities of Europe such as Paris, Rome, and Venice, where female breasts were often exposed in revealing clothing.

During the Enlightenment, breast, politics, and human breast milk came together as symbols of revolution. Breastfeeding was considered by many to be an essential practice,

and Marianne, the symbol of the French Revolution, exposed her breasts explicitly in a metaphor of freedom and struggle against the *ancien regime*. Throughout the nineteenth and twentieth centuries, political policies, rules, and norms affected several aspects of the female breast. These policies and behaviors range from medical concerns, such as the treatment of breast cancer, to how much of the breast should be exposed in public and in the media, to whether breastfeeding in public is acceptable. In addition, in the second half of the twentieth century, the feminist movement fought against laws and policies that forced women to follow strict behaviors through protest, public activities, and symbolic acts such as bra burning.

Breast Cancer Policies: Breast cancer has received great attention from societies and governments, in both developing and developed countries. The World Health Organization has initiated guidelines that have been followed by countries throughout the world. Many policies to prevent and to treat breast cancer are present in countries with state health care systems. Through mass media campaigns, governments have promoted self-breast exams and mammography, among other measures, to reduce the impact of this disease. In the United States, each state has its own policies about breast cancer treatment and prevention, and many preventive actions to combat it are in the hands of nonprofit organizations. For that reason, there is not a standardized government policy to combat it in the United States; however, advertising, pink ribbon campaigns, and organizations such as Susan G. Komen for the Cure have raised awareness of the disease, albeit not without some controversy.

Topless Exposure in Public: Throughout much of the twentieth century, uncovered breasts have been considered a private issue; however, public exposure of breasts has generated intervention by means of laws, restrictions, and social condemnation. During the sexual revolution of the 1960s, there was an increase in topless women (and men) in public areas. In the following years, laws and authorities banned this practice as an act of inappropriate public conduct, particularly in the United States. The Federal Communications Commission has imposed fines on television networks that have televised "wardrobe malfunctions" exposing the breasts of female celebrities. The U.S. Supreme Court, however, overturned the record fine imposed on CBS after Janet Jackson's breast exposure incident (sometimes referred to as Nipplegate) during the 2004 Super Bowl halftime show. Some activists believe that banning toplessness is a discriminatory position supported by patriarchal laws, and in recent years activists have attempted to change the minds of authorities and modify laws and codes about clothes. Some of the most important topless movements are Gotopless (United States and worldwide) and Bara Bröst (Sweden).

Breast Exposure as a Means to Change Politics: Since the 1960s, exposure of the female breast as a means of political protest and nonconformity has become more common than in previous decades, particularly in Western countries. This change was possible thanks to the women's liberation movement and sexual revolution, which permitted the empowerment of women over their own bodies and the elimination of social taboos regarding the exposure of breasts in public to protest against political systems or unequal laws that affect women. Political and social tolerance toward going topless in Europe, Australia, and some parts of the United States has led to a decline in top-free protesters. In contrast, in some countries where toplessness in public spaces is banned, the increase of topless protests to challenge political systems has become quite common, such as protests by the feminist

Ukrainian protest group FEMEN or by female students in Latin America who have protested against education reforms.

See also Bra Burning; Controversies; Feminism; Hiding Places; Iconography; International Norms and Taboos; Pink Ribbon Campaigns; Rochester Topfree 7; Susan G. Komen for the Cure; Topless Protests; Women's Movement

Further Reading

Foucault, Michel. *Discipline and Punish: The Birth of the Prison.* New York: Vintage, 1995.
Foucault, Michel. *The History of Sexuality,* 3 vols. New York: Random House, 1978–1986.
McLaren, Margaret A. *Feminism, Foucault, and Embodied Subjectivity.* New York: SUNY Press, 2002.
Orr, Deborah, Dianna Taylor, Eileen Kahl, Kathleen Earle, Christa Rainwater, and Linda Lopez McAlister, eds. *Feminist Politics: Identity, Difference, and Agency.* Lanham, MD: Rowman & Littlefield, 2007.
Yalom, Marilyn. *A History of the Breast.* New York: Knopf, 1997.

■ SAUL M. RODRIGUEZ

PORNOGRAPHY

As profoundly feminine, the breasts are icons of female sexuality. In Western society, the female breast is one of the most exposed body parts in pornography, particularly in heterosexual pornography. In pornographic discourse, the breasts are not simply shown in their biological incarnation but also are subjected to a discursive representation of the genre, which sees the breast as separated from, for instance, its maternal function, presenting it as purely an organ of sexual pleasure, whether visual or physical. Just as the breast is considered as the most persistent signifier of femininity, the exposed *single* breast is the most common representation of female breasts. One of the most prevalent examples of such iconic images is of the Virgin Mary, an image popularized in early Renaissance art. A painting, *Virgin and Child* by Jean Fouquet (c. 1480), features a young woman with one breast exposed and erect, pointed toward the naked baby who is sitting on her lap. The model for the Virgin Mary is thought to be Agnès Sorel, the first officially recognized courtesan of King Charles VII of France.

The word pornography comes from the Greek words πόρνη (*pornē*, "prostitute" and πορνεία—*pornea*, "prostitution"), γράφειν (*graphein*, "to write or to record," with the derived meaning "illustration"; cf. "graph"), and the suffix -ία (-*ia*, meaning "state of," "property of," or "place of"), thus meaning a written description or illustration of prostitutes or prostitution. During the 1800s, *pornographie* was in use in the French language with the same meaning, which however began to lose its connotation with prostitution at the beginning of the nineteenth century, when it also entered the English language. In today's sense, pornography can be defined as the explicit depiction of sexual organs and sexual activity designed for the sexual arousal of an audience.

Pornography has existed since the beginning of civilization. For as long as humans have been able to draw or write, they have crafted erotic images and stories. The ancient Greeks and Romans produced vases, frescoes, statues, and many other artifacts with sexually explicit images. The earliest preserved exposed female breast in sculpture of the Classical period can be found in the *Battle of Lapith Greeks and Centaurs* (460s BCE) from

the west pediment of the Temple of Zeus at Olympia. The female nude, with a specific emphasis on breasts, became a huge subject in sixteenth-century art, in the Italian Renaissance painting of the era in particular, when men looking at women dominated art. Since men were the major recipients and creators of the works of art, the pornographic images within those forms of art employ the male gaze in their representation of the female body. The most popularized imagery of the breasts was that of a single breast exposed or the breasts separated by clothing or jewelry. The Renaissance also saw the first works of literate pornography. The Italian writer Pietro Aretino (1492–1556) is regarded as the originator of European pornographic writing. His work *The School of Whoredom* depicts 14-year-old Pippa, whose mother Nanna introduces her to the secrets of erotic life, mainly through revealing the details of her work as a courtesan.

Pornography in the contemporary sense (i.e., for the purpose of sexual arousal) did not come into being until the nineteenth century. In ancient times through the medieval period, it is difficult to distinguish pornography from art and other forms of social and political discourse. The uncovered breast may communicate many messages conveyed through nudity that are connected to culturally established meanings. For instance, various books and manuscripts produced by Church fathers often produced obscene engravings of breasts or genitalia and sexual activity on the margins of the text, which were used as commentary on the sinful nature of people who commit religious and moral transgressions. In Early Modern Europe, until the beginning of the nineteenth century, pornography was most often a part of political satire, a vehicle to criticize religious and political authorities. During the Enlightenment, pornographic works served the purpose of educating people, mainly men, about the body and sexuality, according to the spirit of the era. Between the 1790s and the 1830s, pornography began to lose its political connotations and became a commercial phenomenon, of which the main purpose was sexual pleasure. The commercialization of pornography as a separate genre was possible thanks to the development of printing and the spread of pornographic images to popular culture. Before commercial printing, erotic images were handcrafted and expensive; thus, they were affordable only to a very small group of wealthy men. After the 1820s, the major recipients of printed pornography for sexual arousal were wealthy men, professionals, and clerks.

The new approach and understanding of pornography are also evident in *Memoirs of a Woman of Pleasure* (*Fanny Hill*) by John Cleland, which was published in England in 1748 and was one of the first examples of pornography in the form of a novel. The book was frequently reprinted and widely translated; however, it was banned in the United States until the 1960s. Although the novel was written by a man, it focuses almost single-mindedly on its depiction of female sexuality and the female desire of the main protagonist, Fanny. The book was accompanied by illustrations featuring the female character, usually with exposed naked breasts or genitalia, or both, engaged in various sexual activities with a male partner. The most influential in terms of pornographic imagery to date are works by Donatien Alphonse François, the Marquis de Sade (1740–1814). In his writing, Sade covered all the themes that are often viewed in contemporary pornography. Violence, torture, and even murder are all connected to sexual arousal in Sade's works. For that reason, he is mostly associated with sadomasochistic pornography.

Today, pornography is dominated by the films and videos viewed on the Internet, the majority of which are produced in the United States. In 1959, Russ Meyer released *The Immortal Mr. Teas*, one of the first pornographic films that depicted extensive female nudity without the pretext of naturalism. The main character, Mr. Teas, has X-ray vision, which enables him to see all women without their clothes. Female protagonists, various women professionals wearing uniforms where cleavage and parts of their breasts are exposed, surround the male protagonist. The film, which evidently employs the male gaze, initiated the process of fetishizing the breasts, large breasts in particular, which from the 1960s became the primary exposed sex organ in American culture. This is reflected particularly in heterosexual pornography. Commercial gay and lesbian pornographic films were not made until the 1980s. Although woman-to-woman sex scenes frequently appear in mainstream heterosexual pornography, they appeal to male fantasies.

There are different subgenres of pornography. These are classified according to the sexual orientation of the participants (e.g., gay pornography and lesbian pornography), their physical characteristics, or a fetish, such as a breast fetish. All of these different kinds of pornography employ a somewhat different gaze, but the pornographic industry nevertheless has been dominated by heterosexual pornography: the female breasts are on display to arouse men. This mirrors the gendered division of looking. The traditional social role of men is to look at women, and the social role of women is to be looked at. The breast acts as the cultural icon for this visual relation. In heterosexual pornography, the breasts provide sexual pleasure for male viewers but almost never for the woman to whom they are attached. Breasts are a medium of visual expression of the woman's excitement and readiness to welcome male desire. For that reason, breasts are often emphasized and even exaggerated through close-ups or through shots that draw the viewers' eyes toward the breasts. Therefore, pornographic breasts often are not representative of an average woman's breasts but an exaggerated ideal. In soft-core pornography (i.e., pornography that does not depict penetration, as divergent from hard-core pornography), naked breasts are usually shown as uplifted and swollen, with erect nipples that indicate sexual arousal. Most of the models and porn stars in pornographic genres are slim, young women with medium or large symmetrical breasts. The pornographic images of female breasts, shaped by the fantasies of the male spectators, influence and shape the ideal of the breast in women. Many women attempt to shape their breast by surgical alterations to meet this ideal. Breast implants are the most common form of plastic surgery, and girls are seeking augmentation at increasingly younger ages.

Due to feminist critique regarding male-orientated pornography, where the female body appears to be an object of merely male pleasure, during the last decades a new type of pornography has emerged that embraces female sexuality and women's fantasies. Pornographic films by English film director Anna Arrowsmith (aka Anna Span) focus on female pleasure and portray women enjoying sex, including heterosexual, lesbian, and bisexual sex. Arrowsmith's films feature more shots that look at the men (employing the female gaze) than in an average heterosexual pornographic film. They also show women with more realistic bodies.

See also ART, INDIAN AND AFRICAN; ART, WESTERN; BREAST AUGMENTATION; CELEBRITY BREASTS; CONTROVERSIES; LITERATURE; MOVIES; PHOTOGRAPHY; RELIGION

Further Reading

Garland-Thomson, Rosemarie. *Staring: How We Look.* New York: Oxford University Press, 2009.

Hall, Anna C., and Mardia J. Bishop. *Pop-Porn: Pornography in American Culture.* Westport, CT: Praeger, 2007.

Hunt, Lynn. *The Invention of Pornography: Obscenity and the Origins of Modernity, 1500–1800.* New York: Zone, 1993.

Slade, Joseph W. *Pornography and Sexual Representation: A Reference Guide,* vols. 1 and 2. Westport, CT: Greenwood, 2001.

Yalom, Marilyn. *A History of the Breast.* New York: Knopf, 1997.

■ ANETA STEPIEN

POSTPARTUM BREASTS

During the postpartum or puerperium period, which is the 6 weeks immediately following childbirth and the expulsion of the placenta, the new mother's body undergoes definite physiological, anatomical, and psychological changes. The further development of the breasts and the establishment of lactation are the most important of these changes.

The production of milk by the glandular cells in the breast and the secretion of milk through the suckling of a newborn on the mother's nipple and areola are processes controlled by both pituitary and ovarian hormones. Suckling, however, is a critical component of the hormonal pathway.

Suckling causes the anterior pituitary gland to produce the hormone prolactin, which in turn stimulates the production of milk in the glandular cells. Suckling also induces the posterior pituitary gland to produce oxytocin, which acts on the muscle cells surrounding the milk ducts to produce the "let-down" sensation and enable the ejection of milk. When the cells around the glands and under the areola contract, the mother has a very definitive sensation of contraction and release. Some women find this sensation pleasant, and other women find it uncomfortable. The oxytocin-stimulated "let-down" can happen without an infant sucking. Just the thought of the infant or of breastfeeding, or the cries of the mother's newborn, can stimulate this reflexive pathway.

Breast milk can be stimulated at a time unrelated to the postpartum production of milk. This is called the *relactation* process and can be used for induced lactation. Relactation is critical when a mother desires to breastfeed an adopted infant. Relactation is also important after interrupted lactation, when a mother has had to wean a child (usually due to either maternal or infant illness) but there is a desire to resume breastfeeding. Eventually, the physiological process of milk production and release will be stimulated by suckling alone; however, for relactation purposes, this process is usually aided by giving the breastfeeding mother additional hormones.

The critical "let-down" sensation is a psychological as well as physiological reflex, and pain, illness, or stress can interfere with the mother's expression of milk. An inhibited "let-down" reflex can lead some postpartum women and their caretakers to diagnose a "failure" of the new mother to produce milk. The most common sequence of events is that a disturbed "let-down" reflex and ability to release the milk lead to a reduction in suckling by the infant, which fails to stimulate further milk production. This

physiological-psychological cycle is extremely frustrating for a postpartum mother, and it can and does lead to failed attempts at breastfeeding.

For successful postpartum breastfeeding, the infant must lie fully facing the mother's breast, and must have the areola in his or her mouth and not just the tip of the nipple. Newborns are capable of stimulating the lactiferous sinus, which is located behind the mother's areola, with the force of their gums. In the first few months of breastfeeding, the mother's nipples can become quite sore, as the force that the infant exerts is considerable. Sore and cracked nipples are common and are treated by keeping the nipples dry and clean, and sometimes with extra lubrication. In addition to considerable pain, there can be minor localized bleeding at the site of the cracked nipples. Successful lactation requires patience on the part of the mother, and support and encouragement from her postpartum caregivers.

Postpartum production of breast milk and breastfeeding an infant are physiological, psychological, and behavioral processes. Culture helps to determine if the mother will breastfeed, when, for how long, and how frequently. The mother's mental state determines if oxytocin will be effectively and sufficiently released and her breastfeeding efforts will be met with success. Supportive caregivers can significantly influence the breastfeeding process in the initial days of the postpartum period.

Mastitis is an inflammation of the breasts, usually due to retained milk and a possible milk protein reaction by the mother. If mastitis is not treated rapidly, it can lead to a breast abscess and an infection in the glandular structures of the breasts. Breast milk is normally sterile, but retained milk and inflammation can allow bacteria to enter the milk and the glandular structures of the breast. Mastitis is aggressively treated with antibiotics and frequent draining of the breasts, preferably by the suckling of the infant, but, if not, then by hand expression.

The benefits of colostrum and the early initiation of breastfeeding have only recently been recognized. There is a noticeable difference in the consistency and color of the colostrum, which is yellowish and more viscous, and the milk, which is whiter and of a clearer consistency. After delivery, human milk takes 24 to 72 hours to reach production levels, provided there is consistent stimulation from the infant during that time. Human breast milk takes an additional few weeks to "mature," and it changes consistency and color over the postpartum period. The breast milk produced by each woman is unique in its appearance and may have slightly different amounts of milk "fats."

Human breast milk is different from other animal milks in that it contains different quantities of lactase, calcium, phosphorus, and protein. Human milk also contains enzymes, which help the infant avoid infections in their intestines. An infant can be fed exclusively on breast milk, with no other liquids or foods, for between 4 and 6 months. Breast milk is sterile, is the right temperature for a newborn, and contains antibodies against infectious diseases that the mother has been inoculated against. The human immunodeficiency virus (HIV) can pass through breast milk; however, it has been demonstrated that infants who are frequently and exclusively breastfed may feed without becoming infected from an HIV-positive mother.

In the postpartum period, breastfeeding is extremely advantageous for the new mother. In the first few minutes after birth, the stimulation of the mother's nipples will cause the

uterine muscles to contract, which aids in the expulsion of the placenta and the clamping down of the uterine muscles around the placental site. Immediate breastfeeding helps the mother and infant bond, and it also further shrinks and contracts the uterus, which helps the mother to stop bleeding. The benefits of early breastfeeding have been demonstrated to assist the mother through the first few months postpartum, and actively breastfeeding mothers have a quicker return to normal activity levels with an easier recovery in the postpartum period.

See also AREOLAE; BREAST ANATOMY; BREASTFEEDING; BREAST MILK; HORMONES; MASTITIS; NIPPLES; PREGNANCY; WEANING

Further Reading

Bennett, V. Ruth, and Linda Brown, eds. *Myles Textbook for Midwives*. Edinburgh, UK: Churchill Livingstone, 1993.

Earle, Sarah. "Why Some Women Do Not Breast Feed: Bottle Feeding and Fathers' Role." *Midwifery* 16, no. 4 (2000): 323–330.

Kramer, Michael S., and Ritsuko Kakuma. *The Optimal Duration of Exclusive Breastfeeding: A Systematic Review*, WHO/NHD/01.08 and WHO/FCH/01.23. Geneva: World Health Organization, 2001.

Spencer, Jeanne P. "Management of Mastitis in Breastfeeding Women." *American Family Physician* 78, no. 6 (September 15, 2008): 727–731. Retrieved May 10, 2014, from http://www.aafp.org/afp/2008/0915/p727.html

■ CLAUDIA J. FORD

PREGNANCY

At puberty, a woman's breasts enlarge under the influence of the ovarian hormones, and more mammary ducts and glands are formed. However, it is during the physiological and hormonal changes of pregnancy that a woman's breasts undergo their most profound development. Once a woman is pregnant, even if she does not carry a live infant to term and give birth, the changes to her breasts are permanent.

The human breast consists of fat, connective tissue, the glands of milk-producing cells, and ducts that drain the milk to the nipple and the exterior. This glandular tissue is arranged in lobes or clusters of milk-producing cells, surrounded by cells that assist in the propulsion of the milk to the nipple. Under the influence of the complex hormonal changes and hormonal interactions of pregnancy, all of these structures develop, increase, and grow in preparation for the production of breast milk by the glandular cells. Estrogen helps the ductal systems develop. Progesterone stimulates the development of the glands and prepares the nipples by making them more erect. Progesterone also stimulates the small glands that surround the nipples to produce a lubricating substance.

In the very early stages of pregnancy, the breasts begin to grow and to feel tender, heavy, or even sore. Health care professionals advise women to be refitted for the correct bra size during pregnancy to support their growing breasts. Women are also advised to keep their nipples clean, but not to use soap on them, as soap is drying to the nipple. A woman's breast growth may contribute to her weight gain during pregnancy. Changes in

breast size, especially during a first pregnancy, may be quite surprising and either welcome or disturbing to a woman.

The glandular cells of the breast begin to make colostrum early in pregnancy and may leak fluid as early as the fourth month. The mother's nipples grow more erect, and the surrounding areola darkens noticeably. The breasts do not produce milk, normally, until the postpartum period when the levels of estrogen fall, which allows prolactin levels to rise. Prolactin and oxytocin are the hormones that enable and maintain lactation. The infant's suckling stimulates the continued production of prolactin. Prolactin may suppress ovulation in the breastfeeding mother, which is why breastfeeding has traditionally been used as a method of delaying pregnancy and spacing births.

Breast milk development, and breastfeeding after childbirth, requires a series of physiological events that include further structural changes in breast tissue and hormonal regulation. These events begin in pregnancy. Without suckling an infant during the postpartum period, however, the breasts will cease to produce milk within 14–21 days.

See also Breast Anatomy; Breastfeeding; Hormones; Postpartum Breasts

Further Reading

Angier, Natalie. *Woman: An Intimate Geography.* New York: Anchor, 2000.
Bennett, V. Ruth, and Linda Brown, eds. *Myles Textbook for Midwives.* Edinburgh, UK: Churchill Livingstone, 1993.

■ CLAUDIA J. FORD

PROSTITUTION

The term "prostitution" broadly denotes the exchange of sex for money or other consideration. In some countries such as Mexico, prostitution is legal if the prostitute is over 18 years of age. Prostitution in Mexico is regulated and monitored in order to prevent the spread of sexually transmitted diseases and the sexual exploitation of children. In other parts of the world, prostitution is illegal, such as in the United States, where prostitution is a crime in 49 states. Nevada is the only state where some counties have legalized prostitution as long as it is confined to licensed brothels. A universal legal definition for prostitution is difficult to ascertain because the act of prostituting one's self in exchange for some form of benefit is interpreted differently in different areas of the world. As well, the term prostitution is not fixed and stable since it is exchangeable with the phrase "sex work," which comprises a range of sexual activities for hire that include "stripping, pornography, and phone sex." The term sex work has been used to represent prostitution since 1978 and underscores the labor involved in the performed sexual activity and the compensation received.

Prostitution, although conventionally associated with women performing sexual acts for men, is nongendered. Prostitution allows for sex workers to manifest all gender types since it is consumer driven. The economics of supply and demand are at work in the field of prostitution. The consumer, commonly referred to as a "john" if the consumer is

male, articulates the demand, which can include a specific type of gender, such as male, female, or transgendered. A prostitute who embodies the consumer's desired gender is in a position to supply the services requested, if willing. Because of a consumer's sexual preference, prostitution allows for expressions of gender that extend beyond the "male–female" gender binary.

The prostitute's body is at the center of the exchange of sexual services performed by the prostitute. A prostitute's breasts are financial commodities, especially for female prostitutes, because of society's hypersexualization of them and the ideology of breasts as sexual objects. Breasts are portrayed in society as belonging to men for their sexual enjoyment, not women's sexual enjoyment. Breasts are for men's visual and tactile pleasure. Accounts of prostitution demonstrate that the display of breasts constitutes the initial exchange between the prostitute and the client. In a description of a prostitute's arrest at a massage parlor, the court heard that the prostitute commenced the exchange of sex for money by offering the undercover police officer a topless massage, which would be an additional charge to the cost of the massage. In another example, the prostitute initiated the exchange by revealing her breasts and then displaying her genitals. Both examples display the important function of breasts in initiating a financial exchange for sex between the prostitute and the client. The breast is the starting point for contact between the client and the prostitute's body. The sexual acts then become more invasive as they include touching and penetration of the areas of the body that society deems to be intimate and sexual. The more contact with the prostitute's body, the more expensive the cost of the service for the client.

The breasts also serve a reproductive function for female prostitutes who become mothers. Female prostitutes, like all women, can choose to breastfeed their children. However, because prostitutes are at risk for sexually transmitted diseases, they risk passing on these diseases to their children. For instance, prostitutes are at risk of contracting the human immunodeficiency virus type 1 (HIV-1) since that virus is transmitted through bodily fluids, such as blood and semen. Female prostitutes who have HIV-1 may infect their babies with the virus during pregnancy through the placenta, where nutrients from the mother's blood are extracted and transmitted to the fetus. The virus may also be transmitted from the mother to the infant postpartum through breastfeeding. Despite the possibility of HIV-1 infection for the infants of prostitutes and other women with HIV-1, the World Health Organization and the United Nations International Children's Emergency Fund advocate that mothers with HIV-1 breastfeed their infants if they live in disadvantaged locations where infant death from infectious diseases, malnutrition, and starvation occur. Children born in these areas have a higher risk of dying from such maladies than through contracting HIV-1 through breastfeeding. However, women infected with HIV-1 who live in areas where infant mortality rates are low are advised not to breastfeed their children.

The high-risk lifestyle of prostitutes who smoke, engage in drug use, and drink alcohol also affects their infants through breastfeeding. Studies show that these substances are transmitted from the mother to the child through the mother's milk and adversely affect the infant. The milk becomes toxic, resulting in the infant suffering from such afflictions as increased respiratory infections, irritability, bouts of vomiting, and seizures.

Prostitution concentrates on the sale of the sex worker's body for the sexual gratification of the client. The breasts of female prostitutes can play an integral part in the sale of

sex in initiating the transaction by visually stimulating clients. Breasts can further sexually gratify clients through contact. The breasts also have a maternal function for female prostitutes who become mothers and choose to breastfeed their infants. However, research continues to reveal that breast milk from mothers who engage in high-risk lifestyles can potentially harm their infants. The breasts of female prostitutes participate in their identities as mothers, women, and sex workers.

See also BREASTFEEDING; BREAST MILK; PORNOGRAPHY; RED LIGHT DISTRICTS; STRIPTEASE; TOPLESS DANCING

Further Reading

Black, Rebecca F. "Transmission of HIV-1 in the Breast-Feeding Process." *Journal of the American Dietetic Association* 96, no. 3 (March 1996): 267–274.

Bliss, Katherine Elaine. *Compromised Positions: Prostitution, Public Health, and Gender Politics in Revolutionary Mexico City*. University Park: Pennsylvania State University Press, 2001.

Ditmore, Melissa Hope. *Prostitution and Sex Work*. Santa Barbara, CA: Greenwood, 2011.

McLemore, Megan. *Sex Workers at Risk: Condoms as Evidence of Prostitution in Four US Cities*. New York: Human Rights Watch, 2012.

Ugarte, Marisa, Laura Zarate, and Melissa Farley. "Prostitution and Trafficking of Women and Children from Mexico to the United States." *Journal of Trauma Practice* 2, nos. 3–4 (July 1, 2003): 147–165.

Ward, L. Monique, Ann Merriweather, and Allison Caruthers. "Breasts Are for Men: Media, Masculinity Ideologies, and Men's Beliefs about Women's Bodies." *Sex Roles* 55, nos. 9–10 (November 2006): 703–714.

■ NATALIE E. DEAR

PUBERTY

Puberty is the physical transition from childhood to adulthood. However, human breast development begins well before puberty. Human breasts first begin to develop at around 5 weeks of gestational age, when the mammary buds form. At around 7 weeks of gestational age, parathyroid hormone–related protein (PTHrP) triggers differentiation of the mammary bud, and further development is controlled through a series of hormonal releases. Development of the breast continues to occur during the first 2 years of life and usually stops until puberty. Depending on the hormonal balance of the growing child or adult, breasts may develop. Breast maturation after birth is called thelarche, although this term is usually not used to refer to male breast development. The development of the human breast is commonly divided into five stages and is based on typical female development:

Stage 1: Papilla elevated above the chest wall (preadolescent)
Stage 2: Breast and papilla elevated; increased areola diameter (budding, or thelarche)
Stage 3: Continued enlargements of areolae and breasts
Stage 4: Papilla and areola elevated above the breast
Stage 5: Papilla elevated; areola regressed (mature)

Ethnic and geographical variations exist in the age of onset of puberty; female puberty in North America usually begins between 8 and 12 years of age. During typical female puberty, the hypothalamus produces gonadotropin-releasing hormones that trigger the release of the gonadotropins luteinizing hormone (LH) and follicle-stimulating hormone (FSH) in the pituitary. These two hormones act on the ovaries to produce estrogens and progesterone, which affect breast development directly. Although there are a number of hormones that affect breast growth and development, estrogens are the primary hormones that act on breasts during puberty. Estrogens are also produced in the skin and fat and from the conversion of androgens to estrogens. In people without ovaries, breasts may develop naturally if estrogen levels are high compared to androgen levels. Thelarche begins with a firm and tender lump under the nipple–areola complex and can occur on both sides at the same time or at different times. With continued estrogen, the milk duct network begins to grow and differentiate, and vascular and connective tissues also develop at this time. Recent research has found that insulin-like growth factor 1 (IGF-1) is an important hormone for breast development. Without the presence of both estrogens and IGF-1, mammary glands do not develop fully. The combination of growing mammary, vascular, and connective tissue leads to increased breast size. The speed of breast development and the breast size at maturity are very individual, with size partially dependent on the amount of body fat.

It usually takes around 4 years to progress from stage 2 to stage 5. Sudden, sustained high levels of estradiol (an estrogen that is commonly prescribed for hormone replacement therapy) or progesterone result in the quick development of small, conical breasts with underdeveloped mammary glands. In people whose female puberty is induced through hormone replacement therapy, care must be taken to mimic a natural puberty in order to allow the breasts to mature. Estradiol doses are increased gradually over usually a 2-year period with cyclical progesterone doses to control menstruation. In some cases, growth hormone (GH) may be prescribed in order to increase height, and GH additionally affects breast development by increasing growth and differentiation of the mammary glands as well as differentiation of the milk ducts.

See also BREAST ANATOMY; HORMONAL TREATMENT; HORMONES

Further Reading

Colvin, Caroline Wingo, and Hussein Abdullatif. "Anatomy of Female Puberty: The Clinical Relevance of Developmental Changes in the Reproductive System." *Clinical Anatomy* 26, no. 1 (2013): 115–129.

Howard, Beatrice A., and Barry A. Gusterson. "Human Breast Development." *Journal of Mammary Gland Biology and Neoplasia* 5, no. 2 (2000): 119–137.

Watson, Christine J., and Walid T. Khaled. "Mammary Development in the Embryo and Adult: A Journey of Morphogenesis and Commitment." *Development* 135, no. 6 (2008): 995–1003.

■ ISRAEL BERGER

PUBLIC ART

Public art refers to any work of art that is created and displayed in a space accessible to the general population. Public art taps into the idea that art is something that enriches lives and can help society to think critically about various social issues. Art has a long history as a tool for communication, and many different kinds of art can be considered public, from architecture to sculpture, murals, performance, and graffiti. Public art has been used for memorials, glorification, education, beautification, and cultural representation. It has often included representations of the human body, including breasts. For example, busts of Marianne, the emblem of the French Republic, can be found displayed in French government offices and public areas. She is often depicted in Roman attire, sometimes with bare breasts.

There are a number of ways to think about public art. There is art that is fully integrated within the location and might also make use of the surrounding site as inspiration, whether through its history or cultural aspects. Architecture has long been important to a society's function and sense of identity. For example, ancient Egyptian funeral complexes speak of the importance placed upon the ruler and the cultural beliefs regarding death and afterlife. Ancient Greek buildings were conceived of as sculptures in and of themselves. They were meant to evoke human responses and command importance regarding their function and as part of the Greeks' public persona of culture and power.

Both sculpture and murals have been popular forms of public art for thousands of years. The Romans erected statues of emperors who became deities after their death. They also invented the triumphal arch—a monument that would have an enduring influence in Western culture. The Renaissance saw a greater number of church and civic sponsors for public art. Guilds held competitions that encouraged the participation of all of the citizens of a city-state, whether through submission of art or opinion. Murals reach people who might not visit a museum. The twentieth and twenty-first centuries have dramatically changed the function and form of public art. The Mexican mural painting movement in the 1920s and 1930s showcased the talents of artists like Diego Rivera (1886–1957), David Alfaro Siqueiros (1896–1974), and Jose Clemente Orozco (1883–1949).

Some other forms of public art include "land art" or "earthworks," which are monumental and site-specific installations that make use of the land. Ephemeral art is specifically designed to entail the transitory elements in nature. Graffiti refers to the work of illicit "street artists," who might tag the side of a building or another area in the public purview.

Art is a powerful form of expression, and because of this it can lead to issues of censorship. Some people might challenge what is being communicated or be offended by what is being represented, and thus attempt to censor it because of religious, political, or sexual beliefs. Art has also been used to challenge, raise awareness, and critique a society's ideals. Performance produces works in which the movements, gestures, and sounds of persons communicating with an audience replace physical objects. Documentary photographs are generally the only evidence remaining after these events. The breast has been an element in a number of public art installations, sculptures, and performances. It always seems to add to the dynamic effect of the overall piece.

An early example of performance art that makes use of the female body is a work by Yves Klein, *Anthropométries de l'époque bleue* (performed on March 9, 1960), where he directed the nude women as his living brushes as they covered themselves in paint and made

imprints of their breasts and torsos for a live audience. In 1971, *Womanhouse* was created as a daring, collaborative site installation for the California Institute of the Arts under the direction of artists Judy Chicago and Miriam Schapiro. The building was slated for demolition, and thus the women were allowed to create a temporary public art installation and hold numerous performance pieces during the exhibition. Each room became sites for transformation that addressed the relationship between biology, social roles, and gender constructions. For example, Vicki Hodgett's *Eggs to Breasts* featured a kitchen with the ceiling and walls covered with three-dimensional fried-egg "breasts." Louise Bourgeois created her own latex costume (1970), which bound her from the neck to the knees in multiple breast shapes, calling to mind the goddess Diana. Artists Anne Gauldin and Denise Yarfitz first performed *The Waitress Goddess Diana* (1978), where Gauldin was dressed in a white uniform that was covered with multiple breasts down her front. Austrian-born Valie Export used her performance pieces as a way to attempt to separate the female body from the eroticized body. She performed *Touch Cinema* (1968) by creating a box to wear that was open in the front to allow the "spectators" to stick their hands in and touch her breasts. Her goal was to create contradiction—a cinema of touch rather than vision.

Ana Mendieta created a series called *Glass on Body Imprints* (1972), where she pressed and manipulated her body parts, particularly her breasts, against a square piece of Plexiglas, which then radically distorted her body, making it seem more sculptural than erotic. Annie Sprinkle, a prostitute and porn star turned artist and sexologist with a PhD, is known for her work as a visual and performance artist. She has performed *The Bosom Ballet* in a number of different venues, where she stretches, manipulates, and jiggles her breasts to music. She has traditionally performed this to "The Blue Danube Waltz" under a pink spotlight with dark opera gloves on. She also performed it as a tap dance where she glued taps all over her breasts and fingertips to amplify the sound.

Renowned British artist Mark Quinn garnished both praise and criticism with his large marble sculpture called *Alison Lapper Pregnant* (2005). Lapper, a friend of Quinn's, is disabled, and at the time of the sculpture she was 8 months pregnant, which created an image very different from the typical depiction of a female. The result was a large white marble sculpture placed on a plinth prominently showcasing her nude breasts and pregnant belly. Public art will continue to be a presence within society and challenge what is considered acceptable in the public forum.

See also ART, INDIAN AND AFRICAN; ART, WESTERN; ICONOGRAPHY; MYTHOLOGY; SCULPTURE; THEATRE

Further Reading

Bresc-Bautier, Genevieve, Bernard Ceysson, Jean-Luc Daval, Maurizio Fagiolo Dell'Arco, Reinhold Hohl, Antoinette Le Normand-Romain, et al. *Sculpture: From the Renaissance to the Present Day.* Cologne, Germany: Taschen, 1999.

Broude, Norma, and Mary D. Garrard, eds. *The Power of Feminist Art.* New York: Harry N. Abrams, 1994.

Stokstad, Marilyn, and Michael W. Cothren. *Art History*, 4th ed. Upper Saddle River, NJ: Pearson, 2010.

Taylor, Brandon. *Contemporary Art: Art since 1970.* Upper Saddle River, NJ: Pearson, 2005.

■ LORI L. PARKS

R

RACE AND RACISM

Race is a multivalent term that articulates race as "natural" and "biologically" determined. However, the definitions of race are socially constructed and ideologically determined. The constructed definitions of race include ethnicity and biology markers in which individuals are segregated according to race groups that comprise, but are not limited to, white, black, brown, and Asian. Cultural researchers assert that Western society constitutes a hierarchical structure in which people are grouped according to their race based on their physical characteristics, which become categories that are inscribed with value. Society concentrates on race in order to establish and categorize an individual's identity so as to situate the person within society's hierarchy.

The discourse of race foregrounds systemic racism in that physical characteristics that manifest the dominant, privileged race are valued over those that constitute the other. In Western society, the physical characteristics that society ascribes to the white race manifest power and authority over those that are associated with nonwhite races. Members of the white race embody power over those who are not white. For instance, Western society values blond straight hair, which is associated with the white-skinned population. In contrast, society dislikes and discriminates against curly black hair, which it describes with such negative connotations as "coarse" and "kinky," because it is associated with the black-skinned population. Valuing physical characteristics that are deemed to belong to the white population creates a hierarchy that locates the white race at the top and all nonwhite races below it. Race ensures the authority of white privilege and maintains the binary of white over black.

Race creates "knowledge" of cultures that depends on stereotyping physical characteristics. Because of the Western world's focus on and sexualization of the female breast, a racial narrative has developed around breast size that categorizes women of different races with different breast sizes. Asian women are stereotyped by Western society to have smaller breasts than American white women. Conversely, black women are presumed to have larger breasts than their white female counterparts. Popular culture in the Western world, through such mediums as television, film, and advertising, has created an ideology that values large breasts, presenting them as sexually arousing for men. A woman's breast size has become directly proportional to her physical attractiveness and her sexuality, as long as she also has a low waist-to-hip ratio. Women with larger breasts and narrow waists

are thought to be more attractive, feminine, and "sexier" than women with smaller breasts. Even though Western society values larger breasts over smaller breasts, it does not value black women, who are believed to have larger breasts, above white women because skin color dominates the categorization of race and its discourse. Regardless of having large breasts, a black-skinned woman is other to the white woman.

A study reveals that men in the United States rate breasts as "the most sexually stimulating" characteristic of women's bodies. Men chose women "with breasts larger than the average female breast size," believing them to be more sexually desirable than women with smaller breasts. Because of these attitudes and constant images in media that advance the ideology that women with large breasts are more physically and sexually attractive, women of all skin colors in the United States have become dissatisfied with their breast size. The rate of women undergoing breast augmentation surgery has increased steadily since 2000. Women who choose to have their breasts surgically increased believe that larger breasts will increase their femininity, self-esteem, and sexuality. Women state that the motives behind wanting to increase the size of their breasts stem from images in the media that portray women with larger breasts. As well, some of these women state that they have been encouraged by their male partners to have their breasts surgically enlarged.

Female breasts are considered to belong to men for their sexual enjoyment. Anthropological research reveals that in cultures where women appear bare-breasted, breasts are still deemed to be sexual and for the pleasure of men during copulation. Such sexual behavior and belief systems work on women's psyches, affecting how women understand their bodies and for whom their bodies serve. Studies are undertaken around the world to comprehend how men in different geographic locations view female breasts in relation to their own sexual desires. In Israel, China, and France, men, like their American counterparts, preferred women with larger breasts, perceiving them as more sexually attractive than women with smaller breasts. Cultural scientists point to the globalization of Western ideals of female sexuality as reasons for these preferences.

Studies have also found that men perceive breasts as an indication of a woman's reproductive ability. Women with larger breasts are considered to be more fertile than women with smaller breasts. In patriarchal societies, men are expected to produce heirs, especially male, who will carry on the family name. Such expectations persuade men to choose female mates who have large breasts in the hope that the women will be successful in producing children. In a study conducted on men in Papua New Guinea, an area with a high birth rate, women with larger breasts are desired because they are considered to have a high probability of conceiving children for their mates.

There have been few research studies undertaken that contradict the results of the above-mentioned case studies that reveal that men desire women with larger breasts. However, the results of one study on male breast preferences on the Caribbean island of St. Kitts found a group of men whose choices challenged previous findings. The researchers expected the male participants to desire women with larger breasts because of Western-world influences through tourism and media. However, the participants preferred women with smaller breasts. One possible reason for this is that the fertility rate in St. Kitts has decreased over the years, which may correspond to a decrease in the male desire for women with larger breasts; women are no longer desired for their perceived fertility potential. Another explanation might be that men and women on the island are being

influenced by the Western desire for thin bodies with lower body mass indexes. Men might desire women with a more slender body type over a heavier body type, with the leaner body inevitably having smaller breasts.

Scientists continue to research how discourses of race intersect with body image and sexuality. The racial categorization of physical characteristics produces a narrative that identifies and compares women of different cultures by their breast size. Race, combined with the global dissemination of the Western world's preoccupation with and hypersexualization of breasts, results in men located in different geographic locations adopting the same ideology that breasts have only a sexual function and that female breast size is directly proportional to a woman's physical attractiveness. Women from different races have become dissatisfied with their breast size because of the viral hypersexualization of the breast.

See also BARBIE DOLLS; BAARTMAN, SAARTJIE (C. 1770S–1815); BREAST AUGMENTATION; INTERNATIONAL CULTURAL NORMS AND TABOOS; MEDIA

Further Reading

ASPS Public Relations. "2011 Cosmetic Plastic Surgery Statistics." Retrieved January 25, 2013, from http://www.plasticsurgery.org/News-and-Resources/2011-Statistics-.html

Barash, David P., and Judith Eve Lipton. *How Women Got Their Curves and Other Just-So Stories: Evolutionary Enigmas*. New York: Columbia University Press, 2009.

Dixson, Barnaby J., A. F. Dixson, B. Li, and M. J. Anderson. "Studies of Human Physique and Sexual Attractiveness: Sexual Preferences of Men and Women in China." *American Journal of Human Biology* 19, no. 1 (January–February 2007): 88–95.

Gray, Peter B., and David A. Frederick. "Body Image and Body Type Preferences in St. Kitts, Caribbean: A Cross-Cultural Comparison with U.S. Samples Regarding Attitudes towards Muscularity, Body Fat, and Size." *Evolutionary Psychology* 10, no. 3 (2012): 631–655.

Gueguen, Nicolas. "Women's Bust Size and Men's Courtship Solicitation." *Body Image* 4 (2007): 386–390.

Higginbotham, Elizabeth, and Margaret L. Andersen. *Race and Ethnicity in Society: The Changing Landscape*. Belmont, CA: Thomson/Wadsworth, 2006.

Ward, L. Monique, Ann Merriweather, and Allison Caruthers. "Breasts Are for Men: Media, Masculinity Ideologies, and Men's Beliefs about Women's Bodies." *Sex Roles* 55, nos. 9–10 (November 2006): 703–714.

■ NATALIE E. DEAR

RED LIGHT DISTRICTS

A red light district is an area or district in a city in which many buildings of prostitution are located. The origin of this term dates to the late nineteenth century and is allegedly used because many of the brothels used red lights. Prostitution (the act or practice of engaging in sexual intercourse for money) is often described as the "oldest profession," and it has long been recognized as an enduring feature of urban life. References to prostitution have been found in ancient Sumerian texts, and Hammurabi included a provision for prostitutes in his Code of Hammurabi (c. 1780 BCE) whereby inheritance rights are protected for prostitutes. Commercial brothels in China can be dated to the seventh century BCE. They were used as another means for increasing the state's income and were relegated to specific areas of the town.

Ancient Greek literature refers to three categories of prostitutes. On the lowest tier were slave prostitutes (*pornai*); then freeborn street prostitutes; and, finally, the educated higher class prostitute or entertainer (*Hetaera*), who was always female and could potentially enjoy a level of influence within society. There were government-supported brothels located in high-traffic areas of ancient Greek urban spaces. Prostitution would remain accessible and legal throughout the Greek and Roman periods until early Christian emperors began to discourage it. By the Middle Ages, prostitution was an accepted part of urban life. King Henry II of England (in 1161) mandated inspections of London brothels.

During the Renaissance (fourteenth and fifteenth centuries), many government-funded brothels were established in busy Italian cities. There were two categories of prostitutes: those considered common, and the *Cortigiana onesta* or honest prostitute who, like the ancient Greek *Hetaera*, was looked at favorably because of her intellect, wit, and charm, which made her valuable beyond her offered sexual services. As early as 1358, the Great Council of Venice held the view that prostitution was important to society. Venetian courtesans contributed to revenue through taxes and fines. To prove they were female, they were encouraged to stand naked from the waist up to attract customers. The neighborhood of Castelleto was a district for prostitution where many women bared their breasts while standing on the Ponte delle Tette, or Bridge of Breasts.

After the French Revolution (1789–1799) ended, the government began a new Bureau des Moeurs (Bureau of Morals) in Paris, which eventually spread throughout the country. Their task was to monitor the various prostitution establishments and see that they complied with the law. Historically, the media have perpetuated images of prostitution that distinguish prostitutes as a "deviant" group, different from the "normal" population. In the United States, on the western mining frontier, prostitutes constituted an important and identifiable socioeconomic group. Their presence was established with the early tent towns and continued to evolve to small cottages or rooms above saloons. "Cribs" were a series of single rooms outfitted with a bed, washstand, chair, door, and window. The women would live elsewhere and come to the "crib" to do business. This setup was a stark contrast to the brothel, where there would be nicer surroundings and a madam to manage the space.

Amsterdam's red-light district, De Wallen, is one of the best-known areas for prostitution in the world. It has become a popular tourist destination that some have described as similar to a modern open-air shopping mall in the United States. The neon atmosphere presents windows of women to choose from. In the Netherlands, prostitution is accepted as a social fact and has been legalized since 2000, although it is still heavily regulated to control any illegal immigration. In addition, prostitutes are registered and taxed. Germany's Reeperbahnin in Hamburg is also a semipublic area where registered prostitution is concentrated and thus more easily subject to stricter controls.

See also PORNOGRAPHY; PROSTITUTION

Further Reading

Brants, Chrisje. "The Fine Art of Regulated Tolerance: Prostitution in Amsterdam." *Journal of Law and Society* 25, no. 4 (December 1998): 621–635.

Hubbard, Phil. "Sexuality, Immorality and the City: Red-Light Districts and the Marginalisation of Female Street Prostitutes." *Gender, Place and Culture* 5, no. 1 (March 1, 1998): 55–72.

Wonders, Nancy A., and Raymond Michalowski. "Bodies, Borders, and Sex Tourism in a Globalized World: A Tale of Two Cities—Amsterdam and Havana." *Social Problems*, no. 4 (2001): 545–571.

■ LORI L. PARKS

RELIGION

Since prehistoric times, breasts have been an element in religious celebrations, worship, and imagery. Stone Age idols found throughout the world have protruding breasts and often excessively large buttocks and stomachs. Most likely, these figurines were fertility symbols or mother goddesses, who were worshipped for their powers over procreation and lactation.

In ancient Egypt, the goddess Isis, the mother goddess, was often depicted nursing a pharaoh—bestowing upon him divinity through her milk. Other Egyptian goddesses were also shown with large or nursing breasts. Depictions of the male god, Hapi, the god of the Nile, show him with female breasts, too. This symbolized his fertility, since it was the overflowing of the Nile River each year that permitted crops to be grown and the people of Egypt to be nourished.

Ancient Greek *Kourotrophos* cults revered mothers and those who nursed or taught children. Small statues of breastfeeding mothers were often placed at shrines to honor the goddesses and treats, such as breast-shaped cakes, were also left at the shrines. The life-sized multibreasted statues of Artemis of Ephesus are another example of breast veneration and the life-giving properties of breast milk.

The statues and paintings found in Indian temples often display erotic figures of male and female deities. The women have small waists, large breasts, and full hips. The figures are graceful and sensual, and they depict an ideal of fertility and eroticism. One example is the statues of Parvati and Shiva at the Halebidu Temple in Karnataka. The figures are draped in pearls. Parvati has large, firm breasts. The goddess often depicts both fertility and sexuality—she was born to

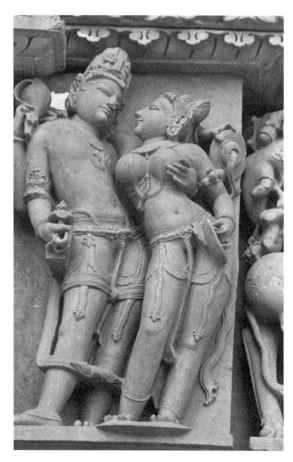

Shiva caresses Parvati's breast in this temple statue, Khajuraho, India. Zzvet/Thinkstock by Getty

tame and marry Shiva. Once the couple weds, their lovemaking is so intense it disrupts the cosmos.

Early Judaism celebrated fertility and life-sustaining breasts as well. When 90-year-old Sarah, the wife of Abraham, gave birth to Isaac, she exclaimed, "Whoever would have told Abraham that Sarah would suckle children?" (Genesis 21:7). References to breasts in the Bible, however, are not limited to tributes to fertility. The *Song of Songs*, for example, includes erotic images of breasts.

Throughout the centuries, references to and displays of breasts have been a part of Christian writings and art. In thousands of paintings and sculptures, the Virgin Mary, the mother of Jesus, is pictured nursing the infant. Such images are referred to as *Maria Lactans*. Well-known artists, including Leonardo da Vinci, Michelangelo (Michelangelo di Lodovico Buonarroti Simoni), Titian (Tiziano Vecellio), Joos van Cleve, Jan van Eyck, and Albrecht Dürer, created works of art featuring the nursing Madonna. Unknown artists also painted and sculpted *Maria Lactans* for churches, for shrines, and for the private chapels or residences of wealthy patrons. Sometimes, the lactating Virgin appeared with grapes to symbolize the Eucharist.

The Virgin's milk was said to have miraculous properties. For example, according to legend, Mary appeared to St. Bernard while he prayed, and sprinkled milk from her breasts on his lips. The lactation of St. Bernard is another popular subject in religious art. At many shrines, vials of what were reputed to be milk from the Virgin Mary's breasts were venerated and sought after by pilgrims.

Devotional texts and art also use the imagery of a lactating Jesus. Men and women drink his blood and receive nourishment. In some medieval iconographic art, such as *The Savior* by Quirizio da Murano, Jesus offers his wound as though it was a nipple, or fills a cup with blood flowing from the wound on his chest. In other works of art, sometimes called the Double Intercession, Jesus and the Virgin Mary appear in parallel poses—he offers his bleeding wound, and she offers her breast.

A number of female saints and martyrs of the early Christian church were revered for their dedication to chastity and rejection of bodily needs. Some of them were tortured, and their breasts were mutilated. Saint Agatha of Sicily, for example, had her breasts cut off by order of the pagan governor. She later became the patron saint of nursing mothers. The breasts of saints were often said to exude fluids that nourished or cured. When Saint Christina the Astonishing was in the desert and without food, she was said to have prayed to God. Her virginal breasts then filled with milk, and she was able to nourish herself with it for 9 weeks. Later, when she was locked in a cellar because she was thought to be insane, her breasts filled with oil that healed the sores of one of her tormentors.

Breasts, particularly nursing breasts, appeared regularly in the sermons and religious texts of Puritan ministers. John Cotton, Cotton Mather, and Samuel Willard, among others, exhorted their parishioners to feel the love of Jesus in language that used imagery of nursing, nourishment, and spiritual ecstasy. The redeemed, both female and male, would lie in "Christ's bosom" and be ravished by him. When believers died, they could hope to rest at the breast of Jesus. Ministers also compared spiritual nourishment with the nourishment that infants received at their mothers' breasts. In fact, Puritan ministers often referred

to themselves as breasts of God. Good and faithful Christians were urged to suck at this breast of knowledge to receive the word of Christ.

Death, rebirth, and fertility themes can also be found in the mythology of Native American peoples. There are many legends of the Corn Mother, who has to die in order to produce corn (maize) to feed her children. In one version told by some Iroquois-speaking tribes, the corn grows from the dead Corn Mother's breasts, while beans and squash grow from other parts of her body. The Keresans, a Pueblo group, say that the Corn Mother planted her heart and told her children that the corn that grew from it would be like milk from her breasts.

See also ART, INDIAN AND AFRICAN; ART, WESTERN; BIBLE; FERTILITY SYMBOLS; ICONOGRAPHY; SAINTS AND MARTYRS; VIRGIN MARY

Further Reading

Bynum, Caroline Walker. *Holy Feast and Holy Fast: The Religious Significance of Food to Medieval Women.* Berkeley: University of California Press, 1987.

Godbeer, Richard. *Sexual Revolution in Early America.* Baltimore: Johns Hopkins University Press, 2002.

Leeming, David, and Jake Page. *Mythology of Native North America.* Norman: University of Oklahoma Press, 1998.

Leverenz, David. *The Language of Puritan Feeling: An Exploration in Literature, Psychology, and Social History.* New Brunswick, NJ: Rutgers University Press, 1980.

Yalom, Marilyn. *A History of the Breast.* New York: Knopf, 1997.

■ MERRIL D. SMITH

ROCHESTER TOPFREE 7

On June 21, 1986, seven feminists removed their tops and bared their breasts in public during a picnic at Rochester, New York's popular Cobbs Hill Park. They did so as an act of civil disobedience in protest against a state law requiring women to wear tops in public, which they felt was discriminatory since men could go topless in public.

The 50-year-old Penal Law § 245.01, or "Exposure of a Person" law, stated that women in New York State could breastfeed infants in public, but could only go topless in public in very specific circumstances that were deemed entertainment. It was illegal for women to show their areolae—the pigmented area of the breast around the nipples—and the nipple itself. The law did not restrict men from showing areolae or nipples.

The seven women—Nikki Craft, Kathleen Reilly, Ramona Santorelli, Mary Lou Schloss, Deborah Seymour, Elsie Jo Tooley, and Lynn Zicari—were arrested at Cobbs Hill and charged with violating the law. They appealed.

Six years later, on July 7, 1992, the seven were acquitted when the state's highest court reversed Penal Law § 245.01, declaring it unconstitutional and ruling that women have the right to be topless anywhere in public that men can be topless. Women still cannot, however, be topless in public in the state for commercial purposes or advertising—the only commercial-purpose exception again being very specific circumstances deemed entertainment, such as performance in an exhibition, play, or show.

Today, the topfree movement is a worldwide cultural and political movement that works for women's rights to bare their breasts in public. Santorelli continues to play an active role.

See also CONTROVERSIES; TOPLESS PROTESTS

Further Reading

Topfree Equal Rights Association (TERA). "Rochester Topfree Seven." Retrieved December 2, 2012, from http://www.tera.ca/legal.html#Rochester

The People &c., respondent, v. Ramona Santorelli and Mary Lou Schloss, appellants, et al., defendants. 80 N.Y.2d 875, 600 N.E.2d 232, 587 N.Y.S.2d 601 (1992). July 7, 1992. Cornell University Law School Legal Information Institute. Retrieved December 2, 2012, from http://www.law.cornell.edu/nyctap/I92_0160.htm

■ ELIZABETH JENNER

ROUSSEAU, JEAN-JACQUES (1712–1778)

Jean-Jacques Rousseau was a renowned Genevan philosopher, political activist, social commentator, and musical composer during the French Romantic Period. Though Rousseau is remembered for having penned several substantial works (including *The Social Contract* and *The Confessions of Jean-Jacques Rousseau*), perhaps none has remained as pervasively influential as *Émile*, or *Treatise on Education*, a text that revolutionized the French educational system following the French Revolution. In *Émile*, Rousseau envisions a tutor instructing a young student, the text's namesake, in an idyllic, rural setting, as befits Rousseau's beliefs that children learn best from having experiences in Nature. Rousseau conceptualizes how parents could cultivate the ideal citizen, starting from infancy, wherein he advocates for maternal breastfeeding. Though contemporarily considered to be a normalized practice, Rousseau's insistence that mothers breastfeed their own children was a revolutionary concept for eighteenth-century, upper-class mothers, for whom hiring wet nurses was commonplace.

Nevertheless, Rousseau maintained that a child's "real nurse is the mother." He insisted that the nurse–child relationship functioned as a formative experience for a child, from which a child learns how to form other social ties. Thus, it was essential that children bond with their mothers, as the family served as the hub of a smoothly functioning society. Though Rousseau's theories also adhere to a strict understanding of designated gender roles, his work did promote the importance of maternal breastfeeding as a beneficial practice for both mothers and children.

See also BREASTFEEDING; ICONOGRAPHY; LITERATURE; WET NURSING

Further Reading

Damrosch, Leopold. *Jean-Jacques Rousseau: Restless Genius.* Boston: Houghton Mifflin, 2005.

Dent, Nicholas J. H. *Rousseau: An Introduction to His Psychological, Social, and Political Theory.* Oxford: Blackwell, 1988.

Riley, Patrick, ed. *The Cambridge Companion to Rousseau*. Cambridge: Cambridge University Press, 2001.

Rousseau, Jean-Jacques. *Émile*, translated by Allan Bloom. New York: Basic Books, 1979.

■ SARAH E. BRUNO

RUSSELL, JANE (1921–2011)

Jane Russell is remembered as a mid-twentieth-century film star and a popular "pinup" among servicemen during World War II (1939–1945) and the Korean War (1950–1953). Russell was born on June 21, 1921, in Bemidji, Minnesota, and discovered at age 19 by Howard Hughes. Russell became a sensation due to controversial publicity shots for her first film, *The Outlaw* (1941), and would star in nearly 20 films between 1943 and 1957. Her costars include Bob Hope (*The Paleface*, 1948), Marilyn Monroe (*Gentlemen Prefer Blondes*, 1953), and Clarke Gable (*The Tall Men*, 1955).

Hughes cast Russell, who stood 5'7" and measured 38D-24-36, in his independent western, *The Outlaw*. Russell's breasts were highlighted through the film with low-cut blouses and adapted undergarments; they were likewise central to the film's promotion. Film posters depict Russell laying atop haystacks with ample cleavage exposed—one hand tousling her hair, the other wielding a pistol. These provocative advertisements instantly turned Russell into a sex symbol, but they also drew negative attention from the censors. The Production Code Association (PCA) was established in 1934 to regulate and enforce morality standards in film production and promotion. The PCA deemed *The Outlaw* "pornographic," and Hughes became embroiled in censorship battles that affected the film's release for over 5 years. Ultimately, Hughes' defense juxtaposed "PCA-accepted" public images, as well as those of nude-subject museum masterpieces, against the relatively moderate amount of skin exposed in *The Outlaw*—the case set precedent when it was dismissed.

Forty years after *The Outlaw*, Russell's breasts once again made her a household name in the 1980s when she became a TV spokesperson for Playtex 18-Hour Bras. Russell died of respiratory failure on February 28, 2011, at the age of 89.

See also ADVERTISING; CELEBRITY BREASTS; MOVIES; PORNOGRAPHY

Further Reading

Leff, Leonard, and Jerold L. Simmons. *The Dame in the Kimono: Hollywood, Censorship and the Production Code from the 1920s to the 1960s*. New York: Grove and Weidenfeld, 1990.

Pauly, T. H. "Howard Hughes and His Western: The Maverick and the Outlaw." *Journal of Popular Film* 6, no. 4 (1978): 350–368.

Russell, Jane. *Jane Russell: My Path and My Detours*. New York: Franklin Watts, 1985.

■ STEPHANIE LAINE HAMILTON

S

SAINTS AND MARTYRS

The word *saint* comes from the Latin *sanctus*, meaning "holy." Saints are holy, virtuous people of the Christian faith who have been canonized—officially declared saints after death by Church leaders. In the Catholic branch of Christianity, a miracle must be attributed to a deceased holy person as part of the process of canonization, except in cases of martyrdom. Saints are often prayed to for help through life's difficulties or for the miraculous healing of physical or psychological ailments, and many people believe saints can intercede between God and the prayerful supplicant on the supplicant's behalf. Saints are also viewed as role models worthy of reverence and emulation.

Martyrs are people who have been killed for their faith or spiritual beliefs. The word *martyr* comes from the Greek *martur*, meaning "witness," because those killed for religious reasons are considered to have borne witness, or shown that God is real through an incredible or miraculous ability to withstand torture or accept death rather than deny the existence of God. Martyrs are often given the choice to recant their belief in God or be tortured and killed, yet they choose agony rather than deny God. Martyrs frequently become canonized as saints.

Female saints and martyrs are often associated with the sexual innocence and purity of virginity. Many pledged their bodies to God and refused to partake in any immodest acts or sexual activities throughout their lives. Usually they have not married because they viewed themselves as married to God. It was therefore a great psychological as well as physical cruelty to publicly display and mutilate the breast in response to the female's refusal to deny her relationship with God and acquiesce to men's sexual demands.

Accounts of women in the throes of martyrdom repeatedly describe breasts being exposed, kicked, amputated, shot with arrows, ripped into and pulled at with metal hooks, burned with red-hot branding irons, bound with willow branches, and twisted off, as well as nipples being torn off breasts. Attila the Hun shot Saint Ursula's breast with arrows, killing her for her refusal to marry him. Roman soldiers sadistically applied red-hot irons to Saint Reparata's breasts, mutilating them. Saint Agnes's breasts were burned with firebrands while she hung upside down. At age 12, Saint Christine was stripped naked and paraded around a city, and then her breasts were hacked off. Saints Eucratis, Euphemia, Dorothy, Thecla, Erasma, Helconis, and others also had breasts cut off.

Saint Agatha of Catania, Sicily, is perhaps the saint most often associated with the breast. In the third century, she refused to give in to the sexual advances of the pagan

governor Quintinian, and she mocked his gods rather than sacrificing to them. In response, he ordered her breasts cut off. They were mutilated by Roman soldiers before being removed.

It is common among those who venerate saints to pray to them for help, protection, or healing. If the saint was a martyr, they usually pray for something related to the specific harm the saint endured during martyrdom. Many therefore appeal to Saint Agatha for assistance with breast-related issues—help with breastfeeding problems, protection against diseases of the breast, and the healing of a breast tumor or breast cancer. Saint Agatha is considered the patron saint of breasts.

Some stories involving breasts and saints do not contain torture. In one, Saint Macrine, a fourth-century virgin, had a breast tumor, and her breast became close to gangrenous. She refused

The Martyrdom of St. Agatha, Jean Bellegambe, 1528. RMN-Grand Palais/Art Resource, NY

to let it be looked at or operated on by a doctor out of modesty—the doctors of that time were all men. It is said God healed her because he was pleased by her decision to remain untouched by men. In another story, rays of light shot out from the breasts of Saint Keyne of Wales' mother while she was pregnant with her. Her mother is said to have dreamed she was nursing a dove. Saint Veronica Giuliana reportedly nursed a lamb in memory of Jesus—the Lamb of God. Saint Bernard received spiritual nourishment from the Virgin Mary, who appeared before him and squeezed a stream of milk from her breast into his awaiting mouth.

See also Breastfeeding; Breast Cancer; Breast Mutilation; Religion; Virgin Mary

Further Reading

Gallick, Sarah. *The Big Book of Women Saints.* New York: HarperCollins, 2007.

Gallonio, Rev. Antonio. *Tortures and Torments of the Christian Martyrs.* Los Angeles: Feral House, 2004.

Streete, Gail. *Redeemed Bodies: Women Martyrs in Early Christianity.* Louisville, KY: Westminster John Knox Press, 2009.

■ ELIZABETH JENNER

SCULPTURE

Sculpture is one of the oldest and most enduring disciplines of the visual arts. Sculpture is the practice of shaping figures or designs in the round (a freestanding sculpture viewed from all sides) or in relief (raised from a largely flat background) through the use of a wide variety of material such as marble, modeling clay, or casting in metal.

The breast has figured prominently in sculpture throughout time. Prehistoric female sculptures have appeared in Spain, Central Europe, and Russia. They have been fashioned out of stone, clay, and bone, and they are most notable for their emphasis of breasts, buttocks, and stomachs. One famous example is *The Woman of Willendorf*, c. 24,000–22,000 BCE. This small, abstract, bulbous figure was originally painted in red ochre. Many scholars connect her symbolically to fertility (due to the exaggerated forms of the breasts and belly and the red color). Neolithic antlers have been found with carvings of breasts in Switzerland, and in Germany vases formed with multiple breasts have been found. In the Neolithic village of Çatal Höyük, located in present-day south-central Turkey, archeologists have found rows of clay breasts plastered onto the walls of what is believed to be important shrines. Details are added through the use of animal teeth, tusks, and beaks placed where the nipples would be.

In ancient Egyptian writing, "sculptor" translates as "he who keeps alive." This reflects the important place that sculpture had within this society and its connection to their belief system, specifically the afterlife. The Egyptians created funerary *Ka* statues that would provide a place for the individual spirit of the deceased to stay for eternity. These statues followed specific conventions for representing the ideal and royalty. The role of these statues was an attempt to unify the material world with the spiritual through the permanence of stone. There is generally not a lot of nudity in Egyptian sculpture, although when aristocratic females are depicted they are wearing a transparent dress that reveals the outline of their breasts and pubic triangle. There are examples of goddesses represented in Egypt. Fertility elements are symbolized by the goddess Isis, a milk-giving cow as well as the throne of pharaohs and a tree of life. The ascending pharaoh might be represented suckling at the breast of the goddess who acts as a royal throne. The milk from these breasts confers immortality.

Two major (pre-Greek) civilizations flourished during the Bronze Age (3200–1100 BCE) on the islands of Crete and the Cyclades. The Cyclades are a group of islands in the southwestern Aegean, comprising some 30 small islands and numerous islets. Many sculptures have been found, with female figures far outnumbering the male figures and ranging in size from several inches to life sized. Carved out of white marble and abstracted, they are very different from the earlier prehistoric representations of the female figure. The female sexual characteristics have been reduced to two circles and a triangle. In addition, they would have been embellished with paint and other kinds of ornamentation. By 3000 BCE, Bronze Age people known as the Minoans were living on the island of Crete. Like the Cyclades, Minoan art reflects their island civilization with visual representation referencing nature imagery, bright colors, flowing lines, and some form of a nature goddess with exposed, swelling breasts, a pinched waist, and bell-shaped skirts.

The Greeks are credited with creating a standard of excellence to which all art should aspire, as well as a preoccupation with visual appearances. Thus, they sought to create human forms that embodied their notion of beauty and sexuality, and invested them with moral qualities. Although they are indebted to the Egyptian influence in sculpture, they

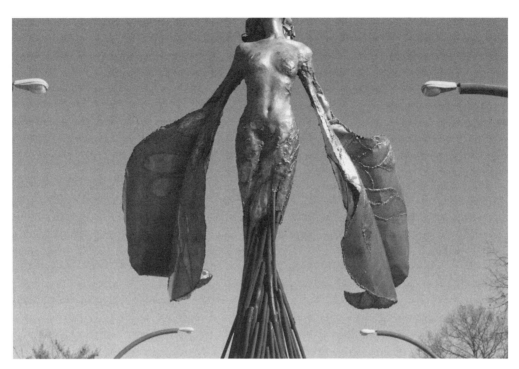

"Eos" by Dessa Kirk. Artist Dessa Kirk chose a classical subject, Eos, Goddess of the Dawn, for the Public Sculpture Invitational in Columbus, Indiana. The goddess is typically presented as a beautiful woman with rosy arms and fingers. In this sculpture, her naked torso arches towards the sky, as her winged arms sweep back. Although the women of classical Greek and Roman mythology are often portrayed with their breasts exposed, some people in more recent times have objected to public art featuring nudity. Photograph in the Carol M. Highsmith Archive, Library of Congress, Prints and Photographs Division.

quickly evolved into a much more naturalistic style. The sculpture of the Greek Archaic period (c. 620–480 BCE) is initially reminiscent of the more stiff and upright sculptures of the Egyptians. The standing male nude (*kouros*) first became important during this period and visually associated the male body with athletic prowess and moral excellence in character. Attitudes toward female nudity were different. The female body was associated with procreation, and for about five centuries the Greeks created the standing female sculpture (*Kore*) clothed. There was also a cult known as the *Kourotrophos*, which focused on the principle of suckling in small statues of nursing mothers that might be placed in sanctuaries and tombs. The prominence of the female figure in early cultures is supplanted by a focus on the male nude in Greek art.

Athleticism was important to the Greeks, especially as they shifted into the Classical period (c. 480–323 BCE). Male sculptures were primarily nude and shown with ideal proportions (a relationship in size between a work's individual parts and the whole). Beauty was based on an underlying canon based on mathematical proportions and the finely honed physiques of male athletes. They also developed the use of *contrapposto*, a pose that refers to a shift in weight or counterbalance that results in a greater sense of naturalism. The female was not initially sculpted in the nude. The *Three Goddesses* (from the east

pediment of the Parthenon, Acropolis, Athens, c. 438–432 BCE), now housed in the British Museum, is indicative of a "wet drapery" style where the clothing is depicted as if it is almost transparent and molded to the body. It tends to reveal more than it conceals. Aphrodite (Venus), the goddess of love, became a popular sculpture from the fourth century onward; she is typically depicted in varying states of undress and with her breasts clearly emphasized. The Romans became the inheritors of the Greek tradition, where idealized statues in ancient Greece would be copied in the Roman Empire and later rediscovered in fifteenth-century Italy.

In India, there are deliberately seductive sculptures of Yakshi (a nature spirit associated with fertility) from Sanchi, which date to the first century BCE. The female form is depicted with swelling breasts, belly, and pubic triangle. Female figures can also be found in the multitude of carvings that adorn the Indian temples, which represented a "cosmic mountain" and were aligned with the rising and setting sun. The intricate carvings suggest dancing and erotic scenes depicting the physical union between the male and female. The openly erotic nature is in startling contrast to the generally repressive nature of the medieval Christian art being created in Europe.

Medieval society did not apply the classical proportions to the representation of the human body; instead, proportional criteria were used to define morality rather than the body's physicality. Much of the art attempted to embody the perfection of an idea, and the body was often depicted as distorted to further communicate its moral status. Medieval attitudes toward female nudity was associated with sinfulness and often used to illustrate the story of Adam and Eve or in Last Judgment scenes on church portals.

The Renaissance (from the fourteenth to the seventeenth century) brought a rediscovery of Greco-Roman cultural values and returned the nude to the forefront of sculpture. This was not the ideal based on a set of mathematical proportions, but an attempt to capture the natural world around them. Mythological female figures became an important subject for the arts. In Rococo art (first half of the eighteenth century), nudity was more suggestive, where Neoclassical female nude sculptures looked back to antique forms and poses for inspiration. From the nineteenth century on, sculpture was affected by the varying styles popular then (Neoclassical, Romanticism, Realism, etc.), as well as a growth of public awareness through exhibitions. The sculpture is also typically nude. With the advent of the twentieth century, traditional renderings of the body were shattered as Cubists and other avant-garde artists imagined new ways to convey their subject. Postmodernism emerged midcentury and tapped into the growth of consumerism and the general sense of disillusionment in a postwar world. Modernism, a philosophy that praised the new, looked to technological advances to better the world and the increasingly restrictive ideals that constituted the proper aesthetic. Postmodernism can be considered a reaction to this, and postmodern art has become an exploration of the subjective, the mundane; it can be playful or critical. It is less a style and more of an engagement with ideological structures of norms, which include an often frank emphasis on class, gender, and race.

See also ART, INDIAN AND AFRICAN; ART, WESTERN; ICONOGRAPHY; KOUROTROPHOS CULTS; MYTHOLOGY; PUBLIC ART

Further Reading

Bresc-Bautier, Genevieve, Barbara Rose, François Souchal, Reinhold Hohl, Anne Pingeot, Friedrich Meschede, et al. *Sculpture: From the Renaissance to the Present Day*. Cologne, Germany: Taschen, 1999.

Collins, Judith. *Sculpture Today*. London: Phaidon, 2007.

Duby, Georges, Philippe Bruneau, and Jean-Luc Daval. *Sculpture: From Antiquity to the Middle Ages*, edited by Georges Duby and Jean-Luc Daval. Cologne, Germany: Taschen, 1999.

Potts, Alex. "Installation and Sculpture." *Oxford Art Journal* no. 2 (2001): 7.

Richter, Gisela Marie Augusta. *A Handbook of Greek Art*. New York: Da Capo Press, 1987.

■ LORI L. PARKS

SEXISM

Sexism is the belief that one sex is superior to the other. In a patriarchal society, sexism is the oppression of women by men. It is not only a reflection of individual beliefs, but also part of the institutional structure. Sexism is a system that oppresses women through attitudes, assumptions, everyday practices, institutional rules, structures, and the culture at large. It is a system that validates the subordination of women. Sexism limits the talents and opportunities of women. It can be found in all institutions; for example, in many economies, women are highly concentrated in low-paying jobs, limiting their opportunity for advancement and upward social mobility.

Sexism has traditionally been viewed as hostility toward women; however, American psychologists Peter Glick and Susan T. Fiske have claimed it is more than a unidimensional term. They contend there are two types of sexism: hostile and benevolent. Hostile sexism is sexism that is similar to the traditional idea of sexism, justifying patriarchy, in favor of strong restrictions on the role of women and an overall discounting of women in general. Benevolent sexism, similar to hostile sexism in that it favors patriarchy, approaches the role of women a bit differently. Benevolent sexists like women and assign them special privileges based on traditional gender roles. That being said, benevolent sexists do not approve of women straying from their traditional gender roles.

Although many young people believe sexism is a thing of the past, it remains persistent in modern society and is deeply entrenched in U.S. culture. At the core of sexism is the social construction of gender, where in a patriarchal society, everything male and heterosexual is seen as the norm and everyone outside of that norm is seen as less able or less worthy. Sexism operates within all our institutional structures and comes to be thought of as normal. While sexism provides advantages to some (namely, men), it also limits opportunities. Through the normalization of sexism in society where men receive privileges and amass the majority of resources and power, women come to internalize this unequal distribution as reality. In addition to internalizing the unequal distribution of resources, they also internalize all the attributes that are associated with the reasons why the dominant group continues to subordinate them. Philosopher Marilyn Frye has used the metaphor of a birdcage to describe sexism. Sexism is pervasive throughout society. Although it appears to be permeable, in reality, like a birdcage, sexism keeps its victims trapped. Sexism is obvious in the way some men view women as objects of beauty for their own sexual pleasure.

The beauty standard that is set for women by men through sexism is often fixated on body parts, particularly the breasts. When women are minimized to simply a part of the body, namely the breasts, sexism becomes very apparent. A man's gaze is often directly in line with a woman's chest, rather than her face. In addition, women are often judged on their beauty based on their breast size. In studies on breast size, both men and women regularly judged the preferred breast size to be larger than the actual typical breast size. The overestimating of breast size is reflective of sexist beauty standards dictated by men.

See also ADVERTISING; MEDIA; STEREOTYPES

Further Reading

Frye, Marilyn. "Oppression." In *Race, Class, and Gender in the United States*, edited by Paula S. Rothenberg, 149–152. New York: Worth, 2014.
Glick, Peter, and Susan T. Fiske. "An Ambivalent Alliance: Hostile and Benevolent Sexism as Complementary Justifications for Gender Inequality." *American Psychologist* 56 (2001): 109–118.

■ SARA SMITS KEENEY

SLANG

The word breast dates back to at least the eighth century and the Old English word *breost*, which derives from the Indo-European term *bhreus*, meaning "to swell." Teat, the term used for an animal's nipple, was used to denote the same body part of women between the tenth and sixteenth centuries, and then the word "nipple" from the word *neb*, which meant "bird's beak," replaced it. The word "areola," used to describe the dark area around the nipple, comes from the word "area." It first appeared in the eighteenth century.

Throughout the centuries, people have used countless terms to refer to a woman's breasts. The popular term "boobs" derives from the late seventeenth-century slang term "bubbies," which later became "boobies" and finally "boobs." The sixteenth-century's age of exploration led to geographical euphemisms like "globes" or "hemispheres." In Francis Grose's 1785 *Dictionary of the Vulgar Tongue*, the following slang terms for breasts appear: apple-dumpling shops, cat-heads, dairy, diddleys, and kettledrums. Two more specific terms were included in the 1811 edition: "Miss or Mrs Van Neck" was a woman with large breasts, while to be "chicken-breasted" meant having extremely small breasts.

The twentieth century saw a proliferation of slang terms for breasts. In the 1920s, the term "tit" was derived from "teat" but was used to describe the whole breast, not just the nipple. (The 1960s British term "bristols" comes from this: in Cockney rhyming slang, "Bristol city" equals "titty.") In the 1930s, a term specifically for large breasts arose—*zaftig*, a Yiddish word meaning "juicy." "Knockers" as a word for breasts came about in the 1940s from the visual similarity between door knockers and breasts. The 1970s gave rise to the terms "honkers" and "hooters" because breasts resembled bicycle horns and could be squeezed like them as well.

Many slang terms are short-lived. In the twentieth century, many such terms have originated in the new film technology. The names of popular duos from movies or television

are often substituted for a woman's popular duo: Abbott and Costello, Mickey and Minnie, Lucy and Ethel, Bert and Ernie, Laverne and Shirley, Mork and Mindy, Wilma and Betty, Thelma and Louise, and Lilo and Stitch.

Many colloquial terms for breasts refer to the fact that women typically have two of them; "the twins" and "the pair" are obvious examples. A popular book series (1904–1979) for young people gave rise to the term "Bobbsey Twins." Other terms refer to items that come in pairs, such as "headlights," "high beams," or "eyes."

Shape is another popular source of slang terms. Several cant terms refer to breasts as bags or sacks of some sort (e.g., "fun bags" or "skin sacks"). Others allude to the manner in which breasts protrude from a woman's body—"balcony," "bumper," "cliff," or "shelf."

Some of the more popular euphemisms for breasts are shape- or touch-inspired words deriving from foods. Almost any variety of round fruit has been used as a substitute for the word breast, from "grapes" to "melons." The fruit chosen often reflects the size of the breasts to which they are referring. "Baps" is a British slang term for breasts that references a type of bread roll.

Some terms are limited to describing breasts that are either especially large or small. In the fifteenth century, the word "bolster" meant pillow. From this came the slang term used to describe a woman with large breasts: she was said to be "bolstered." ("Pillows" is slang for breasts today.) Since the sixteenth century, the term "buxom" (originally meaning accommodating) has been used to describe a woman with an ample chest. For very small breasts, there are "bee stings" or "mosquito bites."

As breasts are functional and produce milk to feed a woman's offspring, several euphemisms allude to this ability (e.g., "jugs," "bottles," and "milk cans"). It is thought that the term "dugs," which has been used for breasts since at least the sixteenth century, is derived from the Danish term *dægge*, meaning "to suckle."

The advent of breast augmentation surgery in the mid-twentieth century led to terms like "bolt ons," "boob jobs," "fake boobs," and "silicon sacks." There are several slang terms for bad implants. "Breadloafing" and "uniboob" are terms describing when breast implants migrate toward each other. "Bottoming out" or "double bubble" is when implants move down below the level of the breast fold. The reverse situation is "highballing."

Finally, there are also slang terms for bras. A popular one is "over-the-shoulder boulder-holder." Others include "double-barreled slingshot," "booby trap," and "upper-decker flopper-stopper."

See also Areolae; Breast Augmentation; Breast Anatomy; Media; Movies; Nipples

Further Reading

Morton, Mark. *The Lover's Tongue: A Merry Romp through the Language of Love and Sex*. Toronto: Insomniac Press, 2003.

Williams, Florence. *Breasts: A Natural and Unnatural History*. New York: W. W. Norton, 2012.

Yalom, Marilyn. *A History of the Breast*. New York: Knopf, 1997.

■ TONYA LAMBERT

SLAVES, AS SEX OBJECTS

Slaves are people owned by their masters and mistresses, and throughout history slaves have had little or no redress in cases of sexual advances by their owners. In classical, pre-Christian Rome, sexual relationships with slaves, both men and women, were mostly undertaken without notice or comment. In North Africa, the Middle East, and China, concubines, or slave mistresses, had some limited rights, and their children were usually born free and able to inherit from their fathers. Concubines, however, often faced enforced seclusion from society, lack of freedom to move or marry, and coerced sex. Stories from these places and times tell of attractive, sexually desirable enslaved women being freed from bondage on the basis of their beauty, but there are few records of this occurrence, and it was probably rare.

Between the sixteenth and nineteenth centuries, approximately 12 million Africans were brought to the Americas as slaves. Race added a new component to the sexual dynamics of master–servant relations. European women covered their bodies in several layers of clothing, and except for when breastfeeding, their breasts were not usually seen. The idealized breasts of European women were high and firm. In contrast, African women's bodies were often visible to strangers and uncovered by clothing. The travel accounts of European explorers in Africa depict the black women they encountered as both sexually desirable and monstrous. Such accounts often mention that the African women they saw had such long breasts that they dragged on the ground when the women bent over to plant crops. Other fanciful accounts describe women who tossed their breasts over their shoulders to feed the infants they carried on their backs.

Even some eighteenth-century English abolitionists, such as John Atkins, considered black women as animal-like and capable of having sexual intercourse with apes. He, too, described the pendulous breasts of black women that were long enough to flip over their shoulders. Black women were thought to feel no pain during childbirth, further distancing them from white, Christian women. These descriptions of black women as little more than reproducing animals provided a justification for their enslavement—and, as slaves, it was vital that they reproduce to provide their masters with more slaves.

Thus, there was an economic incentive for the white patriarch to impregnate his property, as the form of slavery that developed in the United States was one of lifetime bondage in which the enslaved status of the mother determined the status of her offspring. Slave women were frequently forced into unwanted sexual liaisons with enslaved men for purposes of breeding. The white owner's sexual relationships with his female slaves created an increase in his economic capital with the birth of each mixed-race, enslaved child.

White servants also encountered sexual harassment and rape. For example, the eighteenth-century Virginia planter William Byrd kept diaries in which he often recorded his sexual activities with his wives (he was married twice), white servants, and black slaves. Sometimes these activities were groping sessions that included the fondling of the woman's breasts. Nonetheless, white, female servants had some rights, if limited; even bound servants could expect freedom at some point, or the chance to find employment elsewhere. The sexual violence perpetrated against enslaved African women was exacerbated by the fact that they had no rights at all.

In some areas of the American colonies, particularly in the seventeenth century, white men who had sexual relations with enslaved women were officially and publicly humiliated,

and punished for their transgressions. In other places, such as the eighteenth-century West Indies, sexual liaisons between white men and black women were not only tolerated but also expected. In places such as Jamaica, where the white population was far outnumbered by the black slave population, white masters engaged in a variety of physical and psychological tactics to maintain their power. One of these tactics was the sexual violation of black women. In addition, as white women were bound more and more by restrictions of respectability and modesty, black women were considered to be licentious and sexually insatiable. It was even argued that the satisfaction of white male lust on the bodies of black women ensured the morals and virtues of white women. Sexual relationships with enslaved women were complicated by the futility of protest from the white mistress, and her retreat into resentment, denial, and complicit silence.

Sexual slavery still exists, and sex trafficking is a multibillion dollar international business involving women and children of all races. Recent demonstrations against sex trafficking have included topless protests by Femen, a group founded by Anna Hutsol in 2008. The Ukrainian city of Odessa is a major center for the global sex trade, but Femen has demonstrated in several cities, including Milan, Moscow, and Istanbul.

See also BAARTMANN, SAARTJIE (C. 1770S–1815); PROSTITUTION; SLAVES, AS WET NURSES; TOPLESS PROTESTS

Further Reading

Berry, Daina Ramey. *Swing the Sickle for the Harvest Is Ripe: Gender and Slavery in Antebellum Georgia.* Urbana: University of Illinois Press, 2007.

Burnard, Trevor. "The Sexual Life of an Eighteenth-Century Jamaican Slave Overseer." In *Sex and Sexuality in Early America*, edited by Merril D. Smith, 163–189. New York: New York University Press, 1998.

Campbell, Gwyn, Suzanne Miers, and Joseph C. Miller. *The Modern Atlantic*, vol. 2 of *Women and Slavery.* Athens: Ohio University Press, 2008.

De Ramus, Betty. *Forbidden Fruit: Love Stories from the Underground Railroad.* New York: Atria Books, 2005.

Gaspar, David Barry, and Darlene Clark Hine, eds. *More Than Chattel: Black Women and Slavery in the Americas.* Bloomington: University of Indiana Press, 1996.

Jones, Jacqueline. *Labor of Love, Labor of Sorrow: Black Women, Work, and the Family, from Slavery to the Present.* New York: Basic Books, 2010.

Morgan, Jennifer L. *Laboring Women: Reproduction and Gender in New World Slavery.* Philadelphia: University of Pennsylvania Press, 2004.

White, Deborah Gray. *Ar'n't I a Woman?: Female Slaves in the Plantation South.* New York: W. W. Norton, 1985.

■ CLAUDIA J. FORD AND MERRIL D. SMITH

SLAVES, AS WET NURSES

A wet nurse is a woman who breastfeeds an infant that she did not give birth to. In all societies that have utilized the labor of female slaves, wet nursing has been one of the slave's potential duties. Slave wet nurses have been employed in all societies from the earliest known historical times, most often by women of high rank who choose not to breastfeed, for a failure of lactation in a new mother, and/or in the event of the death of the mother during childbirth or the immediate postpartum.

In ancient Rome, slaves were employed as wet nurses by all social classes. Wet nurses have historically been used, either by hire or as slaves, for infants who had been abandoned or orphaned and were under public charge. Wet nursing was a common employment option for lower-class women in Europe in the sixteenth through eighteenth centuries. From ancient times to the present, a belief has persisted that the character of a wet nurse could shape that of the infant she suckled. Among southern slaveholders, however, this belief did not take hold. Instead, beginning in the antebellum period, Southerners sentimentalized the image of the black "Mammy" who nursed both black and white babies, an image that lasted into the twentieth century.

In the American South from the seventeenth through nineteenth centuries, a mother's death in or shortly after childbirth was the most frequent cause of seeking an African slave to serve as a wet nurse. However, when maternal duties were felt to be too onerous, an American slave owner could, and did, turn to the African women she owned to take on part or all of the duties of breastfeeding.

The travel diaries of foreign guests show that outsiders viewed incidents of cross-racial breastfeeding with both fascination and disgust. Childcare among southern slaveholders was delegated to their slaves, but it appears that slave-owning white women did breast-feed their infants as much as possible. The records of foreign visitors to the United States during the eighteenth and nineteenth centuries confirm this view, as they remarked on the fact that slave-owning mistresses often suckled their own children. Slave wet nurses were used most often after the death of the mother, for respite care, and for the indolent.

By the mid-nineteenth century, when public nursing was no longer viewed as acceptable, the wealthiest American women turned over breastfeeding to hired wet nurses in the North, or to slaves in the South. If slave wet nurses could not be found within the household, farm, or plantation of a needy family, it was common practice for husbands to advertise for the services of white or African women, slave or free, both by word of mouth and in local newspapers. If the wet nurse was in bondage, she had little choice or decision-making power on the assignment of wet-nursing duties. Slave wet nurses with young infants were forced to neglect their own children for the care and breastfeeding of their enforced charges, sometimes with dire consequences to the slave wet nurse's own child.

The impression remains of white Americans in the southern states using enslaved African wet nurses frequently and customarily. Research in diaries, plantation records, and newspapers, however, does not confirm this as an unvarying practice. It is true that on southern plantations, about 20 percent of mistresses used a slave as a wet nurse, either full- or part-time. Even though the practice of using a slave wet nurse was not ubiquitous, the image of the enslaved African woman as a wet nurse to her young white masters was used by Abolitionists to condemn the practices and hypocrisies of slave–master relationships in the South.

See also BREASTFEEDING; BREAST MILK; POSTPARTUM BREASTS; SLAVES, AS SEX OBJECTS; WET NURSING

Further Reading

Clinton, Catherine. *The Plantation Mistress: Woman's World in the Old South*. New York: Pantheon Books, 1982.

Fox-Genovese, Elizabeth. *Within the Plantation Household: Black and White Women of the Old South*. Chapel Hill: The University of North Carolina Press, 1988.

Kennedy, V. Lynn. *Born Southern: Childbirth, Motherhood, and Social Networks in the Old South*. Baltimore: Johns Hopkins University Press, 2010.

McMillen, Sally. "Mothers' Sacred Duty: Breast-Feeding Patterns among Middle- and Upper-Class Women in the Antebellum South." *Journal of Southern History* 51, no. 3 (1985): 333–356.

Morgan, Jennifer L. *Laboring Women: Reproduction and Gender in New World Slavery*. Philadelphia: University of Pennsylvania Press, 2004.

■ CLAUDIA J. FORD

SPORTS BRAS

Sports bras are technical innovations as well as emblems of women's entrance into the world of competitive athletics. Usually constructed out of elastic or stretch material, sports bras also come in multiple styles: bandeau, compression, tank top, and racerback, among them. These bras are designed to minimize the bouncing, soreness, and chafing that occur during physical activity.

Generally, they function in one of two ways: either by compressing the breasts against the wall of the chest to immobilize the breasts, or by separating the breasts, enclosing each one in a supportive cup made of resilient material. Despite efforts to completely eliminate bounce, sports bras actually only reduce bouncing by 55 percent, as opposed to the 38 percent reduction afforded by a regular bra.

One of the first pieces of underwear to incorporate elastic was the "sports corset," in 1911. Though brassieres designed for different physical activities were patented throughout the twentieth century, it was not until the athletic craze of the 1970s that an athletic bra, recognizable by today's standards, was developed. University of Vermont graduate students Lisa Lindhal and Hinda Miller, both runners themselves, found their inspiration in the jockstraps worn by male athletes.

Their first prototype consisted of two jockstraps sewn together: the oval pouches formed the compression-style front panels, the waistband was retooled to fit around the torso, and the leg straps became the straps of the bra. Notably, the straps were crossed in the back, in a style now known as "racerback." This helped keep the breasts in place and prevented strap slippage. At first called the "JockBra," the name was soon changed to JogBra, as some retailers found the name offensive. In the first year of production, the JogBra sold 25,000 units. Current estimates for the market share of sports bras range from 6 to 10 percent of the total bra market, comprising anywhere from $300 to $400 million in annual retail sales.

See also BRASSIERE; EXERCISE; UNDERGARMENTS

Further Reading

Ace Fitness. *Active Support: Ace Studies Sports Bras*. 1998. Retrieved May 11, 2014, from http://www .acefitness.org/getfit/studies/SportsBra.pdf

Bastone, Kelly. "The History of the Sports Bra." *Sports Bra History*. Ladies Only Sports, 2012. Retrieved May 11, 2014, from http://www.ladiesonlysports.com/sports-bra-history/

Schultz, Jamie. "Discipline and Push-Up: Female Bodies, Femininity, and Sexuality in Popular Representations of Sports Bras." *Sociology of Sport Journal* 21 (2004): 185–205.

■ ERIN PAPPAS

STEREOTYPES

Stereotypes are simplified descriptions applied to every person in a particular category. Normally, stereotypes are exaggerated and based on little or no empirical evidence. Therefore, stereotypes can be harmful to people who are categorized by stereotyping. Minority groups, or those without privilege and power in society, are often the targets of stereotypes; however, anyone can be stereotyped. Stereotypes insist on either/or categories and leave little room for negotiation. They impose often unsophisticated and highly reactive filters through which one individual judges another without any reflection or interaction.

Stereotypes are based on little evidence; rather, through anecdotes and cultural transmission, they are perpetuated from generation to generation. Although stereotypes persist, they are almost always false for three main reasons. First, all stereotypes ignore individual differences. Instead, they are generalized statements that are applied to each member of a particular group. Second, although some stereotypes are based loosely on some truth, each overlooks any relevant facts and grossly distorts reality. Finally, stereotypes are motivated by strong bias and used as a guide to how we value individuals in a particular category.

Stereotypes are formed by society and reflect the values of the dominant group. Stereotypes are learned through socialization. Three dominant forces of socialization perpetuate and transmit stereotypes: parents, peers, and the media. Parents may pass on stereotypes to their children without conscious thought. Gender stereotypes can simply be transmitted through the categorizing of mother's (woman's) and father's (man's) work within the household. Peers reinforce stereotypes already established by parents, and also introduce individuals to new ideas. Stereotype socialization by peers often depends on the social group of the individual. Finally, one of the strongest agents in creating and perpetuating stereotypes is the media. The mass media is a means for delivering impersonal communication to a large audience. The media is not solely responsible for creating and sustaining stereotypes; rather, it reflects the ideas and images of the society at large. Advertising, an influential part of mass media, is rife with stereotypes, especially gender stereotypes.

Gender stereotypes are extremely ideological in nature. One common gender stereotype perpetuated by the media is the figure of the "dumb blonde." The "dumb blonde" stereotype is illustrated through blonde hair, a slim body, large and visible breasts or cleavage, and clothing that displays the body in a sexual manner. Clearly, this stereotype is based on the appearance of the body, with particular attention to the breasts. This stereotype gives proof that the body (especially breast size) is socially mediated. Along with the curvaceous body image associated with the dumb blonde stereotype, other characteristics also accompany this stereotype. Women who are stereotyped as "dumb blondes" are also believed to have an insatiable sexual desire and little intellect.

Stereotypes also are attached to women based on the size of their breasts. Large-breasted women are characterized as popular, confident, successful, and sexually attractive. At the same time, smaller breasted women are perceived as intelligent, moral, modest, hardworking, and confident. The result of these stereotypes based on breast size has led to a record number of cosmetic surgeries, specifically breast augmentation, breast reduction, and enhancement. The motivation for these breast surgeries can be seen as a direct result of the internalization of the often inaccurate stereotypes attached to breast size.

See also ADVERTISING; BREAST AUGMENTATION; BREAST REDUCTION; INTERNATIONAL CULTURAL NORMS AND TABOOS; MEDIA; SEXISM

Further Reading

Furnham, Adrian, and Viren Swami. "Perception of Female Buttocks and Breast Size in Profile." *Social Behavior and Personality* 35, no. 1 (2007): 1–8.

Milestone, Katie, and Anneke Meyer. *Gender and Popular Culture*. Cambridge: Polity, 2012.

Ross, Susan Dente, and Paul Martin Lester. *Images That Injure: Pictorial Stereotypes in the Media*. Santa Barbara, CA: Praeger, 2011.

Tantleff-Dunn, Stacey. "Breast and Chest Size: Ideals and Stereotypes through the 1990s." *Sex Roles* 45, nos. 3–4 (2002): 231–242.

■ SARA SMITS KEENEY

STRIPTEASE

Contemporary Western striptease is an erotic performance of clothing removal, traditionally performed by women, with roots in American burlesque. Arguably, the most recognizable period of burlesque history is the period lovingly labeled the "Golden Age," which reached its peak in the 1930s in New York City. These shows moved into historic Broadway theatres and were characterized by large sets, elaborate costumes, and famed dancers such as Gypsy Rose Lee. In 1937, New York Mayor Fiorello LaGuardia waged a moral war on burlesque, cumulating in a refusal to grant licenses to any theatre that used the term "burlesque" in any way and pushing burlesque out of the city. Although burlesque historian Robert C. Allen has argued that LaGuardia precipitated the end of burlesque's golden age, the burlesque format and striptease continued as traveling shows and fairs, and in a variety of theatres and nightclubs well into the 1960s. While these shows featured both comics and exotic dancers, the emphasis increasingly shifted to striptease. During this period, burlesque dancers or *strippers*, generally stripped down to pasties (nipple coverings that are often decorated with sequins or tassels and come in a variety of colors and styles) and to G-strings that covered their genitals.

The end of burlesque is often situated in the late 1960s and is commonly thought to have stemmed from an inability to compete with the new accessibility of nudity made available by the sexual revolution, the introduction of pornography into the mainstream, and a variety of more modern erotic entertainments such as go-go dancers. The first barebreasted, or "topless," go-go dance in the United States was performed in June 1964 at San Francisco's Condor Club. Striptease scholar Kirsten Pullen has observed that when 18-year-old cocktail waitress Carol Doda danced atop a hydraulic grand piano that was slowly lowered to stage level to gradually reveal her bare breasts, Doda and topless go-go were an instant success. San Francisco became the front-runner for nude entertainment, merging elements of traditional burlesque and topless go-go. The city is also the location of the Michelle brothers' O'Farrell Theater, a former X-rated movie theatre, which pioneered more personal striptease performances known as *lap dancing* in 1980.

Pole dancing later emerged, derived from a concept of continuous and rotating girls performing at any point that a patron might enter the club, as opposed to previous assigned

This neon sign for "Strippers" displays an image of a naked woman with large, perky breasts. Axstokes/Thinkstock by Getty

"show times." This new striptease format was often performed bare-breasted, although some states did, and still do, require some form of nipple covering. Both lap dancing and pole dancing are often credited as the source of the strip club boom, which saw strip clubs roughly double in major American cities between 1987 and 1992. Most contemporary Western strip clubs still utilize the pole- and lap-dancing format.

As striptease is the oldest entertainment showcasing the live, erotized female body in the United States, it has been a site of great religious, political, and feminist debate. Today, rules and regulations surrounding striptease vary by jurisdiction, and they involve questions of nipple coverage, G-string removal, the serving of alcohol, taxation, and artistic merit. Most recently, in the fall of 2012, Night Moves, a strip club in Albany, New York, lost a court case in which they petitioned to be granted artistic status, thereby making them eligible for tax exemptions.

From a feminist perspective, stripping has been an important issue in modern feminist discourse. In 2010, Iceland was thought to be the "most feminist country in the world" when it banned strip clubs in an attempt to take a stand against the exploitation of women. Beginning in the 1970s, women's groups such as Women Against Pornography, most notably spearheaded by Susan Brownmiller, Gloria Steinem, and Audre Lorde, turned their attention to the sex industry, pornography, peep shows, and striptease, and the subsequent implications on violence against women. In opposition to this stance is the sex-positive feminist movement, which champions right to personal agency and sexual expression. A characteristic of this movement is the feminist scholar who works as a stripper in order to better understand the lived experiences of the dancers and questions class or morally based objections to sex workers' choice of employment. Debates surrounding striptease and erotic entertainments are often thought to have split the women's movement. The discussions tend to focus on objectification versus emancipation theory in contemporary strip clubs.

See also FOLIES BERGÈRE; NIPPLES; PASTIES; TOPLESS DANCING

Further Reading

Allen, R. *Horrible Prettiness: Burlesque and American Culture*. Chapel Hill: University of North Carolina Press, 1991.

Barton, B. *Stripped: Inside the Lives of Exotic Dancers*. New York: New York University Press, 2006.

Bindel, J. "Iceland: The World's Most Feminist Country." *The Guardian*, March 25, 2010.

Egan, D. *Dancing for Dollars and Praying for Love: The Relationships between Exotic Dancers and Their Regulars*. New York: Palgrave Macmillan, 2006.

Foley, B. *Undressed for Success: Beauty Contestants and Exotic Dancers as Merchants of Morality*. New York: Palgrave Macmillan, 2005.

Frank, K. *G-Strings and Sympathy: Strip Club Regulars and Male Desire*. Durham, NC: Duke University Press, 2002.

Hanna, J. "Exotic Dance Adult Entertainment: Ethnography Challenges False Mythology." *City and Society* no. 15 (2003): 165–193.

Levy, A. *Female Chauvinist Pig: Women and the Rise of Raunch Culture*. London: Pocket Books, 2005.

Liepe-Levinson, Katherine. *Strip Show: Performances of Gender and Desire*. London: Routledge, 2002.

Pullen, K. *Dancing Sex, Revolution, and History: The Case of Carol Doda*. Nashville, TN: American Society of Theater Research, 2012.

Shteir, R. *Striptease: The Untold History of the Girly Show*. Oxford: Oxford University Press, 2004.

Virtanen, M. "Lap Dance a Tax-Exempt Art? Night Moves, Albany Strip Club, Takes Nude Dancing Case to New York Court." *Huffington Post*, September 5, 2012.

Willson, J. *The Happy Stripper: Pleasures and Politics ot the New Burlesque*. London: I. B. Tauris, 2008.

Zeidman, I. *The American Burlesque Show*. New York: Hawthorn Books, 1967.

■ KAITLYN REGEHR

SUSAN G. KOMEN FOR THE CURE

The nonprofit charity Susan G. Komen for the Cure, commonly called the Komen Foundation, has raised and spent over $2 billion to fund breast cancer education and research projects since 1982. A breast cancer survivor herself, Nancy G. Brinker founded the organization as a promise to her older sister who was dying of the disease. Brinker wanted to bring the sensitive subject of breast cancer into the national discourse in order to heighten awareness of the problem, dispel misconceptions about the disease, and increase early detection. Headquartered in Dallas, Texas, Komen has affiliates around the country and is engaged in over 30 countries. It has popularized the use of a pink ribbon to symbolize the fight against breast cancer.

Susan Goodman Komen died in 1980 at age 36. The former homecoming queen and model had been diagnosed with breast cancer at the age of 33. At that time, treatments were relatively primitive and cancer specialists few in number. Susan refused a full mastectomy, instead opting for less invasive surgery. Although it removed the lump from her breast, it did not prevent the cancer from spreading. Later, both radiation treatments and chemotherapy failed too.

The foundation raises money from large corporate sponsors and with the help of an army of 100,000+ volunteers. It sells its own pink products as well, but is best known for its fundraising walks and runs, including three-day, 60-mile walks that it holds throughout the country. Its purpose is to seek answers about the cause of breast cancer, how to cure it, and how to prevent it. In pursuit of these goals, Komen spent approximately $333 million on various projects, according to its 2010–2011 annual report. Of this, 54 percent went

to health education, 23 percent to medical research, 16 percent to health screening and prevention, and 7 percent to subsidizing treatment.

Late in 2011, the foundation became involved in controversy when it stopped awarding grants to Planned Parenthood, and then reversed the decision. Contributions from individuals and groups decreased significantly. Further controversies erupted over Brinker's role in the organization, and on how the organization actually spends the money it receives. In 2013 and 2014, several of the group's walks were cancelled.

To its credit, Susan G. Komen for the Cure has increased awareness of breast cancer and lessened the stigma associated with it. Consequently, many other grassroots and corporate organizations have joined the fight against the disease. Since its inception, early screening and the use of mammography have led to improved detection and what some believe is a significant drop in mortality rates for breast cancer. The foundation claims a 33 percent reduction in such rates since 1991 as a result of its efforts.

See also AVON FOUNDATION; BREAST CANCER SUPPORT GROUPS; BREAST CANCER TREATMENT; CONTROVERSIES; PINK RIBBON CAMPAIGNS

Further Reading

Brinker, Nancy G., and Joni Rodgers. *Promise Me: How a Sister's Love Launched the Global Movement to End Breast Cancer.* New York: Three Rivers Press, 2010.

Susan G. Komen for the Cure. Retrieved May 31, 2014, from http://www.komen.org

■ MATHEW WILSON

TELEVISION

At the beginning of the 1960s, women started breaking out of their role as housewives and gradually began to take active roles on television. Initially, women on the screen could only be seen in films and commercials, and their roles, as well as the amount of programs featuring women, were limited. Most of the commercials of the time displayed the subordination of women to men. The advertisements featured young and attractive women who enticed men to buy products. Regardless of the product being sold, the voice-overs were male, whereas the female was a voice of seduction, even when the commercials advertised merely cleaning products or food. The images of women on the screen and their clothing reflected the cultural restraints on women at that time. Girdles, in particular, were essential garments for women until the mid-1960s. They shaped the female body by narrowing the waistline and lifting the breasts, creating a rigid and controlled figure that expressed respectability and modesty. The first appearance of women on television coincided nevertheless with a new fashion for large breasts, popularized by movie actresses, especially Marilyn Monroe and Jayne Mansfield, whose bodies were celebrated by the media.

The late 1970s saw a new breakthrough in representing female characters on television. Aaron Spelling's 1970s television crime drama *Charlie's Angels* featured independent, attractive young women who were single and had exciting careers as private investigators. Although female characters had leading roles, critics agree that *Charlie's Angels* primarily focused on the sex appeal of the main protagonists rather than the story itself. The series gained popularity among men mostly because none of the main protagonists wore a bra, which drew particular attention to their breasts. By the 1980s, there was a much wider range of female characters on TV: married and single mothers, single career women, and divorced or widowed women were all represented. Many TV programs included women professionals, such as lawyers, policewomen, doctors, and other highly educated and well-paid professionals. At the same time, during the 1980s, exposed female nudity gradually began to be shown on primetime television. The Public Broadcasting Service (PBS), the American public broadcasting television network with hundreds of television stations, was the first network to display national programming that featured frontal female nudity on television in anthropological documentaries and in movies, for example *Walkabout* (1971) by Nicolas Roeg, with a scene of Jenny Agutter's full-frontal nudity. In most of the cases,

the nudity was restricted to exposing female buttocks and breasts. Although by the end of the 1980s, many stations had stopped broadcasting programs that contained nudity, due to complaints from viewers, the beginning of the 1990s brought a new series of TV programs that extensively exposed female nudity.

The American show *NYPD Blue*, which is ranked in the top 20 of primetime programs and which broadcasted from 1999 to 2002, featured male and female nudity as well as sexual activity, although exposed female breasts were never shown. Another top-rated program, *Sex in the City*, six seasons of which aired on HBO from 1998 to 2004, introduced new representations of women, particularly those living an urban life. It featured sex scenes and also scenes with partial and full-frontal female nudity. However, *Sex in the City*'s approach to femininity and female sexuality challenged the conventional concepts of women's roles in society, and the series proved influential in creating new ideals for many women in the United States and beyond. *ER* (1994–2009) and *CSI* (2000–), two of the United States' top-10 TV series since the inception of these programs, which also gained popularity in European countries, feature police, doctors, and other professional women who wear tight, low-cut tops under their jackets or white coats that expose their cleavage. Although women in these TV series are misrepresented, their images are equally highly influential in terms of women's office attire, which has been changed to become more and more revealing.

As a public domain, television is defined as a predominantly male area of activity, whereas women have traditionally been ascribed to the domestic and private realm and their presence on television reflects that. In male-dominated cultures, the position of women on television as well as the extent of their presence on air can be very limited. In Western countries, women are mostly represented in commercials, movies, and soap operas, according to statistics, although television, especially in the twenty-first century, frequently shows women outside of the domestic context. In particular, women who hold positions of authority in modern societies are expected to project self-restraint in their appearance and hence minimize the nurturing and especially sexual dimensions of their appearance. Since the female breast and legs have been highly sexualized, women who are public figures, such as politicians, women in business, and professionals, are expected to cover those parts of the body, in particular. At the opening of the Oslo Opera House in April 2008, German Chancellor Angela Merkel created a lot of controversy when she wore a black, low-cut dress that drew attention to her breasts, even though the event was not official. Similarly, women newsreaders keep in mind that when women speak on television, how they look frequently overrules interest in what they say.

Since the beginning of women's presence on the screen, the female body has been sexualized and the exposed naked parts of the female body have been used to increase programs' viewing rates or in order to sell the products advertised on television. The annual *Feminist Primetime Report* issued by the National Organization for Women examines the appearance of women on TV in all the primetime programs on the six American broadcast networks (ABC, CBS, Fox, NBC, UPN, and WB). The main concerns raised in this publication were the significant lack of older women, ethnic minority women, and women with realistic bodies on television. According to the report, the vast majority of actresses on television are thinner, younger, and more beautiful than women in real life.

See also ADVERTISING; BEAUTY IDEALS, TWENTIETH- AND TWENTY-FIRST-CENTURY AMERICA; FEMALE ACTION HEROES; MEDIA; MOVIES; RUSSELL, JANE (1921–2011)

Further Reading

Baehr, Helen, and Gillian Dyer. *Boxed In: Women and Television*. New York: Routledge & Kegan Paul, 1987.

Cole, Ellen, and Henderson Daniel, Jessica. *Featuring Females: Feminist Analyses of Media*. Washington, DC: American Psychological Association, 2005.

Macdonald, Myra. *Representing Women: Myths of Femininity in the Popular Media*. New York: Hodder Headline, 1995.

■ ANETA STEPIEN

THEATRE

References to breasts appear in the works of antiquity and in those of contemporary playwrights. Breastfeeding is one common theme. Allusions to breastfeeding can be found in plays throughout the centuries and across the globe. Breastfeeding is frequently used to represent a woman's devotion to motherhood, whereas female characters who refuse to breastfeed often demonstrate a lack of maternal feeling and are considered unfeminine, or even dangerous. In *The Libation Bearers*, the second play in the *Orestia*, a trilogy of plays by Aeschylus (525–456 BCE), Clytemnestra, who murdered her husband, King Agamemnon, in the first play, has a nightmare in which she gives birth to a snake. The snake nurses at her breast, drawing blood along with the milk. She then sends funeral libations to her husband's grave to appease the gods that she fears she has angered.

The plays of William Shakespeare (1564–1616) feature numerous references to breastfeeding. Despite opposition by medical and religious authorities who opposed the practice, mothers throughout the Renaissance period, especially those of the aristocracy, commonly employed wet nurses to breastfeed their children. Until the late seventeenth century, it was an accepted belief that the blood in a woman's womb, the blood that nourished the unborn child, traveled to the breasts, turned white, and became the breast milk that fed the infant after birth. This milk then had a great influence on the child's development, as he or she literally ingested the blood of its mother. Shakespeare's narratives incorporate these beliefs about breast milk—that its ingestion, and not simply the emotional bonds formed during nursing, affected the way in which a child developed. In *The Winter's Tale*, Leontes wants to limit his wife's influence on their son, tellingly named Mamillius, and so he employs a wet nurse. The Nurse in *Romeo and Juliet* is both emotionally and physically closer to her charge than her own mother, Lady Capulet, but the text hints that the Nurse's 3 years of breastfeeding Juliet made Juliet "undutiful" to her own parents. In *Richard III*, the Duchess of York is eager to distance herself from her evil son, declaring that "from my dugs he drew not this deceit." In contrast, Volumnia, the mother of Cauis Martius Coriolanus, in the play *Coriolanus* insists that her son's "valiantness" was sucked from her body.

Milk and blood are also featured in *Macbeth*. Lady Macbeth fears her husband is "too full o' the milk of human kindness." She calls on the spirits to make her strong—masculine—by

taking her female breasts and "my milk for gall." She taunts Macbeth and challenges him to kill Duncan as he swore to do by arguing that if she had sworn to kill an infant nursing at her breast, she would pluck it from her nipple and dash its brains out.

Breastfeeding appears in plays all over the world, and it is often used, as it is in *Macbeth*, to symbolize good or evil. Manavedan (1585–1658) wrote the Sanskrit classic *Krishnanattam*, an eight-play dance drama story of Krishna. In one scene, the beautiful Lilitha becomes the monster, Puthana. The process occurs while Lilitha is breastfeeding. At the beginning of the scene, Lilitha's song to the baby Krishna tells him to drink the milk from her breasts. When she begins to feed the child, she appears to be the archetypal good mother; however, the audience knows her breasts are smeared with poison. As the child nurses, Lilitha begins to writhe in agony and attempts to tear the baby from her breast, but she is unable to detach him. She finally falls in agony on top of the infant, and the evil Puthana appears. Young men play all of the female roles.

Sarah Ruhl's contemporary play, *In the Next Room, or The Vibrator Play*, which premiered in 2009, examines breastfeeding in a different way. The humorous play focuses on the nineteenth-century use of electric vibrators to treat "hysteria." In the play, Dr. Givings treats his female patients while his wife breastfeeds their baby in the parlor. Having never experienced an orgasm, she wonders about the sounds she hears emanating from the next room. Mrs. Givings cannot produce enough milk, so the couple hires an African American woman as a wet nurse, thus bringing about an examination of race as well as sexuality. Ruhl wrote the play while she was breastfeeding her own baby.

The discussion—and appearance—of breasts in theatre is not confined to breastfeeding. Breast cancer is a topic in some contemporary plays. One example occurs in Anna Deavere Smith's *Let Me Down Easy*, in which she plays 20 different characters culled from interviews with 300 famous and unknown people about their experiences with illness and health care. One of the stories is that of Ruth Katz, a breast cancer survivor, whose records appear to be lost. After learning that she is the associate dean at the Yale School of Medicine, the doctor who was examining her at the Yale hospital finds her files within half an hour.

For centuries, women were not permitted to act in plays because it was considered immodest. Male actors took the female roles, further complicating plays that contained cross-dressing characters. Women who dress as men have to bind their breasts; men who dress as women add the illusion of breasts, softness, and curves. They behave in a "feminine" manner. In traditional performances of *Krishnanattam*, young men play the roles of both men and women. During Shakespeare's era, adolescent boys took the female roles. In Shakespeare's play *Twelfth Night; or, What You Will*, the character Viola disguises herself as a man after being shipwrecked and believing her twin brother, Sebastian, is dead; thus, the boy playing the role portrayed a woman dressed as a man. Twelfth night, the holiday, marked the end of the Christmas season. It often became a sort of carnival day, during which servants and masters might exchange roles, and men might dress as women, or women as men. Outside of the theatre and festivals, however, cross-dressing by men or women was a crime in England.

Chinese dramas of roughly the same era (the sixteenth and seventeenth centuries) also include stories of heroines disguised as men. Xu Wei's two plays, *Ci Mulan tifu congjum* (*Maid Mulan Joins the Army in Her Father's Stead*) and *Nü zhuangyuan cihuang de feng* (*The*

Female Top Graduate Declines a She-Phoenix and Gets a He-Phoenix), dramatized existing popular tales. Xu's success may have inspired other Ming and early Qing period dramatists to create cross-dressing plays. Until about 1930, men played all of the female roles in Chinese opera.

Jeffrey Hatcher's *Compleat Female Stage Beauty* (2006) is based on an actor, Edward Kynaston, in Restoration England whose world is turned upside down after King Charles II permits women to act on the stage. Kynaston was acclaimed for his portrayals of Desdemona, Ophelia, Cleopatra, and other Shakespearean tragic heroines. In Hatcher's play, the actor who plays Kynaston portrays an actor who plays actresses on stage.

After the seventeenth century, although women's breasts were sometimes permitted to be displayed in unmoving, albeit lavish tableaux, nudity was not allowed in mainstream theatre in the United States or Great Britain until the 1960s. The idea of the nude tableaux is explored in the movie *Mrs. Hendersen Presents* (2005, dir. Stephen Frears), which is based on the story of the London Windmill Theatre. The nude shows at the Windmill continued through the bombing of London, and the theatre's famous motto, "We Never Closed," was often jokingly changed to "We Never Clothed."

The rock musical *Hair* was one of the first popular shows that featured nudity. In 1961, Sally Kirkland became the first dramatic New York actress to appear nude in a play in an off-Broadway production of Terrence McNally's *Sweet Eros*. More recently, in the 2013 Broadway production of *Breakfast at Tiffany's*, Richard Greenberg's adaptation of Truman Capote's novel, the bathtub scene was expanded. Emilia Clarke, as Holly Golightly, appeared totally nude during this scene, revealing breasts and the rest of her body to the audience, and causing a sensation. The theatre threatened to evict anyone caught taking photographs during the show.

See also BREASTFEEDING; BREAST CANCER; CROSS-DRESSING IN HISTORY; CROSS-DRESSING, IN LITERATURE; MOVIES; TELEVISION; WET NURSING

Further Reading

Bharucha, Rustom. *Theatre and the World: Performance and the Politics of Culture.* New York: Routledge, 1993.

Greenblatt, Stephen. *Will in the World: How Shakespeare Became Shakespeare.* New York: Norton, 2004.

Howard, Jean E. "Crossdressing, the Theatre, and Gender Struggle in Early Modern England." *Shakespeare Quarterly* 39, no. 4 (Winter 1988): 418–440.

Li, Siu Leung. *Crossdressing in Chinese Opera: Reconfiguring American Literary Studies in the Pacific Rim.* Hong Kong: Hong Kong University Press, 2003.

Sparey, Victoria. "Identity-Formation and the Breastfeeding Mother in Renaissance Generative Discourses and Shakespeare's Coriolanus." *Social History of Medicine* 25, no. 4 (October 2012): 777–794.

■ MERRIL D. SMITH

TOPLESS BEACHES

Sunbathing has been considered by several cultures across the world as a beneficial practice to improve mental and corporal health. At the same time, contemporary medicine has proved its benefits—in moderate exposure—to strengthen human bones; to help to

regularize sleep cycles through the production of melatonin; to get better assimilation of vitamin D, which is very useful to prevent cardiovascular diseases and other body deficiencies; and, moreover, to generate serotonin, a neurotransmitter related to human feelings of happiness, contentment, comfort, and well-being. Sunbathing on the beach increases the natural benefits of this practice, due to marine mineral nutrients, fresh air to the lungs, and the feeling of relaxation by means of contact with nature, including the mixture of sand and sea breezes.

Women in some traditional cultures such as Indo-American, Polynesian, and African tribes did not wear any kind of clothes on the top part of their bodies, exposing their breasts freely without social condemnation. However, after the arrival of European explorers, particularly Christian missionaries, to these territories between the fourteenth and nineteenth centuries, this practice was forbidden because of precepts of morality that considered the breast to be an object of sexual desire. For many years, the top-free practice was rejected by social, legal, and religious codes; nonetheless, in the twentieth century, this practice was accepted little by little in some societies, specifically in Western countries.

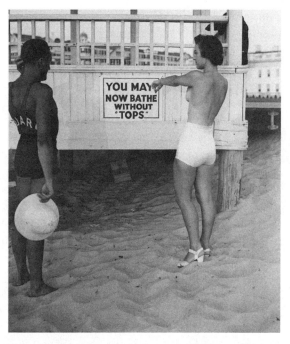

To explain her bare breasts to the lifeguard on this New Jersey beach, the woman points to the sign that says, "You May Now Bathe Without Tops." No doubt, this 1939 ordinance was meant for men only. © Bettmann/Corbis/AP Images

After the Second World War, women in Europe, the United States, and other countries achieved full political rights, and progressively, between the 1950s and 1970s, they attempted to achieve social rights inside their societies as well. The sexual revolution in the 1960s was very important in removing some religious and moral concepts about the female body and nudity, and particularly about uncovered breasts in public spaces. In this way, beaches were the ideal places to test women's liberation and the idea about self-control over their bodies, including top-free practices in several beaches in Europe, Australia, the western coast of the United States, and Brazil. Perhaps the most famous and the pioneer topless beach in the world was Saint Tropez (France), a natural landscape popular among European celebrities and royalty. During the 1960s, actresses such as Brigitte Bardot and Anita Ekberg helped to popularize the practice of going topless on the beach. The mass media generated a positive social response to this practice.

Being topless on beaches became a symbol of freedom to women in several societies between the 1960s and 1980s, and it was common to see many women without the top

parts of their swimming suits, or even wearing a "monokini," a type of swimming suit design by Rudi Gernreich that exposed the breasts. Aside from health and liberation reasons, some women also went topless to tan their bodies perfectly. For these reasons, other beaches became very popular in the summer and on sunny days, both in Europe such as Ibiza and the Italian Riviera, and in other areas, such as the Black Sea and Brazilian Copacabana beaches during these decades.

However, in the 1990s and the first decades of the twenty-first century, going topless on beaches has become less popular, due to changes in cultural, health, and fashion styles related to the care of the breast, particularly concerns about skin cancer and the cult to achieve the perfect figure, which makes some women unwilling to uncover their breasts. In spite of that, at the turn of the new millennium, several websites such as ILovetheBeach.com and Eurobeach.com apotheosized topless beaches as examples of nature, female beauty, and freedom, which have provoked the interest of some in going topless on non-Western beaches.

See also CELEBRITY BREASTS; CONTROVERSIES; FASHION; MOVIES; POLITICS

Further Reading

Rielly, Edward J. *The 1960s: American Popular Culture through History*. Westport, CT: Greenwood, 2006.

Schildt, Axel, and Siegfried Detlef. *Between Marx and Coca-Cola: Youth Cultures in Changing European Societies, 1960–1980*. New York: Berghahn, 2006.

Steele, Valerie. *The Berg Companion to Fashion*. London: Berg, 2010.

■ SAUL M. RODRIGUEZ

TOPLESS DANCING

Topless dancing, literally bare-breasted dancing, may occur for a range of reasons; however, this entry focuses on topless dancing on a theatrical stage in ornate, if very small, costumes, rather than stripping in which clothes are removed provocatively in front of the audience. The performers, referred to as "showgirls," do not overplay the sexuality of their body through gesture, choreography, or other codes of performance—rather, they project an elegant persona.

The tradition emerged in Belle Époque Paris, when bare breasts found their way onto the stage thanks to the relaxation of laws pertaining to theatre in France at the end of the nineteenth century, giving rise to a range of approaches to female public nudity, from tableaux vivants to striptease (where more was inferred than shown). The Folies Bergère became synonymous with topless dancing, developing the spectacle revue formula that featured lavish sets and costumes. Two separate troupes of showgirls graced the stage: chorus girls or "les girls," and mannequins or "nudes." The former were an English troupe of formation dancers. An Irish woman, Margaret Kelly, known as Miss Bluebell, created a group of chorus dancers called the Bluebell Girls in the 1930s, and they became the main group of chorus girls at the Folies Bergère. The nudes were local, French beauties who had simpler dance steps that showed off their outfits, which ranged from draped fabrics to just a tiny cache sexe, a triangle of ornate fabric strategically gummed.

One of the stars of the Folies Bergère was the American all-around entertainer, Josephine Baker, who danced topless there. Her infamous "banana dance" represents the Parisian appetite for exotic bodily display in the 1920s.

In New York, Broadway impresario Florenz Ziegfeld emulated the Parisian spectacle with his Ziegfeld Follies. Constrained by laws that only permitted static nudity, he used tableaux vivants, staging scenes from famous paintings with posed topless showgirls. Similarly, at London's Windmill, Laura Henderson innovated a rolling show, *Revuedeville*, incorporating tableaux vivants to comply with similar laws that remained in place until the 1960s.

Contemporary topless showgirl dancing continues the Folies Bergère tradition. Showgirls are still called either "Bluebells" or "Nudes" at both Paris's Lido and Las Vegas's Jubilee! They maintain the choreographic dance moves that do not draw attention to their toplessness—they do not touch their breasts, move on all fours, shimmy, grind, or move in any way sexually explicitly. Rather, their costumes, which include their tall headdresses, emphasize their height, and their movements are controlled and sustained, making them appear to glide across the stage with ease. The controlled movement is partly to avoid breast-bouncing moves, but it is also necessary because their costumes are very heavy, incorporating feathers, sequins, and crystals adorning their arms and arrangements emerging from backpacks and headdresses.

See also Dance; Folies Bergère; Striptease; Theatre

Further Reading

Felter-Kerley, Lela "Dressing Down: Nudity in Belle Époque Theatrical Entertainment." *Proceedings of the Western Society for French History* 32 (2004). Retrieved May 11, 2014, from http://hdl.handle.net/2027/spo.0642292.0032.017

Stuart, Andrea. *Showgirls*. London: J. Cape, 1996.

Tilburg, Patricia A. *Colette's Republic: Work, Gender, and Popular Culture in France, 1870–1914*. New York: Berghahn, 2009.

■ ALISON J. CARR

TOPLESS PROTESTS

Topless protests, or protests in which women have bared their breasts to demonstrate or complain against policies or events, have a long history. Modern-day topless demonstrations are usually protests against the objectification of women's breasts and bodies. Sometimes, however, nudity is used for shock value and to draw attention to a cause, such as nuclear disarmament or animal rights. In various times and places, women displaying their breasts has had different meanings. Women in ancient Rome sometimes bared their breasts as an apotropaic gesture, or physical act, intended to ward off bad luck during captivity, wars, or periods of mourning. Such gestures, which also included the lifting of skirts to expose a woman's genitals, were common, too, in medieval Europe and in parts of Africa.

Most scholars agree that one of the most famous naked protests in history, the ride of Lady Godiva, never took place. According to legend, the medieval town of Coventry, England, was reeling under oppressive taxation. Godiva pleaded with her husband,

Leofric, to lower the taxes. He finally agreed to do so if she rode naked on her horse at midday through Coventry. She agreed to his request, and he lowered the taxes. It appears that monks at the Benedictine Abbey of St. Albans inserted this tale into historical chronicles written about two centuries after Godiva's death. She was a real woman, but her name was Godifu. She lived in eleventh-century Coventry during a time of great political turmoil. Her husband was a powerful man, but she also held land and wealth in her own name under Anglo-Saxon law. The tale, which became more popular in later centuries when the subplot of the "Peeping Tom" was added, includes the erotic subtext of a naked female body and voyeuristic gazes, but Godiva maintains her virtue and the townspeople maintain their morality. Godiva covers her body with her hair, and the people remain indoors behind shuttered windows so they do not see her unclothed body. Peeping Tom looks at her, and, depending on the version, he is either struck blind or dead for his transgression. The legend of Lady Godiva's ride is unlike the actual modern-day protests of women who display their breasts

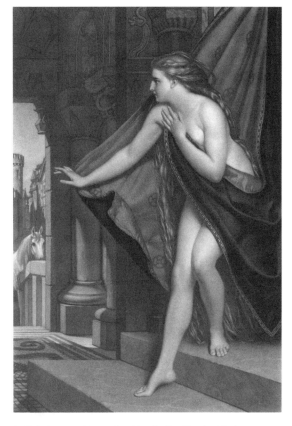

In this image, the naked Lady Godiva hesitates to step out into the open. Her horse awaits in the background. According to legend, Lady Godiva rode naked through the streets of Coventry, covered only by her long hair, in order to get her husband to lower the onerous taxes he placed upon the town. *Lady Godiva*, c. 1874. LC-DIG-pga-00084; courtesy of the Library of Congress Prints and Photographs Division

and consciously attempt to turn the objectification of women's bodies upside down.

The twentieth and twenty-first centuries have seen a number of different types of protests in which women have bared—or threatened to bare—their breasts. In 1929, Igbo women in southeastern Nigeria protested and campaigned against taxation and demanded to have the oppressive warrant chiefs removed. The British government had ignored customary Igbo power distribution when they instituted indirect rule in 1914. The "Women's War," which developed after a woman was asked to respond to census questions and possible taxation, spread across Igboland. Women used a traditional form of protest that involved following a man around everywhere to shame him into admitting his transgressions. The women dressed in traditional warrior clothes, loincloths without tops, and painted their faces. They were nonviolent, but the British administration did not understand Igbo culture. Many saw the women as crazed, half-naked savages, and

they became anxious about the protests. Police officers shot into the crowds, and over 50 women were killed. As a result of the campaign, however, women did receive written guarantees that they would not be taxed, and the warrant chiefs were removed.

In Liberia, Leymah Gbowee gathered an army of women, the Women of Liberia Mass Action for Peace, to end the Second Liberian Civil War in 2003. They used nonviolent protests and became so strong that they forced President Charles Taylor to meet with them. Gbowee threatened to strip naked to make the warlords negotiate during peace talks. Eventually, the women succeeded in bringing about peace and helped to topple Taylor's regime.

In 1984, a group of topless women and men marched through the streets of Santa Cruz, California. They were protesting against how women's bodies were displayed and objectified in advertising and pornography. In 1986, in Rochester, New York, seven women removed their tops at a public park. They were protesting a state law that required women, but not men, to wear tops in public. The women became known as the Rochester Topfree 7. They were arrested and tried, but acquitted in 1992. The topfreedom movement in the United States, Canada, and Europe seeks to advance the idea that women and girls should be able to go topless where men and boys are permitted to do so. They also promote women's right to breastfeed in public.

In 2006, Anna Hutsol, Oksana Shacko, and Alexandra Shevchenko founded the group Femen in Ukraine to protest religious patriarchy, dictatorships, and the sex industry. In 2010, the group began protesting topless, eventually scrawling messages across their bare breasts. The organization holds training sessions, and it has attracted women in many other countries. Femen's protests have expanded beyond Ukraine's sex industry to many other locations and causes, including the Vatican to oppose patriarchy in religion, Milan to oppose ultrathin fashion models during Fashion Week, and Tunisia to support a Tunisian woman, Amina Sboui, who posted topless photos of herself online and was arrested.

See also BRA BURNING; BREASTFEEDING; BREASTFEEDING, IN PUBLIC; CONTROVERSIES; TOPLESS BEACHES; TOPLESS DANCING; WAR

Further Reading

Cochrane, Kira. "Rise of the Naked Female Warriors." *The Guardian*, March 20, 2013. Retrieved May 11, 2014, from http://www.guardian.co.uk/world/2013/mar/20/naked-female-warrior-femen-topless-protesters

Donoghue, Daniel. *Lady Godiva: A Literary History of the Legend*. Oxford: Wiley-Blackwell, 2003.

Igbo Women Campaign for Rights. Global Nonviolent Action Data Base. Swarthmore College. Retrieved May 11, 2014, from http://nvdatabase.swarthmore.edu/content/igbo-women-campaign-rights-womens-war-nigeria-1929

Yalom, Marilyn. *A History of the Breast*. New York: Knopf, 1997.

■ MERRIL D. SMITH

TRAINING BRAS

Also called a trainer bra or bralette, a training bra is a brassiere made for girls, meant to conceal nipples and breast buds during the early stages of puberty. Typically offering little

or no support for developing breasts, training bras are manufactured in the style of a pullover garment, including thin straps and an elastic band, which hold the bra in place. These bras are most often unlined, lightweight, and made from stretch fabric. Training bras sometimes include soft bra cups and may be sewn into camisoles. They are intended to help young girls grow accustomed to wearing adult brassieres and lingerie. In Western countries, training bras often signify a young girl's coming of age, a first step toward womanhood.

There is evidence of training bras being marketed in the United States as early as the 1920s, but the garment did not receive much consideration from parents, doctors, or bra manufacturers until the early 1950s. Previous understandings of brassieres as frivolous or unnecessary for young girls were replaced in the 1950s by discussions of their medical and psychological benefits. Some doctors believed that an adolescent girl required a training bra in order to prevent sagging breasts, stretched blood vessels, and poor circulation, all conditions that would create problems in nursing children. Ultimately, training bras were initially manufactured to prepare young girls for the responsibilities of motherhood.

Some feminist scholars oppose training bras on the grounds that they serve no functional purpose except to construct a form of gendered discipline for young girls, producing and exploiting fears around body image. Patty Sotirin argues, for example, that training bras encourage young girls to participate in ideological habits of presentation and desire through self-surveillance, self-discipline, and self-objectification.

See also BRASSIERE; SPORTS BRAS; WONDERBRA

Further Reading

Brunberg, Joan Jacobs. *The Body Project: An Intimate History of American Girls*. New York: Vintage, 1997.

Farrell-Beck, Jane, and Colleen Gau. *Uplift: The Bra in America*. Philadelphia: University of Pennsylvania Press, 2002.

Sotirin, Patty. "Consuming Breasts: Our Breasts, Our Selves." In *Gender in Applied Communication Contexts*, edited by Patrice M. Buzzanell, Helen Sterk, and Lynn H. Turner, 123–146. London: Sage, 2004.

■ CHRIS VANDERWEES

TRANSGENDER/TRANSSEXUAL

The term transsexual was popularized in the 1960s by endocrinologist and sexologist Harry Benjamin as a diagnosis for people whose assigned sex category was not typically associated with how they described their gender. Since the 1980s, the term transgender has been used to describe people who do not fit stereotypical descriptions of transsexual people, but who do not express or identify their gender in a culturally expected way. Transgender is often used as an umbrella term. *Trans* means "to cross" or "across" in Latin. Thus, the term "transgender" implies movement from one gender category to another. There are no universally agreed definitions for "transgender" or "transsexual"; more recently, the two terms have been treated as having either interchangeable or contradictory meanings, depending on the context. Both terms have been used to describe people whose assigned sex category is not typically associated with how they identify or

express their own gender. In some psychological and medical environments, these terms are defined in a way that treats only the gender self-descriptions of people labeled as "transsexual" as authentic and valid, and in ways that restrict the access of people labeled as "transgender" to medical gender affirmation. The shifting and contested definitions of these terms have led many people to simply use "trans" or trans with an asterisk (trans★), terms that are intended to include both transgender and transsexual without reifying a prescriptive definition of either term. Many people who are labeled as trans by others identify simply as women or men, whereas others identify their gender as trans. Some people identify as a culturally specific nonbinary gender such as genderqueer, Two-Spirit, *kathoey*, *kinnar*, or *hijra*; as bigender or pangender (having more than one gender); or as agender (having no gender).

A trans framework may not be applicable to societies in which there is no typical transition period from one recognized gender status to another and the shift from one category to another is formally recognized in a single ritual, ceremony, or verbal declaration that does not require medical or bureaucratic approval. For example, the Bugis society on Southern Sulawesi, Indonesia, recognizes five genders. People of the Bissu gender, who have particular sacred duties in Bugis culture, often begin to be recognized as Bissu based on their self-reported mystical dreams during adolescence. More recently, the term gender independent has been used to describe people whose externally assigned sex classification as female or male does not reflect their own understanding of their gender.

Many people whose experiences, histories, or identities can be described as trans or gender independent have used various methods to adapt their chests to achieve a physical appearance that reflects visual expectations for their gender. These expectations vary by time period and culture. Many people of trans experience seek surgical intervention to reconstruct a chest that is typically associated with how they classify their gender. Although many people receive hormone replacement therapy and/or surgery that reduces or increases breast tissue, most people use other methods to conceal or accentuate breast tissue prior to hormonal and/or surgical intervention. Some people prefer not to use any chest adaptation methods. Chest adaptation to transform a person's physical appearance into that typically associated with another gender has featured in popular film and television.

In addition to hormonal and surgical procedures, practices associated with chest adaptation for men and transmasculine people who were assigned as female may include wearing bulky clothing, hunching over, and using various methods of chest binding for gender affirmation. Some men and transmasculine people bind their chests using Ace bandages and/or duct tape, practices that can cause damage to muscles and joints, skin blisters, and breathing difficulties. Some popular clothing options used for chest compression are tight-fitting sports bras, surgical compression vests, gynecomastia vests, and elasticated back braces worn with the tight part over the chest. Cheaper homemade versions of commercially available compression vests are often created by making alterations to common household garments such as pantyhose. Although cutting out the crotch of pantyhose and using the legs as sleeves may be a low-cost method of binding, this technique may impair circulation and cause tissue damage. A wide variety of chest adaptation and compression garments are available for purchase over the Internet. Several community organizations around the world operate binder exchange programs through which used chest binders

can be donated to men who need them. Binder donations often come from men who have had or are planning to have male chest reconstruction surgery. These programs are intended to reduce the number of men and transmasculine people who use unsafe binding methods and reduce financial barriers to gender affirmation.

Practices associated with chest adaptation for women and transmasculine people who were assigned as male include various commercially available breastforms and prostheses, as well as popular practices such as taping to enhance cleavage. However, many women of trans experience prefer their natural breast growth from estrogen or minimal breast tissue to prosthetics. Some women of trans experience use injectable silicone to augment hormone-induced breast tissue growth, particularly women who cannot afford breast implants and young women who are unable to obtain breast implants through official means without parental approval. Silicone injections can have dangerous effects that range from permanent tissue damage to infections and even death. The silicone used in these injections is often below the standard of medical-grade silicone. These injections are typically given by people without prior training in safe injection techniques and procedures.

Chest adaptation can be an important component of gender affirmation. Gender-independent people have an increasing variety of chest adaptation methods from which to choose. As the commercial supply of binders and prosthetics increases, costs are likely to decrease. These new chest adaptation methods are likely to provide increased safety, affordability, and comfort.

See also BREAST AUGMENTATION; BREAST BINDING; BREAST REDUCTION; HORMONAL TREATMENTS; HORMONES; IMPLANTS

Further Reading

Davies, Sharyn Graham. "Thinking of Gender in a Holistic Sense: Understandings of Gender in Sulawesi, Indonesia." *Advances in Gender Research* 10 (2006): 1–24.

Gehi, Pooja S., and Gabriel Arkles. "Unraveling Injustice: Race and Class Impact of Medicaid Exclusions of Transition-Related Health Care for Transgender People." *Sexuality Research and Social Policy* 4, no. 4 (2007): 7–35.

Khan, Liza. "Transgender Health at the Crossroads: Legal Norms, Insurance Markets, and the Threat of Healthcare Reform." *Yale Journal of Health Policy Law and Ethics* 11 (2011): 375.

Plis, Ryan, and Evelyn Blackwood. "Trans Technologies and Identities in the United States." *Technologies of Sexuality, Identity and Sexual Health* (2012): 185.

■ Y. GAVRIEL ANSARA

TRANSVESTITE

The term "transvestite" was coined in 1910 by German sexologist Magnus Hirschfeld as a descriptor for "the erotic urge for disguise." Hirschfeld believed that erotic desire motivated some people to dress in attire that was not typically associated with their recognized social gender. In Hirschfeld's view, "transvestites" were "sexual intermediaries" who were neither "pure female" nor "pure male." This inaccurate conflation of visual presentation choices with physical characteristics, sexuality, and gender identity persists in various forms in the fields of endocrinology, philosophy, psychology, sexology, and theology, and

it is a frequent element of popular culture and mass media from the United States and the United Kingdom. The term "transvestite" is often misused to describe women who were assigned as "male" and who experience gender delegitimization because they do not fit a stereotypically female vocal range or visual appearance. In popular media, women who were assigned as "male" and who may identify as women of trans experience are often misgendered as being "transvestites."

Caricatures of "transvestites" have featured frequently in art, film, literature, and theatre. During the Elizabethan era (1558–1603) in England, female characters in the theatre were performed by prepubertal boys or young men because it was illegal for women to participate in plays. The formal ban on women's participation in Beijing opera lasted from 1772 until 1912, although women par-

A "drag queen" strikes a pose. Ryan McVay/Thinkstock by Getty

ticipated unofficially during the 1870s and impersonated men; there was even an all-women's Beijing opera troupe in Shanghai. One of the most famous modern "transvestite" characters is Dr. Frank N. Furter from the 1975 cult classic film *The Rocky Horror Picture Show*, a horror comedy based on a musical stage play. During one internationally famous musical number, he identifies himself as "just a sweet transvestite, from Transsexual, Transylvania." Dr. Furter (played by actor Tim Curry) wore women's lingerie and garters for the role. Women wearing trousers became increasingly socially acceptable in the United States after actress Marlene Dietrich wore them in the 1930 film *Morocco*.

The more recent term "transvestite" (sometimes abbreviated as TV) is often used to describe people who wear clothing that differs from expectations for the gender in which they live publicly. This term has typically been used to describe men who present themselves visually some or all of the time in ways that are consistent with cultural expectations for women in their society. Whereas the concept of the transvestite has been assumed to have ties to same-gender attractions, "cross-dresser" (sometimes abbreviated as CD) has been used primarily in reference to men who have sexual and affectional attractions only for women, and not as frequently to describe women or people of lesbian, bisexual, or gay experience. Although the term "transvestite" originally described people whose clothing

choices were motivated by erotic desire, the term is often used to describe anyone who "cross-dresses." The term "cross-dresser" falsely assumes that all people's genders fit into a woman–man gender binary; it is unclear if any clothing worn by someone who identifies as genderqueer or bigender would constitute "cross"-gender dressing.

Men who "cross-dress" for the purpose of public entertainment without a particular erotic component are known as drag queens, particularly when they perform in gay and bisexual environments. Women who "cross-dress" for performance are called drag kings. Although drag kings and drag queens are featured most prominently in lesbian, gay, and bisexual social networks, some drag kings and drag queens actually identify as exclusively straight or heterosexual. Drag kings and drag queens often take on performance names that have humorous or suggestive connotations, such as Penny Tration, Auntie Bacterial, Ben Dover, and Peter Pants. The phrase "being in drag" has entered the popular lexicon and is often used to describe any context in which someone takes on a particular role or appearance. For example, wearing a suit and tie is sometimes described as "work drag." Some women of trans experience are involuntarily placed in the position of having to accept work as drag queen performers due to the limited employment opportunities that result from discrimination.

Many clothing and accessory companies now cater primarily or exclusively to "cross-dressers" and drag queens, and a few provide products specifically made for drag kings. Among the products available for approximating stereotypically female appearance are breastforms in a variety of materials, textures, shapes, sizes, and quality. These products range from cheap foam fillets that provide minimal bra padding to ultra-realistic, adhesive silicone breasts with detailed, skin-like areolae and puckered nipples. Another type of specialty clothing commonly worn by drag performers includes the gaff, a type of underwear designed to conceal the genital bulge of people with typically male genitals who seek to present a smooth, typically female genital appearance. Adhesive realistic facial and chest hair products and chest compression garments are designed to help drag kings obtain a typically male appearance. Drag kings use "soft packers" to simulate the appearance of a typically male genital bulge, using materials that range from rolled-up cotton socks to adhesive medical-grade silicone penile prosthetics. Some drag kings use "hard packers," which provide the rigid feel and shaft length of an erect penis, and are usually made from medical-grade silicone. Stand-to-pee (STP) devices are sometimes used by drag king performers.

Mainstream psychiatry pathologizes people based on their gender-associated clothing and grooming. Despite a lack of credible evidence that cross-dressing is any form of psychiatric disorder, the controversial "transvestic fetishism" diagnosis is listed in the 2013 American Psychiatric Association's *Diagnostic and Statistical Manual of Mental Disorders*, fifth edition (DSM-5). This diagnostic category is an example of discriminatory views about gender in the field of psychiatry and has no valid scientific basis. The diagnosis has been called ethnocentric due to its failure to adequately account for cross-cultural variability in which garments are considered appropriate for people based on local gender norms. For example, a man in the United States can receive a psychiatric diagnosis for wearing a skirt that is virtually indistinguishable from the kilts worn as traditional men's garments in Scotland. This official use of psychiatric diagnoses to reinforce societal norms

has been described by some international human rights organizations as a key threat to civil liberties.

The concept of the "transvestite" or "cross-dresser" has been critiqued as inherently ethnocentric. In many societies and cultures around the world, men's traditional clothing includes nonbifurcated garments that are structurally similar to skirts and dresses. Clergy from major world religions have historically worn nonbifurcated garments, a trend that continues today. Vestments worn by the pope and other Catholic officials bear greater structural and visual resemblance to contemporary women's clothing than to typical men's clothing. Muslim men who wear trousers typically wrap a cloth known as an izar around their waists for modesty before entering sacred spaces or commencing prayer. In Yorubaland in Nigeria, men dress and adorn themselves as women to honor and appease their powerful women ancestors, deities, and elders during public festivities known as *gélédé*.

Although pink is sometimes assumed to be a historically "feminine" color that constitutes "cross-dressing" when worn by men, pink clothing has not been limited to women and girls in an international context. The Société des Ambianceurs et des Personnes Élégantes (The Society for the Advancement of People of Elegance) is a Congolese men's social and aesthetic fashion movement known colloquially as Le Sape. For *sapeurs*, as members of the society describe themselves, wearing bright and vivid shades of pink is a normative expression of being a gentleman. Historical evidence also documents that pink was not universally or exclusively associated with girls in English and U.S. contexts prior to the 1950s.

"Cross-dressing" can be a tool for political protest, including protests against sexism. In the early 1900s, women's voting rights activists known as suffragettes in the United States and England began to wear trousers, and some "cross-dressed" to emulate Saint Joan of Arc. In 2013, Kurd Men for Equality protested against an Iranian court ruling that punished a man convicted of domestic abuse by forcing him to parade through the streets of Marivan in Iranian-controlled Kurdistan wearing Kurdish women's clothing. This attempt at public humiliation promoted the view that being a woman is shameful or a punishment. Numerous Kurdish men posted pictures of themselves on Facebook wearing women's clothing with captions to challenge sexism and promote women's equality. The protest gained over 9,000 supporters in its first week, with over 100 men sharing their photographs. Some women also joined the protest by posting pictures of themselves wearing traditional men's clothing.

See also Cross-Dressing, in History; Cross-Dressing, in Literature; Intersex; Transgender/Transsexual

Further Reading

Blackmer, Corinne E., and Patricia Juliana Smith. *En Travesti: Women, Gender Subversion, Opera*. New York: Columbia University Press, 1995.

Dirik, Dilar. "Kurdish Men for Gender Equality." *Kurdistan Tribune*, April 25, 2013. Retrieved May 11, 2014, from http://kurdistantribune.com/2013/kurdish-men-for-gender-equality

Drewal, Henry John, and Margaret Thompson Drewal. *Gelede: Art and Female Power among the Yoruba* (Traditional Arts of Africa Series). Bloomington: Indiana University Press, 1990.

Grayson, Saisha. "Disruptive Disguises: The Problem of Transvestite Saints for Medieval Art, Identity, and Identification." *Medieval Feminist Forum* 45, no. 2 (2009): 138–174.

Hopkins, Steven J. "'Let the Drag Race Begin': The Rewards of Becoming a Queen." *Journal of Homosexuality* 46, nos. 3–4 (2004): 135–149.

Howard, Jean E. "Cross-Dressing, the Theatre, and Gender Struggle in Early Modern England." *Shakespeare Quarterly* 39, no. 4 (1988): 418–440.

Lawal, Babatunde. *The Gélédé Spectacle: Art, Gender, and Social Harmony in African Culture.* Seattle: University of Washington Press, 1996.

Paoletti, Jo B. *Pink and Blue: Telling the Boys from the Girls in America.* Bloomington: Indiana University Press, 2012.

Wu, Guanda. "Should Nandan Be Abolished? The Debate over Female Impersonation in Early Republican China and Its Underlying Cultural Logic." *Asian Theatre Journal* 30, no. 1 (2013): 189–206.

■ Y. GAVRIEL ANSARA

U

UNDERGARMENTS

Undergarments are worn next to the skin beneath the outer layer of clothing and are not normally revealed in public. Like clothing in general, some of the functions attributed to underclothes are protection from the cold, as support, to create a shape for the clothing to be worn on top of it, and cleanliness. Undergarments are also associated with eroticism, especially in regard to the female gender. Undergarments are created to fit and reflect the prevailing body ideal—emphasizing or downplaying elements of the body, including the breasts, according to the current fashion. For example, to create the popular 1920s boyish look, flappers often wore bandeaux to flatten their breasts, a style that contrasted with the full-breasted fashions of previous decades.

Early forms of undergarments were sometimes made of animal skins; later examples were made of woven cloth. The medieval attitude toward underclothing was consistent with a belief in the body's inherent sinfulness. Modesty was achieved by the long length of the garments, which were worn in layers (underwear in the modern sense did not come into wide use before the nineteenth century). Men wore a loincloth, which is a simple piece of fabric that gathered the genitals, with the tops of the cloth meeting around the hips and tied with a lace. This became standard by the fourteenth century. Men's underwear generally had less artificial structure—with the exception of the mid-sixteenth-century codpiece that was based on earlier designs from armor but became intricately decorated objects.

Understructures, such as stiffened bodices or hooped skirts, gradually became more popular and apparent in women's fashions. These structures were like a second skeleton and often at odds with the natural form of the body. By the late sixteenth century, cushioned pads made of rolled fabric and filled with cotton wool were tied around the hips to create a greater form for the dress going over it. Women's undergarments, as well as the gowns they wore over them, were often adjustable to allow for pregnancy and to make breastfeeding easier. Petticoats often tied at the sides and so could be adjusted. Stays and corsets could be laced in the front instead of the back. Some eighteenth-century stays even had a flap over each breast, similar to a modern-day nursing bra.

Up until the nineteenth century, underwear can be viewed as part of the gendered division for clothing in much of the Western world. This changed when women began to

wear underwear previously worn only by men. This essentially amounted to two tubes of cloth for the legs attached to a waistband. "Drawers" challenged the long-held association and gendering of garments, according to which divided (like trousers) was associated with masculinity and undivided (skirts) with femininity. The erotic potential did not go unnoticed. They were of an open-crotch construction made in feminine fabrics, with the additional ornamentation of ribbon and lace. During the first few decades of the nineteenth century, young women would let the lace trim of their drawers extend beyond the hem of their skirts. This proved too controversial for the coinciding ideals of modesty and morality.

Women's fashions began to be influenced by the stage, children's wear, and their more active involvement with sports. By the mid-nineteenth century, the open-crotch drawers became the standard for women of the middle classes. By the end of the century, images of women in various stages of undress at their toilette or in a bordello became a popular subject for artists to depict. Cancan dancers shocked the public with the enticing display of their undergarments and legs.

The twentieth century brought a revolution in materials. Elastic, Lycra, and rayon allowed for more practical, flexible, and comfortable support. The period between the two world wars hastened a new attitude toward the function of clothing. Women's undergarments shrank significantly in size. A considerable amount of the body was now covered by a single layer of fabric, which signaled an end to two of its primary functions: preserving warmth and disguising or transforming the shape of the body.

This century also blurred the lines between public and private as underwear made the leap to outerwear. The potential power of this new kind of eroticized body can be seen in the 1950s sex siren Carroll Baker's lacy nighties in *Baby Doll* (1956) and Elizabeth Taylor's lace-trimmed slip in *Cat on a Hot Tin Roof* (1958). Woody Allen introduces us to the comic side of underwear (and a mainstream term) as he and a horny friend spot a woman's "visible panty line" in the film *Annie Hall* (1977). Yet it is Madonna who did the most to make visible corsetry and suspender belts (Dolce & Gabbana or Jean-Paul Gaultier) popular in the 1980s, leading the way to a contemporary world of variety in fabric, style, comfort, and price.

See also BRASSIERE; CORSETS; FASHION

Further Reading

Carter, Alison. *Underwear: The Fashion History*. New York: Drama Book Publishers, 1992.

Cole, Shaun, Muriel Barbier, and Shazia Boucher. *The Story of Underwear*. New York: Parkstone International, 2010.

Ewing, Elizabeth. *Dress and Undress: A History of Women's Underwear*. New York: Drama Book Specialists, 1978.

Lynn, Eleri, Richard Davis, and Leonie Davis. *Underwear: Fashion in Detail*. London: V&A, 2010.

Phillips, Janet, and Peter Phillips. "History from Below: Women's Underwear and the Rise of Women's Sport." *Journal of Popular Culture* 27, no. 2 (Fall 1993): 129–148.

■ LORI L. PARKS

UNICEF

The United Nations International Children's Emergency Fund, commonly known as UNICEF, is one of the prominent specialized agencies of the UN headquartered in New York City, and it is responsible solely for long-term humanitarian and developmental assistance to children and mothers. One of the strong action points of UNICEF is its emphasis on breastfeeding, which has been considered to have the greatest potential impact on child survival of all preventive intervention.

Based on studies it has conducted, UNICEF claims that breastfed children have at least six times greater chance of survival in the early months than nonbreastfed children. Breastfeeding drastically reduces the death rate of infants from two major child killers, acute respiratory infection and diarrhea, and other infectious diseases are also drastically reduced in children when they are breastfed.

To enable mothers to establish and sustain exclusive breastfeeding for 6 months, the World Health Organization and UNICEF recommend the following:

- Initiation of breastfeeding within the first hour of life;
- Exclusive breastfeeding: the infant receives only breast milk without any additional food or drink, not even water;
- Breastfeeding on demand as often as the child wants, day and night; and
- No use of bottles, teats, or pacifiers.

UNICEF emphasizes breastfeeding because of its unique benefits, which include:

- Having a profound impact on a child's survival, health, nutrition, and development
- Breast milk only provides all the nutrients, vitamins, and minerals an infant needs for growth for the first 6 months.
- Breast milk carries antibodies from the mother that fight diseases in babies.
- The act of breastfeeding stimulates proper growth of the mouth and jaw and the secretion of hormones for digestion.
- Breastfeeding creates a special bond between the mother and baby.
- Breastfeeding lowers the risk of chronic conditions later in life, such as obesity, high cholesterol, high blood pressure, diabetes, childhood asthma, and childhood leukemia.
- Studies have shown that breastfed infants score higher on intelligence tests than formula-fed babies.

World Breastfeeding Week is celebrated every year on August 1–7, on the anniversary of the Innocenti Declaration. The Innocenti Declaration was adopted in 1990 and was subsequently endorsed by the World Health Assembly and UNICEF's Executive Board. UNICEF supports World Breastfeeding Week as a strategy for the protection, promotion, and support of breastfeeding. World Breastfeeding Week is an opportunity to renew global focus on the critical role of breastfeeding in reducing childhood illness and mortality. Every year, there is a theme through which breastfeeding is promoted. For 2013, the theme was "Breastfeeding Support: Close to Mothers." This is to sustain continuous

breastfeeding with community support. It is attractive because it is a cost-effective and highly productive way to reach a larger number of mothers more frequently.

See also BREASTFEEDING; BREASTFEEDING, IN PUBLIC; CONTROVERSIES; INTERNATIONAL CULTURAL NORMS AND TABOOS; WEANING

Further Reading

Horta, B. L., R. Bahl, J. C. Martines, and C. G. Victoria. *Evidence on the Long-Term Effects of Breastfeeding: Systematic Reviews and Meta-Analyses.* Geneva, Switzerland: World Health Organization, 2007. Retrieved May 10, 2014, from http://whqlibdoc.who.int/publications/2007/9789241595230_eng .pdf

Womenshealth.gov. "Mothers and Children Benefit from Breastfeeding." February 27, 2009. Retrieved May 10, 2014, from http://web.archive.org/web/20090316071541/http://www.4woman.gov/ breastfeeding/index.cfm?page=227

World Health Organization/UNICEF. *Breastfeeding Counselling: A Training Course. Directors Guide, Trainer's Guide and Participants' Guide.* Geneva, Switzerland: World Health Organization, 1993.

■ MARY A. AFOLABI-ADEOLU

V

VIRGIN MARY

The Virgin Mary is acknowledged throughout the Christian world as the Mother of God, and as having experienced a unique miracle of conceiving her divine child while remaining a virgin. Within the Catholic tradition, she is given still more acknowledgment as an intercessor who can obtain many miracles, and as a suitable object for public veneration. The Virgin Mary is not worshipped, as worship is due only to God, but devotees do pray to her and believe her to have heavenly powers. Mary is, therefore, the most pervasive image of ideal femininity in the Christian world.

Mary's breasts and her breastfeeding of Jesus have been the subjects of cultural preoccupations. In medieval European art, she is often represented holding the child, with her breast outlined under a robe, the maternal pose drawing attention both to her femininity, her maternity, and to her symbolic role as a source of sustenance for her followers. Some images—for example, those in the Mappa Mundi in Hereford Cathedral (c. 1300)—depict Mary with her robe open and breasts bared. In Renaissance art, with its more naturalistic portrayals of the human body, she is sometimes depicted breastfeeding Jesus—for example, in Leonardo da Vinci's *Madonna Litta* (c. 1480, St. Petersburg, Hermitage). Such images were termed the *Maria lactans*.

Equally symbolic and material were the relics of the Virgin's milk. In shrines and cathedrals, these phials were put on display for veneration and were credited with miraculous powers. Our Lady of Walsingham, in England, is a famous shrine that claimed to have drops of the Virgin's milk. The creation of milk relics ceased around the time of the Reformation, and they were removed from public devotions during the nineteenth and twentieth centuries. In a change of consciousness, they came to be seen as vulgar and false, rather than miraculous. This is a symptom of modernist thinking, which is unsympathetic to the supernatural and folkloric.

Miracle stories about the Virgin's milk include the legend that St. Dominic, in 1214, had a vision of Mary who expressed milk from her breast, which he drank. Similar stories are told about other saints, including St. Bernard, who had drops of the Virgin's milk scattered on his lips. In a general sense, the milk of the Virgin Mary was seen as a counterpart to the sacrificial blood of Christ. Both were the subjects of similar shrines, relics, and devotions, which have declined in the post-Enlightenment world.

Although devotions to the Virgin as a nursing mother are now marginal in Catholicism, they have not disappeared, and currently statues of Our Lady of La Leche, a Madonna breastfeeding, are popularized in the Philippines and are credited with miraculous powers.

Sándor Radó, a psychoanalytic writer, describes the fear of privation as a constant psychological drive and suggests. "Drinking from the breast, however, remains the shining example of the unfailing, pardoning proffer of life. It is certainly no accident that the nursing Madonna with the child has become the symbol of a powerful religion and through her mediation the symbol of a whole epoch of our Western culture."

It should be noted, however, that in Eastern Orthodox Christianity, icons of the Virgin Mary do not feature any representations of her breasts or of nursing. The Eastern icons are in flat style, delineated without shading, and they always dress the Madonna in concealing robes, with a veil. Mary is usually known as the Holy Virgin or the Mother of the Word in the Eastern sphere. Exactly why the Virgin's breast is not featured in the Eastern Orthodox world is not easy to determine. It seems to be the result of a formal and stylized artistic tradition, coupled with a less permissive attitude toward displays of the flesh.

Scholars in gender studies have looked at the role of breast images in the cult of the Virgin Mary and those of the female saints. Themes of idealization are explored, and also of binary opposites that draw upon the demonic world of witches, who were said to suckle demons on their unnatural paps. It is obvious that in symbolizing the most pure and benevolent image of motherhood, Mary is also used to address social anxieties and to present prescriptions for women's roles in society. The breast of the Virgin is the type of ideal that can be used to isolate women's bodies from their natural functions, and to appropriate femininity to authoritarian norms. Mary is both the Virgin and the Mother, adored and incorruptible, an unattainable ideal for ordinary women. This is a sometimes troubling exemplar. However, perceptions of her are always subject to redefinition and change. It is possible that in the future, Catholic art informed by feminist culture will produce new lactating Madonnas who affirm women's rights, independence, and powers.

See also ART, WESTERN; RELIGION; SAINTS AND MARTYRS

Further Reading

Goffen, Rona. "Mary's Motherhood According to Leonardo and Michelangelo." *Artibus et Historiae* 20, no. 40 (1999): 35–69.

Price, Merrall Llewelyn, "Bitter Milk: The *Vasa Menstrualis* and the Cannibal(ized) Virgin." *College Literature* 28, no. 1 (Winter 2001): 144–154.

Todd, Elizabeth H. "Mary, Dogma, and Psychoanalysis." *Journal of Religion and Health* 24, no. 2 (Summer 1985): 154–166.

■ THÉRÈSE TAYLOR

W

WAR

War has existed since antiquity, both as armed conflicts between nations and as fights between smaller groups. Since ancient times, women have been a part of these conflicts. They have participated as active or reluctant combatants, been captured and distributed as prizes of war, and helped maintain the home fronts. To participate in combat, women have disguised themselves as men by binding their breasts. As victims of wartime rape and as captive sex slaves, women have had their breasts mauled and mutilated.

Women's breasts have been a feature in artists' representations of wartime events and in government-sponsored political propaganda. The legendary rape of the Sabine women, for example, has been a popular subject for artists over the centuries. The event was supposed to have taken place shortly after the founding of Rome. According to the legend, the men of Rome needed wives and abducted the Sabine women. In many of the artistic renderings of this event, the women's breasts are bare. For instance, in Peter Paul Rubens's *The Rape of the Sabine Women* (c. 1635–1640), the women are clothed in seventeenth-century garments, but some of the women's breasts are exposed, perhaps to indicate their gowns had been torn during the struggle with their captors, or to impart a classical air to the scene.

During World War I, a bare-breasted Marianne, a symbol of France, appeared in patriotic posters. In these depictions, she called on French citizens for help and defied the Germans. In the United States, Columbia became increasingly more sexual, and her breasts more defined and visible as Liberty Bond posters evolved during World War I. The airplanes flown on bombing missions during World War II often carried images of voluptuous, and sometimes bare-breasted, women painted on their exteriors.

Amazons, the legendary female warriors, were said to have descended from the Greek god of war, Ares. Homer mentioned the Amazons in the *Iliad* (c. eighth century BCE). He described them as a society of fierce women who slept with the men they vanquished to produce offspring, but kept only the female children born to them. However, tales of Amazons in Greek mythology predate Homer. According to legend, Amazons cut off their right breasts to make it easier for them to use a bow and arrow. In depictions of Amazons fighting against Greek warriors, the women are usually shown with one bare breast, while the other—the one that has been cut off—is covered. Often, the Greek warriors in these ancient works of art are shown striking or stabbing the women in their breasts.

Although the Amazons, as described by Greek authors, were mythical, they may have been based on fact. Ancient burial mounds in Pokrovka, Russia, for example, contain the remains of nomadic tribes, the Sauromatians (600 BCE) and the Sarmatians (c. 400 BCE). The women were buried with weapons; their bones and remains indicate that they spent much of their lives on horseback and fought in battles.

In ancient Rome and its outposts, some women fought as gladiators. Scholars differ about how common female gladiators actually were, but literary references and archeological evidence indicate they did exist. One stone sculpture from the Asia Minor city of Halicarnassus, now in the British Museum, depicts two female gladiators. The sculptor recorded their names, Achillia and Amazon. Some scholars believe another artifact, a small bronze sculpture, approximately 2,000 years old and housed in the Museum für Kunst und Gewerbein in Hamburg, Germany, could be of

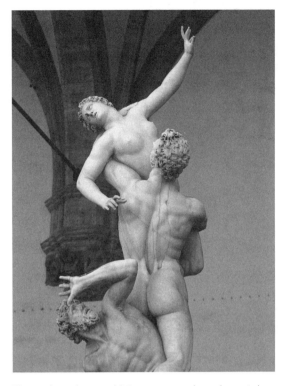

Throughout human history, women have been taken as spoils of war. In this sixteenth-century sculpture, Giambologna depicted the well-known story of the rape of the Sabine women. Giambologna, *Rape of the Sabine Women*, 1583. wjarek/Thinkstock by Getty

a woman gladiator. The topless figure holds a curved sword over her head as she looks down, possibly at the opponent she has defeated. Like male gladiators, female gladiators fought with bare chests. The clothing of Roman women was normally modest and covered their entire bodies, and they did not as a rule use weapons. The combination of uncovered breasts and weapons provided an erotic thrill to the men watching the event. Although it was an exotic spectacle, the women gladiators who engaged in it underwent training, fought, and died, as their male counterparts did.

There were many female warriors in ancient and medieval Japan. According to legend, the medieval Lady Yatsushiro fought as a warrior on horseback while pregnant. Hangaku, the daughter of a samurai, dressed as a man and shot arrows at the warriors attacking Echigo Castle in 1201. A nineteenth-century commentator on Bushido, "the way of the warrior," did not see a contradiction between being a warrior and maintaining femininity. Young girls, he noted, were trained to use weapons, and to keep a dirk at their "bosom" to use if needed against enemies or for suicide to protect their own honor.

Many women have bound their breasts and donned male clothing to fight as soldiers or escape from enemies. For example, during the American Revolution, Deborah Samson

(or Sampson) fought as a male soldier, Robert Shurtleff or Shirtleff, in the 4th Massachu-
setts Regiment. She was wounded twice, but no one discovered she was a woman until
she became ill at Yorktown. She was then discharged. Her former officers helped her later
to receive back pay and a pension from the State of Massachusetts. After her death, her
husband, Robert Gannett, successfully petitioned for survivor benefits. After her husband
deserted her, Hannah Snell disguised herself as a man and fought as a British marine. She
published an account of her life in 1750, *The Female Soldier: Or the Surprising Life and
Adventures of Hannah Snell*. There are many other women in many other wars who also
bound their breasts and pretended to be men in order to fight.

Rape and sexual assault have been features of war since antiquity. The Women Under
Siege project is currently tracking reports of rape in conflicts throughout the world during
the twentieth and twenty-first centuries. Such rapes often include mutilation of the wom-
en's breasts and genitals.

Rape and sexual harassment within the U.S. military have been a problem, too. One
notorious incident involved the Tailhook Association, a private organization of naval
and marine aviators, active and reserve, pilots, defense contractors, and others. After their
annual convention in 1991, held in Las Vegas, Nevada, a lawsuit filed by Lieutenant Paula
Coughlin and others revealed that a number of women had been sexually assaulted
during the convention. Each night, they were forced to run "the gauntlet," during which
drunken male soldiers groped the women's breasts and genitals in the hotel's hallway
and attempted to remove their clothing. Some women, according to reports, bared their
breasts willingly, and some men exposed themselves and ran naked. The navy dismissed
Lt. Coughlin's complaints, so she brought the case to court, suing the Tailhook Associa-
tion and the Las Vegas Hilton Hotel for not providing adequate security. Sexual harass-
ment and assault continue in the U.S. military. A report released by the Pentagon on May
7, 2013, estimated that 26,000 servicewomen and servicemen had been sexually assaulted
in 2012.

The U.S. armed services have also had some difficulties in adjusting uniforms and
combat gear to women's figures. It is difficult to maintain a professional appearance in
clothing that does not fit, but in the case of body armor, a poor fit can be dangerous. The
ill-fitting body armor can create pressure points and chafing that can make it difficult for
women to move or use their weapons. New designs will feature more curves in the chest
and hips, including "bra-shaped darting."

Women in uniform have also encountered criticism and harassment for breastfeeding
their infants while in military uniform. The military permits breastfeeding women to
defer overseas deployments and to take breaks for breastfeeding or pumping their breasts.
There are no rules against breastfeeding while in uniform, but many believe that it is
unprofessional or "unmilitary." Photographs of Air Force Sgt. Terran Echegoyen and Staff
Sgt. Christina Luna breastfeeding their babies in a 2012 photo shoot gained the women
unwanted attention and sparked a controversy.

Military training has produced physical changes in the breasts of some men. Male
soldiers in the German Wachbataillon unit have developed enlarged left breasts because
of the way their rifles hit their chests during drills. The repeated thumping apparently
stimulates hormones, producing one-sided gynecomastia.

See also AMAZONS; BREAST BINDING; BREAST MUTILATION; CONTROVERSIES; CROSS-DRESS-ING, IN HISTORY; ICONOGRAPHY; MYTHOLOGY; TOPLESS PROTESTS

Further Reading

Manas, Alfonso. "New Evidence of Female Gladiators: The Bronze Statuette at the Museum für Kunst und Gewerbein of Hamburg." *International Journal of the History of Sport* 28, no. 11 (November 2011): 2726–2752.

Mulrine, Anna. "Army Uses 'Xena: Warrior Princess' as Inspiration for New Body Amor for Women." *The Christian Science Monitor,* July 9, 2012. Retrieved May 11, 2014, from http://www.csmonitor .com/USA/Military/2012/0709/Army-uses-Xena-Warrior-Princess-as-inspiration-for-new -body-armor-for-women

Nitobe, Inazo. *Bushido: The Warrior's Code.* 1899, compiled and edited by Charles Lucas. Burbank, CA: Ohara, 1979.

Women Under Siege. Women's Media Center. Retrieved May 11, 2014, from http://www.women undersiegeproject.org

Yalom, Marilyn. *A History of the Breast.* New York: Knopf, 1997.

■ MERRIL D. SMITH

WEANING

In the context of breastfeeding, weaning is the process of gradually withdrawing an infant's compulsory and frequent supply of mother's milk and introducing an adult diet. Note that emphasis is placed on gradual withdrawal until weaning totally takes place.

Controversy exists as to how and when to wean an infant. UNICEF and WHO recommend exclusive breastfeeding for the first 6 months of a baby's life, and its continuance until the child is at least one year old. This has, however, proven challenging to mothers because of modern demands when mothers have to return to work shortly after the birth of their babies. Within the process of weaning, there is often a conflict when the mother tries to force the infant to cease nursing, and at the same time, the infant attempts to force the mother to continue.

What, then, is the right age to wean infants? What foods should be used to wean them? To answer the first question, weaning is informed by various reasons that are personal to the mother—it could be her return to work, her health, or just a belief that the time is right. The American Academy of Pediatrics (AAP) recommends feeding babies only breast milk for the first 6 months of life; thereafter, a combination of solid foods and breast milk until the baby is at least one year old. Others maintain that weaning should start after the first birthday. There is no rigid formula on how best to wean babies, but a few suggestions include the following:

- Wean during the day, and breastfeed at night.
- Introduce formula and bottle use, so that the baby can get used to feeding by other family members.

On what to wean babies with, certain requirements need to be considered: the child's ability to bite and chew, and also his or her neck coordination. Different societies have a variety of foods used in weaning infants. In the United States, pureed vegetables such as

carrots or sweet potatoes; pureed fruits such as bananas, or cooked pears or apples; and non-wheat-based cereal such as baby rice, sago, or corn meal are often used. In Africa, particularly in West African countries, the first weaning food is called pap, *Akamu*, *Ogi*, or *Koko*, and it is usually made from maize (*Zea mays*), millet (*Pennisetum americanum*), or guinea corn (sorghum). In fact, many Nigerian mothers introduce this food as early as 3 months mixed with breast milk and formula milk.

On the whole, breastfeeding is an intimate activity that fosters a strong bond between mother and child, and while some mothers find it difficult to let that go, others are eager for freedom. Whatever the feeling, mothers must know that weaning is not particularly an easy task for babies; as such, it is a period that calls for patience and understanding.

Weaning should be a process, rather than an event. Depending on how you go about it, weaning can take days, weeks, or months. Abrupt weaning should always be avoided, if at all possible, for the sake of both mother and baby. If a woman suddenly stops nursing, her breasts will respond by becoming engorged, and she may develop a breast infection or breast abscess. Her hormone levels may also drop abruptly, and depression can result.

Abruptly withdrawing the breast can cause emotional trauma in the baby. Since nursing is not only a source of food for a baby, but a source of security and emotional comfort as well, taking it away abruptly can be very disturbing. There is absolutely no way to explain to a baby why he or she suddenly cannot nurse anymore. Weaning gradually lets a mother slowly substitute others kinds of attention to help compensate for the loss of the closeness of nursing.

See also BREASTFEEDING; BREAST MILK; BREAST MILK, EXPRESSION OF; MOTHER–INFANT BOND

Further Reading

Dettwyler, Katherine. "A Natural Age of Weaning" (brief version of the chapter "A Time to Wean," in *Breastfeeding: Biocultural Perspectives*, edited by Patricia Stuart-Macadam and Katherine A. Dettwyler, 39–73 [New Brunswick, NJ: Transaction, 1995]). Retrieved May 11, 2014, from http://www.whale.to/a/dettwyler.html

Karmel, Annabel. *Baby Weaning Guide.* Retrieved May 11, 2014, from http://www.annabelkarmel.com/nutrition/babies-6-months/weaning-guide

King, J., and A. Ashworth. *Changes in Infant Feeding Practices in Nigeria: An Historical Review* (Occasional Paper no. 9). London: Centre for Human Nutrition, London School of Hygiene and Tropical Medicine, 1987.

WHO/UNICEF. *Weaning from Breast Milk to Family Food: A Guide for Health and Community Workers.* Geneva: World Health Organization, 1988.

■ MARY A. AFOLABI-ADEOLU

WET NURSING

Wet nursing, in which a lactating woman breastfeeds another woman's child, has existed since prehistoric times. Before bottles and formula were widely available, another woman often fed a baby if the mother died, was ill, could not produce enough milk, or chose not

to nurse her child. This could be a temporary situation or a long-term arrangement, and the wet nurse might be a friend or relative, a paid servant, or a slave.

References to wet nurses can be found in ancient literature. For example, the Babylonian Code of Hammurabi (c. 1700 BCE) declared that a wet nurse who nursed a second child without the consent of the parents of her first charge should have her breasts cut off. In the biblical book of Exodus, a wet nurse was found to feed Moses, who had been discovered floating in a basket on the Nile by the Pharaoh's daughter. The nurse happened to be his own biological mother.

According to both Pliny the Elder (23–79) and Tacitus (56–120), breastfeeding was already in decline among wealthy women of the Roman Empire in the first century. Both men looked back to the days when Roman matrons breastfed their infants themselves, and in the process imbued their young with civic virtue. It was believed that infants ingested the virtues and failings of those who nursed them. Thus, when the wives of the elite turned over their infants to the care of wet nurses, the babies did not receive their mothers' strengths—or weaknesses. According to legend, Romulus and Remus, the twin founders of Rome, were nursed by a she-wolf. From her, they got strength, aggression, and power. Well into the twentieth century, some people have continued to believe that infants ingest moral qualities and emotional characteristics along with the breast milk they swallow—even if they no longer believed that breast milk was a mother's blood turned white, as previous generations did.

In sixteenth- and seventeenth-century England, many aristocratic women declined to breastfeed their babies and used wet nurses instead. This practice tended to be more common among Catholic women than Protestants, who viewed breastfeeding as a duty of mothers, following biblical precedent. Queen Anne (1574–1619), the wife of King James I of England (1566–1625), also expressed the notion that she should breastfeed her royal children so as not to have them take in the qualities of an inferior wet nurse.

Throughout the centuries, there have been religious and medical proscriptions against engaging in sexual intercourse while breastfeeding, so some husbands insisted that their infants be wet-nursed in order to have unrestricted access to their wives' bodies. Women generally do not ovulate while they are engaged in regular breastfeeding. Even though men and women did not know why breastfeeding delayed conception, they did know breastfeeding women did not usually become pregnant. By using a wet nurse, couples could increase the likelihood of a new pregnancy.

Religious leaders and medical authorities in colonial America frowned upon the use of wet nurses, but most realized that it was sometimes a necessity. In fact, since people at that time believed colostrum, the first milk produced by mothers, was not good for babies, another woman often fed a newborn during its first few days until the mother's milk came in. In the eighteenth century, breastfeeding was glorified as a virtuous act in both the United States and France. By the nineteenth century, when it was not considered seemly to nurse one's infant in public, some women employed wet nurses in order to participate in social events. In slaveholding regions in the American South, and elsewhere in the world, wet nurses were often slaves.

Wet nurses were sometimes forced to wean their own infants in order to nurse the babies of other women. Some women became wet nurses after the death of a baby left

them with full breasts of milk. European foundling hospitals relied upon poor wet nurses to feed the abandoned babies brought there. The high mortality rates in these institutions—sometimes as high as 85 percent—led many to speak out against the practice of wet nursing. Yet wet nurses were needed, and newspapers in the eighteenth- and nineteenth-century United States carry many advertisements for wet nurses.

In the American South, cross-racial nursing was common and accepted. Slave women often suckled the babies of their mistresses. Occasionally, a white plantation mistress nursed the infant of a slave to prevent its death. In most cases, this was an economic move rather than a sentimental one. For the most part, Southerners did not believe that character was transferred in breast milk. In the post–Civil War South, the image of the idealized "Mammy" who nursed both black and white infants became prominent.

In the urban north of the nineteenth century, wet nurses were most often young—nearly all were under 30 years old, and a significant number were younger than 21. Most of them were poor. Many of them were single mothers, or they had husbands who had died or deserted them. A majority of them were immigrants—most often Irish—or the daughters of immigrants.

Early in the twentieth century, human breast milk banks opened in the United States, Europe, and Australia. The commodification of breast milk led to decreased demand for wet nurses. Recently, however, the demand for wet nurses has increased. Breast milk banks usually supply milk to premature or critically ill infants. Some mothers who want breast milk for their infants but are unable to breastfeed them themselves have turned to wet nurses. There are now agencies that supply wet nurses, just as they do other domestic workers.

See also BREASTFEEDING; BREAST MILK; BREAST MILK, DONATION/BANKING/SELLING; SLAVES, AS WET NURSES

Further Reading

Golden, Janet. *A Social History of Wet Nursing in America: From Breast to Bottle.* Columbus: Ohio State University Press, 2001.

Gordon, Claire. "The Return of Wet Nursing." AOL Jobs, March 18, 2012. Retrieved May 11, 2014, from http://jobs.aol.com/articles/2012/01/20/the-return-of-wet-nursing/

Williams, Florence. *Breasts: A Natural and Unnatural History.* New York: W. W. Norton, 2012.

Yalom, Marilyn. *A History of the Breast.* New York: Ballantine, 1997.

■ MERRIL D. SMITH

WET T-SHIRT CONTESTS

It is unclear where and when wet T-shirt contests originated, although they became popular in Palm Beach, Florida, bars in the 1970s. In the 1977 movie *The Deep*, Jacqueline Bisset swam underwater in a thin, white T-shirt that clung to her bare breasts, increasing the box office appeal of the movie and leading to a surge of wet T-shirt contests. Wet T-shirt contests are a staple of college spring breaks at bars in California, Florida, and other resort areas, including destinations outside of the United States, such as Cancun, Punta

Students participate in a wet T-shirt contest sponsored by MTV on South Padre Island, Texas, March 26, 2008. Rich Gershon/ Getty Images

Cana in the Dominican Republic, and the Bahamas, where college students under 21 can drink legally. Many bars provide the T-shirts, which are often skimpy and cut to expose a woman's breasts. The women are drenched with water and parade in front of bar patrons, who often call out for the women to remove their tops. Some women do, and some strip completely. The contest venue usually offers cash prizes to the winners of their contests.

Wet T-shirt contests have generated controversy, and they have generated many court cases. For example, in June 1997, pilots on a Boeing 727 traveling from Portland, Oregon, to a Mexican resort allegedly judged a wet T-shirt contest organized by a male flight attendant and also permitted the female contestants to enter the cockpit, which is against FAA regulations. The Miami-based Falcon Air flight had been chartered to take 150 high school students from across the Northwest to Mexico to celebrate graduation. In another case, Monica Pippin, then 16 years old, entered a wet T-shirt contest in Daytona Beach, Florida, and won the $100 grand prize. In 2002, Pippin filed suit against Playboy Entertainment, Anheuser-Busch, Deslin Hotels, Best Buy, and others after she discovered that she had been included in a video, *Playboy Exposed: All American Girls and Girls Gone Crazy: Spring Break*, which a neighbor viewed on cable television. Pippin admitted to lying about her age to the contest promoters, but she claimed she had not given them permission to use her image in adult material. In 2006, Pippin settled with Playboy Entertainment and Anheuser-Busch. Other underage young women have also brought lawsuits against Playboy and other businesses that promote wet T-shirt contests.

More recently, some students have declined to engage in wild behavior during spring break outings, as they recognize their antics can appear at any time on Facebook, YouTube, or other Internet and social media sites. Knowing that their friends and acquaintances, as well as total strangers, can take and post a photo in seconds, many have become discreet in public, and that includes not entering wet T-shirt contests. Others, however, live for notoriety, and they hope to have photos of themselves drinking and engaging in wild and sometimes sexually explicit behavior. Some students in the United States, Canada, and Europe have reported entering wet T-shirt contests to win the prize money to pay

tuition and rent. In 2007, a local bar offered to pay $500 toward tuition to the University of Guelph (Ontario, Canada) for a female student who won its wet T-shirt contest.

It is not only students who have entered wet T-shirt contests or become mired in controversy in the aftermath. In 1983, one of the largest law firms in Atlanta, King and Spalding, decided to hold a wet T-shirt contest featuring their female summer associates. The firm was already in the midst of a sex discrimination lawsuit. Facing criticism from within the firm, the company decided to hold a swimsuit competition instead. The woman who won the competition was a third-year law student from Harvard. She was offered a position in the firm.

In 2003, photos of news anchor Catherine Bosley, taken while she was on vacation with her husband in Key West, Florida, surfaced on the Internet. Bosley had entered a wet T-shirt contest and later danced naked on the bar. She had been an anchor with WKBN for 10 years. She resigned from her job and later brought a lawsuit against *Hustler* magazine, which published a photo of her without her consent.

See also CONTROVERSIES; MEDIA; MOVIES

Further Reading

Donohue, John. "Prohibiting Sex Discrimination in the Workplace: An Economic Perspective." Faculty Scholarship Series Paper 44, 1989. Retrieved May 11, 2014, from http://digitalcommons.law.yale.edu/fss_papers/44

Graham, Kevin. "Lawsuit Says Video Exploits Teen's Naïveté." *Tampa Bay Times*, April 28, 2006. Retrieved May 11, 2014, from http://www.sptimes.com/2006/04/28/Hillsborough/Lawsuit_says_video_ex.shtml/

Hall, Anna C., and Mardia J. Bishop. *Pop-Porn: Pornography in American Culture*. Westport, CT: Praeger, 2007.

■ MERRIL D. SMITH

WITCH'S TEAT

A witch's teat is an unnatural appendage on the body of a witch. According to European theology and folklore, the teat was the means for the witch to suckle "familiars." These familiars—usually cats, but sometimes toads, weasels, or puppies—were agents of the devil and sometimes shape-shifting demons. The witch's teat, or tit, had the appearance of a mole, a scar, or a fold of flesh.

The search for the witch's teat was an essential element in the examination of women accused of witchcraft. The revelation of any such mark was often presented last at a witch's trial and was regarded as proof of damnation—and therefore justification for the death penalty that would follow. The examination of witches continued in the New World, most notably in the Salem witch trials. A surgeon and eight women examined Bridget Bishop on the morning of her trial. According to the trial records, they found "a preternatural excrescence of flesh between the pudendum and anus much like to teats and not usual in women." Although a second examination in the afternoon revealed her

"clear and free . . . from any preternatural excrescence," the damage had been done; the judges had heard evidence of a witch's teat (Gragg 92). Bridget Bishop was the first person executed in the Salem witch trials, on June 10, 1692.

The witch's teat was similar to the witch's mark, which was believed to be a mark on the body where the Devil had branded the accused woman as his own. Lesions and discolorations of the skin are so common that few could survive such an examination.

Women were often entirely shaved during a trial for witchcraft, which allowed examination of their bodies with greater scrutiny. The famous text on the prosecution of witches, *Malleus Maleficarum* (in English, *Hammer of the Witches*), states, "And the Inquisitor of Como has informed us that last year, that is, in 1485, he ordered forty-one witches to be burned, after they had been shaved all over." There was a concentration upon the witch's sexuality, and the observation of marks and teats was often made in reference to "privy parts." That witchhunts were a direct attack upon women's gendered bodies is made particularly evident through study of the notion of the witch's teat.

The teat was usually said to be cold to the touch, and it was a source of blood for the feeding demons. It is thus in opposition to warmth, nourishment, and life. Witches were also credited with the ability to suck on the bodies of infants and drain them of their blood. All of these tales establish the witch as the opposite of virtuous femininity, and the witch's tit is the binary opposite of the mother's breast.

The colloquial term "cold as a witch's tit" is a vestigial survival, in the English language, of beliefs taken quite seriously until the late modern era.

See also BREASTFEEDING; RELIGION; SLANG; VIRGIN MARY

Further Reading

Gragg, Larry D. *The Salem Witch Crisis*. Westport, CT: Praeger, 1992.

Roper, Lyndal. "Witchcraft and Fantasy in Early Modern Germany." *History Workshop*, no. 32 (1991): 19–43.

Willis, Deborah. "Shakespeare and the English Witch-Hunts: Enclosing the Maternal Body." In *Enclosure Acts: Sexuality, Property, and Culture in Early Modern England*, ed. Richard Burt and John Michael Archer, 96–120. Ithaca, NY: Cornell University Press, 1994.

■ THÉRÈSE TAYLOR

WOMANHOOD

Womanhood is the state of being a woman, an adult human. It is a period in which a girl has passed through childhood and adolescence, generally around the age of 18, and has passed the menarche—the first menstrual period of a female-bodied individual. In attaining this period, many cultures have initiation rites, or rites of passage, that symbolize a girl coming of age. In the biological makeup of a woman, certain characteristics differentiate her from a man. Physically, she is identified by breast and hip enlargement; there are also the female sex organs involved in the reproductive system.

Breasts are a significant part of a woman's body. Women regard their breasts as import-
ant for sexual attractiveness, and as a sign of femininity and beauty, which is important
to their self-esteem. In some cultures, breasts play a role in human sexual activity. Breasts
and especially the nipple are female erogenous zones. They are sensitive to touch as they
have many nerve endings, and it is common to press or massage them with hands or orally
before or during sexual activity. Some women can achieve an orgasm from such activities.
Research has suggested that the sensations are genital orgasms caused by nipple stimu-
lation, and these sensations may also be directly linked to "the genital area of the brain."
Sensation from the nipples travels to the same part of the brain as sensations from the
vagina, clitoris, and cervix. Nipple stimulation may trigger uterine contractions, which
then produce a sensation in the genital area of the brain.

Many people regard the female human body, of which breasts are an important aspect,
to be aesthetically pleasing as well as erotic. Research conducted at the Victoria University
of Wellington showed that breasts are often the first thing men look at, and for a longer
time than other body parts. Many people regard bare female breasts to be erotic, and
they can elicit heightened sexual desires in some men in some cultures. Many women
regard their breasts as important to their sexual attractiveness, as a sign of femininity that
is important to their sense of self.

Some women are obsessed about the attractiveness of their breasts. They fear sagging,
and so do not breastfeed, or do not do it for long. When a woman considers her breasts
deficient in some respect, she might choose to undergo a plastic surgery procedure to
enhance them, either to have them augmented or to have them reduced, or to have them
reconstructed if she suffered a deformative disease, such as breast cancer. After mastectomy
(the removal of a diseased breast), the reconstruction of the breast or breasts is done with
breast implants or autologous tissue transfer, using fat and tissues from the abdomen.

The English word breast is derived from the Old English word *breost* (breast, bosom,
from the Proto-Indo-European base *bhreus*, meaning to swell, to sprout). The breast is the
tissue overlying the topmost chest muscles in the left and right sides. Women's breasts are
made of specialized tissues that produce milk during the birth of children to feed them.
The breast also produces fatty tissue, and the amount of fat determines the size of the
breast. In mature women, the breast is more prominent than in other mammals. Both men
and women develop breasts from the same embryological tissues; however, the female sex
hormones, mainly estrogen, promote breast development, which does not occur in men
due to the higher amount of testosterone.

The mature female breast is composed of essentially four structures: lobules or
glands, milk ducts, fat, and connective tissue. The lobules group together into larger
units called lobes. On average, there are 15–20 lobes in each breast, arranged roughly
in a wheel spoke pattern emanating from the nipple–areola area. The distribution of
the lobes is not even, however. There is a preponderance of glandular tissue in the
upper outer portion of the breast. This is responsible for the tenderness in this region
that many women experience prior to their menstrual cycle. It is also the site of half
of all breast cancers. The lobes empty into the milk ducts, which course through the
breast toward the nipple–areola area. There, they converge into 6–10 larger ducts called

collecting ducts, which enter the base of the nipple and connect with the outside. During lactation (breastfeeding), the breast milk follows this course on its way to the feeding infant.

There are four basic breast shapes: big, small, sagging, and asymmetrical. Some women have a very big bust that can cause them backaches. As a result of this, bra size is of topmost importance. According to the U.S. bra industry, the most common bra cup size in the United States used to be B, but it has now become C due to increasing obesity. Sagging of the breasts is common among women due to gravity; the breast naturally assumes a hanging position. "Asymmetrical breasts" means having one breast larger than the other, and most women have one larger breast, particularly the left one being bigger than the right. Breast size is not constant but varies during the menstrual cycle, pregnancy, and breastfeeding. Breasts are susceptible to numerous benign and malignant conditions. The most frequent benign conditions are puerperal mastitis, fibrocystic breast changes, and mastalgia (breast pain). Breast cancer is one of the leading causes of death among women.

Some scientists believe the rounded breasts that protrude from the human mother's body evolved to allow human infants, who have flatter faces and smaller jaws than our earlier ancestors. If human infants had to nurse with their faces squashed against a flat chest, they would not be able to breathe through their noses, and they would suffocate. Unlike other mammals, newborn human infants must be held and their necks supported while they nurse. The nipples of human breasts are flexible and unmoored; they come down to the baby. Thus, human female breasts are functionally designed to feed human infants.

Breastfeeding is the feeding of an infant or young child with breast milk directly from the female human breast (i.e., via lactation) rather than from a baby bottle or other container. Babies have a sucking reflex that enables them to suck and swallow milk. Many specialists recommend that mothers exclusively breastfeed for 6 months or more, without the addition of infant formula or solid food. There are conflicting views about how long exclusive breastfeeding remains beneficial.

After the addition of solid food, mothers are advised to continue breastfeeding for at least a year. The World Health Organization (WHO) recommends nursing for at least 2 years or more. Human breast milk is the healthiest form of milk for babies. Breastfeeding promotes health and helps to prevent disease. Experts agree that breastfeeding is beneficial and have concerns about the effects of artificial formulas. Artificial feeding is associated with more deaths from diarrhea in infants in both developing and developed nations. There are a few exceptions, such as when the mother is taking certain drugs, is infected with human T-lymphotropic virus, or has active untreated tuberculosis. In developed countries with access to infant formula and clean drinking water, maternal HIV infection is an absolute contraindication to breastfeeding (regardless of maternal HIV viral load or antiretroviral treatment) due to the risk for mother-to-child HIV transmission.

WHO and the American Academy of Pediatrics (AAP) emphasize the value of breastfeeding for mothers as well as children. Both recommend exclusive breastfeeding for the

first 6 months of life. The AAP recommends that this be followed by supplemented breast-feeding for at least one year, while WHO, as mentioned above, recommends that supplemented breastfeeding continue for 2 years or more. While recognizing the superiority of breastfeeding, regulating authorities also work to minimize the risks of artificial feeding.

The symbolism of breasts to women and the primary function of breastfeeding contribute to the concept of womanhood. Today, the normal natural breast seems to be going out of fashion, especially in the developed world, where the obsession with ideal and perfect breasts emphasizes upright and pointy breasts, as exhibited by models and young actresses. While U.S. culture idealizes firm and youthful breasts, some cultures venerate women with wrinkled, saggy breasts, indicating mothering and the wisdom of experience.

See also BREAST ANATOMY; BREAST AUGMENTATION; BREASTFEEDING; BREAST ORGASM; BREAST RECONSTRUCTIVE SURGERY; BREAST REDUCTION; FEMINISM; MEDIA; POSTPARTUM BREASTS; PUBERTY; WOMEN'S MOVEMENT

Further Reading

Bentley, Gillian R. "The Evolution of the Human Breast." *American Journal of Physical Anthropology* 32, no. 38 (2001): 30.

Cole, Ellen, and Esther D. Rothblum. *Breasts: The Women's Perspective on an American Obsession.* New York: Routledge, 2012.

Davis, Kathy. *Reshaping the Female Body: The Dilemma of Cosmetic Surgery.* New York: Routledge, 1995.

Murthy, Padmini, and Clyde Lanford Smith. *Women's Global Health and Human Rights.* Boston: Jones & Bartlett, 2010.

Tortora, Gerard J., and Sandra Reynolds Grabowski. *Introduction to the Human Body: The Essentials of Anatomy and Physiology*, 5th ed. New York: John Wiley & Sons, 2001.

Yalom, Marilyn. *A History of the Breast.* New York: Ballantine, 1997.

■ MARY A. AFOLABI-ADEOLU

WOMEN'S MOVEMENT

A movement seeking to promote and improve the position of and attitude toward women in society. Many look to the publication of London-born Mary Wollstonecraft's *A Vindication of the Rights of Women* (1792) as a watershed moment in the struggle for equal rights of women. In the 300-page document, Wollstonecraft discusses many different aspects pertaining to women's rights, with her overriding theme arguing that the two sexes are equal in intellectual and moral capacities.

The "first wave of feminism" is a reference to a meeting held in Seneca Falls, New York, on July 19, 1848, which has since become known as the Seneca Falls Convention. This is the first time that a large group of women gathered to discuss the problems relating to women, and it heralded the appearance of organized groups of women as a force in the Western world. The meeting was organized by Lucretia Mott (1793–1880) and Elizabeth Cady Stanton (1815–1902), who adopted a "Declaration of Sentiments and Resolutions," which mirrored the U.S. Declaration of Independence in style and opens by addressing the repeated injuries on the part of men toward women, such as denying women the right

to vote, to own property, and to have access to higher education, profitable employment, and entry into the ministry.

The movement was predominantly composed of white middle-class women, although some black women were involved. In 1851, Sojourner Truth (born Isabella Baumfree, c. 1795–1883), a freed slave, addressed a meeting in Akron, Ohio. In her groundbreaking speech, "Ain't I a Woman?" she demolished the arguments that women were the weaker sex by making strong connections to the conditions that she and her fellow slaves had lived under. Some did not believe the six-foot-tall, strong, powerful speaker was a woman. When a crowd of men began to heckle her during a speech in Silver Lake, Indiana, in 1858, Truth exposed her breasts to them and recited a list of male white children she had breastfed.

American women finally got the vote in 1919, although their sisters in Great Britain had received this right earlier in 1916 as recognition for their invaluable services to Great Britain during World War I. In fact, 19 countries in Europe and North America adopted female suffrage during or right after World War I. Italy, France, and Switzerland denied women the vote until after World War II.

In the aftermath of World War II, the lives of women in developed countries changed dramatically. New advances in technology changed the ideas and in some case the burdens of homemaking. Life expectancies increased, and thousands of new kinds of jobs emerged from the growth of the service sector. Despite these transformations, cultural attitudes and legal precedents continued to reinforce sexual inequalities. Simone de Beauvoir's (1908–1986) *Le Deuxième Sexe* (*The Second Sex;* 1949) became a worldwide bestseller and would provide the important theoretical underpinnings for the second wave of feminism. Beauvoir, a noted French philosopher, presented an interdisciplinary study of women in relation to psychoanalysis, history, biology, myth, and literature. One of her arguments is that women have always been placed as subordinate to men. This inequality is not due to nature; rather, it is due to women being trapped by their traditional upbringing and training. In the 1960s and 1970s, a new wave of feminism—or, rather, a second wave—arrived. This movement had much larger implications for society as a whole, with ties to the civil rights movements of the 1950s and 1960s. Betty Friedan's *The Feminine Mystique* (1963) signaled the underlying discontent of women and a new way of looking at gender roles, as she focused on the postwar middle-class wife in the United States.

One of the notable symbols to emerge out of the second-wave feminist movement was the image of bra burning. This was used to reinforce the stereotype of the ugly radical feminist who did not have the looks to be loved by men, and it was a poignant symbol of women's refusal to be subjected to male fantasies of beauty. The concept originated when feminist protesters of the 1968 Miss America Pageant planned to stage a burning of "woman garbage" in a "freedom trashcan." This never took place due to the inability to get a permit from the Atlantic City Fire Department.

The end of the twentieth century has brought about considerable improvement to the status of women. Yet the question of liberation is still an issue within the first decades of the twenty-first century, but in addition to equal rights and equal pay, liberation also includes the freedom of women to control and protect their own bodies in such areas as reproductive rights, ending rape and sexual violence, increasing funding for breast cancer research, and promoting the acceptance of breastfeeding in public.

See also BRA BURNING; BREAST CANCER SUPPORT GROUPS; BREASTFEEDING, IN PUBLIC; CONTROVERSIES; FEMINISM; POLITICS; TOPLESS PROTESTS

Further Reading

DuBois, Ellen Carol. *Feminism and Suffrage: The Emergence of an Independent Women's Movement in America, 1848–1869.* Ithaca, NY: Cornell University Press, 1999.

Flanz, Gisbert H. *Comparative Women's Rights and Political Participation in Europe.* New York: Transnational, 1982.

Flexner, Eleanor, and Ellen F. Fitzpatrick. *Century of Struggle: The Woman's Rights Movement in the United States.* Cambridge, MA: Belknap Press of Harvard University Press, 1996.

Marilley, Suzanne M. *Woman Suffrage and the Origins of Liberal Feminism in the United States, 1820–1920.* Cambridge, MA: Harvard University Press, 1996.

Nicholson, Linda J., ed. *The Second Wave: A Reader in Feminist Theory.* New York: Routledge, 1997.

■ LORI L. PARKS

WONDERBRA

A brand of push-up brassiere, the Wonderbra is meant to lift and support the bustline, giving the appearance of larger breasts and enhancing cleavage. The Wonderbra became hugely popular during the 1990s.

Created in 1964 by Louise Poirier, a Canadian designer, the Wonderbra gives the appearance of larger breasts by using 54 separate design components (compared to 25 components in a standard bra), including a bra cup composed of three parts, underwires, a precision-angled back, tight straps, and removable pads. Poirier initially created the bra for Canadelle, a Canadian lingerie company, but Courtland Textiles, a UK-based manufacturer, licensed the rights from Canadelle, producing and marketing the Wonderbra in Europe under its Gossard Lingerie brand from the late 1960s until 1993.

In 1991, the Sara Lee Corporation purchased Canadelle and regained control of the Wonderbra in 1994, when Gossard's licensing rights expired. In 1994, Sara Lee launched a provocative and hugely successful Wonderbra advertising campaign in the United Kingdom. The ads famously featured Czech model Eva Herzigova admiring her breasts in a Wonderbra with a variety of captions underneath, some of which read, "Your Dad's Worst Nightmare," "Hello, boys," and "Newton was wrong." During this time, Playtex, a division of Sara Lee, began producing and marketing the Wonderbra in the United States, launching its campaign by suspending a 2,800-square-foot image of Herzigova in a Wonderbra over Times Square in New York City. When Sara Lee initially reintroduced the Wonderbra to North American and European stores, the garment was reportedly selling at a rate of one every 15 seconds, resulting in first-year sales of approximately $120 million. Other companies, attempting to capitalize on the success of the Wonderbra campaign, quickly produced competitive brands, such as the Ultrabra (Gossard) and Miracle Bra (Victoria's Secret).

Sara Lee sold its intimate apparel brands in 2006, including the Wonderbra. The Wonderbra brand in 2013 was again the property of Canadelle, a subsidiary of HanesBrands Inc.

See also ADVERTISING; BRASSIERE; CORSETS; MAIDENFORM; MODELS AND MODELING; SPORTS BRAS; TRAINING BRAS; UNDERGARMENTS

Further Reading

Farrell-Beck, Jane, and Colleen Gau. *Uplift: The Bra in America*. Philadelphia: University of Pennsylvania Press, 2002.

Rechert, Tom. *The Erotic History of Advertising*. New York: Prometheus, 2003.

■ CHRIS VANDERWEES

Y

YANK, THE ARMY WEEKLY

Yank, the Army Weekly was a five-cent weekly publication of the U.S. War Department from June 1942 through December 1945, with a peak circulation of 2.6 million issues. Its publication offices were in New York City, and it published 21 different editions in 17 countries, with each issue containing content from the main office and from local bureaus. Enlisted soldiers were its primary creators and audience, and each issue contained news articles, letters to the editor, photographs, cartoons, poems, and illustrations depicting World War II from soldiers' points of view—officers were only allowed to write letters to the editor. *Yank* provided soldiers with up-to-date military information and helped them relax from the stresses of war with humor and distraction. One of the most popular features in *Yank* was a pinup girl, who was depicted in attire showcasing her body. Some pinup girls were on the front or back covers of the magazine, but many were on the inside pages. The creators of *Yank* presumed that their readership was young, heterosexual, white, and male, so they included pinup photographs of women whom they thought would appeal to such an audience. Most were of Western European origin, though some, such as Maria Montez and Rita Hayworth, were Latina but were portrayed as "white." Many of *Yank*'s pinup stars were actresses that are still well known in the present, including Hedy Lamarr, Marilyn Monroe, Betty Grable, Dorothy Day, Ingrid Bergmann, Donna Reed, and Lucille Ball.

The pinup girls were between 17 and 32 years old, and they wore clothes and structured bras and girdles that enhanced their breasts, hips, bottoms, and legs. They were portrayed individually, in indoor or outdoor scenes, with dark lipstick, thick eyebrows, and heavily styled hair. Their attire ranged from formal wear to swimsuits to lingerie to showgirl costumes. Some pinup girls, such as the popular Anne Gwynne, were called "Sweater Girls," as they wore thin, tight sweaters that fit snugly over their bras. Their bras, called Torpedo, Bullet, or Cone bras, positioned their breasts in highly structured conical points. They were often smiling directly at the camera, with their backs arched to show their breasts more clearly. Sometimes, like Angela Greene in the July 30, 1944, edition, they were photographed from above so that the viewer had the impression of looking down her blouse. Alternatively, pinup girls were sometimes shown braless, such as Linda Darnell in the May 12, 1944, issue. Darnell was seated in hay with her blouse partially

unbuttoned and one shoulder pulled down, so the viewer could clearly see the outline of her breasts without a bra.

Pinup girls were an important aspect of *Yank* amid the latest stories on the war's progress. They were a key part of *Yank*'s mission to remind its readers to look ahead to a peaceful future as civilians, and World War II veterans continue to have fond memories of them almost 60 years later.

See also BEAUTY IDEALS, TWENTIETH- AND TWENTY-FIRST-CENTURY AMERICA; CELEBRITY BREASTS; *ESQUIRE*; FASHION; MOVIES; PHOTOGRAPHY; *PLAYBOY*

Further Reading

Foster, Renita. "'Yank' Magazine Energized Soldiers, Reminding Them of the Reasons for Fighting." Official Home Page of the United States Army, August 20, 2009. Retrieved May 10, 2014, from http://www.army.mil/article/26343/__039_Yank__039__magazine_energized _Soldiers__reminding_them_of_the_reasons_for_fighting

McGurn, Barrett. *Yank: The Army Weekly, Reporting the Greatest Generation.* Golden, CO: Fulcrum, 2004.

Yank: The Story of World War II as Written by the Soldiers. Washington, DC: Brassey's, 1991.

■ DONNA J. DRUCKER

SELECTED BIBLIOGRAPHY

Allen, R. *Horrible Prettiness: Burlesque and American Culture*. Chapel Hill: University of North Carolina Press, 1991.

Angier, Natalie. *Woman: An Intimate Geography*. New York: Anchor Books, 2000.

Arnold, Rebecca. *Fashion, Desire and Anxiety: Image and Morality in the 20th Century*. New Brunswick, NJ: Rutgers University Press, 2001.

Aronowitz, Robert. *Unnatural History: Breast Cancer and American Society*. New York: Cambridge University Press, 2007.

Ayalah, Daphna, and Isaac Weinstock, *Breasts: Women Speak about Their Breasts and Their Lives*. New York: Simon & Schuster, 1979.

Baehr, Helen, and Gillian Dyer. *Boxed In: Women and Television*. New York: Routledge & Kegan Paul, 1987.

Baetens, Pascal. *Nude Photography: The Art and the Craft*. New York: Dorling Kindersley, 2007.

Bailey, Eric J. *Black America, Body Beautiful: How the African Image Is Changing Fashion, Fitness, and Other Industries*. Westport, CT: Praeger, 2008.

Banner, Lois W. *American Beauty*. New York: Alfred A. Knopf, 1983.

Barash, David P., and Judith Eve Lipton. *How Women Got Their Curves and Other Just-So Stories: Evolutionary Enigmas*. New York: Columbia University Press, 2009.

Bauer, Heike, ed. *Women and Cross-Dressing 1800–1939*, 3 vols. London: Routledge, 2006.

Benedet, Rosalind. *After Mastectomy: Healing Physically and Emotionally*. Omaha, NE: Addicus Books, 2003.

Benshoff, Harry M., and Sean Griffin. *America on Film: Representing Race, Class, Gender, and Sexuality at the Movies*, 2nd ed. Hoboken, NJ: John Wiley & Sons, 2011.

Berry, Daina Ramey. *Swing the Sickle for the Harvest Is Ripe: Gender and Slavery in Antebellum Georgia*. Urbana: University of Illinois Press, 2007.

Blackmer, Corinne E., and Patricia Juliana Smith. *En Travesti: Women, Gender Subversion, Opera*. New York: Columbia University Press, 1995.

Bland, Kirby I., and Edward M. Copeland III. *The Breast: Comprehensive Management of Benign and Malignant Disorders*. St. Louis, MO: Saunders, 2004.

Blanton, DeAnne, and Lauren M. Cook. *They Fought Like Demons: Women Soldiers in the American Civil War*. Baton Rouge: Louisiana State University Press, 2002.

Bliss, Katherine Elaine. *Compromised Positions: Prostitution, Public Health, and Gender Politics in Revolutionary Mexico City*. University Park: Pennsylvania State University Press, 2001.

Bordo, Susan. *Unbearable Weight: Feminism, Western Culture, and the Body*, 10th anniversary ed. Berkeley: University of California Press, 2003.

Bouson, J. Brooks. *Embodied Shame: Uncovering Female Shame in Contemporary Women's Writings.* Albany, NY: SUNY Press, 2009.

Brandt, Bill. *Perspective of Nudes.* New York: Amphoto, 1961.

Brinker, Nancy G., and Joni Rodgers. *Promise Me: How a Sister's Love Launched the Global Movement to End Breast Cancer.* New York: Three Rivers Press, 2010.

Brown, Jeffrey A. *Dangerous Curves: Action Heroines, Gender, Fetishism, and Popular Culture.* Jackson: University Press of Mississippi, 2011.

Brown, Petrina. *Eve: Sex, Childbirth and Motherhood through the Ages.* West Sussex, UK: Summersdale, 2004.

Brownmiller, Susan. *In Our Time: Memoir of a Revolution.* New York: Dial Press, 1999.

Brunberg, Joan Jacobs. *The Body Project: An Intimate History of American Girls.* New York: Vintage Books, 1997.

Buszek, Maria Elena. *Pinup Grrrls: Feminism, Sexuality, Popular Culture.* Durham, NC: Duke University Press, 2006.

Bynum, Caroline Walker. *Holy Feast and Holy Fast: The Religious Significance of Food to Medieval Women.* Berkeley: University of California Press, 1987.

Campbell, Gwyn, Suzanne Miers, and Joseph C. Miller. *The Modern Atlantic,* vol. 2 of *Women and Slavery.* Athens: Ohio University Press, 2008.

Carlsen, Mary Baird. *Creative Aging: A Meaning-Making Perspective.* New York: W. W. Norton, 1991.

Carter, Alison. *Underwear: The Fashion History.* New York: Drama Book, 1992.

Chin, Angelina. *Bound to Emancipate: Working Women and Urban Citizenship in Early Twentieth-Century China and Hong Kong.* Plymouth, UK: Rowman & Littlefield, 2012.

Cogan, Frances B. *All-American Girl: The Ideal of Real Womanhood in Mid-Nineteenth-Century America.* Athens: University of Georgia Press, 1989.

Cohen, Daniel A., ed. *The Female Marine and Related Works: Narratives of Cross-Dressing and Urban Vice in America's Early Republic.* Amherst: University of Massachusetts Press, 1997.

Cole, Ellen, and Jessica Henderson Daniel. *Featuring Females: Feminist Analyses of Media.* Washington, DC: American Psychological Association, 2005.

Cole, Ellen, and Esther D. Rothblum. *Breasts: The Women's Perspective on an American Obsession.* New York: Routledge, 2012.

Cole, Herbert M. *Icons: Ideals and Power in the Art of Africa.* Washington, DC: Smithsonian Institution Press, 1989.

Cole, Shaun, Muriel Barbier, and Shazia Boucher. *The Story of Underwear.* New York: Parkstone International, 2010.

Craig, Maxine Leeds. *Ain't I a Beauty Queen? Black Women, Beauty, and the Politics of Race.* New York: Oxford University Press, 2002.

Crais, Clifton, and Pamela Scully. *Sara Baartman and the Hottentot Venus: A Ghost Story and a Biography.* Princeton, NJ: Princeton University Press, 2009.

Crompvoets, Samantha. *Breast Cancer and the Post-Surgical Body: Recovering the Self.* Basingstoke, UK: Palgrave Macmillan, 2006.

Damrosch, Leopold. *Jean-Jacques Rousseau: Restless Genius.* Boston: Houghton Mifflin, 2005.

Davis, Kathy. *Dubious Equalities and Embodied Differences: Cultural Studies on Cosmetic Surgeries.* Lanham, MD: Rowman & Littlefield, 2003.

Davis, Kathy. *Reshaping the Female Body: The Dilemma of Cosmetic Surgery.* London: Routledge, 1995.

Davis-Kimball, Jeannine. *Warrior Women: An Archaeologist's Search for History's Hidden Heroines.* New York: Warner Books, 2002.

Ditmore, Melissa Hope. *Prostitution and Sex Work.* Santa Barbara, CA: Greenwood, 2011.

Doherty, Lillian E. *Gender and the Interpretation of Classical Myths.* London: Duckworth, 2001.

Downing, Christine. *The Goddess: Mythological Images of the Feminine.* New York: Continuum, 2000.

Driscoll, Catherine. *Girls: Feminine Adolescence in Popular Culture and Cultural Theory*. New York: Columbia University Press, 2002.

Dunn, Stephane. *Baad Bitches and Sassy Supermamas: Black Power Action Films*. Chicago: University of Illinois Press, 2008.

Eco, Umberto. *History of Beauty*. New York: Rizzoli, 2010.

Eco, Umberto. *On Ugliness*. New York: Rizzoli, 2011.

Edgren, Gretchen. *The Playmate Book: Six Decades of Centerfolds*. London: Aurum, 1996.

English, Bonnie. *A Cultural History of Fashion in the 20th and 21st Centuries: From Catwalk to Sidewalk*, 2nd ed. New York: Bloomsbury, 2013.

Entwistle, Joanne. *The Fashioned Body: Fashion, Dress and Modern Social Theory*. Cambridge: Polity, 2000.

Ewing, Elizabeth. *Dress and Undress: A History of Women's Underwear*. New York: Drama Book Specialists, 1978.

Faludi, Susan. *Backlash: The Undeclared War against American Women*. New York: Three Rivers Press, 1991.

Farrell-Beck, Jane, and Colleen Gau. *Uplift: The Bra in America*. Philadelphia: University of Pennsylvania Press, 2002.

Fields, Jill. *An Intimate Affair: Women, Lingerie, and Sexuality*. Berkeley: University of California Press, 2007.

Fildes, Valerie. *Breasts, Bottles and Babies: A History of Infant Feeding*. Edinburgh: Edinburgh University Press, 1986.

Finigan, Valerie. *Saggy Boobs and Other Breastfeeding Myths*. London: Pinter & Martin, 2009.

Finnane, Antonia. *Changing Clothes in China: Fashion, History, Nation*. New York: Columbia University Press, 2008.

Fischer-Hansen, Tobias, and Birte Poulsen. *From Artemis to Diana: The Goddess or Man and Beast*. Copenhagen: Collegium Hyperboreum and Museum Tusculanum Press, 2009.

Foley, B. *Undressed for Success: Beauty Contestants and Exotic Dancers as Merchants of Morality*. New York: Palgrave Macmillan, 2005.

Foucault, Michel. *The History of Sexuality*, 3 vols. New York: Random House, 1978–1986.

Frank, K. *G-Strings and Sympathy: Strip Club Regulars and Male Desire*. Durham, NC: Duke University Press, 2002.

Fraser, Antonia. *The Warrior Queens*. New York: Vintage Books, 1990.

Fraterrigo, Elizabeth. *Playboy and the Making of the Good Life in Modern America*. New York: Oxford University Press, 2009.

Galen. *Method of Medicine*, vols. 1–3, translated by I. Johnson and G. Horsley. Cambridge, MA: Loeb Classical Library, Harvard University Press.

Gallick, Sarah. *The Big Book of Women Saints*. New York: HarperCollins, 2007.

Gallonio, Antonio. *Tortures and Torments of the Christian Martyrs*. Los Angeles: Feral House, 2004.

Garland-Thomson, Rosemarie. *Staring: How We Look*. New York: Oxford University Press, 2009.

Gaspar, David Barry, and Darlene Clark Hine, eds. *More than Chattel: Black Women and Slavery in the Americas*. Bloomington: University of Indiana Press, 1996.

Giles, Fiona. *Fresh Milk: The Secret Life of Breasts*. Sydney: Allen and Unwin, 2003.

Godbeer, Richard. *Sexual Revolution in Early America*. Baltimore: Johns Hopkins University Press, 2002.

Goff, Barbara. *Citizen Bacchae: Women's Ritual Practice in Ancient Greece*. Berkeley: University of California Press, 2004.

Golden, Janet. *A Social History of Wet Nursing in America: From Breast to Bottle*. Columbus: Ohio State University Press, 2001.

Goldman, Leslie. *Locker Room Diaries: The Naked Truth about Women, Body Image, and Reimagining the Perfect Body*. Cambridge, MA: Da Capo Press, 2007.

Gross, Michael. *Model: The Ugly Business of Beautiful Women*. New York: William Morrow, 1995.

Hadzisteliou Price, Theodora. *Kourotrophos: Cults and Representations of the Greek Nursing Deities*. Leiden: E. J. Brill, 1978.

Hall, Anna C., and Mardia J. Bishop. *Pop-Porn: Pornography in American Culture.* Westport, CT: Praeger, 2007.

Hollander, Anne. *Seeing through Clothes.* New York: Viking Press, 1978.

Holmes, Morgan. *Critical Intersex.* Aldershot, UK: Ashgate, 2009.

Holmlund, Chris. *Impossible Bodies: Femininity and Masculinity at the Movies.* New York: Routledge, 2002.

Hotchkiss, Valerie R. *Clothes Make the Man: Female Cross-Dressing in Medieval Europe.* New York: Garland, 1996.

Hunt, Lynn. *The Invention of Pornography: Obscenity and the Origins of Modernity, 1500–1800.* New York: Zone Books, 1993.

Jacobson, Nora. *Cleavage: Technology, Controversy, and the Ironies of the Man-Made Breast.* New Brunswick, NJ: Rutgers University Press, 2000.

Jeffreys, Sheila. *Beauty and Misogyny: Harmful Cultural Practices in the West.* New York: Routledge, 2005.

Jordan, Jessica Hope. *The Sex Goddess in American Film, 1930–1965.* New York: Cambria Press, 2009.

Karkazis, Katrina. *Fixing Sex: Intersex, Medical Authority, and Lived Experience.* Durham, NC: Duke University Press, 2008.

Kedrowski, Karen, and Marilyn Sarow. *Cancer Activism: Gender, Media, and Public Policy.* Champaign: University of Illinois Press, 2007.

Kennedy, V. Lynn. *Born Southern: Childbirth, Motherhood, and Social Networks in the Old South.* Baltimore: Johns Hopkins University Press, 2010.

King, Samantha. *Pink Ribbons, Inc.: Breast Cancer and the Politics of Philanthropy.* Minneapolis: University of Minnesota Press, 2006.

Koda, Harold. *Extreme Beauty: The Body Transformed.* New York: Metropolitan Museum of Art, 2004.

Koloski-Ostrow, Ann Olga, and Claire L. Lyons. *Naked Truths: Women, Sexuality and Gender in Classical Art and Archaeology.* London: Routledge, 2004.

Kord, Susan, and Elisabeth Krimmer. *Hollywood Divas, Indie Queens, and TV Heroines: Contemporary Screen Images of Women.* Toronto: Rowman & Littlefield, 2005.

Kroll, Eric, ed. *Bunny's Honeys: Bunny Yeager, Queen of Pin-Up Photography.* Cologne: Taschen, 1994.

Kushner, Rose. *Breast Cancer: A Personal History and an Investigative Report.* New York: Harcourt Brace Jovanovich, 1975.

Landers, James. *The Improbable First Century of* Cosmopolitan *Magazine.* Columbia: University of Missouri Press, 2010.

Laqueur, Thomas Walter. *Making Sex: Body and Gender from the Greeks to Freud.* Cambridge, MA: Harvard University Press, 1990.

Latteier, Carolyn. *Breasts: The Women's Perspective on an American Obsession.* New York: Haworth Press, 1998.

Laver, James. *Modesty in Dress: An Inquiry into the Fundamentals of Fashion.* Boston: Houghton Mifflin, 1969.

Lawal, Babatunde. *The Gélédé Spectacle: Art, Gender, and Social Harmony in African Culture.* Seattle: University of Washington Press, 1996.

Leff, Leonard, and Jerold L. Simmons. *The Dame in the Kimono: Hollywood, Censorship and the Production Code from the 1920s to the 1960s.* New York: Grove and Weidenfeld, 1990.

Leopold, Ellen. *A Darker Ribbon: A Twentieth Century Story of Breast Cancer, Women, and Their Doctors.* Boston: Beacon Press, 2000.

Lerner, Barron. *The Breast Cancer Wars: Hope, Fear, and the Pursuit of a Cure in 20th Century America.* New York: Oxford University Press, 2001.

Levy, Ariel. *Female Chauvinist Pigs: Women and the Rise of Raunch Culture.* New York: Free Press, 2005.

Lindisfarne, Nancy. "Gender, Shame, and Culture: An Anthropological Perspective." In *Shame: Interpersonal Behavior, Psychopathology, and Culture,* edited by Paul Gilbert and Bernice Andrews, 246–261. New York: Oxford University Press, 1998.

Longhurst, Robyn, ed. *Maternities: Gender, Bodies and Spaces.* New York: Routledge, 2011.

Lord, M. G. *Forever Barbie: The Unauthorized Biography of a Real Doll.* Fredericton, NB: Goose Lane Editions, 2004.

Love, Susan M. *Dr. Susan Love's Breast Book*, 5th ed. Cambridge: Da Capo Press, 2010.

Lynn, Eleri, Richard Davis, and Leonie Davis. *Underwear: Fashion in Detail*. London: V&A, 2010.

Lyons, Deborah. *Gender and Immortality: Heroines in Ancient Greek Myth and Cult*. Princeton, NJ: Princeton University Press, 1997.

Macdonald, Myra. *Representing Women: Myths of Femininity in the Popular Media*. New York: Hodder Headline PLC, 1995.

Maher, Vanessa. *The Anthropology of Breastfeeding: Natural Law or Social Construct*. Oxford: Berg, 1992.

Marien, Mary Warner. *Photography: A Cultural History*. London: Laurence King, 2006.

Meyers, Marian, ed. *Mediated Women: Representations in Popular Culture*. Cresskill, NJ: Hampton Press, 1999.

Morgan, Jennifer L. *Laboring Women: Reproduction and Gender in New World Slavery*. Philadelphia: University of Pennsylvania Press, 2004.

Morton, Mark. *The Lover's Tongue: A Merry Romp through the Language of Love and Sex*. Toronto: Insomniac Press, 2003.

Nead, Lynda. *The Female Nude: Art, Obscenity, and Sexuality*. London: Routledge, 1992.

Nead, Lynda. *Myths of Sexuality: Representations of Women in Victorian Britain*. Oxford: Basil Blackwell, 1988.

Nielsen, Jerri, with Maryanne Vollers. *Ice Bound: A Doctor's Incredible Battle for Survival at the South Pole*. New York: Hyperion, 2001.

Olson, James S. *Bathsheba's Breast: Women, Cancer & History*. Baltimore: Johns Hopkins University Press, 2002.

Oram, Alison. *Her Husband Was a Woman! Women's Gender-Crossing in Modern British Popular Culture*. London: Routledge, 2007.

O'Reiley, Michael Kampen. *Art beyond the West*. New York: Henry N. Abrams, 2001.

Orr, Deborah, Dianna Taylor, Eileen Kahl, Kathleen Earle, and Christa Rainwater, eds. *Feminist Politics: Identity, Difference, and Agency*. Lanham, MD: Rowman & Littlefield, 2007.

Pallister, Kathryn. "And Now, the Breast of the Story: Realistic Portrayals of Breastfeeding in Contemporary Television." In *Mediating Moms: Mothers in Popular Culture*, edited by Elizabeth Podnieks, 221–232. Montreal: McGill-Queen's University Press, 2012.

Paoletti, Jo B. *Pink and Blue: Telling the Boys from the Girls in America*. Bloomington: Indiana University Press, 2012.

Parker, Holt N. "Women Doctors in Greece, Rome, and the Byzantine." In *Women Healers and Physicians: Climbing a Long Hill*, edited by Lilian R. Furst, 131–150. Lexington: University of Kentucky Press, 1997.

Paster, Gail Kern. *The Body Embarrassed: Drama and the Disciplines of Shame in Early Modern England*. Ithaca, NY: Cornell University Press, 1993.

Pennington, Jody W. *The History of Sex in American Film*. Westport, CT: Praeger, 2007.

Peril, Lynn. *Pink Think: Becoming a Woman in Many Uneasy Lessons*. New York: W. W. Norton, 2002.

Pitzulo, Carrie, *Bachelors and Bunnies: The Sexual Politics of Playboy*. Chicago: University of Chicago Press, 2011.

Potts, Laura K., ed. *Ideologies of Breast Cancer: Feminist Perspectives*. London: Macmillan, 2000.

Power, Nina. *One Dimensional Woman*. Winchester, UK: Zero Books, 2009.

Rechert, Tom. *The Erotic History of Advertising*. New York: Prometheus Books, 2003.

Richlin, Amy. "Pliny's Brassiere." In *Roman Sexualities*, edited by Judith P. Hallett and Marilyn B. Skinner, 197–220. Princeton, NJ: Princeton University Press, 1997.

Robbins, Trina. *Nell Brinkley and the New Woman in the Early 20th Century*. Jefferson, NC: McFarland, 2001.

Rogers, Mary F. *Barbie Culture*. London: Sage, 1999.

Rubinstein, Ruth P. *Dress Codes: Meanings and Messages in American Culture*. Boulder, CO: Westview Press, 2001.

Rudgley, Richard. *The Lost Civilizations of the Stone Age*. New York: Simon & Schuster, 2000.

Russell, Jane. *Jane Russell: My Path and My Detours*. New York: Franklin Watts, 1985.

Sagert, Kelly Boyer. *Flappers: A Guide to American Subculture.* Santa Barbara, CA: Greenwood, 2010.

Scanlon, Jennifer. *Bad Girls Go Everywhere: The Life of Helen Gurley Brown.* New York: Oxford University Press, 2009.

Scully, Pamela, and Clifton Crais. "Race and Erasure: Sara Baartman and Hendrik Cesars in Cape Town and London." *Journal of British Studies* 47 (April 2008): 301–323.

Shiffman, Melvin A. *Breast Augmentation: Principles and Practice.* Berlin: Springer, 2009.

Slade, Joseph W. *Pornography and Sexual Representation: A Reference Guide,* vols. 1 and 2. Westport, CT: Greenwood, 2001.

Smith, Merril D., ed. *Sex and Sexuality in Early America.* New York: New York University Press, 1998.

Sontag, Susan. *Illness as Metaphor.* New York: Farrar, Straus and Giroux, 1978.

Steele, Valerie. *The Berg Companion to Fashion.* London: Berg, 2010.

Steele, Valerie. *The Corset: A Cultural History,* 6th ed. New Haven, CT: Yale University Press, 2011.

Steele, Valerie. *Fashion and Eroticism: Ideals of Feminine Beauty from the Victorian Era to the Jazz Age.* Oxford: Oxford University Press, 1985.

Streete, Gail. *Redeemed Bodies: Women Martyrs in Early Christianity.* Louisville, KY: Westminster John Knox Press, 2009.

Stuart, Andrea. *Showgirls.* London: J. Cape, 1996.

Sulik, Gayle. *Pink Ribbon Blues: How Breast Cancer Culture Undermines Women's Health.* New York: Oxford University Press, 2012.

Suthrell, Charlotte. *Unzipping Gender: Sex, Cross-Dressing and Culture.* Oxford: Berg, 2004.

Taylor, Thérèse. "'Pity and Also Horror': Public Mourning, Breast Cancer, and a French Queen." In *Medicine, Religion and the Body,* edited by Elizabeth Burns Coleman and Kevin White, 107–127. Leiden: Brill, 2010.

Taylor, Timothy L. *The Prehistory of Sex: Four Million Years of Human Sexual Culture.* New York: Bantam Books, 1997.

Teorey, Matthew. "Unmasking the Gentleman Soldier in the Memoirs of Two Cross Dressing Female US Civil War Soldiers." *International Journal of the Humanities* 20, nos. 1–2 (2008): 74–93.

Ulrich, Laurel Thatcher. *A Midwife's Tale: The Life of Martha Ballard, Based on Her Diary, 1785–1812.* New York: Knopf, 1990.

Wade, Lisa, and Gwen Sharp. "Selling Sex." In *Images That Injure: Pictorial Stereotypes in the Media,* edited by Paul Martin Lester and Susan Dente Ross, 163–172. Westport, CT: Praeger, 2011.

Walter, Natasha. *Living Dolls: The Return of Sexism.* London: Virago, 2010.

Ward, Jule DeJager. *La Leche League: At the Crossroads of Medicine, Feminism, and Religion.* Chapel Hill: University of North Carolina Press, 2000.

Warner, Judith. *Perfect Madness. Motherhood in the Age of Anxiety.* New York: Riverhead Trade, 2006.

Wass, Ann Buermann, and Michelle Webb Fandrich. *Clothing through American History: The Federal Era through Antebellum, 1786–1860.* Santa Barbara, CA: Greenwood, 2010.

Weldon, Jo. *The Burlesque Handbook.* New York: It!, 2010.

Wheelwright, Julie. *Amazons and Military Maids: Women Who Dressed as Men in the Pursuit of Life, Liberty and Happiness.* San Francisco: Pandora-HarperCollins, 1989.

Wilde, Lyn Webster. *On The Trail of the Women Warriors: The Amazons in Myth and History.* New York: Thomas Dunne Books/St. Martin's Press, 2000.

Williams, Florence. *Breasts: A Natural and Unnatural History.* New York: W. W. Norton, 2012.

Williams, Linda. *Screening Sex.* Durham, NC: Duke University Press, 2008.

Winchester, David J., David P. Winchester, Clifford A. Hudis, and Larry Norton. *Breast Cancer.* Hamilton, ON: BC Decker, 2005.

Wolf, Joan B. *Is Breast Best? Taking on Breastfeeding Experts and the New High Stakes of Motherhood.* New York: New York University Press, 2011.

Wolf, Naomi. *The Beauty Myth: How Images of Beauty Are Used against Women*. New York: Anchor/Doubleday, 1992.

Wykes, Maggie, and Barrie Gunter. *The Media and Body Image: If Looks Could Kill*. Thousand Oaks, CA: Sage, 2005.

Yalom, Marilyn. *A History of the Breast*. New York: Ballantine, 1997.

Zeitz, Joshua. *Flapper: A Madcap Story of Sex, Style, Celebrity, and the Women Who Made America Modern*, reprint ed. New York: Broadway Books, 2007.

Zimmerman, Susan M. *Silicone Survivors: Women's Experiences with Breast Implants*. Philadelphia: Temple University Press, 1998.

WEBSITES

BREAST CANCER

Avon Foundation for Women: http://www.avonfoundation.org

Provides funding and information for breast cancer research and awareness, and for domestic violence programs and research.

Breast Cancer Action (BCAction): http://bcaction.org

BCAction was founded in 1990. It is a "national, feminist grassroots education and advocacy organization working to end the breast cancer epidemic." One of its major projects is Think Before You Pink, which asks consumers to question the Pink Ribbon products and advertising, and BCAction calls for "more transparency and accountability by companies that take part in breast cancer fundraising."

Breast Cancer Consortium: http://breastcancerconsortium.net

Founded by medical sociologist Gayle Sulik, this international, collaborative, and multidisciplinary project aims to increase the "understanding of the social, cultural, and other system-wide factors that affect breast cancer." The website includes multimedia features, current research projects, resources for further reading, links, and a blog.

Breastcancer.org: http://breastcancer.org

"Breastcancer.org is a nonprofit organization dedicated to providing the most reliable, complete, and up-to-date information about breast cancer." All of its medical information is reviewed by medical professionals.

Dr. Susan Love Research Foundation: http://www.armyofwomen.org/drlovefoundation

The organization, founded by Dr. Susan Love, is dedicated to finding out how to prevent and cure breast cancer.

Edwin Smith Surgical Papyrus: http://archive.nlm.nih.gov/proj/ttp/flash/smith/smith.html. Purchased by the American archeologist Edwin Smith in 1862, this is one of the oldest surviving medical texts in the world, created about 1600 BCE. It is written in the hieratic script of ancient Egypt. Although primarily concerned with battle trauma, there is some discussion of chest tumors.

National Breast Cancer Coalition (NBCC): http://www.breastcancerdeadline2020.org/about-nbcc

Cofounded by Dr. Susan Love, this umbrella organization of more than 180 breast cancer advocacy groups currently has a goal to end breast cancer by January 1, 2020. The website features a real-time deadline countdown.

Silent Spring Institute: http://www.silentspring.org

This institute was named to honor Rachel Carson, who died of breast cancer 2 years after the publication of her book, *Silent Spring*, which helped to launch the environmental movement in the United States. The institute was founded in 1994. Its goal is to examine the environment to find ways to prevent causes of cancer, with breast cancer being a primary area of research.

U.S. National Library of Medicine: http://www.nlm.nih.gov/digitalprojects.html
Numerous online books, images, and exhibits. Many discuss breasts and breast cancer.

BREASTFEEDING

International Lactation Consultant Association: http://www.ilca.org/i4a/pages/index.cfm?pageID=1
A worldwide organization of lactation consultants. It provides resources and education on breastfeeding. The site includes a directory that is updated every 2 weeks for people searching for a lactation consultant. World Alliance for Breastfeeding Action: http://www.waba.org.my
Founded in 1991, the WABA is a global network of individuals and organizations that are concerned with the protection, promotion, and support of breastfeeding worldwide. The WABA sponsors conferences and events, as well as World Breastfeeding Week (see http://worldbreastfeedingweek.org).

PROTEST AND SOCIAL AWARENESS

Topfree Equal Rights Association (TERA): http://www.tera.ca. TERA is an organization that aims to help women, particularly in the United States and Canada, who encounter difficulty going without tops in public places. It also educates and informs the public about this issue.
Women under Siege, Women's Media Center: http://www.womenundersiegeproject.org. Tracks rapes in war, which often involve breast and genital mutilation.

TELEVISION AND MOVIES

Below is a sampling of shows and movies out of the thousands that feature, display, or provide information about breasts. For more information on the breasts in film, *see* FEMALE ACTION HEROES; HOLLYWOOD; MOVIES; PINUP GIRLS; PORNOGRAPHY; RUSSELL, JANE; TELEVISION.

Albert Nobbs (2012, dir. Rodrigo Garcia). Glenn Close stars as Albert Nobbs, a woman who passes as a man in order to survive in nineteenth-century Dublin.

Baywatch (1989–2001). This popular television show was about a group of lifeguards on a beach. The show was mainly an excuse to watch attractive people in skimpy bathing suits run on the beach. Two of the female stars were Pamela Anderson and Carmen Electra.

"Breast Hysteria," *Bullshit* (first aired April 5, 2007). In this episode of magician-entertainer Penn Jillette's and Teller's series, they interview people about breastfeeding and exposing breasts in public, and also consider the value of Pink Ribbon campaigns.

Coffy (1973) and *Foxy Brown* (1974; both dir. Jack Hill) were two of the most popular blaxploitation films of the 1970s. Both movies star Pam Grier. In these movies, her breasts are prominently displayed and her character uses them to great effect to seduce and distract the villains.

The Deep (1977, dir. Peter Yates). Jacqueline Bisset swims underwater in a thin, white T-shirt that clings to her bare breasts, helping to spark wet T-shirt contests.

"The Doorman," *Seinfeld* (first aired February 23, 1995). In this episode, Kramer invents a man bra he wants to call "the bro." George Costanza's father, Frank, wants to call it the "Mansseire."

Everything You Always Wanted to Know about Sex but Were Afraid to Ask (1972, dir. Woody Allen). This film includes a scene with a giant runaway breast that terrorizes the local population.

Miss Representation (2011, dir. Jennifer Siebel Newson). This American documentary explores how women are represented in the mainstream media.

Mrs. Doubtfire (1993, dir. Chris Columbus). Robin Williams stars as a newly divorced father who is determined to see his children. He dresses as a woman, and his ex-wife hires him as her housekeeper. In one scene, while he is dressed as Mrs. Doubtfire, he accidentally sets his fake breasts on fire.

Mrs. Henderson Presents (2005, dir. Stephen Frears). This British comedy is based on the true story of the Windmill Theatre in London. After a 70-year-old widow, played by Judi Dench, purchases the theatre, she decides to add female nudity to the revues. The government declares that the nude performers must remain still to be considered art (and thus not subject to censorship). Performances continue through World War II bombings of London.

No Family History (2008, dir. Sabrina McCormick). This documentary focuses on Robin Caslenova's experience with breast cancer. Her story is linked with the high incidence of breast cancer on Long Island, New York, and the film discusses environmental factors as a cause of the disease.

Pink Ribbons, Inc. (2012, dir. Léa Pool). Based on the book by Samantha King, this full-length documentary debunks the myths of the Pink Ribbon industry.

Shakespeare in Love (1998, dir. John Madden). In this romantic comedy-drama, Viola (Gwyneth Paltrow) dresses as a man to act on stage. William Shakespeare (Joseph Fiennes), who is struggling to finish *Romeo and Juliet* (which he first calls *Romeo and Ethel, the Pirate's Daughter*), falls in love with her. There are shots of breasts and breast binding and unbinding.

Showgirls (1995, dir. Paul Verhoeven). A young woman arrives in Las Vegas determined to become a showgirl. The movie was rated NC-17 and contains nudity and sex.

Some Like It Hot (1959, dir. Billy Wilder). In this Oscar-winning comedy, Tony Curtis and Jack Lemon are musicians who accidentally witness the St. Valentine's Day massacre in Chicago. To escape the gangster mob, they dress as women and join an all-female band, which includes Marilyn Monroe's character, Sugar Kane Kowalczyk. The movie's tag line was "Marilyn Monroe and her bosom companions."

The Outlaw (1943, dir. Howard Hughes). This odd western is supposed to be about Billy the Kid, but it focuses mainly on Jane Russell's breasts in revealing attire.

ABOUT THE EDITOR AND CONTRIBUTORS

Merril D. Smith is an independent scholar, author, and editor of several books, including *History of American Cooking* (2013), *Women's Roles in Eighteenth-Century America* (2010), and *Encyclopedia of Rape* (2004).

CONTRIBUTORS

Tosin F. Abiodun is a graduate student studying African history at the University of Texas at Austin.

Mary A. Afolabi-Adeolu teaches government and history at Zamani College, Kaduna, Nigeria.

Y. Gavriel Ansara is completing his PhD in psychology at the University of Surrey and is internationally recognized for his health policy work.

Rachelle Beaudoin is an artist who uses video, performance, and wearable sculpture to explore feminine iconography and identity within popular culture. She is a lecturer at Saint Anselm College, New Hampshire.

Israel Berger holds a PhD in psychology from the University of Roehampton in London, England, and is a medical student at the University of Sydney.

Sarah E. Bruno is an English 1 instructor at Lehigh University, where she received her MA in English and her graduate certificate in women, gender, and sexuality studies in May 2013.

Kelly L. Burgess is a licensed and registered dietician and the owner of To Better Health, LLC, a nutrition-counseling private practice in West Deptford and Cherry Hill, New Jersey.

Alison J. Carr is an artist and writer. She received her PhD from Sheffield Hallam University in 2013, where she is an associate lecturer. She completed her MFA at the California Institute of the Arts in May 2009 and BA (Hons) in fine art at Sheffield Hallam University in 2001.

Matthew Cheeseman, PhD, is a researcher at the University of Sheffield. He can be contacted at http://www.twitter.com/eine and keeps a website at http://www.einekleine .com.

Amber E. Deane, PhD, is an assistant professor in the Department of Behavioral Sciences with a specialization in medical sociology at Albany State University in Albany, Georgia. She is interested in the social construction of health and illness.

Natalie E. Dear has a PhD from the University of Alberta, Canada. Her research concentrates on the representation of women in medieval and early modern literatures.

Nora Doyle is a PhD candidate in history at the University of North Carolina at Chapel Hill.

Donna J. Drucker is a postdoctoral fellow in the Topologie der Technik Graduiertenkolleg at the Technische Universität Darmstadt, Germany.

Jennifer Rachel Dutch graduated from the Pennsylvania State University, Harrisburg, with a PhD in American studies specializing in foodways. Her research focuses on home cooking traditions in the twenty-first century.

Michelle Fitzsimmons received her MA in public history at the University of Missouri–Kansas City. She specializes in the history of medicine.

Claudia J. Ford is a doctoral candidate in environmental studies and a midwife.

Jennifer D. Grubbs is a PhD candidate in anthropology at American University, Washington, D.C. Her dissertation, titled "Queer(ey)ying the Ecoterrorist: Neoliberal Capitalism, Political Repression as Discipline, and the Spectacle of Direct Action," coalesces intersectional research on activism, state violence, and liberation.

Stephanie Laine Hamilton is freelance writer and historical consultant in Crowsnest Pass, Alberta, Canada.

Oliver Benjamin Hemmerle, from Mannheim, Germany, is currently visiting professor at Stendhal-Grenoble 3 University, France.

Matthew Hollow is a research associate on the Tipping Points Project in the Institute of Hazard, Risk and Resilience, Durham University, UK.

Elizabeth Jenner is a test developer at the Educational Testing Service. She lives in Princeton, New Jersey.

Sara Smits Keeney is an assistant professor of sociology at Saint Anselm College in Manchester, New Hampshire.

Rhonda Kronyk is a PhD candidate at McGill University. Her main area of interest is gender and public identity in Restoration London.

Tonya Lambert, MA, is a freelance author and historian living in Edmonton, Alberta, Canada.

Fibian Lukalo is a visiting international scholar of educational anthropology at the School for Advanced Research in the Human Experience, Santa Fe, New Mexico.

Alina Łysak graduated from pedagogy and cultural anthropology studies. She is currently working on a doctorate thesis devoted to multicultural counseling.

Visam Mansur is a professor of English literature at Beykent University in Istanbul, Turkey.

Lorcan McGrane has studied at the University of Ulster, Dublin Institute of Technology, and University of East Anglia (UEA) in the areas of media studies and film and television studies. He has taught courses on Hollywood cinema and television sitcom at UEA, and graphic design theory, cultural theory, and gender studies at Norwich University College of the Arts and Lowestoft College. His current writing projects include *Superheroic Bodies: The Corporealities of Contemporary Film Superheroes*.

Tariqah Nuriddin is an assistant professor of sociology at Howard University in Washington, D.C. Her broader research focuses on social inequality, mental health, coping behavior, and the health of vulnerable populations. Currently, she is working on a qualitative exploration of past health practices and home remedies among formerly enslaved African Americans.

Erin Pappas is a Chicago-based writer and librarian.

Lori L. Parks, PhD, is currently teaching art history as an adjunct professor at Miami University, Ohio. Her research interests focus on issues pertaining to the body and its representation in art, visual culture, and theory through an interdisciplinary approach.

Kaitlyn Regehr is a television presenter and choreographer whose work examines the history of women's sexuality and its representation in performance. She is currently writing a PhD at King's College London.

Saul M. Rodriguez is a social scientist and independent researcher.

Laura Schechter received her PhD from the University of Alberta in Edmonton, Alberta, Canada.

Cristina Lucia Stasia received her PhD in English from Syracuse University and has published on postfeminism, female action cinema, and the bisexual star text of Angelina Jolie.

Aneta Stepien is Thomas Brown Assistant Professor in the School of Languages, Literatures and Cultural Studies at Trinity College Dublin. She is coordinator of Polish studies and teaches various modules on Eastern and Central European history, culture, and literature.

Gayle Sulik, author of *Pink Ribbon Blues: How Breast Cancer Culture Undermines Women's Health*, is a medical sociologist affiliated with the University at Albany (State University of New York) Department of Women's Studies and founder of the Breast Cancer Consortium.

Thérèse Taylor teaches modern history and media studies at Charles Sturt University, Australia. She is the author of numerous articles and also a scholarly biography, *Bernadette of Lourdes: Her Life, Her Death and Her Visions* (London Continuum Press, 2003).

Victoria Team is a postdoctoral research fellow at the Mother and Child Health Research Centre, La Trobe University, Australia.

Adriana Teodorescu is a PhD researcher at "1 December 1918" University in Alba Iulia, Romania.

Chris Vanderwees is a PhD candidate in the Department of English Language and Literature at Carleton University, Ottawa, Ontario, Canada.

Victoria Williams, PhD, is an independent scholar researching British folklore and European fairy tale, British and American film (particularly the female Gothic films of the 1940s and the work of Alfred Hitchcock), and Victorian art and literature.

Mathew Wilson is an independent scholar and historian living in Sarasota, Florida.

Dorothy Woodman received her PhD in English and film studies from the University of Alberta in Edmonton, Alberta, Canada.

Edyta Zierkiewicz is an assisting professor at Wroclaw University, Poland, in the Pedagogy Institute, Counseling Department. She is author of *Rozmowy o raku piersi. Trzy poziomy konstruowania znaczeń choroby* (*Talks about Breast Cancer: The Three Layers of Meaning Constructing of Sickness*; Wroclaw, Poland: Atut, 2010). She is currently working on a book about representations of breast cancer in popular women's magazines and reception of these images by their readers, and another about a president of a federation of breast cancer survivors in Poland.